Believing and Seeing

Symbolic meanings in southern San rock paintings

For my mother and in memory of my father

This is a volume in **Studies in Anthropology**, under the consulting editorship of E. A. Hammel, University of California, Berkeley. *A complete list of titles appears at the end of this volume.*

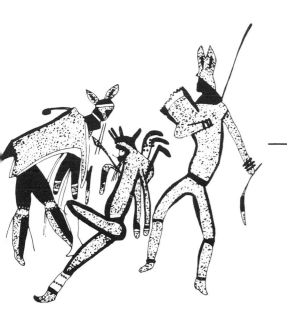

Believing and Seeing

Symbolic meanings in southern San rock paintings

J. David Lewis-Williams

Department of Archaeology
University of the Witwatersrand, Johannesburg

1981

ACADEMIC PRESS

A Subsidiary of Harcourt Brace Jovanovich, Publishers
London New York Toronto Sydney San Francisco

ACADEMIC PRESS INC. (LONDON) LTD.,
24/28 Oval Road, London NW1

United States Edition published by
ACADEMIC PRESS INC., 111 Fifth Avenue, New York, New York 10003

British Library Cataloguing in Publication Data

Lewis-Williams, J. David
 Believing and seeing. — (Studies in anthropology)
 1. Rock paintings — Africa, South — Criticism
and interpretation
 2. San (African people)
 I. Title II. Series
 732'.2'09684 N5310.5.S6

ISBN 0-12-447060-2
LCCN 80-42370

Printed in Great Britain by The Lavenham Press Ltd.

David Lewis-Williams in *Believing and Seeing* presents a penetrating study of San* rock paintings in the Drakensberg Mountains in South Africa. The study of the paintings leads to a thoughtful and clarifying discussion of symbols and their function, in general, and to the interpretation of the function of the rock paintings as symbols in the ancient San culture. Furthermore, the study makes a valuable contribution to current ethnographic studies of the living San—it links various elements of the ancient culture as they appear in the paintings with concepts and values which the San hold in the present.

Southern Africa is one of the world's richest treasuries of Stone Age art, comparable to the famous caves of the Dordogne in central France and those of northern Spain. The Drakensberg Mountains have the greatest concentration of paintings of all the many areas in southern Africa in which rock art is found. There are thousands of sites in its ravines and gorges where the last of the now extinct southern San left the enigmatic record of their thoughts and beliefs.

The existing paintings on the Drakensberg rocks are not as old as the paintings at Lascaux, Altamira, and the other caves of France and northern Spain. It is not known how far back into South Africa's Stone Age the *tradition* of painting reaches; the oldest paintings actually *existing* on the rocks are believed to reach no further back than South Africa's Late Stone Age, according to A. R. Willcox, who is a specialist and a great authority on the paintings. He estimates the oldest to be no older than 1500 B.P. There could have been older paintings which have vanished. The Drakensberg paintings are in open rock shelters and exposed to weathering, rather than protected in deep caves like the European paintings.

One of the very interesting aspects of the Drakensberg paintings is not their great antiquity, but the fact that man's ancient stone age tradition of painting is brought to touch upon the present.

*The name *San* may be unfamiliar to some readers and in need of explanation. The San are Africa's well known Bushmen who have engaged the interest of all manner of people, scientists and non-scientists, since the arrival of the Dutch at the Cape of Good Hope over three centuries ago. Feeling that the name Bushman was derogatory when it was first applied, and that the name continues to hold derogatory connotations, several anthropologists of the current younger generation have adopted another name—*San*. The Bushmen have no name for their people as a whole; San is their name in the Hottentot language. The name is being used more and more widely in current publications and may indeed become the generally accepted race name of those people, if it is not so already.

Having used the name *Bushman* for years in my own writings about the !Kung Bushmen, I continued using it. I felt it had ceased to be a derogation and had become the race name, and, although I had no particular objection to the name *San*, I felt it was too late for me to change. However, since Dr Lewis-Williams uses *San* in this book, I am glad on this occasion to change and I do so in this Foreword.

The painters were still at work as late as the middle of the nineteenth century. A few of the paintings depict European trekkers with horses, wagons, and guns.

Dr Lewis-Williams began his study of the rock paintings in 1959. The turn of the decade into the 1960s was a propitious time, in that new research techniques were coming into use, new archaeological and ethnographic data were accumulating, and attitudes were changing.

During the 1950s interest in rock art had been lively; but firm knowledge was scant. It was the fashion to ask, of the paintings, who?, where?, when?, how?, and why? What was the meaning of the many, to our eyes, strange and enigmatic images? Walter Battiss in *The Artists of the Rocks* (1948) wrote of various opinions on which people took sides, and gave his answer:

One school holds that there is Egyptian influence in the art, the other that the art is autochthonous. One school claims that foreigners are depicted in the paintings, the other school says they are Bantu figures and Bushmen in ceremonial dress. One school says that extinct animals, such as the mammoth, the giant buffalo, the Cape horse, are depicted in the engravings. One school believes that the engravings and paintings are the work of the same people, another that they are separate and distinct. One school maintains that all the paintings in the Union are by one people over a period of time, another, that different peoples painted in the rock-shelters.

One can dive into this maelstrom of opinions and be utterly lost. Happily there are a few sober ways of approaching prehistoric art. The first is to ignore all theories and to look at the originals of prehistoric art as one would look at paintings in an art gallery, that is, to look at them so that the *eye* enjoys them for their calligraphy, their colour, their composition, their form and structure. That is pure aesthetic enjoyment. A great deal of prehistoric art is beautiful to look at! The other sober way is to go up the mountains and down into the valleys to the sites and to discover for oneself what the rock-shelters reveal.

It was the fashion among some to doubt that the painters were San. Some claimed that available archaeological evidence was insufficient to prove the connection between the San and the paintings; some other prehistoric race might have made them. There was much discussion over Abbé Breuil's suggestion of foreign influence having somehow reached the Brandberg and Drakensberg fastnesses. In the nineteenth century, G. W. Stow tells us, the /Xam San (the southern San) were regarded by their enemies as "the lowest of the low", "hardly above the animals", "vermin". At best they were thought to be retarded, childlike, and heedless, not capable of making beautiful works of art, especially the beautiful shaded eland paintings and the exquisite elands engraved on the boulders. We encountered similar views lingering on in South West Africa as a stereotype. To the people we met who held that the San were retarded or "vermin", our high opinion of the intelligence of the Nyae Nyae !Kung, our respect of their customs, our admiration and liking for them was quite beyond belief. Believing it impossible that we were making our expeditions to study the culture of the "vermin", they thought we must be secretly prospecting for diamonds.

Gradually some of the questions yielded to accumulating data. It became certain that the Drakensberg painters and those in most other sites were indeed San, though some paintings of less artistic merit in some other areas may have been made by Bantu-speakers or Bergdama. The questions that remained unanswered regarded why the Drakensberg painters painted, and what was the meaning of the many strange and enigmatic images. One commonly held opinion was that the enigmas could never be resolved and that, in any event, it was pleasant to leave the paintings shrouded in mystery.

Dr Lewis-Williams took another view; he believed that the paintings could be understood. He realized that as his first step he must learn their content. From Stow in the 1870s until the 1950s, every collector had disregarded many of the paintings, had selected certain ones to copy, and further selected which ones to publish, according to his own interests. Dr Lewis-Williams was aware of the warnings that Dorothea Bleek and van Riet Lowe had given of distorted impressions introduced by, as Dorothea Bleek had said, "the white man's selectivity". For his sample of study, he chose two areas rich in paintings, Giant's Castle and Barkly East, and began the ambitious and painstaking task of recording every painting: 3,600 in all. With exceptionally keen power of observation and thoughtful attention, he took note of every human figure, every animal, every object. He eventually submitted this inventory to numerical analysis. He could thus make a statement on the content of the paintings as the San had left them and he could show that certain themes were of special significance to the San. He could also refute some ideas that had become popular. Pictures of hunting scenes do not predominate, as had been assumed. He found no evidence to support the idea that the paintings had been used for sympathetic magic to control the game, secure the hunter's success, or make the game prolific.

Dr Lewis-Williams was not alone in taking the exacting modern approach of numerical analysis. Another young researcher was studying a large sample area in the same way. Patricia Vinnicombe, author of the splendid book, *People of the Eland*, had grown up among paintings in the vicinity of her home in Natal and had made tracings of them for years. She began in 1958 to apply a numerical analysis to her immense collection. These two young researchers have different insights on some points, but they confirm and enrich each other's work. The work of both reveals that although some of the paintings, especially scenes of cattle raids, of combat with Bantu, and scenes showing Europeans, were apparently painted to show what the events looked like, the bulk of the paintings were not purely representational, nor were they *art pour l'art*, made for the pleasure of the artist and the beholder. The paintings held deeper meanings for the San; they were the expression of beliefs and values.

In his endeavour to penetrate the meaning of the paintings, Dr Lewis-Williams brought three bodies of ethnographic material into convergence with the numerical analysis of his samples. More thoroughly, I believe, than any of the other researchers, he studied the nineteenth century literature, especially the Orpen material and the unpublished as well as the published material of the Bleek family, giving keen attention to exactly what San informants had said about the paintings they were shown. There was two-way illumination: sometimes a detail of the painting was illuminated by the text of the San informant; sometimes a detail of the text was illuminated by the paintings.

Another source of information that Dr Lewis-Williams examined was the ethnographic data that

had been recently accumulating about the !Kung living in South West Africa (Namibia) and Botswana. My family and I had begun an ethnographic study of the !Kung of the Nyae Nyae area in South West Africa in 1951. We had spent a year with them in 1952-3 and shorter periods of study on five other expeditions through the decade. Through that decade, the !Kung we worked with remained completely independent hunter-gatherers, living by their own old cultural forms. Change was to come later.

During the 1960s interdisciplinary studies of the !Kung in western Botswana were being conducted by the Harvard Kalahari Research Group and several other anthropologists working independently. Dr Lewis-Williams made a thorough study of the ethnographic reports and, admirably prepared, he made his own field trip to the !Kung in Botswana in 1975 and worked with !Kung informants with the help of Dr Megan Biesele. Because of his mastery of the details in the paintings and because he had greater knowledge of the nineteenth century literature than any of the other researchers, he could ask questions and elicit information from the !Kung that had not been brought out before. Again there was interplay and mutual illumination between the ethnography and the paintings.

Dr Lewis-Williams's direct communication with me was about certain San rituals—the curing dance, the trance behaviour of the medicine men, and the Eland Dance of the menarcheal rite. These rituals are a common heritage, performed in essentially the same form by all the extant San groups in the Kalahari that we visited, Naron, Auen, !Aikwe, Tsaukwe, !Kõ and /Gwi, as well as !Kung. I received Dr Lewis-Williams's every com-

munication with excitement. He sent accurate detailed tracings which opened my eyes and riveted my attention to the paintings as no other reproductions had. One has a fine visual experience looking at the splendid modern photographs of the paintings in the books of Willcox (1956, 1963) and Pager (1973), but the details are brought out best by tracings. The similarity between the painted scenes Dr Lewis-Williams sent me and scenes that were familiar to me was striking. The formation of the dances, postures of the people, the garments, rattles, bows, arrows, hunting bags were all similar, but not the digging sticks. The San in the rocky Drakensberg used weighted digging sticks, whereas in the Kalahari sands the digging sticks are unweighted. I felt that without doubt I was seeing in the paintings cultural elements that had persisted for unknown centuries, and were still vital to the living San. I felt I had reached across language barriers and thousands of miles of space. I was deeply moved to feel so direct a link with man's past.

The eland emerges as a central symbol. In *Believing and Seeing*, Dr Lewis-Williams examines it as it appears in the paintings of the southern San and in the northern San *rites de passage*, in rain rites, in trance behaviour, and in its relationship to the southern San deity /Kaggen.

The eland is so prominent a symbol in the living San *rites de passage*—the menarcheal rite, the rite of a young hunter's first eland kill, the marriage rite—that Dr Lewis-Williams gracefully calls it an *"animal de passage"*. The way in which he shows these *rites de passage* to be related to each other (a triptych) is, in my opinion, a valuable contribution in itself to San studies.

The eland symbol is made visible in innumer-

able southern San rock paintings on the walls of the shelters where the southern San people lived. The several northern San language groups that we visited are not painters, perhaps because they live on the deep Kalahari sand and have no rocks. Music is their great art, and it is in music that they have preserved an eland symbol. Nicholas England in his Ph.D. thesis, *Music Among the ju'/'wa-si of South West Africa and Botswana* (p. 483), tells us that the eland is associated with a unique and ancient musical scale from an old (perhaps very old) layer of musical culture. Only two songs built on that scale are extant, The Great Eland Song sung at the menarcheal rite and The Rain Song. The songs are sung in the same manner by all the above-mentioned San language groups, notably with sounds of eland footbeats represented, and with a certain rising pitch.

Thoughtfully and empirically, Dr Lewis-Williams comes to his understanding of the meaning and function of the eland symbol. That is what this book, *Believing and Seeing*, is about. The eland symbol is designed to bring a cluster of values to the people's consciousness by association of ideas. The eland has diverse associations having to do with the well-being of individuals and the well-being of the group; the menarche, rain, fertility, the hunter's success, eland fat, fatness of the people, plenty, social cohesion, the values of the curing rite and trance. In the "complex web of San thought and belief," to use Dr Lewis-Williams's phrase, the meaning of the symbol lies in the awareness that all the contexts are related.

In *Believing and Seeing* the study of San rock art is brought to a new stage and the present ethnography of the San is enriched and illuminated.

Lorna Marshall

March 1981 *Cambridge, Massachusetts*

Rock art from Palaeolithic Europe to twentieth century Australia poses many problems. Perhaps the most intriguing is the meaning of the art; like the "silent forms" on Keats's urn, the rock paintings "tease us out of thought as doth eternity". In most parts of the world an elucidation of the enigmatic depictions seems a forlorn enterprise: the student has no guide other than the art itself and ambiguous archaeological remains. In these impoverished circumstances writers have sometimes concentrated on the form or structure of the rock art. Analyses in western Europe, for instance, have pointed to certain formal properties which suggest that the art is systematic rather than the idiosyncratic depictions of individually inspired artists. Unanimity on even this initial and apparently empirical level has not yet been achieved, but, when we try to move from the "grammar" of the art to semantics, the difficulties seem insuperable. It is at this point that many writers forfeit their readers' indulgence.

In southern Africa the conditions for the ambitious task of interpretation are far more propitious. The often remarkably beautiful art of this region was executed by the San (Bushmen) who formerly occupied most of the sub-continent, but today survive only in the Kalahari Desert. There are literally thousands of San rock art sites containing innumerable depictions. By 1981, 3931 art sites had been recorded by the Archaeological Data Recording Centre in Cape Town; many more are known but have not yet been reported. This impressive total excludes the very numerous and important sites in Zimbabwe, Namibia, Botswana and Lesotho. There is an embarrassment of riches. But quantity alone does not necessarily facilitate understanding. Fortunately, there are two ethnographic sources in southern Africa which make the interpretation of this vast corpus a more sanguine undertaking. This ethnography provides independent evidence on the social structure and ideology of the painters—an invaluable aid not enjoyed by students of the European Palaeolithic art.

The older of the two ethnographic sources comprises many thousands of pages which were taken down verbatim from nineteenth century San. None of the informants was himself a painter, but they recognized the art as the products of their own people, and they had the same cognitive system as the last artists. To this primary source may be added the growing ethnography on the modern Kalahari San. Although these people belong to a different linguistic group and are widely separated in time and space from the southern artists, it has become increasingly clear that they too have a very similar cognitive system. In the following chapters I analyse numerous rituals and metaphors which are described in the nineteenth century record and which are still preserved in the Kalahari.

It is these rituals and metaphors, I argue, that are the real keys to the art. Once we have identified the relevant ritual contexts we can "read" the rock art in a way that is impossible in most parts of the world. What were formerly considered baffling and confused images are in fact carefully constructed statements. The southern African art thus provides a remarkable insight into the way in which rock art functioned in at least one hunter-gatherer society. It would, of course, be rash to suggest that what we can learn from the San art illuminates rock art elsewhere, but it does at least provide a well documented case study. Any data on so elusive a goal as understanding hunter-

gatherer rock art is to be prized.

My quest started a long while ago, and my debt to many people has grown over the years. Indeed, a task of this nature which involves so much field work in addition to more ''academic'' research cannot be completed without the assistance of generous and tolerant friends. Now, as a prelude to describing the results of what has really been a collaborative effort, I welcome the opportunity to thank them.

I owe a great debt of gratitude to Megan Biesele who not only answered my written questions, but also acted as my guide and interpreter in the Kalahari. Lorna Marshall, to whom all students of the San are so indebted, has also been most generous with her own material and has kindly written a Foreword. Pat Vinnicombe has, over a

number of years, afforded me friendly and generous cooperation. Alex Willcox, the doyen of southern African rock art studies, kindly gave permission to copy one of his photographs, and Neil Lee and Bert Woodhouse permitted me to use two of their copies. Paul den Hoed drew Fig. 30 and Peter Sievers Fig. 1. John Argyle's trenchant criticism and friendly encouragement can be discerned on every page; he meticulously supervised an earlier incarnation of this book which was submitted as a Ph.D. thesis to the University of Natal.

Many other friends, too numerous to name, accompanied me on field trips and assisted with the laborious work of recording the paintings. Students from the Departments of Archaeology and Social Anthropology, University of the

Witwatersrand, and Kearsney College, Natal, also provided indispensable assistance in the field.

I owe a particular debt of gratitude to the President and Council of Clare Hall, Cambridge, for granting me an Associate Fellowship in 1974. The Librarian of the Jagger Library, University of Cape Town, gave permission for me to read and quote from the extensive Bleek collection; and the Director of the South African Public Library, Cape Town, has allowed me to use material in his care. I gratefully acknowledge research grants from the Departments of Archaeology and Social Anthropology, University of the Witwatersrand. Arlene Guslandi kindly typed and retyped parts of the manuscript.

March 1981 *J. David Lewis-Williams*

Contents

Illustrations

Orthography

Many of the San words used in this book contain sounds unfamiliar to English-speakers. In addition to the more usual phonetic representations the following symbols are used for the clicks which are a distinctive feature of the Khoisan languages; I take the descriptions of these sounds from Marshall (1976, p. xx).

/ *Dental click.* The tip of the tongue is placed against the back of the upper front teeth; in the release, it is pulled away with a fricative sound. English-speakers use a similar sound in gentle reproof.

! *Alveolar-palatal click.* The tip of the tongue is pressed firmly against the back of the alveolar ridge where it meets the hard palate and is very sharply snapped down on release. A loud pop results.

≠ *Alveolar click.* The front part of the tongue, more than the tip, is pressed against the alveolar ridge and drawn sharply downward when released.

// *Lateral click.* The tongue is placed as for the alveolar click. It is released at the sides by being drawn in from the teeth. Drivers of horses sometimes use lateral clicks to signal their horses to start or go faster.

☉ *Labial click.* The frontal closure is made with pursed lips; when the lips are released, the sound is like a kiss. This click is found only in southern San languages.

Another sound which appears frequently is X. It is a guttural sound as in the Scottish *loch*.

Illustrations

The illustrations of rock paintings in this book are black and white reductions of the colourful originals. Full-colour reproductions would have been aesthetically preferable, but colour printing is prohibitively expensive and not essential to an understanding of the text. Unless otherwise stated in the caption, solid black represents red, the most common colour, but where red is juxtaposed with black, it has been impossible to be consistent; the less prominent of the two colours, be it red or black, is then usually stippled. Stippling is also used to show the shading or fading of colours; readers should bear in mind that stippling is not a feature of the original paintings. White always represents that colour in the original paintings.

Part I

Chapter 1

Rock Art and Semiotic

You can write down the word 'star', but that does not make you the creator of the word, nor if you erase it have you destroyed the word. The word lives in the minds of those who use it. Even if they are all asleep, it exists in their memory.

C. S. Peirce (1931, II, p. 169).

The people who made the paintings with which this book is concerned have all been long asleep, and will not awaken to reveal what their memories held about their art. The paintings, scattered by the thousand in the rock shelters of southern Africa, are an astonishing yet enigmatic testimony to the complex beliefs of their creators. There has been some debate about the authorship of this abundant art, but it is now generally agreed that most of it was painted by the San or, as they are more popularly known, the Bushmen. These people were hunter-gatherers who lived over most of southern Africa; today the only surviving San live in the region of the Kalahari, and have become one of the best known hunter-gatherer societies.[1] Less is known about those who formerly lived to the south and executed the paintings. Although their art has become justly famous for its extraordinary beauty, the meaning of the paintings has remained obscure: the last artists died nearly a century ago.

Nevertheless, despite there being no southern informants whom we can now approach, I believe the significance of the art is indeed recoverable and that it communicated ideas and values central to San thought. The paintings were not all "innocent playthings", as the missionary Arbousset (1846, p. 252) described them, but were images which, because of their centrality in San belief, must have had a powerful impact on the original San viewers. Obviously, any attempt to distinguish and interpret these images must start from the paintings themselves and from the con-siderable, if unsatisfactory, literature on the southern San; but it is also necessary to adopt a model of the way in which the paintings communicated the ideas and values which I discuss in Part Two of this book.

The model I employ is a semiotic one deriving initially from the work of Charles Sanders Peirce and Charles Morris. My use of it represents a departure from some of my previous essays in this field; I have formerly favoured a linguistic model of the kind advocated by Lévi-Strauss (1968) and Leach (1976) and used so effectively by Humphrey (1971) and others. But I have become somewhat dissatisfied with the linguistic model because it tends to impute to the data a form which they do not posses (see Sperber, 1975). The linguistic model is only *one* member of the more general class of "communication" or "signs". To interpret visual signs as a kind of language is, therefore, to reduce one member of the class to

3

another member. To avoid this "reductionist" approach, I prefer, at the present stage of research, to use the *general* theory of signs as enunciated by Peirce and Morris. Even in using the Peirce-Morris semiotic, I have tried not to construct too elaborate a model that establishes a proliferation of distinctions and nomenclature that cannot really be derived from the material itself. Too enthusiastic an application of either the semiotic or the linguistic model lends the study a spurious complexity tending to imply knowledge in areas actually dominated by ignorance. I see little value in introducing terms which, by the nicety of their distinctions, will create an impression of confidence where none is warranted. Throughout the study, therefore, I try not to apply even the comparatively simple model I have selected where it is not justified by the material and where its application would be a deception: there are many things we do not know and, short of the unlikely discovery of a hitherto unknown body of ethnographic data on the extinct southern San, we never shall know. It is as well to acknowledge here at the beginning of our enquiry that there are very real intrinsic limitations in the material and therefore in the applicability of my chosen model. Nevertheless I believe the model helps to clarify our understanding of the art.

This model takes the paintings as "signs" and, in the words of Peirce (1931, II, p. 142), proposes that "a *sign* is a representamen of which some interpretant is a cognition of a mind". By "interpretant" I mean a disposition in the mind of the interpreter of the sign to respond to it in a certain way. Arriving at some idea of what that interpretant may have been in the minds of those now long dead is an end often considered unattainable,

but to which I optimistically strive. The nature of this elusive interpretant is clarified by a recognition of the fundamental trichotomy of signs, though, unfortunately, the nomenclature of the trichotomy is confused; various writers have created their own terminologies and, in doing so, have even irresponsibly inverted the terminology of their colleagues. This is not an appropriate place to argue the merits of the particular terminology I have derived from Peirce and Morris; I simply state it as clearly as I can so that there will be no confusion of my terms with the same terms as used by others. The trichotomy to which I refer is the *icon*, the *index* and the *symbol*, all three of which are subsumed under the general term *sign*. In discussing each of these three, I simultaneously show how the work of previous writers on southern African rock art can be classified and understood in terms of the trichotomy.

The only way of *directly* communicating an idea in art is by means of an icon; the icon may be thought of as diagrammatic, in that it exhibits a similarity to the subject of discourse, or, in Peirce's phrase, the object. There is between the icon and the object a relation of reason: the icon refers to the object it denotes by virtue of the icon's own characteristics. Not all characters are shared by the icon and the object; a portrait, for instance, may reflect form but not skin texture. To treat the rock paintings as pure icons is, then, rather like discussing them as if they were scale models; and this, in effect, is what the most widely accepted school of thought in the interpretation of San rock art does. Writers of this school imply that a painting of, say, an eland conveys merely, "This is what the original looks like". Black (1962, p. 220), in his discussion of "scale models", points out that they

are usually designed to serve a purpose such as to show to a curious, admiring audience what a real ship looks like, or, on a more complex level, how a machine works. In their discussions of the rock art, writers of this persuasion speak of the paintings as if they were of the first kind, the "harmless fetishism" of the hobbyist or, in their own phrase, "art for art's sake".

This view that the paintings are nothing more than a glorious efflorescence of stone age aesthetics, scale models to delight the eye, has enjoyed such widespread and continued acceptance partly because there are now no informants to explain the significance of the art.[2] But it is probably the undoubted striking artistic merit of so much of the art that has lent the strongest support to the belief that the paintings are simply *art pour l'art*. Some workers, captivated by the sheer excellence of the paintings as scale models, have felt with Wordsworth that they have "no need of a remoter charm, By thought supplied, or any interest Unborrowed from the eye". The South African artist, Walter Battiss, has been one of the proponents of the view that no supplementary interest is needed. He reiterated his view in a series of handsomely produced volumes published between 1939 and 1948. "Where possible", he declared, "let our souls remain serene in the aesthetic contemplation of the art and not disturbed by the vulgar questions, Who? and When?" (Battiss, 1948, p. 67). More recently the same writer has suggested that it is "healthier that we should not be afraid to describe Bushman art in aesthetic terms"; such an attempt would enable us to look at it "in a much more significant way" (Battiss, 1971, p. 43). He does not, however, explain just why it is "healthier" and "more

significant'', and I cannot repair his omission.

A writer who has also continued to treat the paintings as if they were pure icons, but has adopted a more moderate view than that of Battiss, is A. R. Willcox. He rightly allows some diversity of motives to the San artists that would open up discussion of the paintings as more than icons, but he finally comes down in favour of pure aesthetics. He admits that his view derives from the effect that the art has on himself, not the observations of informants or the general cultural milieu of the San:

The art gives strongly the impression of being *art pour l'art* executed for the pleasure of the artist in the work and the reciprocal pleasure of the beholder (Willcox, 1963, p. 84).

After the publication of views challenging this assessment of the art, Willcox (1973, 1979) re-affirmed his belief that the paintings are, in effect, icons and nothing more, setting up an interpretant of delight and a favourable disposition towards the artist:

Vinnicombe and Lewis-Williams, in studies not yet fully published, seek to show evidence of less material-istic motives, the former for an eland cult, and the latter for religious symbolism, carrying the argument into metaphysical realms whither we cannot now follow him.

Although more statistical analysis may change the picture I see no reason now to revise my opinion that hunting magic played a part in the early development of the art, and that some traces of it perhaps remained to the end; but that the later work was executed mainly as *art pour l'art* (Willcox, 1973, unnumbered page).

Other writers who, like Willcox, have cautiously suggested a variety of motives on the part of the artists, but who have chiefly adopted the iconic view, are Vedder (1938), Burkitt (1928), Cooke (1969), Lee and Woodhouse (1970) and the Rudners (1970). The limitations of an approach which stops short at this point, though numerous, need not long detain us here; I have discussed them at some length elsewhere (Lewis-Williams, 1974b). It is, however, worth mentioning that if the actual content of the art is assessed, not by the general subjective impression of the student, but by the more objective quantitative techniques I describe in Chapter Two, then it shows an almost obsessional emphasis on certain subjects, such as the eland, and an avoidance of other equally familiar subjects, such as the wildebeest, known to have been hunted and eaten by the San. There-fore, although I do not deny that *some* paintings may have been only ''scale models'', I find it perverse to the point of obscurantism to maintain, in the face of the considerable ethnographic data concerning the eland which I discuss in subsequent chapters, that the paintings of that antelope, beautiful though they undoubtedly are, are all merely icons or scale models intended to delight the eye.

Perhaps the most serious objection to the view that the paintings comprise only (or chiefly) aesthetically pleasing icons is that it focuses on the motivations of the individual artists and deflects attention from social and economic factors. The marked uniformity of the art over such extensive geographical areas suggest that we should examine social rather than individual concerns. The art is clearly the product of shared beliefs and behaviour and it is, therefore, cultural factors that we shall examine when, in subsequent chapters, we try to recover the meaing of the art.

So far I have treated only one use of icons: the ''scale model'' made simply to show how the original appears. The icon can, however, be put to other uses. Some writers on the southern San rock art assume that the paintings are, in effect, icons functioning as ''natural signs''. The usual example given in discussions of a natural sign is the occurrence of clouds of a certain type portending rain. As Nagel (1956, p. 107) points out, such examples tend to suggest that natural signs exists only in nature; but that is not so. He defines a natural sign as follows: ''an occurrence is a natural sign for a second occurrence, if the first is *used* as *evidence* for the second''. Whenever an event of the first kind takes place we may expect, on this evidence, an event of the second kind. An assump-tion of essentially this type leads to the mistaken belief that the paintings are ''sympathetic magic''. That is, the painting of an animal—either the act or the finished product—was supposedly taken as a natural sign that an event of a second kind would follow: either an animal of the species depicted would be killed or the species would reproduce prolifically. An existing icon of, say, an eland originally meant as a scale model could also become a natural sign if, for example, a hunter shot an arrow at it on the understanding that a real animal would be so impaled on a future hunt. Writers who have treated the paintings as if they were such natural signs include Balfour (1909), Breuil (1931), Obermaier and Kühn (1930), Frobenius (1931), Holm (1961) and Brentjes (1969). The interpretant implied by these writers is, then, a disposition to hunt with confidence in the success of the hunt.

The most damaging objection to regarding the icons of the San rock art as natural signs is the total absence of supporting evidence in the ethnography. Elsewhere, as in Europe, where there is no ethnography at all relating directly to the palaeolithic cave art, it has, for that very reason, been easier to maintain this interpretation. Indeed, after it was adopted about the beginning of this century under the influence of reports coming mainly from Australia (Ucko and Rosenfeld, 1967, p. 118), it remained current until the recent reassessment of the palaeolithic art by Leroi-Gourhan (1968)[3] and Laming (1962). It is perhaps because all the writers listed in the previous paragraph had European connections that they advocated the same interpretation of the southern African paintings as natural signs. But besides the complete lack of supporting evidence in the San ethnography, the content of the art itself counts against the view, as may be seen from one example to be found in a popular book on African mythology which illustrates a complex panel from a rock shelter in Zimbabwe. The caption, which suggests a magical intention, describes the panel as "crowded" with animals (Parrinder, 1967, p. 105). A count reveals that there are just over 30 animals, but more than 100 human figures. If the word "crowded" is to be used at all, it must surely refer to the human figures and not the animals. The illustration gives no support to the verdict of the caption—an example of the confusion that characterizes so much of the literature. Quantitative inventories reveal that the San art is not, as is popularly supposed, composed mostly of animals and hunting scenes.

So those who have discussed the paintings as if they were icons used as natural signs have gone quite beyond the evidence of both the art and the ethnography; they have not distinguished properly between those matters about which we know something and those about which we know nothing and they have disregarded significant, observable facts of the art. Whereas those who have treated the paintings as if they were icons being used as scale models have not gone far enough, those favouring natural signs have gone too far. Since I am unwilling to go with either party, I shortly propose the direction which I believe the study of the painted signs should take, but before doing so I make a few observations on the second member of Peirce's trichotomy, the index.

According to Peirce (1931, II, p. 370), the index forces the attention of the interpreter to the object without describing it. A low barometer is, for instance, an index of rain although it in no way resembles rain; a sundial indicates the time of day, but resemblance is again ruled out. This characteristic alone debars most of the rock paintings from being regarded as indices: they *do* resemble the object. Moreover, Peirce's scheme requires a real connection between the object and the index: the object affects the index. The weathercock which is an index of the direction of the wind is at the same time affected by the wind; there is a physical connection. Although I doubt whether any of the rock paintings could be said to be pure indices, some of the icons may have possessed the indexical property of connection. If a painting were executed directly after a successful hunt and the fresh blood of that animal were used as an ingredient of the paint, the icon would be indexical in that a physical connection would obtain between the object and the index; the index would, in a sense, be affected by the object and would also point to it. But even in this case, the sign would remain essentially an icon in that it would represent by resemblance the object to which it forced the attention of the interpreter. Moreover, the possibility of indexical connection is too insubstantial to merit any prolonged discussion. Instead I turn to a consideration of the third member of the trichotomy, the symbol.

Peirce holds that the symbol signifies its object by an association of ideas; the mind, that is, associates the object with its symbol for reasons other than visual similarity between the two. These reasons are conventional and are controlled by the culture of the person producing or viewing the symbol. Certain examples of rock art, chiefly engravings, rather than paintings, may well be pure symbols in that they are "abstract" and do not exhibit similarities with their objects as do icons, yet they may have signified values and beliefs which we cannot now know. Such "abstract" paintings do not occur within the two samples which form the basis of this study and I shall not discuss them. Other paintings, such as therianthropes, while not "abstract", represent, by the positional mode I call "conflation" (see below), objects not observable in nature; they may, therefore, conform to Peirce's definition of a symbol.

Even though most of the paintings I consider are not "abstract" symbols or even "conflated" symbols, I take many of them to be icons *fulfilling a symbolic function*. The object of the icon is, for example, an eland; but, I claim, the object of the same icon functioning as a symbol is the value or belief which that antelope was selected by the San to represent. It is at this point that Willcox, for

one, stops short, being unable to follow me into "metaphysical realms". Similarly cautious writers deny, in effect, that the icons of San rock art might in some instances have been symbols and that yet other paintings were "pure" symbols. Much of my argument will consist in adducing data which reprove their caution and make it no longer possible to treat the paintings as if they were all icons behaving as scale models or natural signs; we must be more daring and allow that they were representamens which signified an object by a culturally controlled association of ideas, over and above the properties of similarity which permit the paintings to function on the level of pure icons.

I am, in fact, by no means the first to make this suggestion, even if I am the first to make it in those terms, for it is now just over a century since it initially became apparent that the paintings were more than icons. J. M. Orpen, under conditions which I describe in Chapter Three, undertook an expedition into the Maluti Mountains of Lesotho; there he copied a number of paintings and obtained from a San named Qing a valuable collection of myths. These myths were published in 1874 in the *Cape Monthly Magazine* and again in 1919 in the *Journal of Folklore*, after Andrew Lang (1899) had brought the material to the attention of a wider public. Some of Orpen's own copies of rock paintings[4] and Qing's comments on them appeared together with the myths in the *Cape Monthly Magazine*. One of these copies has been frequently reproduced.[5] These paintings are of particular interest because we have interpretative remarks on them by San from widely separated areas. After Orpen had recorded Qing's views, the copies of the paintings were sent to the publisher in Cape Town where Wilhelm Bleek, the

German linguist who was studying San and other African languages, invited his San informants, who came from the Cape Province south of the Orange River, to comment on them. The remarkable measure of agreement between Qing and Bleek's informants is discussed in Chapter Three; here I note the importance of these paintings in connecting San ritual and mythology with their art. Bleek (1874, p. 13) was entirely convinced of this connection:

The fact of Bushman paintings, illustrating Bushman mythology, has first been publicly demonstrated by this paper of Mr. Orpen's; and to me, at all events, it was previously quite unknown, although I had hoped that such paintings might be found. This fact can hardly be valued sufficiently. It gives at once to Bushman art a higher character, and teaches us to look upon its products not as the mere daubing of figures for idle pastime, but as an attempt, however, imperfect, at a truly artistic conception of the ideas which most deeply moved the Bushman mind, and filled it with religious feelings.

The importance of this passage lies in Bleek's recognition that the paintings are not to be treated as mere icons, but that they signify "the ideas which most deeply moved the Bushman mind"; the paintings were, Bleek realised, icons functioning as symbols.

Later workers in southern Africa have, however, been slow to recognize the contexts in which the icon functions as a symbol. Perhaps because of diffidence in handling the often puzzling Orpen and Bleek material, these workers have tended to avoid or even to denigrate the enterprise of interpreting the art in symbolic terms. Most of those who have tried it have either couched their inter-

pretations in the most general terms or have indulged in wild, free-ranging speculation which virtually ignored the ethnographic sources and tended to discredit the entire subject. An exceptional, cautious writer who, like Bleek, realised that the paintings were more than simply icons was Werner (1908, p. 393) who commented on the eland in the rock paintings:

The prominence given to the eland seems to correspond with the place it occupied in the Bushman imagination. It was to them what the ox is to the pastoral Bantu—not only their principal food provider, but in some sense also a sacred animal.

Werner was, I believe, essentially right in this judgement, but, like so many of her successors, she was unable to support her view by detailed reference to the ethnography. Although Battiss (1958, p. 61) wondered fleetingly if the numerous depictions of eland suggested that "the painters worshipped the eland and that its representation had a very special religious significance", little of value to symbolic interpretation of the rock paintings followed for over 60 years. Then, in 1972, Vinnicombe took up Werner's suggestion and published two papers in which she demonstrated adequately that the paintings should not be discussed as if they were scale models or natural signs, but as symbols. In these two papers she advocated quantitative assessments of the art and discussed the type of San belief that is relevant to a consideration of the art. An example of the application of the principles discussed in these two publications was a paper read in 1972, but which did not appear in print until 1975; it is an important attempt to assess the significance of the paintings of eland.

Vinnicombe's method is to present "texts" drawn from works on sacrifice by Hubert and Mauss (1964) and Robertson-Smith (1927) and then to illustrate the "texts" by reference to the San ethnographic record. She is able to demonstrate a striking "fit" and concludes that the rituals concerning the hunting of eland may be called "sacrifice" in terms of her model. Although her argument is persuasive, the southern San material on which she depends is, in the light of unpublished sections to which she did not have access, open to the somewhat different interpretation I give in Chapter Five. Nevertheless, her conclusion, like Werner's in 1908, is undoubtedly correct: "The eland was the pivot of a value structure around which the stability of the social organism was dependent".

Vinnicombe's most recent publication (1976), the splendid volume *People of the Eland*, was in fact written before her paper on sacrifice, but its appearance was lamentably delayed. It is a signal contribution to the study of San rock paintings and of rock art in general (Lewis-Williams, 1976). The first part of her book is an historical account of the San of the southern Drakensberg which, together with that on the same subject by Wright (1971), makes further historical research virtually redundant. The second section deals more specifically with the paintings and leads to the conclusion that the painted eland were indeed symbols:

The eland was the focus of the Bushman's deepest aesthetic feelings and his highest moral and intellectual speculations. The Mountain Bushmen were known to be people 'of the eland', and in sharing the eland's name, they partook of the eland's entity. As the wind was one with man, so man was one with the eland (Vinnicombe, 1976, p. 353).

Another writer who has taken the fundamental step of recognizing the paintings as symbols is Pager. His first book, a meticulous documentation of the paintings of the Ndedema Gorge (Pager, 1971), is an extremely valuable contribution to the study of the southern San rock art. In a second volume he uses an analysis of superimposed paintings (see Chapter Two below) to suggest that the art ranged from the secular to the sacred and that "rock painting in general and superpositioning in particular were accessories to magico-religious practices" (Pager, 1975a, p. 74). I discuss his and Vinnicombe's views in more detail in subsequent chapters.

Pager, like Vinnicombe, has some trouble handling the data; once it is recognized that the paintings are not all simple icons, but sometimes icons functioning as symbols or even pure symbols, it is essential to have a clear method to control the discussion. The techniques involved in "unpacking" the symbols of the art demand careful consideration and definition. As Morris (1964, p. 20) has said, "For something to signify is a different thing from the often very difficult task of formulating what it signifies". He himself did not make it any easier with his frequent neologisms most of which I shall ignore. I find useful, however, his notion of *semiosis*, the sign process in which the link between the sign and its object is set in a behavioural context. Morris (1964, p. 2), partly following Peirce, states the process thus: a *sign* sets up in an interpreter an *interpretant* to react in a certain way to the *signification* (object) in a specific *context*. If we apply this statement of semiosis to the rock art, it becomes apparent that there are at least two possible interpretants: that set up in the original San viewers and that set up in

the student of the rock art. Those who insist on discussing the paintings as icons functioning as scale models are effectively interested only in the second interpretant which they then impute to the original viewers. If, however, we grant that the signs are icons functioning as symbols, we must transfer our interest from the student's interpretant to the San interpretant; because we are moved to applaud the artists, it does not necessarily follow that the San did or, if they did, that their response ended there. It would, of course, be by no means easy, even with living informants, to ascertain the state of mind set up by a work of art: the state of mind of those long dead is even less accessible. Nevertheless I believe it is possible to make informed surmises on the basis of knowing something about the signification, the object to which the sign directs the interpreter's disposition. In 1972 I proposed a two-stage methodology for arriving at the object of the signs which, I believe, is applicable to the study of rock art not only in southern Africa but elsewhere as well.

The first stage of any study of rock art is to arrive at a clear and objective understanding of the content of the art. This may be stated on two levels: the nature and frequency of the individual representations, and, secondly, the ways in which these representations are related to one another. The techniques involved in the two levels of the first stage of the enterprise I discuss in Chapter Two. The second stage is to interpret the representations in their various contexts; the process of interpretation uses whatever ethnographic sources may be relevant. The first stage is algebraic, the second semantic.[6]

If we are to treat the paintings as *symbols*, a method for the analysis of symbols, going beyond

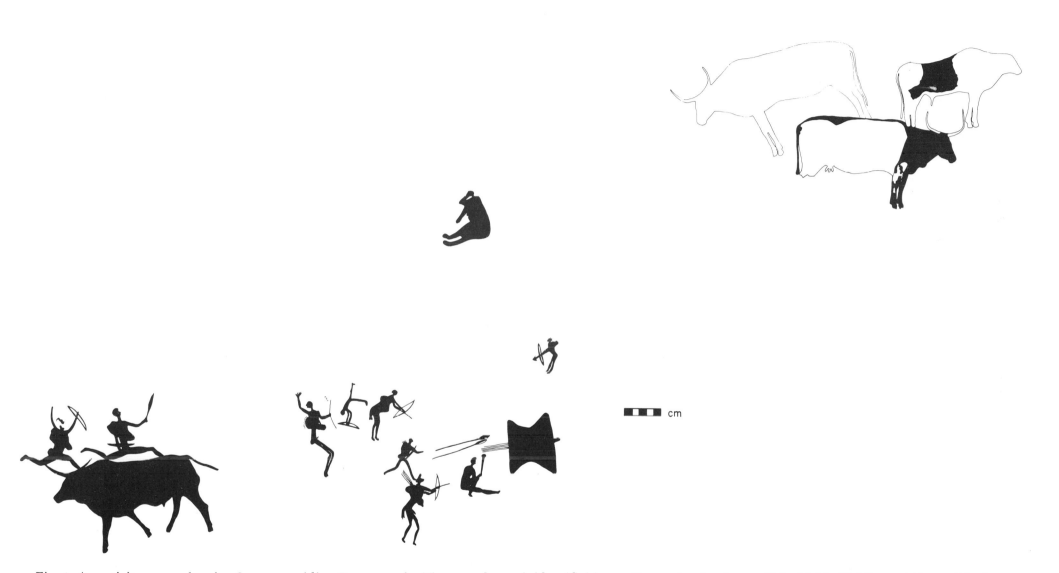

Fig. 1. An activity group showing San men raiding Basuto cattle. The seated man is identifiable as a Basuto by the shape of his shield (Tylden, 1946; van Riet Lowe, 1946); next to him lie his broad-bladed spears and he holds a knobkerrie. Colours: black and white. Steepside, Barkly East.

that of Peirce and Morris, is needed. Such an approach has been offered by Turner (1966, 1967); his method is especially relevant because it derives from the analysis of symbols in rituals and the "meanings" of some of the painted symbols are likewise discernible in rituals. Furthermore, Turner's method is attractive because it was formulated in the context of detailed fieldwork on mainly African symbolism and is not concerned with theories about the fundamental structures of the human mind.

In his discussion of ritual symbolism Turner recognizes three "dimensions": the positional, the operational and the exegetical. In the analysis of ritual these may be attended to simultaneously, but the study of rock paintings requires that they be approached in a certain order. To avoid continual use of the rather inconvenient adjectival forms qualifying "dimension", I sometimes use "position", "operation" and "exegesis" and now show, in a preliminary way, how each may be applied to the study of rock paintings.

In his discussion of the position of a symbol in ritual, Turner stresses the relationship between that symbol and the *gestalt* of symbols which are used in the ritual. According to the position occupied by a symbol in the symbol cluster of a given ritual, certain elements of meaning receive especial emphasis. For the rock paintings, position may be applied in the first stage of analysing their content. It is possible to distinguish four modes of position: activity groups, juxtapositioning, superpositioning and conflation. These modes are not mutually exclusive.

The first mode, the activity group, is most familiar to western viewers. It includes paintings of dances, domestic scenes and hunts. Figure 1 is a depiction of San raiding Basuto cattle. Many, but by no means all, of the paintings in this mode may be purely iconic. Paintings such as the cattle raid at Beersheba (Willcox, 1963, plate 3; Lee and Woodhouse, 1970, p. 160; Pager, 1975, p. 112) or the well-known fight at Battle Cave (Willcox, 1973, plates 20-22; Rudner 1970: plate 60) may well be icons of events functioning as scale models to show the viewers what the actual event looked like. Vinnicombe (1976, p. 44-46) has also suggested that certain paintings may represent specific San cattle raids about which there is historical evidence. Whilst many activity groups may be no more than scale models, other representations of events were, I believe, painted not simply to show how a certain occasion appeared to those who witnessed it, but to proclaim the values associated with the activity depicted and so function as symbols. Depictions of dances, for instance, probably refer not to a single, specific occasion, but to the values dramatized in all dances of that kind.

Like the first, the second mode of position in the art, juxtapositioning, also uses icons, but in some cases it is probable that they were acting as symbols. In juxtapositioning, the relationship between representations is neither scenic nor established by an activity: it does not present a situation which can be observed in nature. An eland, for example, may be placed next to a dance scene not merely to offer an icon of an antelope walking past a group of human beings, but to make of the eland icon a symbol relating by some of its associations to the human activity depicted.

An example of very simple juxtapositioning is at Skopongo III, Giant's Castle (Fig. 2). This panel comprises all the paintings in the small shelter. There are three human figures, one of which is seated and has a child on its back; next to the seated figure is a digging-stick with a clearly drawn bored stone, the stick and the child together suggesting that the figure is female. The domestic nature of the group is inescapable. Below and slightly to the left of the group is a somewhat faded eland which has been over-painted; it is not possible to be sure which was painted first, the eland or the human figures. One's first reaction is to deny any relationship between the human figures and the antelope, but, in the light of the ethnographic evidence I consider in subsequent chapters, I believe this would be an error. On the contrary, I suggest that the panel as a whole made statements on various levels to produce a complex reaction in the original San viewers.

One of these levels is geographical. It seems highly probable that in Natal both the San and the eland moved from lower areas occupied in winter to the Highland Sourveld when the summer rains broke (see Chapter Eight). The eland may, therefore, have been, in addition to its operation on other levels, connected with the geographical and seasonal rhythm of the San bands and the attendant changes in social structure, habitat and exploitation strategies. The Skopongo III artist has possibly related this significance of the eland symbol to the human group by juxtapositioning.

The sociological import of the panel is clearer. Some of the dichotomies within a San band are shown: adults and children, men and women, hunters and gatherers—divisions which must be subordinated to the solidarity of the group. In subsequent chapters I show how the eland is a symbol which bridges or links these very divisions and may therefore appropriately symbolize the unity of the human group with which it is here

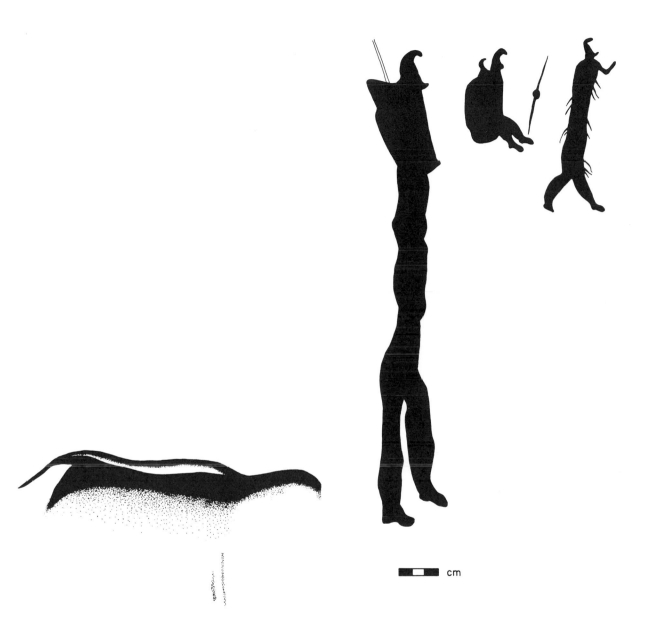

Fig. 2. Skopongo III, Giant's Castle.

juxtaposed. Together, the eland and the human group constitute a balanced, symbolic composition.

It is not, of course, necessary to suggest that the eland was painted by the same artist who did the human figures; it might have been painted before or after. If it was painted after the human beings, it was probably a symbolic summary of the domestic group; if it was painted first, the human group was probably a gloss explicating some of the associations of the eland symbol. Complex, interrelated panels comprising activity groups and many apparently individual depictions probably evolved in this way as a series of artists added their work to develop already implicit concepts.

The third mode of position is superpositioning (Fig. 3). Quantitative studies of this mode (see Chapter Two) have suggested that superpositioning was not, as had previously been supposed, always a result of a random disregard for the work of predecessors, but might sometimes have been a means of linking paintings that was governed by definite conventions. This conclusion, first derived from work at Giant's Castle and Barkly East (Lewis-Williams, 1972, 1974a), has since been confirmed by Pager (1975a) in the Ndedema Gorge. The peculiar nature of the relationship between the components in superpositioning suggests—as with juxtapositioning—that they are more likely to be symbolic, though the individual forms are still iconic. Certainly, it can seldom be argued that the relationship between the upper and lower paintings is "scenic" and was intended to give an impression of perspective.

It is in the fourth mode of position, conflation (Fig. 4), that the iconic form of the representation virtually disappears. These depictions do not resemble any actual existing creature: the elements

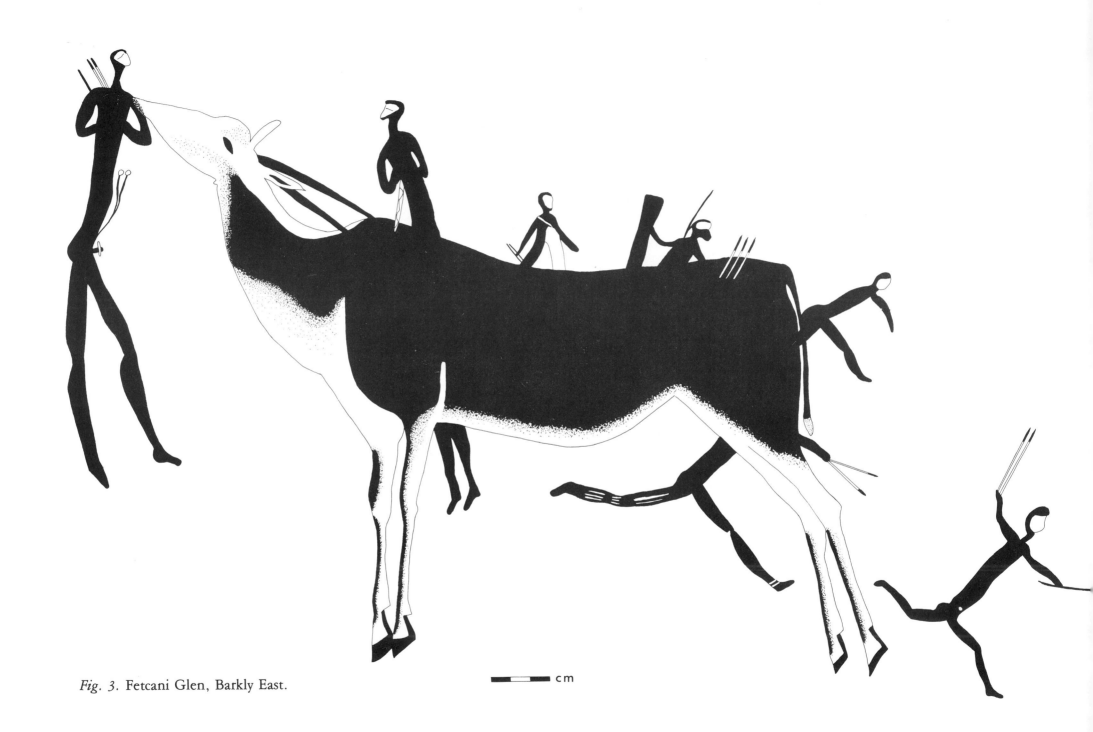

Fig. 3. Fetcani Glen, Barkly East.

of one icon are combined with the elements of another to produce a symbol. An example of conflation is a human figure with antelope hoofs or the so-called "flying buck" (see Chapter Seven). These conflated signs, not signifying anything observable under natural circumstances, are therefore the least "iconic" and the most "symbolic" of the forms with which I deal in this book.

A consideration of these four modes creates a clear idea of the "position" of any given depiction within the whole system of graphic representation that is being studied. It provides an essential foundation for the succeeding stages of discussion.

Turner's second dimension is the operational. In considering "operations" we observe what the ritual participants do with the symbols, and also the composition and structure of the group that is handling the symbol. The first of these observations, in which the meaning of the symbol is equated with its use, is less applicable to the present study because we do not know what the San did with the paintings; this is one of the areas of total ignorance in which speculation is profitless. Certainly, those who think the icons of the art functioned as natural signs suppose that the paintings played a role in certain rituals, but such supposition lies beyond our present competence. If we cannot know what the San did with the paintings, we do, however, know what they did with some of the objects of the icons. We know, for instance, that the eland antelope figured as a symbol in three rites of passage: boys' first-kill observances, girls' puberty rituals and marriage. By the ways in which the participants use the eland in these and other ritual contexts we can come to understand some of the operational significance of

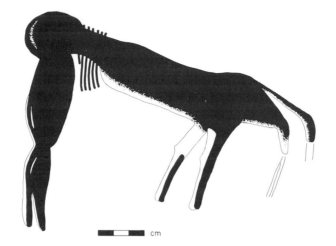

Fig. 4. Willem's Shelter, Kamberg.

the painted icons. There is an interesting analogy to be noted here. In the girls' puberty "Eland Bull dance" of the !Kung an old man plays the role of an eland bull, affixing eland horns or sticks to his head and mimicking its posture and gait. In doing this he becomes an icon of the antelope in that he exhibits certain similarities to it; those acquainted with the habits and appearance of the antelope know at once that he purports to be an icon of an eland and not some other animal. But he assumes more than the iconic status in that he signifies certain values to which he cannot stand in an iconic relationship. Like the rock paintings, he becomes an icon operating as a symbol.

The elucidation of the object signified by the symbol Turner designates the exegetical dimension. In the exegesis of ritual symbols we observe what explanations are offered by indigenous informants. In dealing with the extinct southern San we have to rely on a finite body of data that contains

comparatively little direct exegetical comment on the paintings; the exegetical explanations we do have from the southern San, I assess in Chapter Three. It is no longer possible to expand the body of exegetical material that was obtained from the now-extinct southern San informants, but we can obtain indigenous explanations from the contemporary San of the Kalahari. If this material is to be used in a study of the significance of the southern San rock art, it must be only after careful consideration and clear justification of its relevance, not mixed indiscriminately with the southern material as some writers have done. As I explain in Chapter Three, I have had, largely as a result of my field work with the !Kung, to change my opinion regarding the relevance of such northern material. It is, of course, unproductive to ask !Kung informants to interpret the symbolism of rock paintings from the Drakensberg, but they are able to provide indigenous explanations of symbols used in rituals which we have good reason to believe were also performed by the southern San. In this oblique way we can collect exegetical material that is relevant to an analysis of the rock art. The exegesis of the rock art from the ethnography of the southern San is also not direct, but largely by inference from the symbols used in myth and ritual. In this way the situation in southern Africa differs from both Europe and Australia. In Europe there is a total absence of any exegetical material, direct or inferential; in Australia direct exegetical material is available from the artists themselves, though even under these apparently auspicious conditions there are difficulties. The southern African position is intermediary between these two.

Exegesis is built on three semantic foundations:

the nominal, the substantial and the artefactual. In discussing the nominal basis we observe the name assigned to the symbol in ritual and in non-ritual contexts. Some of the argument in the subsequent chapters is derived from this basis. An example of the type of material relevant to this discussion is the names given by the !Kung to eland. In non-ritual contexts, !Kung men refer to the eland as *n!*; in ritual contexts they call it *tcheni*, dance. Comparable data relating to the eland are available from the southern San and will be discussed in due course. The second basis for exegetical discussion is the substantial. In this area of analysis we observe what natural and material properties of the symbol are selected by the informants for special comment. In the ensuing discussions I take note of what both southern and northern San say about the eland, the characteristics which they find most significant in ritual and in non-ritual contexts. The third basis, the artefactual, is the discussion of the form into which the ritual participants process the symbol. Here we see how the eland antelope is, in a sense, made into meat for sharing customs, fat for use in certain rituals and, possibly, even paint[7] for executing the iconic symbols of the same antelope on the walls of the rock shelters.

In the semantic analysis of the symbols of the southern San rock art, I follow this methodology as closely as the data will permit. Owing to the nature of the material, however, all dimensions of analysis are not consistently applicable: sometimes position is the only one on which we have any data, sometimes it is exegesis alone. The gaps in the southern San record cannot now be filled except by cautious use of northern material: the answers to many problems lived in the memories of those now dead. But before I attempt the final stage of the analysis, the elucidation of what I argue are painted symbols, I begin by discussing the positional dimension of the paintings themselves to provide a clear idea of the content and structure of the art.

Notes

(1) See, for example, Marshall (1976), Lee and De Vore (1976), Tobias (1979) and Lee (1979).

(2) It was the absence of any ethnography that similarly led the first interpreters of the Franco-Cantabrian palaeolithic cave art to adopt the same position, although the view was not so widely accepted in Europe as in southern Africa: the open rock shelters of southern Africa do not readily imply esoteric motives as do the deep caverns of western Europe (Ucko and Rosenfeld, 1967, pp. 165-166).

(3) See, however, Ucko and Rosenfeld (1967), Parkington (1969) and Stevens (1975) for reviews of Leroi-Gourhan's work.

(4) Orpen's complete collection is housed in the South African Public Library, Cape Town. I have not found any paintings of great interest among the unpublished copies.

(5) See Christol (1911, p. 1), van Reenen (1920, p. 31), Frobenius (1931, Fig. 4), Kennan (1959, p. 1), Willcox (1963, Fig. 9), Brentjes (1969, Fig. 6), Smits (1973, Fig. 1).

(6) Munn (1973) in her study of Walbiri iconography advocates essentially the same method: she proposes that the system of visual representations which is the object of study be considered from two perspectives. First, it should be analysed as a representational structure; in this stage attention is given to the internal and formal structure of the representations. Secondly, the art may be discussed as sociocultural symbolism. Having recognized that the Walbiri representations are functioning as symbols, she goes on to discuss the significance and function of individual components and the system as a whole.

(7) When an old Maluti man Mapote, agreed to paint for How (1962, p. 37), he called for "the blood of a freshly killed eland". The use of blood in the manufacture of paint was also reported by Ellenberger (1953, p. 164) and the presence of amino-acids from blood, egg albumen or milk has been detected in paint samples (Denniger, 1971, p. 80). The use of fat, although not specifically eland fat, has been reported by a number of writers (Hutchinson, 1883, p. 464; Dornan, 1917, p. 49; Chapman, 1971, I, p. 116; Baines, 1964, II, p. 13).

The Rock Paintings

The discussion of any corpus of rock paintings as a system of signs and particularly as symbolic signs should start, following Turner, with position; we need a clear and unambiguous statement of the content and structure of the system with which we are dealing. Such a statement should begin with an objective enumeration of the frequency with which the various elements are depicted. It is then possible to assess the role of any given symbol within the whole system. The ways in which the individual components of the system are linked to form groups is the second level of positional analysis. These data, relating to content and structure, are the irreducible minimum from which any serious discussion of a rock painting system must start, be it in southern Africa or elsewhere.

A serious drawback in the work of many interpreters of the southern San paintings has been their neglect of position: paintings have been culled from widely scattered areas and collated to produce a quite false impression of the content of the art. Students of rock art are constantly tempted to be on the move; the lure of better preserved and more interesting paintings in distant parts is often much more attractive than the very laborious task of intensive recording.

The dangers of this selectivity became apparent as long ago as the 1930s with the publication of copies made much earlier by the geologist, George William Stow. In 1870, three years after he began copying, Stow described his purpose in a letter to Professor T. R. Jones:

I have been making pilgrimages to the various old Bushman caves among the mountains in this part of the Colony and Kaffraria; and as their paintings are becoming obliterated very fast, it struck me that it would be as well to make copies of them. . . . This gave rise to the idea in my mind of collecting material enough to compile a history of the manners and customs of the Bushmen, as depicted by themselves. I have, fortunately, been able to procure many facsimile copies of hunting scenes, dances, fightings, etc., showing the modes of warfare, the chase, weapons, disguises, etc. (Young, 1908, p. 27-8).

Most of Stow's copies were not published until 1930 when over seventy plates appeared as *Rock Paintings in South Africa.*[1] With this posthumously published collection Stow unwittingly started a trend that has lasted until the present day: the paintings have continued to be recorded in a highly selective fashion on the assumption that they are scale models of San life as it was lived by the now-extinct southern groups. This was essentially the view of Dorothea Bleek who, in her introduction to Stow's copies, discounted the possibility of the paintings having been natural signs used in rites of sympathetic magic. She was

taken to task for this judgement by the Abbé Breuil (1931) who believed that many of the 72 plates could bear that interpretation. In replying to the Abbé, Dorothea Bleek (1940, pp. xiii-xiv) explained how this false impression arose:

The Abbé did not realise that the proportion was a result of the white man's selection, first in copying, then in publishing. In a huge cave full of paintings Stow would leave unnoticed hundreds of figures of animals and men engaged in ordinary pursuits—walking, running, jumping, fighting, hunting, eating—to copy some little bit that seemed to portray a ceremony or rite, probably a magic one. Likewise in settling which of his copies were to be included in the book, those were chosen first, hence the false proportion. Had it been possible to publish copies of whole caves, it would have been clear to the public that the majority of the paintings could hardly have served a magic purpose.

But Bleek's warning went unheeded, as had van Riet Lowe's (1931, p. 51) earlier caveat: "It is often fatal to work on copies that do not reflect all the work in a cave, and equally fatal to work on copies that are not exact".

The degree of distortion introduced by eclectic sampling is shown by a quantitative comparison of Stow's copies, Helen Tongue's (1909) selective copies and my own non-selective sample from Barkly East; the areas from which these three samples were collected overlap partially. The extent of the early copyists' selectivity is indicated in Table 1. In this and in all other numerical statements a "painting" is a single representation, not a group or scene.

It should be borne in mind that the 38 sites in the Barkly East sample range from small sites with only one painting to large sites with over 200 paintings; the copyists, on the other hand, tended to draw their material chiefly from large, well-known sites. An analysis of the content of Stow's copies suggests that 78% of the paintings are of human beings and 22% of animals. Tongue's selectivity produces a different bias: 59% human, 41% animal. This is closer to my inclusive and non-selective sample from Barkly East: 55% are human beings and 45% animals. An even more striking difference appears in the proportion of

Table 1.
Degree of copyists' selectivity

	Total no. of paintings	No. of sites		Average per site
Stow (1930)	1074	69	±	15
Tongue (1909)	497	30-40	±	14
Lewis-Williams	2361	38	±	62

antelope to other types of animal. Stow's work suggests that only 36% of the animals are antelope and Tongue's gives 48% antelope; my sample shows that 90% of the animal paintings are of antelope. The interest of the early copyists in the unusual paintings is further illustrated by the proportion of felines: Stow shows 2% of all animals in his copies to be felines and Tongue 3% in hers, but the Barkly East sample gives a figure of only 0·8%.

In addition to the selectivity of most workers the poor copies made by some have provided another source of error. The inaccuracy of some copies (or of their reproductions) has recently been demonstrated by Vinnicombe and Schoonraad. Vinnicombe (1976, Fig. 239) has published her recent tracing of one of the paintings that accompanied Orpen's paper on the Maluti mythology. Among other differences, the more recently made tracing shows the "rain strokes" which, although on Orpen's original, were omitted from the published plate. The dangers in the more modern practice of making copies from photographs have been demonstrated by Schoonraad (1965). He contrasts such copies with accurate tracings; the copies made from photographs are shown to be suprisingly inaccurate.

It has become increasingly clear, then, that an interpretative study of the San paintings must not deal with the selective and often inaccurate work of those who regard them as scale models or natural signs, but must stem from a properly defined, limited base. Such a base should comprise records of all the paintings in a limited geographical area; or, if this is not practical, a valid sample. In addition to published sources two such samples are the basis for the interpretations I give in this book. Because there are as yet no generally accepted techniques in this field, I give a brief account of the way in which I compiled the two samples.

Both sample areas lie within van Riet Lowe's (1941, p. 9; 1956, p. 7) "South Eastern Group" of rock paintings. The first is in the vicinity of Giant's Castle. Quantitative field work started in 1968 in the Ncibidwane Valley lying between the upper reaches of the Mooi and Bushman's Rivers (see

Figs 5 and 6). After approximately 1300 paintings had been recorded in 20 comprehensively treated sites, I commenced recording paintings in the valleys of the Kraai and Bell Rivers near Barkly East. This work was completed in January 1976 after some 2300 paintings had been recorded.

The first stage of the recording process is the location of the sites and then the plotting of them on aerial photographs or 1:50000 maps. The searching of valleys with large numbers of possible sites in the form of either shelters in the Cave Sandstone strata, or large boulders scattered in profusion on the valley slopes, is time-consuming. To facilitate the work the party usually divided into two groups, one group to each side of the valley. These groups maintained radio contact and were thus able to guide each other on the steep slopes which render visibility above and below difficult. For each site so discovered the following data were recorded on cards printed for this purpose:

Name of site and number
Co-ordinates
River name
Water availability
Aspect by compass direction
Presence or absence of deposit and/or artefacts
Type of site (e.g. shelter or boulder).

This initial stage of the survey provided some data on the "context" of the art. All the recorded Barkly East sites are rock shelters; at Giant's Castle six painted boulders were recorded. I believe this to be simply a result of a difference in terrain: large boulders, suitable for painting, are more numerous in the valleys of the Giant's Castle area. It was possible to detect artefacts, referable to a Later

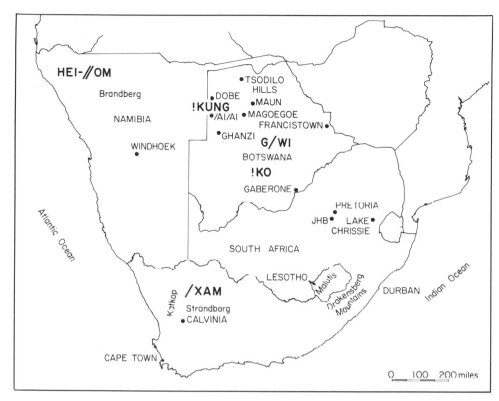

Fig. 5. Map of southern Africa showing places and San groups mentioned in the text.

Stone Age industry, in 75% of the recorded Barkly East painted sites; at Giant's Castle similar artefacts were found in 55% of the painted sites. Most of the sites could have been living sites and the presence of the artefacts in many tends to confirm this conclusion (see Appendix, p. 134).

Further analysis shows that in both sample areas there was a marked tendency for the aspect of the painted sites to range between east and northwest. At Giant's Castle 86% and at Barkly East 89% of the sites face between these two compass directions (for details see Appendix). The general avoidance of the colder, often damp, south-facing shelters in both areas seems also to point to a desire for favourable living conditions. At Giant's Castle the last inhabitable shelter towards the head of every valley surveyed is painted; similar shelters lower downstream may or may not be painted. This seems to reflect an interest in the higher regions, but for what reasons or at what times it is

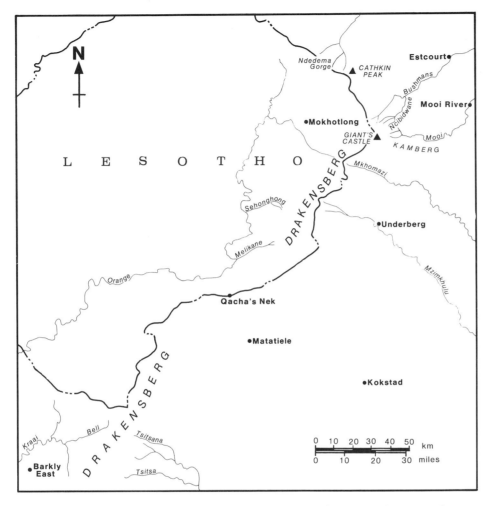

Fig. 6. Map of the central highlands of southern Africa showing sample areas.

boulders. The small shelter in one of them is entered by bending low; the interior is in the form of a dome. On this curved surface is a painting of a lion complete with fearsome claws and teeth. Fleeing from the lion are a number of men above whom are a larger number of "flying buck" (Fig. 31). Some workers believe that the site was used in initiation ceremonies and that the paintings were didactic: my own interpretation is given in Chapter Seven.

Fulton's Rock, a comparable site in the Giant's Castle area with a large number of paintings, is, as I have discovered, open to the cold winds from the mountains and offers little or no shelter from the rain. Lee and Woodhouse (1970, p. 96) have suggested, in a discussion of the possible association of paintings with initiation ceremones, that this site "is just the remote sort of spot that might have provided a focal point for initiates". Its remoteness, however, is felt most keenly by the modern student of rock paintings who has to trudge many arduous miles to reach it.

Another site that attracted attention was the small, overhanging rock at The Meads, East Griqualand (Willcox, 1973, plate 71; 1963, plate 32, Fig. iii; Vinnicombe 1976, p. ii); the rock has now been removed to the Natal Museum, Pietermaritzburg. When it was in position it would not have sheltered even one person, yet it bears a magnificent panel of eland in various positions, foreshortened and exquisitely shaded. It is difficult to understand why an artist would have chosen such a position for his masterpiece. Not only would the painting of the panel have been difficult, but the viewing could be accomplished only with some inconvenience.

Contexts such as these raise difficulties about

now difficult to be certain. In the different topography at Barkly East, this observation is not relevant.

Paintings are also occasionally found, however, in small shelters and on open rocks that could not

have been living sites for a single family, let alone a band. A Barkly East site that has attracted some attention, but which was not included in the sample, is on the farm Balloch. It is situated high on a hill top and consists of a number of large

interpreting all the paintings as iconic scale models and add *prima facie* support to symbolic interpretation. Some of these sites may have been temporary bivouacs of the kind described by Ten Raa (1971, p. 44) in east Africa, but we do not know for certain to what uses they could have been put.

The second stage of the field work is the recording of the individual paintings; this should be as accurate as possible without being tedious. The technique improved with experience. At first a simplified version of the system proposed by Vinnicombe (1967) was adopted, but was eventually replaced by specially printed recording cards. To facilitate the sorting of the data, the cards used for recording representations of animals were printed on red stock and those for human figures on white; inanimates were recorded on green cards. The cards were divided into a number of squares, each square representing a feature of the paintings. The recorders were then required to cross the appropriate squares for each painting. On the cards for human representations, a total of 97 possible characteristics were grouped under the following headings:

Sex
Clothing
Equipment
Head type
Headgear
Special features
Position
Size
Colour
Technique
Preservation
Scene
Elevation

On the cards for animal representations, in addition to species, 52 possible features were grouped in nine categories:

Sex
Special features
Colour
Technique
Preservation
Elevation
Position
Size
Hunt scene

After the completion of the field work, the crossed characteristics were coded numerically to the left-hand edge of the card. The data were then extracted by simply leafing through a block of cards. Vinnicombe transferred her field data to punch cards[2]; this does, of course, greatly facilitate the extraction of the data, but it is questionable if the considerable labour involved in the preparation of the punch cards is justified by the result. It seems that for a sample of fewer than 3000 paintings the system I have used is adequate; beyond that number punch cards may well be desirable. An even more efficient system than punch cards has been used by Pager. He prepared his Ndedema sample for analysis by computer (see Evans, 1971). Such a scheme is, like the punch cards, best suited to very large samples.

Some of the quantitative results obtained from the Barkly East and Giant's Castle samples are tabulated in the Appendix. These results form the primary basis for the present study, but reference will also be made to those of others who have also worked in areas belonging to the so-called "South Eastern Group", particularly the studies by Pager (1971), Smits (1971) and Vinnicombe (1976). A comparison of the quantitative results obtained by these workers with the Barkly East and Giant's Castle samples confirms the assumption that the South Eastern Group comprises a single cultural area.

In all the samples so far available from the South Eastern Group there is a clear but not overwhelming emphasis on human figures and social activities. At Giant's Castle 59·8% of the total sample of 1335 representations are of human beings (this figure includes therianthropes); at Barkly East, 53·9% of the representations are of human beings. Most of these human figures are depicted in social groups, walking, running, sitting, dancing, fighting and hunting; the lone human figure is comparatively rare.

The next largest group comprises antelope. Other animals do not feature prominently in the art. At Barkly East, out of a total of 1048 representations of animals there are, for instance, only four baboons, ten felines and six bushpigs.

Within the category of antelope there is a highly significant emphasis. At Giant's Castle I found that 49·1% of the total sample of 478 antelope were identifiable as eland. The figure should probably be higher than this because many of the depictions classed as indeterminate antelope (28·2%) are very probably of eland; as my skill in identifying the species of representations improved, so the percentage of indeterminate antelope fell to 10·2%. In the Barkly East sample of 942 antelope, 62·2% are of eland. In both samples the next most frequently depicted antelope was rhebok: Giant's Castle 21·5% and Barkly East 25·4%.

Just as striking as the emphasis on eland is the omission of certain other species. The wildebeest,

for example, lived in huge herds in and around the Maluti and Drakensberg area (Backhouse, 1844, p. 337; Stanford, 1962, p. 100; How, 1962, p. 11), where it was hunted and eaten by the San (Arbousset, 1852, p. 367; How, 1962, p. 39); yet very few depictions of this antelope are known. I found none in the Giant's Castle and Barkly East samples; Vinnicombe (1976, p. 364) found three in her sample of 1850 paintings of antelope and Pager (1971, p. 321) only one in his sample of 3058 paintings of antelope. It is clear that the inclusion and exclusion of antelope species depended on certain preferences which applied throughout the South Eastern Group. Therefore even this simple numerical comparison already suggests that we are dealing with a socially controlled system of signs involving the use of antelope species as symbols and not the random whims of individual artists; within that system the wildebeest features scarcely at all[3], while the eland heads the numerical list.

The numerical emphasis on eland is reinforced by another type of emphasis which becomes apparent from an analysis of the colouring used in depicting antelope. Table 2 shows the percentage of eland and rhebok (the second most common antelope) in the Barkly East sample painted with one, two or more colours.

Table 2.
Colouring of eland and rhebok in the Barkly East sample

Species	Monochrome	Bichrome	Polychrome
Eland	8·7%	49·1%	42·2%
Rhebok	34·5%	50·5%	15·0%

This comparison makes it clear that the eland was singled out not only for numerical emphasis, but also for the more elaborate painting techniques; more time and care was lavished on paintings of eland than on any other animal species (see also Vinnicombe, 1976, p. 164).

This striking numerical and technical emphasis is in itself enough to suggest that the painted icons of eland were more than simple scale models to delight the artist and his viewers, but there were yet other techniques employed by the southern San to focus attention on the eland. An examination of these techniques brings me to the second level of positional analysis, structure. In the previous chapter I considered the status as signs of the four structural modes which I believe can be discerned in the southern San rock paintings: activity groups, juxtapositioning, superpositioning and conflation. The quantification of these modes, however, presents some problems.

The first of these modes, activity groups, is almost entirely defined by the activities of human beings; a herd of eland by themselves, for instance, do not constitute an "activity group". The activity groups are less easy to quantify than one would suppose: in a crowded panel it is often difficult to distinguish the limits of groups — if, indeed, limits were intended by the artists. Most of the groups comprise only a few human figures engaged in quite indeterminate activities: they sit, stand, walk, or run. In the Ndedema sample of 1798 human figures only 66 groups perform identifiable activities; of these 66 groups 29 are of hunts and 13 of dances while the remainder includes fights, camp scenes and other activities (Pager, 1971, p. 335). These comparatively few scenes are the ones which interested the early

copyists who thought of the paintings as scale models of San life; but quantification has shown clearly that this is not where the numerical emphasis of the art lies. Although I discuss a number of activity groups in subsequent chapters, I do not wish to give the impression that I believe that paintings of this kind are the most important feature of the art. Activity groups often provide, by the relating of elements, a valuable clue to the meaning of other enigmatic paintings and also to the significance of the plethoric eland paintings. However much I might use certain activity groups in subsequent argument I do so chiefly to clarify certain sets of puzzling paintings and, ultimately, the significance of the dominant element of the art, the eland.

Juxtapositioning is even more difficult to quantify because in many cases it is impossible to be absolutely certain that a relationship was intended by the artists. Nevertheless, I am persuaded that, in examples such as Fig. 2, a relationship between the individual components was intended by the artist. Juxtapositioning was also used, I believe, by the San artists to give unity to complex panels, dense with many depictions. When modern viewers examine such a "reticular" panel, they tend to pick out those parts which correspond most closely to their ideas of grouping and perspective; they isolate the activity groups and the panel as a whole makes no impact. The concept of a "framed" composition is, however, foreign to southern San art and activity groups often grade into numerous juxtaposed paintings which, to Western eyes, are unrelated.

Within these dense, reticular panels as well as in isolated, scattered groups artists sometimes superimposed paintings. When I quantified this struc-

Fig. 7. Human head types: total sample compared with figures in superpositioning. Solid line: figures in superpositioning. Broken line: total sample from Barkly East.

tural mode, I distinguished between overlapping and superpositioning. Cases in which only a small portion of a painting impinges upon another were regarded as overlapping and were not recorded. I adopted this approach because it seemed that overlapping could more easily be accidental than could superpositioning as defined here. I shall not now reproduce my detailed published work on superpositioning (Lewis-Williams, 1972, 1974a); instead I refer briefly to some salient points which I believe suggest that the signs used in this structural mode are functioning as symbols. My suggestions have not, however, escaped criticism (Willcox, 1978b; Lewis-Williams *et al.*, 1979).

It appears from both the Barkly East and the Giant's Castle samples that eland were involved in this structural mode more frequently than any other category of representation. At Barkly East, for instance, 20·6% of the total number of eland are involved in superpositioning, whereas only 5·0% of the rhebok and 4·6% of human figures are so treated. Eland are superimposed by other

eland far more frequently than by any other type of representation. The linking of eland with human figures reflects another marked preference: in the Barkly East sample eland are superimposed on single human figures and human groups in 20 cases; in no instance are human figures superimposed on eland. At Giant's Castle eland are superimposed on human figures in 24 cases, whereas human figures appear on eland in only four instances.

An analysis of the human figures linked with eland by superpositioning shows that there was also a marked tendency for the painters to select figures with a stylized head type generally known as "white faced" (Figs 2 and 7). From an analysis of the Barkly East sample, it appears that there is a further tendency for the white-faced figures themselves to be associated in general with a certain type of hunting. The data are summarized in Table 3.

Table 3.
The association of head types with hunting equipment in the Barkly East sample

Head Type	No. in total sample	With bows, arrows	With spear/ stick
Round	446	84 (18·8%)	89 (19·9%)
Concave	206	61 (29·6%)	46 (22·6%)
White Face	230	85 (36·9%)	59 (25·6%)
Animal	42	7 (16·6%)	12 (28·6%)
Line	45	5 (11·1%)	5 (11·1%)

A chi² test on the round, concave and white face categories shows that it is unlikely that the distribution of the two types of hunting equipment was controlled by chance (chi² = 27·59, $P < 0.001$); the same test on the full five categories gives a chi² value of 35·12 which is still significant. There does, therefore, seem to be a tendency for the white faced figures to be associated with a certain hunting technique—that involving the use of bow and arrow—and also with eland.

Even though I have not given full details of my study of superpositioning, I believe I have said enough to show that there are grounds for believing that this structural mode suggests very strongly that not all the southern San paintings are merely "innocent playthings" or scale models; the apparent preferences governing the use of superpositioning point to the proposition that some iconic paintings were deliberately related to each other to function as symbols in a system of communication.

The fourth structural mode, conflation, comprises largely therianthropic figures: these are usually recognizably human in general form, but are painted with animal heads, hooves or legs. In a few cases, such as the example in Fig. 4, one half of the representation is animal and the other human. Also classified as conflations are the so-called "flying buck" which I discuss in Chapter Seven; these forms, I try to show, represent a conflation in which the human element is sometimes totally eclipsed. Signs in this mode are not very numerous. In Pager's (1971, p. 321) Ndedema sample of 3436 identifiable paintings there are 72 conflated signs. In the Underberg sample of over 8000 paintings, there are 155 human figures with animal attributes and 20 "flying buck" (Vinni-

combe, 1976, pp. 239, 323). However, even though signs in this mode do not constitute a large proportion of the total samples, they represent a curious category which is found consistently over an extensive geographical area; they are, in fact, clear evidence of widely held beliefs rather than the whimsy of individuals. What these beliefs might have been, I discuss principally in Chapters Seven and Eight.

In this summary discussion of the quantification of the four structural modes of the rock paintings and also in my account of the content of the art, I have presented numerical statements which repeatedly indicate that the painters regarded the eland as especially important.[4] Critics of the application of quantitative techniques to rock art claim that statistics may demonstrate almost anything; I respond that one cannot make useful statements about the meaning of the art *without* preliminary quantification. Nevertheless, it must be recognized that the enterprise presents numerous difficulties for those not trained in statistical methods: I have therefore submitted all my statistical statements to persons qualified in these matters.[5] I shall not pursue all the problems involved in the application of quantitative techniques to rock art; instead, I draw attention to the fundamental question of sampling.

In making a numerical statement on the rock art, we must assume, to begin with, that a population exists and, secondly, that we have drawn a random sample from it. There is one "ideal" population of paintings within an arbitrarily defined geographical area during some one period of time; it comprises all the paintings that were ever painted there by San artists, whether destroyed or not yet found. This is a rather daunting

conception, for it indicates that even what we now call the population, that is all the paintings presently existing in the region, is, in a sense, a sample of a larger population. What the relationship might be between the original population and that with which we have now to deal is something of which we cannot be certain. However, we can assume that the existing "sample" is itself random in that every painting in the original population had an approximately equal chance of getting into the sample; that is, we suppose the forces of destruction and our own search for paintings have not introduced undue bias. This is the only statement we can make about the representativeness of the existing sample. What I say in this book, therefore, applies only to the paintings now observable and not to some "ideal" universe of all paintings. If the statements I make under these conditions are not valid, we must assume, too, that most archaeologists ought never to say anything about the "samples" they excavate and, perhaps, that most anthropologists say too much about their samples.

The question of the survival of paintings so that they become part of the sample raises the related issues of sequence and chronology. Does the sample comprise temporally comparable paintings or have they survived from widely separated periods and so do not form a cultural entity? If the paintings are to be interpreted chiefly in terms of ethnography collected during the 1870s, this is clearly an important issue requiring close attention. Various writers have constructed sequences based on complex analyses of ill-defined stylistic features. Breuil (1930), for instance, working in four shelters in the eastern Orange Free State, believed it was possible to distinguish two main

periods comprising a total of 17 phases. Dorothea Bleek (1932a, p. 78), after an examination of 88 shelters, quite understandably found it impossible to concur with the Abbé; her work did "not bear out the idea of a sequence of colours, each being used by a different generation". But she enigmatically adds: "To me there does not seem to be evidence of any change greater than would be natural in an art practised through centuries"; she does not clarify what she understands by "natural" change. Nevertheless, she was certainly justified in finding the Abbé's brand of stylistic definition far too subjective to be of any use; I myself am quite unable to distinguish the phases, or even the periods, which he describes. His confusion of style and subject matter is difficult to disentangle; certainly, as he suggests, some of the more recent paintings depict the presence of white settlers, but I cannot correlate these with his "degenerate" style, whatever that may be.

Willcox has attempted a more modest account of the development of the art. Working in the Drakensberg, he concluded that it was impossible to establish a clear, constant series of phases, but he found

nothing inconsistent with the sequence having followed the order one would expect, that is monochromes first, then bichromes, unshaded polychromes, and shaded polychromes in that order; but it is clear that the monochromes, especially the little red human figures, continued to be painted through all stages of the development of the art (Willcox, 1956, p. 61).

Although it seems correct that the shaded polychromes represent a more recent phase, I doubt the seemingly logical and widely accepted view that the oldest preserved paintings are monochromes.

A sequence with which my own data agree, has been proposed by Vinnicombe (1976, p. 139). In the Underberg area she analysed quantitatively 77 shelters containing superimposed paintings—a more impressive sample than the Abbé's four. Although, like Willcox, she found attempts to recognize phases of development disappointing (see also Harlow, 1967, p. 112), she was, nevertheless, able to recognize four phases.

Vinnicombe believes it would be unwise to claim that the paintings of the first phase were all monochromes, because of the poor state of preservation and the fugitive nature of the colours. She shows there was a predominance of animals in the subject matter. This is a view with which I concur; the notion that painting evolved from monochromes to polychromes seems to be based on apparently reasonable assumptions rather than close observation (see also Harlow, 1967, p. 112). The recently dated painted stones from the Apollo 11 shelter in Namibia confirm the belief that the use of more than one colour in a single painting is of considerable antiquity; the *art mobilier* from this site has been dated by radio carbon to between 19 000 and 27 500 years ago (Wendt, 1974, 1976). In referring to these astonishingly early finds I do not propose an unbroken painting tradition between the Apollo 11 site and the paintings of the Drakensberg; it is possible that two separate traditions are represented. Nevertheless, it is worth noting that bichrome paintings of great antiquity have been found in southern Africa.

Of her phase 2 paintings, Vinnicombe (1976, p. 139) writes that they "include clearer representations of humans and animals in various shades of red, sometimes with additional details in white, and specific compositions are recognizable".

During her phase 3, shaded polychromes make their appearance, although the monochromes continue.

Vinnicombe states, of phase 4, that

During the fourth and final phase shaded polychromes diminish although they persist, and many newly introduced subjects such as guns, brimmed hats and horses appear. There is a greater use of black, yellow ochre and bright vermilion or orange at the expense of the more traditional dark reds (Vinnicombe, 1976, p. 141).

She adds that there is greater variety in the subject matter and attempts at composition in this phase; there is also a more marked emphasis on human figures.

Most of Vinnicombe's findings are borne out by the Barkly East sample. The bright vermilions and orange colours appear exclusively in the upper layers of superpositions. The greatest concentration of superpositions appears to be in the shaded polychrome phase.

The dating of these phases presents considerable problems (Butzer *et al.*, 1979), except for the final one which is readily datable to the nineteenth century on grounds of the subject matter. In an early paper Willcox (1955; see also 1956, p. 61, 1973, p. 38) tried to date the shaded polychrome paintings which characterize the beginning of phase 3. Discussing historical evidence, he suggested approximately 1700 A.D. as the *terminus a quo* for the development of this technique. Pager

(1973), who believes that the shaded polychromes are more widely distributed than had been supposed, has suggested that the execution of these paintings took place between about 1600 and 1870.

The dating of the paintings will have to remain of this imprecise kind until more sophisticated techniques have been developed to deal with paint samples. The analysis of amino-acids by paper chromatography has been applied by Denniger (1971) to samples of paint from the Drakensberg and elsewhere, but, although the dates so far produced are in no way exceptionable, the method has its limitations and should be regarded with reservation. No recognizable paintings from the South Eastern Group have been found in archaeological deposits, but Carter's work in the Sehonghong shelter (Lesotho) has shown by the presence of painted exfoliated fragments in datable strata that paintings were in existence in this site before 450 A.D., but this does not mean that surviving paintings still *in situ* are so old (Vinnicombe, 1976, p. 143).

Even though the dating of the phases of the art has yet to be established, it is possible to say that the surviving paintings of the South Eastern Group appear to constitute a single and perhaps not very long tradition; it is not possible to discern radically different periods which might have been separated by major cultural changes. All phases overlap to a certain extent. Through all four phases, whatever may have been the emphasis placed on the human figure, the eland is a continuing theme. The apparently oldest paintings that I have been able to identify are of eland and the antelope still features prominently in the more recent nine-teenth century groupings incorporating mounted soldiers in British uniforms. It seems most unlikely that many of the paintings currently existing on the walls of rock shelters in the Drakensberg are more than two to three hundred years old. Although the rate of weathering of the Cave Sandstone on which they are painted is unknown, I find it difficult to believe that the paintings in the shelters are of an antiquity that is in any way comparable with that of the Apollo 11 or the southern Cape coast painted stones.[6] This impression is confirmed by the results obtained by Denninger's chromatography. The oldest date obtained by him in the Drakensberg, 800 ± 200 years B.P., came from a phase 1 eland; but he regards this as a provisional date owing to the paucity of the sample. Denninger's other dates for eland range from 400 ± 100 years B.P. to 100 years B.P.[7]

It appears, then, that we are dealing with a corpus of paintings that probably does not extend over a vast time range as do the European palaeolithic paintings and that the eland was an important element of the art in all the phases we are now able to distinguish. The interpretative remarks I make in Part Two must be taken to refer only to these paintings of the last two to three hundred years and not to others of proven higher antiquity. In the light of the probable general unity of the art it seems reasonable, in attempts at interpretation, to use the ethnographic material that was collected from the southern San some hundred years ago. The southern San ethnography, I believe, confirms the implication of the positional analysis of the art that many of the rock paintings are indeed icons functioning not as scale models, but as symbols and that others again are "pure" symbols. It is, therefore, to an evaluation of the ethnographic record in relation to the paintings that I attend in the next chapter.

Notes

(1) The remaining copies were published in 1953 by Rosenthal and Goodwin. The originals of the entire collection are housed in the South African Museum, Cape Town.

(2) Anati (1964, p. 33) also used punch cards to analyse his Camonica Valley rock art data.

(3) To explain the omission of the wildebeest, Vinnicombe (1976, p. 213) has suggested an association between this antelope and social avoidance categories; but she admits that there is no direct evidence for this suggestion. Citing quantitative inventories of paintings and the results of excavations, Vinnicombe (1972a, p. 194) rightly rejects the suggestion that the emphasis on eland and the avoidance of wildebeest in the art is "a true reflection of either the faunal population of the area, or of the diet of the hunters".

(4) See also Maggs (1967), Pager (1971), Smits (1971), Smuts (1973), Vinnicombe (1976).

(5) I thank Dr Bruce Faulds, Dr John Butler-Adam and Mr M. Sutcliffe for their assistance.

(6) See Singer and Wymer (1969), Wendt (1972 and 1976) and Deacon *et al.* (1976).

(7) For a summary of Denninger's results see Pager (1971, pp. 357-359) and Willcox (1971).

Chapter 3

The Ethnography

Although rock paintings are found in numerous parts of the world, it is unusual for the worker to have any ethnographic data to assist in the task of interpretation. Australia, I suggested in Chapter One, is a notable exception; in some areas the art there is still being executed and the actual artists may be interviewed. Elsewhere, as in France, Spain, Italy and North America, there is no, or hardly any, record other than the paintings themselves and archaeological remains.

In South Africa the position is more favourable. By remarkable good fortune there exists a considerable body of ethnographic material about the San of the nineteenth century which, I believe, gives the southern African rock art a very special interest that has not been sufficiently widely acknowledged. In addition to the writings of numerous early travellers who noted occasional points about southern San belief, there are two important nineteenth century sources; both comprise material supplied by San informants who, although not painters themselves, were, as I show in this chapter, familiar with at least some of the art. These sources, compiled by Bleek and Orpen, are the closest to the actual artists and are the basis for the interpretations I present in Part Two. It is largely this Bleek and Orpen material which permits discussion of the painted signs in terms of the approach offered by Turner.

In addition to these nineteenth century sources I also use material obtained from contemporary !Kung informants. In 1972 (Lewis-Williams, 1975, p. 414) I maintained that the student of southern San rock art should ignore material collected from San groups as distant in time and space as the modern !Kung and concentrate entirely on the ethnographic record provided by Bleek and Orpen. In the light of my subsequent field work with the !Kung, I now retract this judgement in favour of a more moderate position. One of the valuable by-products of this investigation of the rock paintings has been the discovery of some unexpected conceptual parallels between the !Kung and the southern San (Lewis-Williams and Biesele, 1978; Lewis-Williams, 1980); these parallels, I argue, make the cautious use of !Kung material legitimate in those areas of thought in which similarities between north and south can be adequately demonstrated. Before describing the way in which my own !Kung material was collected I discuss and assess the two major nineteenth century San ethnographic sources.

The most important and voluminous source of southern San ethnography was compiled by the Bleek family. Wilhelm Heinrich Immanuel Bleek was born in 1827 in Berlin.[1] At the University of Berlin he worked on aspects of Hebrew grammar and this study led him eventually "to the so far unexplored African languages" and resulted in his doctoral thesis which attempted to assign a north

African origin to Khoikhoi. After a short spell in England, he was appointed in 1854 as linguist to the expedition of Dr W. B. Baikie to West Africa. Unfortunately for him (though not for students of the San), he contracted a fever and was unable to proceed up the Niger as he had hoped. He returned to London disappointed and with his mission only partially accomplished. There he was introduced to Sir George Grey who had just been appointed Governor of the Cape Colony, and to Bishop Colenso who was preparing to leave for Natal to which bishopric he had been appointed. Colenso engaged Bleek to undertake the compilation of a Zulu grammar.

Soon after Bleek's arrival with the Colenso party in Natal, his interest in the San was awakened by reports of San cattle raids. His sojourn in Natal was spent, however, not working with San, but recording the Zulu language and traditions; part of the time he spent living with the Zulu people in their kraals—something he was never able to do with the San because of their remoteness and the colonial situation. Towards the end of 1856 he travelled to Cape Town to become interpreter to the High Commissioner, a position which allowed him to continue working on Bantu and Khoisan languages. In 1862 he married Miss Jemima Lloyd, whose sister, Miss Lucy Lloyd, was to play such an important part in the San researches. After some difficult years which included his dismissal by Sir George Grey's successor, Sir Philip Wodehouse, Bleek was appointed curator of the Grey Collection at the South African Public Library, and finally in 1870, through the good offices of men like Darwin, Lyell and Huxley, he was granted a permanent pension of £150 per year.

While working in Cape Town he became further convinced of the importance and urgency of the special study of the Khoisan languages. In 1870 he wrote to Sir George Grey, who remained a life-long friend, to tell him of a situation which was to prove of the utmost importance not only to him but to San studies in general:

But it will be more important to me now to study Bushman for which I have now an excellent opportunity, as there are 28 Bushmen at the Breakwater (Spohr, 1962, p. 35).

The "Bushmen" were /Xam[(2)] who came from the Cape Province south of the Orange River and had been sent as convicts to Cape Town where the new breakwater was being constructed. Realizing that he had an opportunity which, if missed, would be gone for ever, he stopped work on his *Comparative Grammar of South African Languages* to devote himself to the new task.

Bleek started his work with the San prisoners at the breakwater jail, but this location proved uncongenial and he persuaded Sir Philip Wodehouse to permit some of the better informants to live with the Bleek family at their Mowbray home. As the work gathered momentum, Bleek realized that he should not concentrate solely on linguistics; the informants were familiar with an impressive and valuable body of mythological material. The work was accordingly divided between Bleek himself and Miss Lloyd. He concentrated largely on linguistic matters while she devoted herself to the mythology and continued to do so after Bleek's untimely death in 1875. Indeed most of our knowledge of /Xam folklore is a result of Lloyd's efforts. The surviving 27 Bleek notebooks, extending from 1866 to 1874, contain 2621 pages, many of which are given over to lists of words with English and Dutch translations. The Lloyd notebooks cover the period from 1870 to 1884 and comprise no fewer than 10 300 pages of folklore, a formidable collection by any standards. Lloyd died in 1914, having, after much labour and frustration, seen to the publication of *Specimens of Bushman Folklore* in 1911. The work was continued by Bleek's daughter, Dorothea, who published a great deal more of the material that had been collected by her father and aunt. The *Bushman Dictionary*, work on which was started so long ago by Wilhelm Bleek, was not published until 1956, eight years after Dorothea's death.

Before outlining the manner in which the collection was compiled, I give some details about the /Xam informants from whom most of the material was obtained and on whom, therefore, this study heavily depends. From 1879 to 1884 Lloyd worked also with youthful !Kung informants, but I confine my remarks to the /Xam.

The principal informants came from two areas of the Cape Province: the Strandberg (then known as the Strontberg) and, secondly, from the Katkop Mountains which were thought by Bleek (1875, p. 5) to lie 200 miles to the west of the Strandberg, an error repeated by Lloyd (Bleek and Lloyd, 1911, p. xi); it is actually between 90 and 100 miles distant (Rudner, 1970, p. 147). Bleek found that the dialects spoken by these two groups varied slightly and believed that "their native traditions form an independent testimony to the substantial identity of the mythological stories, handed down to the present generation by their ancestors" (Bleek, 1875, p. 5).

This "independence" of the testimonies from the two groups of informants requires careful

definition. Bleek believed that the informants from the two areas never met before or after coming to Cape Town and that their testimonies are independent in the sense that there was no contact between the bands from which they came. However, after Bleek's death evidence became available which suggests that the groups from which the informants came were, in fact, known to each other: representatives of both groups spoke of an old rain medicine man named //Kunn. The Katkop informant, Diä!kwain, described the way in which //Kunn was believed to have the power to give or withhold rain (Bleek 1933, p. 385). The Strandberg informant, (Han≠kassō, who arrived at Mowbray after Diä!kwain had left, said that he had also known the old //Kunn and had come to regard him as his grandfather, although he was really a relation of his maternal grandfather (Bleek, 1933, p. 387). If they were both speaking of the same //Kunn, as Dorothea Bleek's grouping of the accounts implies, we must assume some contact between the groups from which the informants came. Nevertheless, their stays at Mowbray did not overlap and their testimonies are, in that sense, "independent". The variation in dialect, which Bleek nowhere defines, was, in any case, not deemed sufficient to warrant a different linguistic category and both were designated Sl.

The first major informant came from the Strandberg; he was a youth named /A!kunta, or "Stoffel", and was with the Bleeks from August 1870 to October 1873. He was allotted the number L.I. in the Lloyd series of notebooks[3] and contributed about 170 pages of material.

//Kábbo, or "Jantje Toorn", also from the Strandberg, was with the Bleeks from February 1871 to October 1873. He was about 60 years old and was chosen from among 28 adult San in the breakwater jail as one of the best narrators. He arrived at Mowbray on 16th February 1871 and Lloyd recorded her first work with him on 23rd February. The notebooks (numbered L.II.) show a hesitant beginning, but he eventually became an excellent informant and "patiently watched until a sentence had been written down, before proceeding with what he was telling". Lloyd reports that "he much enjoyed the thought that the Bushman stories would become known by means of books" (Bleek and Lloyd, 1911, p. x). Within four months of his moving to Mowbray his term of penal servitude expired, but he elected to remain with the Bleek household. He finally left Mowbray in 1873 together with /A!kunta to rejoin their wives and children; it was //Kábbo's intention to return to Cape Town, but he died before he could do so (Lloyd, 1889, p. 3). While he was with the Bleeks he contributed over 3100 pages of material.

//Kábbo's statements are of particular interest because, although it is not generally recognized, he was apparently a medicine man who had control of the rain. While at Mowbray he was required to work in the garden. In October 1871, finding the ground too hard, he caused rain to fall. He accomplished this feat while in a "dream" (the word for dream, //kábbo, is the same as his own name). In this state, he claimed, he spoke to the rain, asking it to fall, as he used to do in his own country; he also said he went on an out-of-body journey to his home where he spoke with his wife and son (B.26.625-31). His descriptions of rain-making rituals, which I discuss in Chapter Eight, have, in the light of this report, a special value because they are probably first-hand accounts.

//Kábbo was also said to have control of "mantises" (Bleek, 1936, p. 143), a remark which again suggests that he was a medicine man.

Efforts to obtain the services of other members of //Kábbo's family at first failed; finally in January 1878 //Kábbo's son-in-law, /Han≠kassō or "Klein Jantje", arrived in Cape Town, his wife having died on the journey in spite of the assistance rendered by the Civil Commissioner at Beaufort West (Lloyd, 1889, p. 4). Like //Kábbo, he proved to be "an excellent narrator of Bushman lore, and a thoroughly efficient helper". There is evidence that /Han≠kassō had direct access to traditions antedating the arrival of the whites, for Lloyd records that his father, Ssounni, "possessed no Dutch name, because he died before the Boers were in that part of the country" (L.VIII.1.6052). /Han≠kassō remained in Cape Town until December 1879, contributing over 2800 pages in notebooks numbered L.VIII.

The chief informant in the Katkop dialect, Diä!kwain or "David Haesar", was at Mowbray from December 1873 to March 1874 when, anxious about the welfare of his family, he journeyed home to Calvinia. In June 1874 he returned with his sister and her husband, ≠Kásin. ≠Kásin (L.IV.) had also accompanied Diä!kwain on his first visit to Cape Town. Four of ≠Kásin's children eventually found their way to Cape Town. This large group placed a financial strain on the Bleeks, but /Kweiten ta //kēn or "Rachel", ≠Kásin's wife, refused to remain without her children. Bleek was delighted to have the services of a woman informant, but she must have proved unsatisfactory as she contributed only 188 pages (L.VI.); she left Mowbray in January 1875. Diä!kwain himself finally departed in March 1876,

having contributed over 2400 pages of material (L.V.)

Attempts to secure the services of another woman failed. /Xáken-an, an old /Xam woman, was with the Bleek's for a short while in 1884, but "she longed to return to her own country, so that she might be buried with her forefathers" (Bleek and Lloyd, 1911, p. xi).

The ability of these informants to speak a little Dutch and also the Dutch names of some of them show that they had had contact with the white settlers, but it seems to have been limited to exchanging ostrich feathers for tobacco (L.II.24. 2198) and other brief encounters apparently without developing into a serf relationship. On the contrary, there is clear evidence that at least //Kábbo's Strandberg group was still enjoying a hunter-gatherer life. //Kábbo lived for part of the year at a waterhole called //Gubo or Blauputs. This had been "owned" by his grandfather and //Kábbo had inherited it via his father and his elder brother (Bleek and Lloyd, 1911, pp. 305, 307; see also Philip, 1842, p. 184). In addition to //Gubo, //Kábbo also had control of water at two other places to which his band moved seasonally (Bleek and Lloyd, 1911, p. 307). At some times of the year they lived in small scattered groups within sight of each other's fires at night; at other times they came together and established a camp with the huts of //Kábbo's children arranged on either side of his own (Bleek and Lloyd, 1911, pp. 307-309). The huts were built some distance from the waterhole in order not to frighten away the animals that came to drink (Bleek, 1924, p. vi). At the time of //Kábbo's arrest on a charge of having stolen a sheep, the band was eating a springbok which they had shot. The group at this time comprised //Kábbo and his wife, his son with his wife and child, and his daughter together with her husband and child: this group, said //Kábbo, was "not numerous", implying that at other times the band was larger (Bleek and Lloyd, 1911, p. 295).

Less detailed information is available on the Katkop informants, but nothing in the record suggests that their position was any different from that of the Strandberg San. Diä!kwain, in fact, describes an occasion on which a Boer had shot at him and his young son. He had done nothing wrong, but was simply away from home collecting poison to prepare his arrows for shooting springbok (L.V.3.4132 rev.—4133 rev.). Other Katkop San known to the informants had entered into a serf relationship with the white farmers. Diä!kwain gave Lloyd a horrifying account of how one of these, Ruyter, a San man known to him, had been beaten to death by a farmer because he had not herded the sheep well. Diä!kwain himself had evidently worked briefly for white farmers (Bleek, 1932, pp. 326, 328), but other accounts, such as the circumstances of Diä!kwain's first wife's death, also show that he and his family were accustomed to band life (Bleek, 1932, pp. 243-247).

It was, then, informants from this still partly "nomadic" background who supplied most of the Bleek material. In compiling the collection the procedure followed by Wilhelm Bleek and Lloyd was first to record the text in /Xam, for which Bleek developed a phonetic script. The material was entered in quarto notebooks the right hand pages of which were divided into two columns: the /Xam text was entered in one column, the other being left for the translation. Figure 8 shows Lloyd's transcription of the beginning of Diä!kwain's version of the creation of the eland.

The dates in the notebooks show that translation was done more often than not within a few days and then read back to the informants for checking. While the checking was being done, the informants sometimes offered further observations or clarifications; these were noted on the opposite, left hand pages.

When Bleek started work with his informants he concentrated on vocabulary. His initial technique was to point to pictures of various objects and to ask the informants to respond; he then noted down the /Xam word in his phonetic script. After Bleek's death, the names of animals and insects were obtained or checked by Lloyd in May 1878 by taking /Han≠kassō to the South African Museum, Cape Town, and asking him to give the /Xam words for a large number of specimens. The informants' knowledge of Dutch is illustrated by the lists of /Xam words translated into that language by the informants. Sometimes both Dutch and English was used by the informants; Diä!kwain, for instance, offered the following mixture: "so fat and nice and mooi" (L.V.18. 5410). In another place the word /kerri is recorded on L.V.17.5343 rev. as "slechte ding"; Lloyd, in turn, translated this phrase as "a bad thing" and finally it appeared in print as "vermin" (Bleek, 1932, p. 236).

As the work continued and Lloyd's own facility with the /Xam language improved, she left some passages untranslated apart from the occasional obscure word or phrase which, the colour of the ink suggests, she translated at the time of the recording of the /Xam text. Some few passages, left untranslated by Lloyd, were later dealt with by Dorothea Bleek. /Han≠kassō's version of the creation of the eland, for example, was recorded by

Fig. 8. A page from one of Lloyd's notebooks.

Lloyd on 25th March 1878 and translated by Dorothea Bleek on 1st December 1914 (L.VIII.6. 6505). Dorothea Bleek admits that such later translations were not easy: /Xam words appear in a variety of spellings and without knowledge of the context of the passage concerned translation is virtually impossible. Both Bleek and Lloyd tried to record words as closely as possible to the sounds they heard; there is thus a fair variation in the spelling of the /Xam words even within a single passage. The *Bushman Dictionary* is therefore often of very little help with the original texts because it is impossible to find many of the notebook words in it. Happily, the untranslated passages are not extensive. If they defeated Dorothea Bleek who enjoyed the tuition of Miss Lloyd, there is little hope of their being reliably translated now.

Problems of other sorts also beset the Bleeks' work. The informants were, in the first place, not initially accustomed to dictating their narratives with pauses to permit Bleek or Lloyd to record their words. Some, it seems, were irritated by the process, but others learned to sit patiently while the noting down was being done. As we have seen, Lloyd paid tribute to //Kábbo for this capacity. The degree to which this laborious process might have affected the recording of the material is difficult to assess. I have the impression that once the technique had been accepted by an informant the work proceeded with very little damage to the narration, but in the early stages the pauses seem to have confused the informants. Certain work with Diä!kwain, for instance, was translated by Lloyd on 27th December 1873. Early in the January of the following year discrepancies between the later, dictated version of the creation of the eland and the version as first told were

becoming apparent. Lloyd explained this in a note written on 6th January 1874.

D.H. told me the tale this way the 1st time he told it, but not when he dictated it to me—so I make the note of the right story here—It was difficult for him to dictate at 1st, which is probably why I could not get this properly and as he 1st told it to me. I have now heard again that this *is* the right story (L.V.1.3612 rev.).

This particular narrative was started within days of Diä!kwain's arrival at Mowbray, so it is not surprising that difficulties arose. Such confusions sometimes became apparent to the informants when the translation was read back to them; occasionally they were reminded of further details. These additional points were noted on the reverso pages in /Xam and English or in English only.

Another difficulty in assessing the material recorded by the Bleeks is that we do not always know what led the informants to offer a particular narrative. In some cases certain points came up in conversation with the informants who were asked at a later date to supply a detailed account. For example, on 13th December 1875 Lloyd obtained a fragment of a ritual which caught her attention and she made a note of it. The following day the full version was recorded (L.V.20.5594-5604). A detailed account of the mode of making dancing rattles from dried springbok ears was obtained after a reference to them had been made by /Han≠kassō during an account of a dance (L.VIII.2.6133). Occasionally one narrative flows into another. Diä!kwain's version of the creation of the eland grades into a further adventure. On L.V.1.3682 rev., Lloyd noted: "Another adventure of /Kaggen comes here; which

happened afterwards when he had been at home recovering from the fight about the eland." The two tales are published as separate narratives in *The Mantis and his Friends* (Bleek, 1924). Another version of the eland myth leads from the creation of the moon into a long discourse on hunting porcupines by moonlight.

Not all the memoranda which were noted by the Bleeks on scraps of paper, reverso pages and the inside of notebook covers were fulfilled. One tantalizing note reads: "D.H.'s father's drawings. Get in about the ostrich skin and rocks on which he did them" (L.V.17. loose paper), but she apparently did not "get it in".

This incomplete reference brings me to the next important point: the informants' familiarity with the practice of painting. It is strange that the Bleeks did not investigate this aspect of San life more fully: Wilhelm Bleek was certainly interested in the paintings, as his remarks on Stow's and Orpen's copies of them show. Perhaps his apparent lack of interest is a result of not having sufficient copies immediately available; when he did have some, such as those made by Orpen, Stow, Schunke and Durnford, he showed them to the San who were with him at the time; had he lived, we might have had much more valuable exegetical material. Lloyd seemed more concerned with asking the informants to identify the items depicted than with asking about the meaning or purpose of the paintings. Those to whom both she and Bleek showed the copies which were sent to them all accepted that they were looking at pictures that had been made by their own people; there never seems to have been any doubt on that point.

The note which I have just cited certainly shows

that Diä!kwain knew about painting or engraving on rock; the "ostrich skin" on which his father is also said to have drawn probably means ostrich eggshells, as it still does among the !Kung (Biesele, pers. comm.).[4]

Another note concerns an otherwise unidentified place called !Kánn; Lloyd wrote of this place: "Where D.H.'s Father chipped gemsbok, quagga and ostriches, etc., at a place where they used to drink, before the time of the boers" (L.V.24.5963 rev.; Bleek and Lloyd, 1911, p. xiv). Diä!kwain was himself asked if he could make pictures; in response he produced a series of pencil and crayon representations which do not closely resemble the paintings with which we are familiar in the rock shelters. These and drawings made by other informants have been discussed by Rudner (1970), who concludes, rightly, that none of the informants was himself an artist; but she goes further and doubts whether Diä!kwain's remarks concerning his father's pictures at !Kánn are reliable. She wonders whether he "was carried away by months of relating legends and myths to the researchers" and whether he had indeed seen his father make petroglyphs. She concludes that this art form had already died out in the areas from which the Bleek informants came except for "scratchings" commonly attributed to herd-boys (Rudner, 1970, p. 153). If this were indeed the case, it seems unlikely that the art form had been dead for very long. Stow describes meeting a group of southern San in the 1870s. In response to his questions, they said that they did not paint on rock, but they had "heard in the old time of a far distant tribe that did so. They themselves did not paint, but were used to chase the figures with a sharp piece of stone on the face of the rock". Stow remarks that

this "was spoken of in the past tense as if the practice had been discontinued at the present time" (Stow, 1874, p. 247). This encounter may have provided the basis for his theory that there were two distinct divisions of "the Bushman race", painters and engravers (Stow, 1905, pp. 12-13); but for our present purposes we may note that the San remarks suggest that in the 1870s engraving and possibly painting had been discontinued by some San in the recent past and many San were still familiar with the practices.

In addition to the references to southern San artists that I have already cited there is another important one in an unpublished myth which suggests the informant's familiarity with painting. It comes from the beginning of a myth entitled by Lloyd *The Girl of the Early Race of People who married a Baboon*:

Little girls they said, one of them said, "It is //*hára*, therefore I think I shall draw a gemsbok with it." Another said, "It is *tò* therefore I think I will draw a springbok with it." Then she said: "It is //*hara* therefore I think I will draw a baboon with it." Then the baboon sneezed when the child spoke his name, when she was a little girl (?) he sneezed (L.VIII.18. 7608-7609).

This passage contains a number of interesting points, but for the present I simply note that it implies that the narrator, /Han≠kassō, was conversant with the practice of painting. It also appears that he had some knowledge of the ingredients used in the preparation of the paint. //*Hára* is black specularite and *tò* red haematite.

It seems fair, in view of these points, to conclude that, although none of Bleek's informants was himself an artist, some at least were familiar with the practice of painting. The actual rock paintings which they could have known are, it must be admitted, rather different from those of the Drakensberg; there appears to be a much higher proportion of "symbolic" geometric designs and fewer "naturalistic" paintings in the region from which the informants came (Rudner, 1968). More significant, however, than the /Xam informants' familiarity with examples of rock art is the important suggestion that they shared some conceptual patterns with the artists of the Drakensberg.

The second major ethnographic source on which I draw is more directly connected with the Drakensberg paintings and provides a valuable link between the Bleek /Xam collection and the paintings. It was compiled in the Maluti Mountains of Lesotho and thus comes from a region only a few miles from the area from which my Barkly East sample derives.

The collection was made in 1873 when J. M. Orpen, in his capacity as Chief Magistrate, St John's Territory, was asked to act against the rebels of Langalibalele's tribe who had escaped from Natal and were thought to be heading for the area under Orpen's jurisdiction. Because this undertaking meant going into the unknown Malutis, Orpen made enquiries for a suitable guide and learned of a San named Qing. He was said to have been the son of a chief whose "tribe" had been exterminated. He was currently employed as a hunter by Nqasha, a son of Morosi, the Sotho chief. Whilst visiting Nqasha, Orpen also met Qing's two wives who were evidently both San: "diminutive young creatures, and fair complexioned" (Orpen, 1874, p. 2).

Before meeting Orpen, Qing had "never seen a white man but in fighting" (Orpen, 1874, p. 2).

He was a young man with a passion for hunting and considerable equestrian skill. The final paragraph of Orpen's paper suggests either that Orpen returned to the Malutis after this first meeting to interview Qing a second time or that Qing remained in his service after the conclusion of the expedition. At the time of the expedition against Langalibalele Orpen did not know of the tales collected by Bleek. These were drawn to his attention, probably by Stow, after the expedition and Orpen only then asked Qing whether he knew the widely-reported story of the moon and the hare.[5] Qing said he did not know the tale. Apart from a reference to a food avoidance, Orpen does not state explicitly whether Qing's tales were obtained before or after his hearing of Bleek's material; the implication, however, is that most of the material was obtained on the initial expedition and could not thus have been elicited by leading questions suggested by the Bleek tales.

The manner in which Orpen obtained his material is, nevertheless, in some ways even less satisfactory than that in which Bleek obtained the /Xam collection. Orpen says that the tales were given by Qing when they were "happy and at ease smoking over camp-fires". The interviews were conducted by means of interpreters; the language which Qing knew best beside his own was "that of the 'Baputi', a hybrid dialect between Basuto and Amazizi" (Orpen, 1874, p. 3). Orpen's reference to "different translators" may, however, imply more than one stage of translation: it is possible that San concepts were being translated first into "Baputi", then into Xhosa and, finally, into English. In any event, it does not seem as if Qing was speaking San to a San-speaking interpreter. Yet even after such "weakenings" of the material

there are striking resemblances between the Bleek and Orpen collections; this is itself a powerful testimony to the suggestion that the Orpen collection provides a "link" between the /Xam and the rock paintings of the Drakensberg.

By modern anthropological standards the manner in which the Maluti material was collected is unsatisfactory and may have contributed to Orpen's belief that the tales were "fragmentary" —a condition which he also ascribed to Qing's being a young man and therefore knowing the stories imperfectly. In preparing the tales for publication, Orpen therefore did a certain amount of arranging: "I shall string together Qing's fragmentary stories as nearly as I can as he told them to me. I noted them down from him then and since; I only make them consecutive" (Orpen, 1874, p. 3). It is impossible to say how much damage may have been done to the tales in making them "consecutive"; all my attempts to trace Orpen's original notebooks or diaries have so far failed.

Valuable as it is, Orpen's material must therefore be secondary to the Bleek collection: in Orpen's case we have only the arranged, published version originally collected through interpreters, but in Bleek's case we have the original San text with a literal translation. Nevertheless, although we must treat the Orpen collection as inferior, it is not therefore useless. On the contrary, the similarities indicate that we should accord the Orpen collection the closest attention.

I shall not now give a detailed comparison of the two collections, but simply note some of the striking parallels which have a direct bearing on the argument of subsequent chapters of this study where I deal with specific points.

The chief mythological personage in both collections is /Kaggen (*Cagn* in Orpen's orthography). Bleek believed that the character of *Cagn* differed from that attributed to /Kaggen by the /Xam. He thought that the *Cagn* of the Malutis was largely a "beneficent being", whereas the /Xam /Kaggen was only "a fellow full of tricks" (Bleek, 1874, p. 11). Had Bleek lived to hear some of the tales collected by Lloyd after his death, I believe he would have revised this view. In some of these tales there are explicit statements (e.g. L.VIII.3.6301) by the informants which show that the /Xam also regarded /Kaggen, on occasion, as a "beneficent being". This is a point I examine in greater detail in Chapter Nine.

Another point of similarity, crucial to my argument, is that both collections give precedence to the eland, as do the rock paintings. In both collections /Kaggen creates the eland and loves it dearly. In the /Xam version /Kaggen created and nurtured the eland in a "water-pool" in which reeds were growing; in the Maluti version /Kaggen's wife gives birth to the eland, but he nurtures the young eland in "a secluded kloof enclosed by hills and precipices". This place seems to be the equivalent of the /Xam water-hole. In both versions the eland is killed without /Kaggen's permission, and he is angry with the hunters. In the /Xam version it is /Kaggen's son-in-law and grandchildren who kill the eland and in the Maluti version it is his own sons. /Kaggen was in still further ways closely associated with the eland in both regions. These I discuss in Chapter Nine.

There are, then, numerous broad, and even some detailed similarities between the Orpen and Bleek collections which suggest that, although they are evidently separate traditions, they are expressions of the same conceptual framework. This common framework seems to be the reason for the further similarities in the responses of informants from these two regions when they were confronted with copies of rock paintings.

Unlike Bleek, Orpen actually began his work with Qing by asking him about certain rock paintings. Some of these paintings had been pointed out to Orpen by Qing on their journey through the Malutis. At no time was there any suggestion that the paintings had not been done by Qing's fellow San; this is implicit in all he said about the paintings. Four of Orpen's copies of these paintings were published together with his paper (Fig. 9): they are from Melikane, Mangolong (now known as Sehonghong) and from a cave at the source of the Kraai River. This last site is probably within the Barkly East sample area, but I have not been able to find it. Orpen's original copies are now in the South African Public Library, Cape Town, together with other tracings made by him in the Wodehouse district.

Before publication, the copies were sent by the editor of the *Cape Monthly Magazine* to Bleek for comment, but initially without Orpen's paper, and so Bleek showed the copies, before he had seen Qing's comments on them, to Diä!kwain and probably his sister as well, since Bleek writes of "Bushmen" from the Katkop Mountains. Diä!kwain's first comments were recorded by Bleek (B.XXVII.2540-2608); the beginning of this account was later repeated to Lloyd (L.V.3.4075-4085) and finally published in 1933 (Bleek, 1933, pp. 375-376), without the manuscript page numbers and, oddly, without any indication that the material was a response to Orpen's copies. The

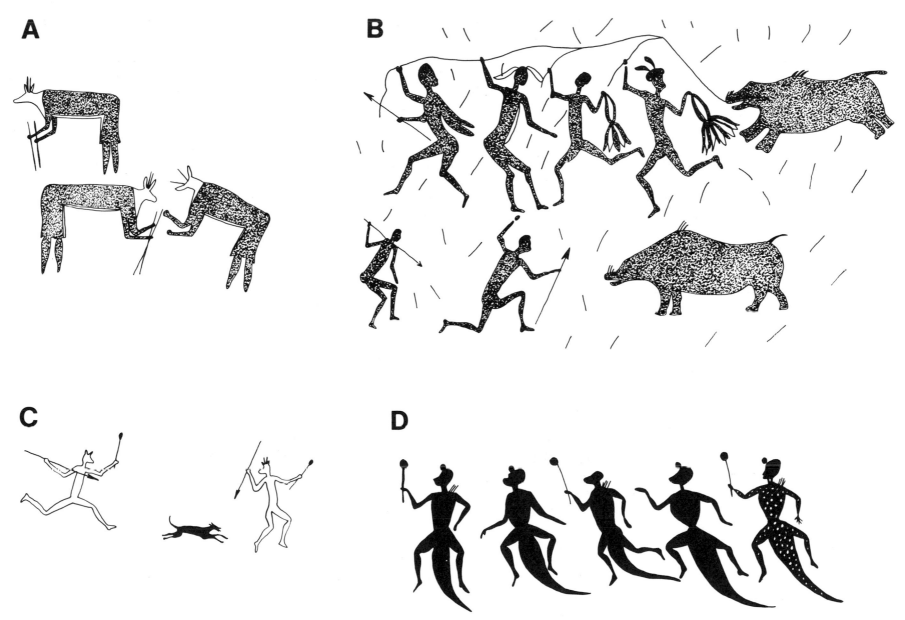

Fig. 9. A black and white redrawing of Orpen's copy of paintings from the Maluti mountains. His captions read A: from the cave of Medikane. B: from the cave Mangolong. C: from cave at source of Kraai river. D: from upper cave at Mangolong.

remarks that *have* been published (Bleek, 1935, pp. 14-15) as given "in explanation of a copy of a rock painting made by the late J. M. Orpen" were apparently made by Diä!kwain when he was shown the paintings a second time in 1876.

We have here a unique and extremely valuable instance of remarks being made by two San informants from widely separated regions on the same paintings: they therefore deserve the closest attention. Bleek (1874, p. 12) regarded the explanations as "differing somewhat", but there are in fact numerous and significant points of similarity which I now briefly indicate because of their importance in demonstrating the link between the Bleek and Orpen collections.

The main reason why Bleek (and subsequent writers) found the explanations "differing somewhat" is that his own informant provided fairly straightforward comments, but Qing's responses were frequently expressed in metaphors which have remained opaque for a hundred years. These metaphors all arise from the experience of trance and include "die" to mean enter trance, "spoilt" to describe a man in deep trance, and "underwater" to convey the sensations of a man in trance. So Qing said that the men with antelope heads (Fig. 9 A) had "died and now lived in rivers, and were *spoilt at the same time as the elands* and by the dances of which you have seen paintings" (Orpen, 1874, p. 2; Orpen's emphasis). I have argued elsewhere (Lewis-Williams, 1980) that this complex statement is probably a combination of several responses in which Qing was trying to explain trance to an uncomprehending but persistent Orpen. What Qing meant was that the men had entered trance, were in an experience analogous to being underwater and that in the

medicine dance they exploited the potency of the eland. Diä!kwain, in a more direct response, confirmed this interpretation by saying that the therianthropes depicted "sorcerers".

There was even clearer agreement about the now celebrated Sehonghong group (Fig. 9 B).[6] Both Diä!kwain and Qing said it depicted a rain-making rite. Men had attached a rope to the nose of the rain-animal and were leading it over the parched land in an attempt to alleviate the drought. In preparation for this potentially hazardous ritual the men had "charmed" the creature with buchu.[7] The informants also agreed, in their characteristic modes of expression, that the rain-making rite was performed by medicine men; indeed, both informants independently confirmed the important role of the medicine men in the production of the art, but Qing's tendency to metaphorical expression has concealed the unanimity. I develop these ideas further in Chapters Seven and Eight.

If we bear in mind that the informants came from widely separated areas and they never saw each other, we must admit that there is an impressive degree of correspondence between the two accounts and that this strongly suggests shared concepts. Bleek (1874, p. 13) thought that these explanations of the Orpen paintings demonstrated for the first time that San paintings "illustrated" San mythology. He went on to claim that "this fact can hardly be valued sufficiently". It is a fact that has perhaps been insufficiently valued by some workers who have tended to dismiss the use of the Orpen ethnography to interpret the paintings. Fock (1971, p. 94), for one, believes that Qing's stories should be taken *"cum grano salis"* and should be used for interpretation only where

they correspond with the Bleek collection; but the correspondences seem to be more numerous and close than Fock supposes and his judgement is probably too conservative. The remarks on the rock paintings and other correspondences suggest that greater reliance may indeed be placed on Orpen's material than has sometimes been supposed.

Whatever the weaknesses of the Orpen and Bleek collections, I have experienced a creative two-way exegetical process between them and the paintings. Sometimes the meaning of the paintings has been clarified by the ethnography and sometimes the meaning of the sources has been revealed by reflection on the paintings. Looking at certain paintings in the light of the nineteenth century ethnography has suggested further unsuspected meaning in the sources themselves: when the art and the ethnography are brought together they illuminate each other. The process of discovery has been (and continues to be) an endless moving backwards and forwards between the paintings and the sources. This mutual illumination between paintings and ethnography, I believe, further strengthens the case for using the Bleek and Orpen material in an interpretation of the paintings. The art and the ethnography are complementary expressions of a single belief system.

Even more distant in space and time from the paintings than the /Xam ethnography of the last century is material obtained from the San presently living in the Kalahari. In spite of their apparent remoteness, I found, somewhat to my surprise, that these contemporary, non-painting people share certain underlying beliefs and attitudes with the extinct southern painters. Whilst the Bleek and Orpen material remains the chief source for my interpretation of the southern San

paintings, I also use, in the following chapters, data collected by myself and others from the !Kung of Botswana. Following the pioneering work of the Marshalls, numerous anthropologists, such as Lee, Biesele and Katz, have made valuable contributions to our knowledge of the !Kung. My use of this remote material, however, requires explanation and clear justification.

A certain amount of confusion surrounds the relationship between the San groups with which I am concerned. Much misunderstanding has arisen from the application of ethnological, physical anthropological and economic criteria to what is essentially a linguistic matter (Westphal, 1963, pp. 243-244). According to his recent research, Westphal (1971) distinguishes three "click" language families, each including several languages and/or dialects (see also Bleek, 1927, 1929a). He calls the families the *Ju*, the *Taa* and the *!Wi*, according to the way in which each renders the word "person". The /Xam belonged to the *!Wi* family (*!kui* in Bleek's orthography); the *Ju* family includes three !Kung dialects and is spoken by the largest number of living San in any one language group. Westphal considers the three language families to be unrelated to one another, but another recent view groups the *Ju* and *!Wi* language families into one "Bushman" group;[8] the remaining languages, spoken by many hunters and non-hunters, are considered to be related to Nama and are designated "Hottentot" (Jenkins and Tobias, 1977, p. 53).

Despite Westphal's insistence on a distinctness of language families, the divisions between them should not be thought of as impervious barriers. Biesele (1975, I, p. 5) has described how the giraffe medicine dance passed from one group to another;

numerous other ideas and beliefs were also held by widely separated groups. Indeed, in view of parallels of this kind and other points, I feel that Jenkins and Tobias are probably right in suggesting that at least !Kung and the southern languages are part of a composite group.

The value of the seemingly remote !Kung material to specific aspects of my work on the southern San rock paintings first became apparent in December, 1974 during discussions with Dr Megan Biesele who had been working with the !Kung for a number of years. As a result of these discussions I joined Dr Biesele in the Kalahari in December of the same year. We had originally hoped to work in the Dobe area, but owing to a variety of complications this proved impossible and Dr Biesele brought a number of her better informants to a camp near Maun. In doing so she explained to them that the purpose of their trip to Maun was to "talk", an occupation to which they had become accustomed during her work with them.

At our camp near Maun the informants were relieved of the task of providing food for themselves and they depended on us except for a certain amount of "veldkos" and an occasional tortoise. This state of affairs did, of course, make any observations of economy impossible, but this was not the purpose of the expedition. The position had, on the other hand, great advantages for the type of work we intended, because the informants, relieved of the daily tasks of providing for themselves, had ample time to sit and talk. On the morning after our arrival, when I was attending to recurrent problems with our vehicle, the informants came across to Dr Biesele to ask when they were going to start "the work they had come to

do". All interviews were conducted in this atmosphere of co-operation.

We started with about a dozen informants, but after a couple of days a number of them returned to the Dobe area leaving us with the following people:

Name		Approximate age	Home
Kan//a	m	65	Magoegoe
!Kun/obe	f	65	Magoegoe (Naron)
Kaishe	m	45	Dobe
Ti!nay	f	45	Dobe
/Xwa	f	7	Dobe
≠Oma !Oma	m	23	Dobe

These were excellent and co-operative informants who took their task very seriously. The interview sessions took up most of each day; their patience and good humour seemed inexhaustible. Some interviews were conducted with only the men and some with only the women as seemed advisable in view of the subject matter. Most sessions were with the whole group.

Throughout the time the informants responded to our questions with the greatest care. When they did not know the answer to a question, they said so; they would not guess. One observed, "You must not say when you don't know." During one of the interviews devoted to the boys' first eland-kill rituals, Kan//a was interrupted by his wife, !Kun/obe, who exclaimed with interest that she did not know about a certain part of the ritual that is performed when women are absent. Kan//a

replied, "This is a serious talk. We are telling these people real things. If we don't know these things, how will we hunt successfully?". The older people seemed to realize that they were the last repositories of their lore and were anxious that we should have a good grasp of the things they considered important.

Although the nature and duration of this field-work leave much to be desired by usual anthropological standards, it nevertheless paid unexpected dividends, the value of which appeared in relation to specific sets of paintings and topics suggested by paintings. The !Kung do not themselves paint, having indeed few surfaces on which to paint; they are, however, aware of the existence of rock paintings in the Tsodilo Hills:[9] they believe that the great god, Gaoxa, put them there. One !Kung woman said that if Gaoxa had not painted the pictures, it must have been the Tsaukwe San, a group living to the south east of the !Kung.

It was therefore with some diffidence that I showed the informants numerous full size, black and white copies of southern San paintings. They all enjoyed looking at the pictures and discussed them in detail with each other and with us. They were able to recognize depictions of single animals and groups of animals with ease, but they took longer to decipher the more complex human groups and scenes: in the Burley I (Fig. 15) painting, for instance, they noticed first the group of eland and only later did they see the two therianthropic figures on which they are superimposed. As they spoke about these two figures, they traced the outlines with their fingers, something they did not do with representations of animals. ≠Oma!Oma explained that he had difficulty in seeing certain things when they were "flat on the page". Why, he asked, did he have no trouble identifying birds in the trees, but when they were illustrated in Roberts's book he became confused? Nevertheless, antelope were identified by all informants without any effort: they recognized not only species, but also types of eland, positions and groups associated with specific times of the year. In sexing an eland they drew my attention to the shape of the antelope's neck rather than to the primary sexual characteristics which were, in some cases, clearly depicted. It is in the interpretation of animal species, sex, groupings and postures that contemporary San informants can, I believe, be of greatest assistance in understanding the content of particular rock paintings; this is a field of study that still awaits extensive exploration. The !Kung's knowledge of animal behaviour (Blurton Jones and Konner, 1976) is impressive and should provide further valuable insights.

There is, on the other hand, nothing to be gained from asking the !Kung to "explain" enigmatic activity groups or conflations; their guesses are no better than ours. The Fetcani Bend group (Fig. 21A; see discussion in Chapter Seven), for instance, they thought represented the //gauwasi (spirits of the dead) because the figures are in such contorted postures; they considered the painting to be a terrifying spectacle. The so-called flying buck paintings puzzled them. One informant said he believed that one of these representations depicted a bird not found in the Kalahari, but which possibly lived in the white man's land: he seemed to discount the possibility of its having been painted by a San artist, although all the informants were willing enough to accept that the paintings of animals had been done by San. These baffled responses, however, to what are really naive questions, should not prevent us from recognizing the other valuable and positive contribution that San informants can make in the indirect ways I describe in subsequent chapters: the potential of the more oblique approach to understanding the art is considerable.

At all times during my work with copies of the paintings and in other discussions I tried to avoid asking leading questions and to allow the information I wanted to come out in general discussion. Many "open-ended" questions led on to detailed discussions during which informants occasionally queried each other's observations in a manner that gave us confidence in the reliability of the replies: I do not think any observations were designed simply to please the anthropologists. When, for instance, I told them that another group of San, far to the south, observed this or that practice they either replied that they were aware that different people did things in different ways or, if they thought the suggestion preposterous, they said that I had been misled.

Some of the most valuable information came to light in reply to questions suggested to me by my reading of the southern San ethnography; these questions had not occurred to other workers in the Kalahari less familiar with the southern material. As the work proceeded, more and more points of similarity between southern and !Kung beliefs became apparent. The possibility of such parallels has already been noted by some writers. McCall (1970) has described the equivalence between hunting and mating in San thought and has suggested that such concepts were "pan-Bushman". Vinnicombe (1972a) has drawn attention to /Xam beliefs comparable to the !Kung concepts of *n!ow* and *n/um*. In subsequent chapters I present

further evidence for /Xam beliefs very similar to the !Kung beliefs concerning *n/um*. I also describe detailed eland hunting rituals, girls' puberty observances, marriage rituals and the practice of trance performance all of which suggest that the !Kung and the /Xam share a common "cognitive culture". So it seems legitimate to use the !Kung material cautiously to explicate some of the sometimes aleatory remarks of the /Xam informants in those areas of thought where equivalences can be demonstrated. At all times, however, I base my discussion on the southern record and cite the !Kung material only where such a procedure is demonstrably permissible.

The three major ethnographic sources which I have now described and assessed provide only restricted material suitable for a *direct* exegetical discussion of the actual southern San rock paintings. They do, however, provide a wealth of material on the objects of the painted signs. From these sources it is possible to cull data on the positional, operational and exegetical dimensions of the objects of the painted signs as they are used by the San in ritual and mythical contexts. It is to a discussion of the paintings in these terms that I give attention in the second and major part of this book.

Notes

(1) Biographical details, unless otherwise acknowledged, are from Spohr (1962).

(2) Bleek found the word "/Xam" in such phrases as */Xâm-ka-!kui* (a "Bushman") and */Xâm-ka-≠kakken* ("Bushman language") and concluded that it referred to "the Bushmen in general as a nation" (Bleek and Lloyd, 1911, p. 144). Today it is generally used to denote the San who lived in the Cape Colony in the vicinity of Calvinia and Kenhardt; I use it in this way.

(3) Each informant's material was recorded in a series of notebooks devoted entirely to his or her contributions. References to the books are given as follows: the initial B or L indicates whether the material was recorded by Bleek or by Lloyd; the following Roman numeral, in the case of the Lloyd books, designates the informant; the succeeding Arabic numerals give first the number of the book and then the page number. The page numbers were added after the completion of the entire collection and run consecutively through the Bleek notebooks and then, starting again at one, through all the Lloyd books. A reference such as L.V.17. 5317, therefore, indicates material obtained by Lloyd from Diä!kwain and noted on page 5317 of book 17.

(4) For descriptions of ostrich eggshell engravings see Stow (1905, p. 50), Meiring (1943, 1945, 1951) and von Luschan (1923). Fragments of engraved ostrich eggshell have been recovered from deposits dated to approximately 3000 B.P. (Humphreys, 1974, p. 117).

(5) This tale deals with the origin of death. See Alexander (1838, I, p. 169), L.IV.4.3882-3900, Bleek (1928, p. 44), Wikar (1935, p. 139), Bleek (1935b, pp. 271-281), Smith (1940, II, p. 282) and Tindall (1959, p. 28).

(6) For a modern, accurate tracing of this painting see Smits (1973, p. 32) or Vinnicombe (1976, p. 337).

(7) A preparation made from a wide variety of aromatic herbs. Bleek (1956, p. 210) gives the names of five plants used by the /Xam. Dr O. Hilliard of the University of Natal has kindly given me the modern forms of these names: *Ocimum canum* Sims; *Peliostomum leucorrhizum; Epaltes gariepina* Steetz; *Hibiscus elliottiae* Harvey; *Lepidium divaricatum* Ait.

(8) See also Traill (1973, 1974, 1979) and Snyman (1974).

(9) See Rudner (1965, 1970), Biesele (1974) and Campbell *et al.* (1980).

Part II

Chapter 4

─────────────────────────────The New Maiden and the Eland─────────

In the first part of this study I have, following Turner, considered "position" in the southern San rock art; this discussion dealt with the content and structure of what I argue is a system of signs, many of which function as symbols. I attempted to establish, in a preliminary and largely quantitative way, that the eland is probably the central symbol of the art: this antelope receives numerical, technical and structural emphasis beyond any other of the painted signs. During my assessment of the ethnographic sources I indicated, still in a brief and preliminary way, that the eland was central in southern San thought among both the /Xam of the Cape Colony and the Maluti San of what is now Lesotho. This antelope must inevitably be the chief focus of any study of southern San thought and art.

In Part One I also made the point that, although we can discuss the "position" of the paintings, there is nothing that can be said about

"operations" with the paintings: we do not know what the San might have "done" (if anything) with the paintings. We do, however, know what they "did" with the objects of some of the painted signs rather than with the paintings themselves. Accordingly in this and subsequent chapters I discuss the operational dimension of the objects represented by some of the signs. This necessarily means going to the ethnography rather than the paintings, but in the course of the discussion I try to show that some of the paintings refer to social contexts in which the "eland symbol" was used either in "operations" with an actual eland or by mime and other means in a more symbolic or metaphorical way.

In discussing southern San symbols in these terms, I have been led to suggest novel interpretations of certain paintings that have been seen quite differently by other workers. If these new interpretations are valid, and I believe they are,

this will provide some justification for adopting the approach I outlined in Chapter One.

As a starting point, I have selected an activity group (Fig. 10) from Fulton's Rock, a site in the Ncibidwane Valley included in my Giant's Castle sample of rock paintings. Apart from some peripheral flaking, the painting has been well preserved. It is done in red, except for a few touches of white; these are on the shoulders of the recumbent figure within the arc, the "infibulation"[1] of the ithyphallic figure to the left and, doubtless to indicate the link shafts, on part of the arrows which lie beside the bow-carrying figure in the lower left of the group. The somewhat faded eland, stippled in my copy, was probably also painted in red and white, the lower white portion having faded into obscurity.

The painting has been published by Lee and Woodhouse (1970, p. 103) who give this interpretation of it:

A central figure, dressed in a long robe, is shown lying on the ground and is enclosed within a circle. People have their hands on the circle as if building a wall. It is quite possible that this may be a burial ceremony with mourners dancing around the dead body.

However, certain features of the content and structure of this activity group make it unlikely that this is correct. In the first place, the curved line, to which Lee and Woodhouse refer, is not a circle, but has an opening at the lower right. It is comparable with another painting (Fig. 11) at the same site showing a similar curved line occupied by two seated figures. As with the painting in Fig. 10, there is an opening in the line at the lower part. To the right of this curved line lie three sticks, two of which are fitted with bored stones.[2] It is most probable that this painting shows a domestic scene in which two people are seated in a shelter or hut (see also Cooke, 1970). By comparison with this group, the curved line in Fig. 10 may be taken to represent an already constructed shelter, not a ''wall'' being built.

Within this shelter, Lee and Woodhouse point to ''a central figure dressed in a long robe''. In fact the figure appears to be recumbent and covered by a kaross,[3] the only kind of ''robe'' known to the San. The two smaller figures to the left of the main one are apparently clapping and are probably female, as the third clapping figure in the ''entrance'' certainly is.

The figures in a ring around the shelter again seem to be predominantly female; at least six of them are bending forward at varyingly acute angles. They also seem to have ''tails'' hanging from their buttocks, as do some of the figures of indeterminate sex. The two figures supposed to

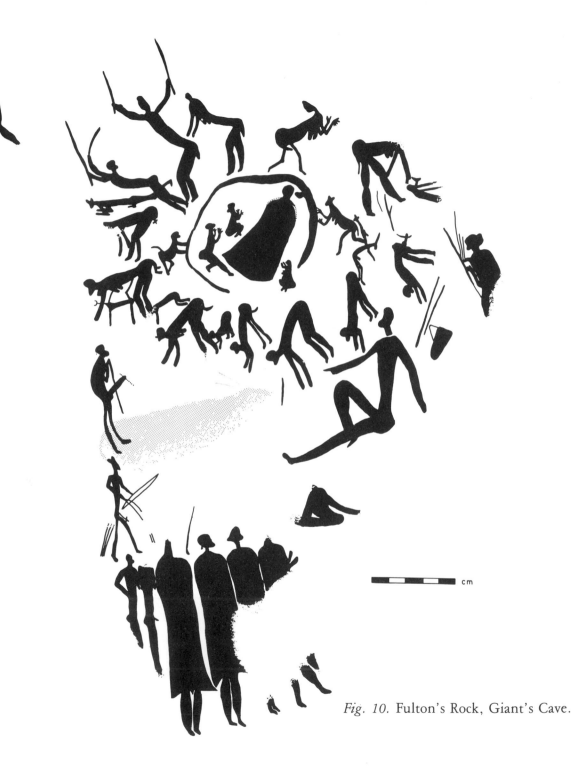

Fig. 10. Fulton's Rock, Giant's Cave.

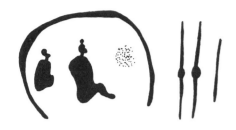

Fig. 11. Fulton's Rock, Giant's Castle.

have "their hands on the circle as if building a wall" may simply have their hands raised in the same clapping gesture as some of the others and their contact with the line of the shelter may be fortuitous. On the other hand they may be completing the construction of the hut. One of them is clearly female and both have "tails".

There are also at least three figures which seem to be male. Two of them bend forward and have what would ordinarily be interpreted as "bars" across or through their penises (the so-called "infibulation"); the curious positions of two of the penises are not unique to this painting. The sex of the two figures at the upper left with upraised arms holding sticks is indeterminate, but they are close to one clearly male figure and to another probably male, so they may be two of a group of males; none of the clearly female figures has sticks or holds its arms above head level. The use of two sticks by male dancers occurs in a large number of paintings, but the sticks are usually held to support the leaning forward body; I do not know of another dance painting in which both arms hold sticks above the head.

Outside this inner ring of dancing figures are several that are clearly male, including the one with the exaggerated, "infibulated" penis; the seated figure to the right is also probably male. In the outer area there are also items of men's equipment: bows, arrows, sticks or spears and what is probably a hunting bag. These outer male figures are apparently turned towards the inner ring as if they are watching it.

These features of the painting do not correspond with the suggestion that it depicts a "burial ceremony". It is true that among the modern !Kung both the sick and the dead lie beneath a kaross, but the interpretation of the dancers as participating in a funeral dance finds no confirmation in the southern San ethnographic record. The dead, it seems, were buried (not immured) and the camp abandoned as quickly as possible. Moreover, Lee and Woodhouse cite no reference to dancing as part of San obsequies, nor have I found any mention of it.

A much more plausible interpretation of the painting, which closely fits the features to which I have drawn attention, is that it represents a girl's puberty dance.[4] There is no certain evidence that such a dance was indeed held by the /Xam or the Maluti San, but, as I explain below, this may be a result of the way in which the material was collected. There is, however, quite detailed material on girls' puberty observances amongst the !Kung. When I showed a copy of this painting to Biesele, her first-hand experience of the !Kung suggested to her the possibility that the scene depicts a girls' puberty dance, an interpretation with which Marshall (pers. comm.) agrees. In the following discussion I rely on Biesele's remarks, the published !Kung literature and also on what

!Kung informants told me; to demonstrate the relevance of this northern material I relate it to what is known about southern San girls' puberty rituals.

In the first place, the girl in the !Kung rituals lies beneath a kaross in a hut as does the recumbent figure in the hut arc. Similarly, amongst the /Xam, the most important recorded custom relating to girls' puberty was the seclusion of the girl in a hut constructed especially for this purpose. The /Xam accounts do not mention the covering of the girl with a kaross, but Potgieter (1955, p. 11) reports that the Lake Chrissie people, southern San who came originally from the Malutis, covered the girl with a kaross and secluded her in her mother's hut. Among the !Kung the seclusion and covering with a kaross is associated with a sickness known as "eland sickness": indeed in !Kung thought the symbolism of menstruation and of sickness are closely similar (Biesele, pers. comm.). The same symbolic association was found in the south. The /Xam used the word *!kouken* to mean to tremble and to be ill, especially as of a girl at her first menstruation (Bleek, 1956, p. 445). The hut in which the girl was secluded was called by the /Xam *!koukenka //nein*, or "the house of illness", as Bleek translates it (Bleek and Lloyd, 1911, p. 201. The suffix *ka* forms the possessive case; *//nein* means a hut).

In addition to the rites of seclusion which are reported for both the /Xam and the !Kung, there is an important further feature in the girls' puberty rituals of a number of northern San groups: it is the Eland Bull dance. Among the !Kung this dance is considered to be the most important element of the observances. A woman will refer to the rites as a whole in these terms,

saying that she did or did not "receive the Eland Bull dance". During the performance of this dance a few women occupy the seclusion hut together with the girl. These and the women dancing outside the hut are said to *!ga* the girl. This verb expresses a number of ideas: the women clapping and dancing around a menstrual hut and all the things which go with this action. So, too, in the Fulton's Rock painting we can see three women in the hut together with the recumbent, kaross-clad figure; they are clapping and therefore probably singing as well.

Other women in the ring outside the hut are also clapping and dancing. As they dance, they bend forward and have "tails" of some sort. This posture bears an extraordinarily close resemblance to that of !Kung women who, in the Eland Bull dance, mimic the mating behaviour of eland cows. On an occasion when the men were not present, !Kung women described the Eland Bull dance to me in some detail.[5] After most of the men have withdrawn from the camp, the women dance with exposed buttocks; this is the only occasion on which women will so expose themselves and it is considered highly erotic, the buttocks being closely associated in the minds of the !Kung with sex. Although the Marshalls had spent much time with the Nyae Nyae !Kung and knew them well, the women had steadfastly refused to dance the Eland dance for them or to remove their karosses in the presence of the anthropologists (Marshall, pers. comm.). Another !Kung group at /Gwia, however, did oblige; having sent the men away to a discreet distance, the women removed their karosses and danced around a shelter in which a girl, playing the part of the menstrual girl, lay covered with a kaross (Fig. 12). If the buttocks are not so exposed,

Fig. 12. Eland Bull dance at /Gwia. (Photo: L. Marshall)

I was told, everybody's eyes would hurt and this could, the informants thought, lead to blindness. For this dance the !Kung women usually wear "tails" of ostrich eggshell beads which hang down between the buttocks, although this is not shown in the photograph taken at /Gwia. In a bending forward position, they dance in a line around the seclusion hut to the accompaniment of clapping and the clicking of iron axes and knives. This metallic sound, to which I have occasion to refer again in my discussion of the boys' first eland-kill rituals, is said to represent the characteristic clicking sound made by the eland's hoofs as it walks.

The posture of the dancing female figures in the Fulton's Rock painting therefore clearly recalls the

Fig. 13. Naron Eland Bull dance. (Photo: L. Marshall)

mime the bull eland's mating behaviour by pretending to sniff at the dancing women who, in turn, move their buttocks violently from side to side, causing the "tails" of ostrich eggshell beads to lash to and fro. My informants seemed to consider this to be the climax of the dance. The whole dance, they claimed, is so beautiful that the girl in the menstrual hut weeps, overcome by the wonder of it.

Figure 13 shows part of this climactic stage of the Eland Bull dance as performed by a group of Naron at the Marshalls' request. The !Kung say that only one or two old men participate in the dance, and sometimes they dance without the men. Among the Naron, however, several men danced and they were not old; this may have been a result of the dance having been especially performed for the Marshalls. The men peeled forked sticks for horns; three of them held the sticks against their foreheads, while a fourth tied his horns on top of his head. One of the men would sidle up to the woman he was following and rub against her side. In the photograph he is turning, with lowered horns, to ward off the other males.

In the painting, beyond the ring of dancing figures, is the peripheral scatter of men and men's equipment. When the !Kung men withdraw from the precincts of the Eland Bull dance they take with them their hunting equipment. The reason for removing the equipment is the potency of the girl, to which I return below.

The point-by-point comparison of the Fulton's Rock painting with the !Kung and other San girls' puberty observances that I have so far given strongly suggests that the painting is not merely an iconic representation or scale model of a girl's

position adopted by the !Kung women mimicking the eland cows ready for mating. Most of these figures are also painted with "tails" which could very well represent a version of the ostrich eggshell bead tails which feature in the !Kung rituals.

Amongst the predominantly female dancers in the painting are the two figures with sticks which seem to be male; none of the clearly female figures is equipped with sticks. It is possible that these

sticks are being used to represent the bull eland's horns, although they are not, at the moment depicted in the painting, being held up to the head. Amongst the !Kung, as the dance proceeds, the one or two older men who have remained in the camp tie eland horns or lengths of burnt wood onto their heads or hold these objects up to their heads and, imitating the gait of the eland, approach the women from the rear. Then they

puberty ceremony, but is also a depiction of one "operational" use of the eland symbol. The symbol is not, in the features I have so far described, an actual eland; it is rather the miming of eland mating behaviour: the eland is thus metaphorically present at the dance and in the painting. The painting, like the dance, I suggest represents one aspect of the significance of the eland symbol.

It is true that this interpretation cannot be directly supported by reference to such an eland dance in the /Xam ethnography, but that is not conclusive evidence that it did not occur. Since most of the Bleek material was obtained from male informants speaking to a woman (Miss Lloyd), it was almost inevitable that they would give her only the restricted male view of the ceremonies and may have known little about it. Certainly they appear to have been most concerned with the misfortunes that would occur if a girl came out of seclusion without taking the appropriate precautions, and also with the disasters that would overtake a man who inadvertently looked at a girl during her first menstruation. They were much less concerned with the customs pertaining more especially to the girl herself. The /Xam men's ignorance of some aspects of female affairs is illustrated in a remark by /Han≠kassō which excused his ignorance of a song about horses on the grounds that it was a woman's song (Bleek, 1936, p. 198). Bleek and Lloyd were themselves aware of this bias in the collection of folklore and greatly regretted not being able to work with //Kábbo's wife who "would have given us a great deal of information known only by the elder people, and especially by the old women" (Bleek, 1875, p. 5).

Despite this limitation in the southern San ethnography, there are indications in it of further associations between, on the one hand, ideas about sex, femininity in general and girls' puberty in particular, and, on the other, eland characteristics and behaviour. These indications further support the supposition that the /Xam could actually have had an Eland Bull dance (or something very like it) and that the Fulton's Rock painting depicts such a dance. To consider these indications I move from what has been largely a discussion of "operations" to exegesis. In exegesis the argument must attend to both the nominal and the substantial bases. For the nominal aspect, I turn to the words used by both the /Xam and the !Kung to describe eland in ritual and non-ritual contexts; for the substantial aspect, I refer to certain attributes of the eland and its behaviour that have been selected by both the northern and the southern San to play an important part in the girls' puberty rituals.

One of the indications that the /Xam did associate girls' puberty rituals with eland mating behaviour lies in the /Xam use of "respect" words.[6] They had two such words for eland, one used by men and the other by women. The general word for eland was *sã*, but in situations where this was considered too "strong" the respect words were spoken. In such circumstances the women used the phrase ≠*koúken-!khwi* (L.VIII.27.8433). Lloyd translated the phrase as "when it lashes its tail" which she arrived at with the help of /Han≠kassō. In view of the associations which I describe in this chapter, the phrase is highly suggestive and deserves close examination.

The word *!khwi* means a tail. The first word of the phrase, ≠*koúken*, poses some problems. It appears that its translation initially defeated Lloyd

who indicates merely '. . . . tail'. A note on 8434 rev., however, reads as follows: "*an há /kuerre ha !khwi* when it lashes its tail". This note and the translation seem to have been added after the first incomplete translation on 8435 had been recorded and when the translation was being checked with /Han≠kassō. At first sight this rendering might not seem very specific, because eland, like many other animals, use their tails to keep off flies; a grazing or walking eland frequently flicks its tail for this purpose. But additional nominal material, both /Xam and !Kung, suggests further significance.

Amongst the !Kung, there are also different respect words applied to eland by men and by women. That for women is *dabba*, and is apparently used almost entirely in the circumstances of the girls' menarcheal rites. At this time, informants insisted, it is essential, especially for the girl herself, to show proper respect to the eland by using the word *dabba*; at other times, when the women feel it is necessary to use a respect word, they may say either *dabba* or *tcheni* (dance), the men's avoidance word. If the girl does not use the respect word, the eland will in future run away and escape from the hunter. I was unable to obtain any further meaning for *dabba*: the women maintained it meant only eland; but the circumstances of its use suggest it refers to that aspect of the eland which is associated with the girls' puberty rituals. It is possible, therefore, that the equivalent /Xam word, "when it lashes its tail", was also used by the women particularly in the puberty context.

The /Xam phrase holds still further significance in the light of what !Kung men told me about the mating behaviour of eland. This information was

obtained during a discussion of animal behaviour in general and not in a discussion of girls' puberty rituals. The men described the manner in which the eland bull approaches the cow from the rear. The bull attempts to sniff the cow and the cow responds by lashing its tail from side to side. After this initial play, the bull mounts the cow. The bull does not lash its tail; it holds it out stiff and straight. It is possible, therefore, to infer that the /Xam women's respect word does not refer to *general* "tail lashing", but to female eland mating behaviour and that /Han≠kassō had this behaviour in mind when, probably with gestures, he assisted Lloyd to translate the women's avoidance word as "when it lashes its tail", rather than, say, "trembling tail" which might have been legitimate in another context.

There is further evidence that the /Xam, like the !Kung, observed this characteristic of eland behaviour and were interested in it. This evidence is found in the paintings. Figure 14 shows part of a painting from Botha's Shelter in the Ndedema Gorge which has been illustrated by Willcox (1963: plate 21; see also Pager 1971: Figs 164 and 167). The full painting shows a group of four eland superimposed on the legs of three hunters who are equipped with bows and arrows. One of the eland, the one I illustrate, has been depicted from the rear. Such paintings, involving a knowledge of foreshortening, are not common in "primitive art" and have drawn comment from a number of writers.

Although these paintings have excited some interest, they are not numerous. In the Giant's Castle sample of 235 eland only 1·7% were depicted as seen from the rear and none from the front. No such rhebok were recorded, but two

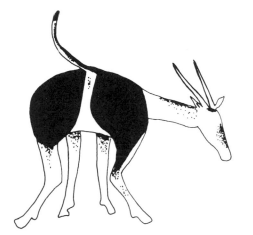

Fig. 14. Botha's Shelter, Ndedema Gorge.

antelope of indeterminate species were painted as seen from the rear. Even fewer were noted in the Barkly East sample: of the 586 eland recorded here only 0·5% were painted from the rear; and, as in the Giant's Castle sample, no rhebok. The system of recording employed in collecting these two samples unfortunately did not note the position of the animal's tail, a feature which I now realise merits attention. Pager (1971, p. 330), however, in a discussion of "Elevation and Perspective", has conveniently illustrated 27 "end-on" views of antelope. At least 19 of these are eland; the others are probably rhebok or other small antelope. Of the 19 eland, only 3 face to the front and 16 are viewed from the back. Two of those viewed from the rear are too fragmentary to permit determination of the tail position, and another two do not appear to have tails. Only one shows the tail pendent. Eleven are shown with the tail raised; of these 9 have the terminal tuft above the level of the rump. My own observations of eland behaviour

in the Drakensberg show that in the normal flicking of the tail the tuft is seldom raised above the level of the rump; the tail curves round the buttocks and the tuft flicks the flanks of the animal. This flicking of the tail is quite different from the raising of the tail in the mating behaviour as described to me by the !Kung informants; it is the mating behaviour position that is, I believe, shown in Fig. 14.

The !Kung informants explained that it is in the initial stages of mating play that the cow lashes her tail from side to side, the stage I have shown is mimed in the Eland Bull dance. When she is ready to be mounted, she raises her tail up and waves it in the air, as depicted in some of the foreshortened paintings; this movement could not, I believe, be described as "lashing". In view of the /Xam avoidance word and the association of the eland with the girls' puberty observances, it seems very possible that the artists were attempting in some of these paintings to depict the eland cow in a mating posture. As I have shown, in paintings of this type it is the rear view, rather than the front, that was favoured; and the painters have furthermore chosen to depict more eland in this posture than any other antelope.

If my assumption is correct that the painters were attempting to depict female eland mating behaviour at least partly because it had the rich symbolic connotations which I explore further below, it follows that they resorted to the development of the advanced techniques involved, not so much to exercise their abilities as artists, but to depict something of major interest to them. "Foreshortening", then, may have been developed by the San artists under symbolic compulsion, rather than as an artistic exercise.

Still further, but more general, evidence also shows that at least some San painters were interested in eland mating. Paintings of actual copulation scenes are very rare in the southern San art; one, involving rhebok, is painted in Knuffel's Shelter, Cathedral Peak (Lee and Woodhouse, 1970, Fig. 21; Pager, 1971, Fig. 26; 1975, p. 39); another, showing eland, is in the Fetcani Glen Shelter, Barkly East. It is part of a densely painted panel of eland, some of which are connected by a meandering red line fringed with white dots. My interpretation of the two eland in question was confirmed by !Kung informants. "When the male mounts," they said, "his tail is out flat, making his back muscles strong."

Although such explicit mating scenes are rare in the art, the painters implied this theme in another way. My !Kung informants were able, by their detailed knowledge of eland and eland behaviour, to interpret a copy of painting in the Burley I Shelter (Fig. 15). A large and very striking pair of striding, male therianthropic figures has been superimposed by a group of five eland. There is no discernible difference in preservation between the upper and the lower paintings. !Kung informants had no difficulty in sexing the eland in my tracing of this painting: the central eland is female, the others male. In response to further questions the informants explained that the group depicted in the painting is characteristic of eland herds in the mating season. It could not be spring, they said, because she will have given birth to her calf and would not be surrounded by the males: "In summer there is new grass for the calf." The informants went on to explain that when an eland cow is ready to calve she goes off by herself. At this point an informant volunteered the remark that

"a really good woman who is not afraid will also go off by herself to give birth". The others agreed. The observation perhaps again reflected the association of eland with human procreation, an association further suggested by another spontaneous observation. The upper left eland was said to be *chai*. This respect word, the informant explained, means "father of small elands". It is used for a big eland with a long, slightly sagging back and with long horns. The word *chai* refers to the fulfilment of the eland's role as a male, the role enacted by the man or men in the !Kung Eland Bull dance. Numerous other groups, such as the one of which the eland in Fig. 14 is part, probably also represent mating herds; yet other paintings, reflecting the same idea, show a female eland followed by a male, another feature of eland mating behaviour (Stainthorpe, 1972, p. 34). This is an important aspect of the eland paintings that has hitherto escaped the attention of rock art workers and would have escaped my notice too had the !Kung not pointed it out to me.

Paintings of mating herds, together with the "nominal" evidence I have adduced, indicate the presence of a pattern of ideas and interests common to the /Xam and the !Kung which concern eland mating and which are reflected in the rock art. The Fulton's Rock painting in particular, seen in the light of this probably common pattern, strongly suggests that the /Xam had, in fact, something very like the Eland Bull dance of the !Kung and other Kalahari groups. Even if they did not actually perform such a dance, however, it is probable that the values symbolized by the eland in this context were very similar among the !Kung and among the /Xam. To the !Kung, at least, the antelope and its metaphorical presence at the

Eland Bull dance symbolizes the values of sex, mating and fertility; values reflected, too, I believe, in many of the southern San rock paintings of eland. But there is much more to the pattern of ideas symbolized by the eland than the rather obvious emphasis on sex and mating with which I have begun.

Part of these further significances came to my attention during a discussion about the Eland Bull dance with !Kung women. In trying to understand why an *eland* dance is performed at the girls' puberty observances, I asked !Kun/obe, an old !Kung woman, why the San do an eland dance and not a gemsbok or a giraffe dance on this occasion. She replied: "The Eland Bull dance is danced because the eland is a good thing and has much fat. And the girl is also a good thing and she is all fat; therefore they are called the same thing."

The informant was here making an explicit equation between the fatness of the eland and the fatness of a girl who undergoes the ceremony. Although I am here primarily concerned with the symbolism of fat, we must not lose sight of its practical, physical value at puberty.[7]

In !Kung thought, fat and sex are linked metaphorically: they have a number of euphemisms for sexual intercourse, one of which is to eat or drink fat (Biesele, 1978, p. 927). The same association of fat and sex seems to be present also in an unpublished /Xam myth (L.VIII.9.6786-6857). A girl named ≠Nūturu danced while the men were out hunting; her face was beautifully white and she turned it up when the hunters returned. The men were so enchanted by her that they gave her the springbok's breasts, which /Han≠kassō, the narrator, explained are noted for their fat: "The wives of these men ate meat, while she was the one to eat

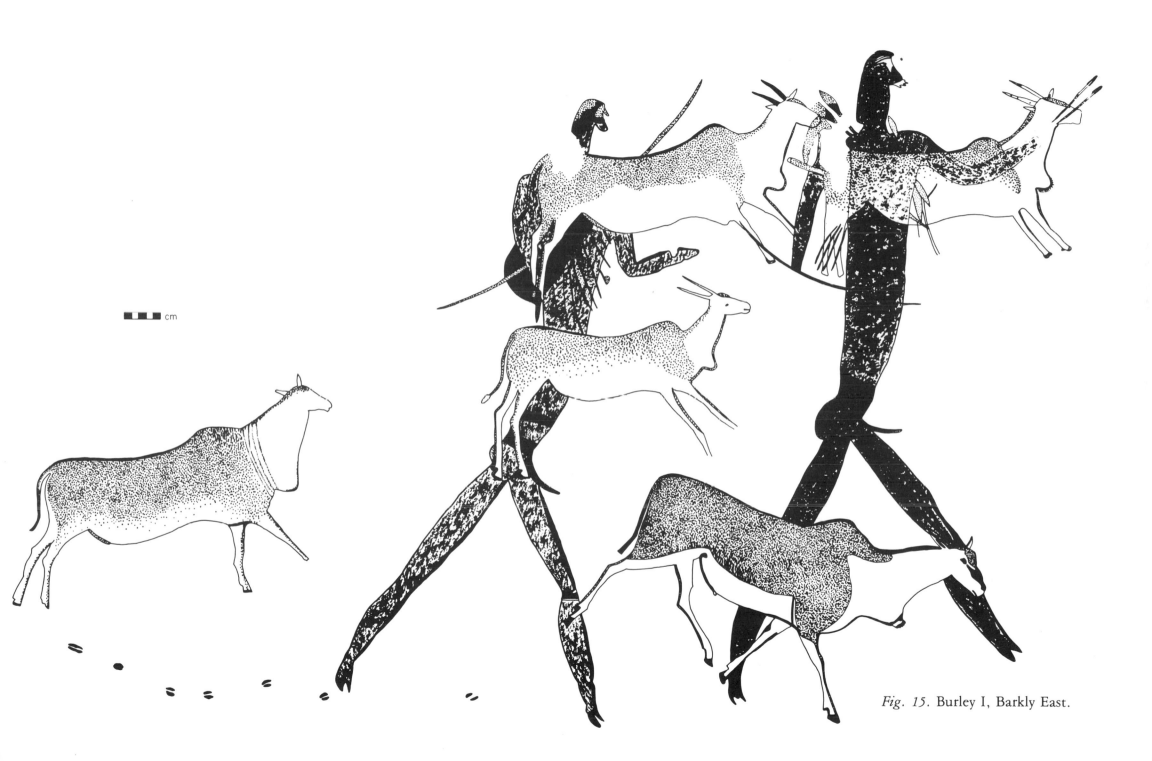

cm

Fig. 15. Burley I, Barkly East.

fat.'' The association of fat and sex is even more explicit in the following remarks: "For the men felt that they had married her, they neglected their wives for her. Therefore they withheld (the fat) from their wives, because they married ≠Nūturu for her face was pretty'' (id. 6804-6805). Whilst we cannot go so far as to say that the /Xam used the expression ''to eat fat'' to mean to have sexual intercourse, as do the !Kung, there does appear to have been the same association of ideas in /Xam thought.

Further ideas associated with fat in the context of the !Kung girls' puberty rituals were developed by !Kun/obe in response to the question, "What are the benefits bestowed by the Eland Bull dance?'' She replied thoughtfully, with a distant look in her eyes,

They do the Eland Bull dance so that she will be well; she will be beautiful; that she won't be thin; so that if there is hunger, she won't be very hungry and she won't be terribly thirsty and she will be peaceful. That all will go well with the land and that rain will fall.

She added that all this applies to the rest of the people too: everybody is caught up in the event. Another informant, Ti!nay, also confirmed the association of the Eland Bull dance with fatness. She said that at the time when she should have ''received'' the Eland dance she was taken by Tswana to a cattle post: ''You can see that for the rest of my life I have been thin.''

The ''fatness'' of the girl at puberty has more than one dimension; this is suggested particularly by !Kun/obe's second statement. The ''fatness'' of the girl is connected with ideas of ''balance'' or ''harmony'' in food supply, the availability of

water, the weather and the land in general. The Eland Bull dance secures this wider harmony not only for the girl, but for all the members of the band.

This, one of the most important aspects of the Eland Bull dance, is directly and strikingly paralleled by observations and statements recorded by the Bleeks. During the time of her seclusion, a /Xam girl was required to eat and drink moderately. To ensure this state of affairs, the food was put in her mouth by the older women and she drank through a reed which was placed in an ostrich eggshell of water with a very small hole. If these practices were observed, *all* the people in the band would in future eat and drink in moderation: there would be neither a glut nor a famine (B.27.3864-3880). She also had to treat water and rain with especial respect; if she failed to do so, she would suffer serious misfortunes and the waterhole would dry up, leaving the entire band without water. A /Xam woman informant, /Kweiten ta//kēn, told Lloyd that a girl coming out of seclusion scattered aromatic herbs on the surface of the water in the waterhole so that it would not dry up (L.VI.1. 3970). In the state of balance there are no privations to be borne, but also no excesses, a condition equally feared because people were thought to fight and quarrel in times of plenty, upsetting the social balance (Bleek, 1933, p. 377).

So far, in this part of my discussion, I have been concerned chiefly with the ''fatness'' of the girl at puberty and the way in which this is related to the ''balanced'' life that is so desired by the San; but there are still other aspects to the concept of ''fatness''. For the !Kung, one of the most important attributes of the eland—especially the male—is its fat. This is the characteristic that most excites

the !Kung and statements on the subject were not difficult to obtain. The fat on an eland bull, they say, may be so great in the region of the heart that a man cannot place his arms around it. ''There is so much fat that when you have melted it down, you have to make a container of the whole eland skin.'' When an old eland bull lies dead on its side, say the !Kung, its forelegs extend splayed out, kept apart by the vast quantity of fat on its breast and around the heart.

This fatness, particularly characteristic of the male, is especially emphasized in some of the rock paintings. Some of the most striking paintings of this type are to be found in a shelter on the Glen Craig farm in the Barkly East district. Four exceptionally imposing eland bulls are painted here. The length of the largest is 1·7 metres. They all have the heavy shoulders and pronounced dewlap that is indicative of the presence of much fat. The colour, a very light almost white tint, suggests the advanced age of the animals, a further indication of much fat. At the time of recording I was unskilled in sexing the paintings of eland; the results of the quantitative surveys therefore contain an unnecessarily high proportion of indeterminate eland. After receiving tuition in this matter from the !Kung, I have come to the conclusion that, although female eland are clearly depicted, most of the paintings are intended to represent large, fat males.

The eland's fat, so emphasized by both the !Kung informants and many of the rock paintings, is actually used by the !Kung as a ritual object in the girls' puberty rituals. While the girl is in seclusion, the women mix eland fat with buchu and rub it on her. She is then said to be very beautiful. The informant, !Kun/obe, claimed that

she herself was very beautiful when she "received the Eland Bull dance". When the girl comes out of seclusion, she is first washed with pounded *tsin* beans mixed with saliva; then she is given eland fat mixed with buchu. She goes with this mixture to every hearth in the camp and places a little of it in each fire. While this is happening everybody cries, "Euu, euu!".[8]

In the first part of this sequence, during which eland fat is used as a ritual object, a direct association is made between the "fatness" of the eland and that of the girl; but there is also a transference of power. Fat is considered by the !Kung to have a pleasing odour, especially when it is cooking; the eland itself is said to smell sweetly of fat. At this stage of the ritual, the girl, who is herself likened to a fat eland, has the fat of an eland closely associated with her, so that, like the eland, she smells pleasantly of fat. Odour, in !Kung thought, is a medium for the transference of power. The smell of a whirlwind, for instance, is said to go into a person and make him sick (Marshall, 1962, p. 239). Supernatural potency, *n/um*, is also carried by smell, as in the burning of the substances in a medicine man's tortoise shell or in the burning of a person's hair (Marshall, 1969, pp. 360, 371). Therefore when the eland fat is rubbed on the girl, the odour of the fat, the essence of the eland, is transferred with its powerful *n/um* to the girl; she, through the fat, participates in the power of the eland and, like the eland, must be respected.

In the second stage, where the girl distributes scented fat, the fat is again used to transfer power, this time from the girl to the people in general. The power flows outwards from her as the centre of the ritual, radiating through the band and it does so through the medium of the scented eland fat.

This part of the ritual was explained by an informant: "Everybody will be hot (eager) for eating and the men will want to go hunting." The remark appropriately associates fatness with hunting because it is the hunter who supplies the greatly desired fat.

This is not the only association between the girl and hunting. !Kun/obe explained that, when a girl experiences her first menstruation, people say, "She has shot an eland". Among the !Kõ the secluded girl shoots a ritual arrow at a skin target at the back of the hut (Traill, pers. comm.). Her sexual role during the liminal period is paradoxical: she is spoken of as if she were a hunter *and* as if she were an eland. Hunting is, of course, a major San activity on which they place considerable value, so it is not surprising that it intrudes in this way into the girls' rituals.

The presence of hunting is, however, more than metaphorical: the girl is thought to have a direct influence on the hunting of the band. If she fails to use the avoidance word *dabba*, the elands will, I was told, run far away and the men will enjoy no success in hunting. When she comes out of seclusion, she is instructed to keep her eyes downcast and not to look around. If she does this, the elands will likewise look down when they are being hunted and the hunter will be able to stalk up to them.

Such a connection between the girl at puberty and hunting in general is also seen in a curious /Xam ritual. To ensure good hunting by the dogs, the girl chewed a piece of meat from an animal which the dogs had killed. She then "sucks off her knee's dirt; when her knee's dirt is with the meat she tells the people to catch hold for her of the dog . . . She spits the meat into his mouth with her

saliva on it" (L.V.20.5592-5596). Another /Xam observance was very similar to the !Kung girl's requirement to keep her gaze downcast: "During the time she is in retreat, she must not look at the springbok, lest they should become wild" (Bleek and Lloyd, 1911, p. 77).

The benefits bestowed by the girl also extend beyond the sphere of hunting to general safety; the "harmony" which she brings is experienced in a variety of ways. The !Kung girl bestows this condition on the adolescent boys of the band. The women cut a little wand of *moretwa* wood, coat it with red ochre and place it in the girl's hand. The boys then come past her one at a time and she hits them with the stick playfully, as if whipping them. When I asked why this was done, the informant replied, "So that they won't get thin, and, if while out hunting, a stick pierces them they will be well". This part of the menarcheal rites was also very closely paralleled among the /Xam. One of Bleek's few women informants said that a girl at puberty took red ochre and "adorned" the young men of the band with it; the manner in which the red ochre was applied to the youths was, unfortunately, not recorded. The informant did, however, go on to explain that the custom afforded the young men protection from lightning—and possibly other dangerous things that she omitted to mention (L.VI.1.3973).

The !Kung girl's potency radiates beyond the adolescent boys to the area around the camp. This ability lasts for a few days after she has come out of seclusion and while she remains in the company of older women. If she sees a snake, she does not cry out, but remains still while the others kill it. The girl then stands over the dead snake; that which comes out of her, said the informant, has powerful

n/um. After this they cut an aromatic herb, the name of which I was unable to obtain, and the girl chews it before spitting it out over the whole area so that snakes will not come near the camp. The same ritual is performed for sharp roots or stumps on which a person may injure a foot. The /Xam informants did not mention any such observances, but it seems that they held similar ideas about the potency of the girl's saliva, as shown by the ritual to ensure good hunting by the dogs.

It is, then, clear that a great deal more than fertility and mating is involved in the symbolism of the girl's puberty rituals. During the time of her seclusion the girl becomes the focal point of the whole band. Everyone is actually or potentially in a ritual relationship with her and her centrality is dramatized by the way in which the women circle around her hut in the Eland Bull dance. She is a powerful force for good in that she is able, through her potency, to bestow the benefits of, specifically, "fatness", rain and successful hunting. These ideas, I suggest, may be summed up in the idea of balanced renovation, economic, social and cosmic. The girl is "new" and has the power to "renew" or ensure the "balance" of life.

The power of the girl to renovate is, I believe, reflected in the /Xam phrase for a girl at her first menstruation, *!kwi/a//ka:n*, translated by Bleek as "new maiden". An examination of this phrase throws further light on the /Xam notion of potency which will be repeatedly encountered in other chapters. The first word of the phrase, *!kwi*, means a person; the suffix */a* is part of the adjective */aiti*, meaning female. An adjective normally follows the noun it qualifies. *!Kwi-/aiti* is usually translated by Bleek and Lloyd as "woman" and *!kwi/a* as "girl". The second

word of the phrase, *//ka:n*, is translated as "new". It can also mean fresh, raw or uncooked. An examination of its usage in other contexts throws light on an aspect of its meaning not conveyed by the English word "new". This aspect of *//ka:n* is illustrated by its use in the phrase *!khwa: //ka:n*, "new rain" or "new water". The /Xam used this phrase to denote rain which was falling or had just fallen (Bleek, 1933, p. 307); they considered such rain to be especially potent and, because of its potency, it had to be respected. Stones were not to be thrown at *!khwa: //ka:n* (Bleek, 1933, p. 300) and a girl approaching such water sprinkled it with buchu. /Han≠kassō explained that the buchu appeases *!Khwa* because he loves its scent very much: "It (*!Khwa*) glides quietly along when it smells things which are unequalled in scent" (Bleek, 1933, p. 300). Rain, in this "fresh" condition, was regarded as being in a high state of potency: in this way it parallels the girl at her first menstruation. She, like the "new" rain, is at her most potent and must be respected. The !Kung still hold this view of both the newly fallen rain and girls at puberty: informants explained to me that rain, when it has just fallen, has very strong *n/um*, as does the girl at puberty. This relationship was succinctly and strikingly expressed by Diä!kwain: "When she is a maiden, she has the rain's magic power" (L.V.13.4989). She could exercise this power by snapping her fingers and so causing lightning (Bleek, 1933, p. 297); more constructively, she "smoked" her father with buchu so that the rain would not kill him with lightning on the hunting ground (L.V.6.4394 rev.; see also Vinnicombe, 1976, p. 310).

In this chapter I have tried to show an inter-

connected set of ideas at the centre of which are both the powerful "new maiden" and the eland. The girl is literally so in the Fulton's Rock painting (and in the photograph of the !Kung dance at (/Gwia), and the eland metaphorically so through its multiple associations with her and in the mime and sounds of the Eland Bull dance. But the !Kung take the presence of the eland yet a stage further. They say that the eponymous antelope actually appears at the dance; its approach frightens the people, but a medicine man reassures them that it is a "good thing" which comes from the great god (Biesele, 1975, II, p. 170). In the light of this belief, it is interesting to note that a painting of an eland is part of the Fulton's Rock scene. In spite of its rather faded condition, it appears to have been added to the composition after the completion of at least one of the human figures on which it slightly impinges. This may at first seem a tenuous point; however, the "visualising" of a metaphor will become an increasingly prominent theme in this study.

The eland metaphor which ultimately finds expression in the "appearance" of an eland at the !Kung dance might have had its origin in the likening of the girl at puberty explicitly to that antelope: both are said to be fat and a "good thing". Although I cannot prove that the /Xam drew the same parallel between the girl and the eland, the numerous points I have raised make it likely that similar associations existed for them. Certain, but not necessarily all, paintings of eland may, therefore, as part of their meaning, have referred to the achievement of adult female status and that state's connotations of fertility and beneficial effects bestowed on the whole band; it is the eland symbol as much as the "new maiden"

herself that brings the desired balanced renewal. The girl is considered to be in a condition of extraordinary potency in which she needs help from the community; the community must also acknowledge and take part in her change of life, if it wishes to enjoy the benefits which accrue from that change. The appearance of a potent "new maiden" in /Xam society was a most significant event in which all shared. The Fulton's Rock painting, which I have analysed in this chapter, is a tondo of concentric social relationships, expressing, I suggest, something of the balance brought by a "new maiden" to the whole band: at the centre is the powerful "new maiden"; around her, arranged in widening circles, are the dancing women and then the men with their hunting equipment—all participating in the great event and receiving the manifold blessings which derive from it. All these benefits were summed up and symbolized by the antelope metaphorically present, the eland, so that it became the "good thing" *par excellence*.

The values associated with the eland in this specific context were, I have suggested, also implicit, together with other aspects of the eland's multi-vocality, in many of the more general paintings of eland. These further facets I discuss in subsequent chaptes. The girls' puberty rituals are but one "panel" in a ritual triptych which also comprises the boys' first-kill rituals and marriage: in all three "panels" the eland is prominent. In the rituals I have described in this chapter its

prominence is largely metaphorical, being suggested by the dancing women, the men playing the part of the eland bulls and the clicking of the axes and knives. In the boys' observances the presence of the eland is more explicit.

Notes

(1) The term "infibulation" has been applied to a single or double bar drawn across the penis. There has been some debate as to whether this feature represents a form of "decoration" or whether it symbolises sexual abstinence (see Woodhouse, 1970; Willcox, 1972, 1978a and Vinnicombe, 1976, pp. 257-259).

(2) Southern San women weighted their digging sticks with bored stones; sticks used by men for digging game pits were not weighted. The use of bored stones on digging sticks was noted by Dunn (1873, p. 34; 1931, p. 33), Orpen (1874, p. 3), Stow (1905, p. 67), Bleek (1935, p. 41; 1936, p. 135) and Thompson (1967, I, p. 58). See also Goodwin (1947).

(3) Kaross: a cloak of animal skin often depicted in the paintings.

(4) I use the phrases "puberty dance" and "puberty rituals" to refer to those observances performed by the San at a girl's first menstruation, but the significances of the observances extend

beyond the marking of the onset of menarche. The rituals also celebrate nubility and the other aspects I develop in this chapter.

(5) The Eland Bull dance has also been described by Bleek (1928, pp. 23), Schapera (1930, p. 119), Metzger (1950, p. 61), Heinz (1966, pp. 118-119) and Marshall (1966, p. 265; 1969, p. 305).

(6) Such "respect" or "avoidance" words are a common feature of many of the indigenous societies of southern Africa. The /Xam used the word *!nanna-sse* to denote the custom of "showing respect" whether by the use of these alternative words or by other ritual avoidances. Like other /Xam words *!nanna-sse* could be used as a noun or as a verb.

(7) Marshall (1976, p. 39), in a discussion of steatopygia, has cited evidence presented by Frisch (1975) that a store of fat is necessary for the onset and maintenance of menstrual cycles. During the period of adolescent growth, the amount of fat stored is almost doubled. Whatever, then, were the symbolic significances of fat in the girls' puberty observances, there was also a practical basis for the association, possibly suggested to the !Kung by the general plumpness of a girl at this time.

(8) This stylised sound, as I explain in Chapter Five, recurs at the boys' first eland-kill rituals and is there explicitly associated with ideas of social harmony and balance.

Chapter 5

---*The New Hunter and the Eland*---

Although the "new maiden" is the apparent focus of the San girls' puberty rituals, it is the eland which, through its metaphorical presence, marks the attainment of her new status and the general beneficent effects of the observances. A similar pattern is, as I show in this chapter, evident in the ritual sequence which marks a boy's first successful eland hunt; but the eland imagery, which gave the girls' rituals their distinctive character, is, in boys' observances, partly translated into "operations" performed with an actual antelope.

The richness of both the /Xam and the !Kung ethnography makes it possible to analyse the significance of the eland in the context of a boy's first-kill in two of the ways I outlined in Chapter One. First, I describe complex ritual operations performed by both the /Xam and the !Kung with an eland antelope. Secondly, the ethnography allows further exegesis of respect words for eland, some of which I commented on in the previous chapter: I here examine the /Xam and the !Kung words used by men in ritual contexts. These analyses bring me a step closer to answering the important question why this particular antelope was singled out for such intensive ritual use, a matter I pursue further in the following chapters.

My discussion of the ritual use of the eland symbol in the girls' puberty observances started with an examination of a particular painting; in this chapter I commence with the ethnography on general hunting observances for all game animals so that we may better understand the specific observances for eland hunting and then, finally, I consider how the ideas and values involved in a boy's first successful eland hunt might have been implicit in some eland paintings.

Although San sometimes run down eland and other antelope, the rituals I describe below are associated only with the use of bow and poisoned arrow. This type of hunting may be divided into two stages: first, the San hunter searches for and then stalks his prey with the consummate skill that has made him famous.[1] The second stage begins when the poisoned arrow penetrates the animal. !Kung arrows, like those which were used by the southern San, are constructed on a link-shaft principle: the poisoned point remains embedded in the animal while the reed shaft falls to the ground.[2] After the animal has been wounded, a period of waiting ensues, during which the hunter returns to the camp. The next day he sets out again with other members of the band to track the wounded animal: the tracking may, depending on the size of the animal and the effectiveness of the poison, take a few days. Both stages of the enterprise are fraught with difficulties, many of which are quite beyond the control of the hunter, but they are especially prominent in the second stage during part of which the hunter must remain inactive, hoping that the poison will act swiftly

and that scavengers will not find the dead antelope before he does; these matters are entirely out of the hands of the hunter. The puny arrows used in this type of hunting cannot produce a quick kill: the outcome of the hunt must remain essentially unpredictable.[3]

Both the /Xam and the !Kung observances relating to the period of the hunter's comparative inactivity vary according to whether the hunt is a first-kill or not. To appreciate fully the nature of the special conditions of first-kill eland hunting it is necessary to distinguish carefully between three different sets of rituals. Failure to make these distinctions has unfortunately caused some writers to misunderstand seriously the important, indeed crucial, /Xam account published under the heading *The Eland's Story* (Bleek, 1932, pp. 233-240).

The first and least complex set of ''respect'' or *!nanna-sse* customs applied to the hunting of *all* antelope. Diä!kwain, in a published account (Bleek and Lloyd, 1911, pp. 270-283), explained that hunters were required to ''respect'' any antelope they had shot, *no matter what species.* They ''respected'' a wounded animal while the poison was taking effect by not eating the meat of fleet-footed creatures. To provide an example, Diä!kwain said that a man who had shot a gemsbok did not eat springbok meat or even touch a springbok; if he did so, the wounded animal escaped. On another occasion the same informant told of further prohibitions applying to any species of antelope (L.V.21.5684-5695). A man who had shot an antelope was obliged not to hurry as he returned from the hunting ground, ''for they [the game] look at our walk as we leave the hunting ground''. He was, furthermore, required not to

eat freely, because certain foods would ''cool the poison''—that is, render it ineffective.[4] When a hunter returned, people immediately offered him food of a certain kind: if he refused the food, they knew he had shot game. They then handed him food which they knew would not ''cool the poison''. When questioned about the matter, the hunter replied evasively that he had merely seen the spoor. The others then understood that he had in fact shot an animal.

These customs required the hunter to behave in one way rather than another because it was thought that a link existed between him and his prey: the whole life of the animal was linked to the life of the hunter in this final crisis.[5] The hunter avoided all manifestation of energy and vigour and behaved as if his life, too, were ebbing slowly. During the period of his inactivity the hunter's mind was fixed on the failing eland: he imagined its stumbling movements and transferred these movements to himself.

A similar link between hunter and prey is expressed in the second set of *!nanna-sse* customs which related *specifically to the hartebeest* (L.V. 17.5262-5299), but there are also additional features not found in the more general observances. The first of these is the intervention of /Kaggen in a particular manifestation; he does not appear to have intervened for the lesser antelope. /Kaggen was believed to go, in the shape of a mantis, to the hut of the man who had shot the hartebeest and to sit on his quiver, while the man himself was still on the hunting ground. /Kaggen did this to tempt the hunter's wife to cast him out of the hut or to throw stones at him.[6] If she was foolish enough to do either, /Kaggen would fly to the wounded hartebeest and tell it ''to get up as it

is needlessly writhing there (id. 5265) . . . The people have not respected [*!nanna-see*] you, you can get up, you can walk'' (id. 5270). If the man's wife killed /Kaggen in the form of the mantis, the hartebeest would recover from the effects of the poison and escape.

/Kaggen also attempted to make the hunter break the link between himself and his wounded prey. To do this /Kaggen pinched the hunter's child during the night. If the hunter, sleeping in his shelter, heard the crying and was awakened, the hartebeest would rise up and escape (id. 5284). The hunter's wife tried to prevent her child from crying by giving it her breast. If the hunter was disturbed by the crying and started up in the night, /Kaggen would have tricked him into breaking the link between man and animal. /Kaggen was believed to take such special interest in the fate of the hartebeest because ''/Kaggen is a hartebeest's thing'' (id. 5265). The hartebeest, /Han≠kassō explained, is /Kaggen's second favourite antelope.

Another additional feature that appears in the observances relating specifically to the hartebeest is the involvement of the hunter's wife. It was she who had to refrain from throwing stones at /Kaggen and keep her child quiet. She had also to see to it that her husband did not smell the aroma of cooking; if he did, the poison in the hartebeest would be ''cooled'', ''for the pot's things are what cools the poison'' (id. 5292). The hartebeest observances, then, go beyond the hunter himself: the preservation of the link between the hunter and his prey has become a wider responsibility.

The two sets of observances which I have now described help to clarify the complexities of those specifically for *eland* hunting. The shortest

account of eland observances was given by //Kábbo (L.II.36., memorandum inside cover) who told Lloyd that /Kaggen buzzed or hissed in the ear of a man "who shot his or an ?eland", presumably to make him move suddenly and so break the link. He also sat on the hunter's eyebrows and looked in his quiver for the arrow which had shot the eland. In order to deceive /Kaggen, the man who shot the eland went off on his own while another man carried the quiver with the offending arrow. In this situation /Kaggen tried to trick the hunter and the hunter, in turn, tried to trick /Kaggen.

The second and more detailed account of eland hunting observances was given by Diä!kwain (Bleek, 1932, pp. 233-240). It embraces the concept of the link between the hunter and his prey as well as intervention by /Kaggen, but it also includes some other pertinent practices which give it a different and highly significant character.

If Diä!kwain's account is read in isolation it is reasonable enough to suppose that it deals with rituals which applied to all hunters in all eland hunts and to conclude that it implies that the eland was the only species which was hunted ritually. However, my reading of the unpublished sources led me to suspect that Diä!kwain was conflating different sets of observances: some observances applied to all hunting situations in which the bow and arrow were used, others were specifically for eland and yet others were for *a boy's first eland-kill*. These last, which give the account its special importance, become evident, as I show below, if we "subtract" from the account the observances of the first two kinds.

My suspicion that the report was principally a description of first eland-kill rituals was dramatically confirmed when, with the /Xam rituals in mind, I elicited from the !Kung their hitherto unknown first eland-kill observances. The importance of the new understanding of Diä!kwain's report, which the unpublished material together with the !Kung rituals gives us, can hardly be overestimated: it enables us to see for the first time the full significance of eland hunting to the southern San (Lewis-Williams and Biesele, 1978).

Not knowing that the eland had any special significance in boys' first-kill rituals, I asked my !Kung informants, "What do you do when you shoot an eland?" They began to describe hunting techniques and rituals as if there were no difference between the two. As their fascinating account proceeded, I realised that I was learning about both the regular observances of general application, such as I had already encountered in the unpublished /Xam ethnography, and also about first-kill observances not previously reported by those who have worked among the !Kung. The informants themselves did not always spontaneously distinguish between the two, so I had to ask if each practice was performed generally or only for first-kill eland. A similar tendency to compound differing rituals was, I believe, present in the account Lloyd obtained from Diä!kwain because on the occasion of a first-kill the general observances are not waived; they are performed together with the further rituals.

It is, of course, a severe limitation of my !Kung material that I did not see any of the rituals being performed. The eland first-kill rituals are, however, now a rare occurrence: they had not been observed by the Marshalls, by Biesele or, as far as I have been able to ascertain, by any of the other workers who spent extended periods with the !Kung. Game restrictions and the scarcity of eland have apparently all but eliminated performance of the rituals. Nevertheless, one of my informants, Kan//a, a man of about 65 years, had himself been through the rituals he described. The others knew details of the rituals, but had not themselves killed an eland nor did they expect ever to do so. Much simpler first-kill rituals involving scarification are now performed for any large antelope killed by a boy. Such kills and rituals mark the attainment of full adult status and eligibility for marriage; the first eland-kills did the same, but involved much more elaborate procedures. It is possible that the gradual extermination of the eland in the Kalahari has forced the !Kung to accept other antelope as suitable for first-kill rituals. Biesele (pers. comm.) was told that only the so-called "red meat" animals could be used in first-kill rituals, but the !Kung do in fact now use the wildebeest, a "black meat" animal.[7]

I am inclined to think that the Diä!kwain report was, like Kan//a's, a first hand account. Parts of the statement, it is true, are given in the third person. Other parts are, I believe significantly, given in the first person: Diä!kwain started by saying, "when *we* have shot an eland *we* do not cross its spoor" (id. 233; my italics). Later, when describing the personal experience of the hunter, he again spoke in the first person: "the Mantis [/Kaggen] seems to be teasing us" and "he is biting our eyes" (id. 236). Here, it seems, Diä!kwain was describing something that he had himself known, not something he had merely heard about; this makes an important statement even more valuable.

To elucidate the real nature of the /Xam rituals described by Diä!kwain and at the same time to demonstrate the numerous similarities between

the /Xam and the !Kung first eland-kill practices I now compare them stage by stage.

The /Xam ritual sequence commenced when an arrow was shot into an eland. When the hunter advanced to find the shaft and examine it to see how it had broken and whether there was any blood on it, he was careful to avoid touching it: "We leave the arrowhead, we first fetch a leaf (?), for we want to pick up the arrow together with the leaf (?), lying on the leaf (?) . . . we do not want the wind to see it, so we try to get it to the quiver and put it in without the wind seeing it" (Bleek, 1932, p. 233).

Similarly, a !Kung boy who concludes from the evidence of the shaft that he has shot his first eland refrains from touching the shaft as he examines it: he turns it over with the point of his bow. If an older man is present, he picks up the shaft and places it in the boy's quiver. If the boy is alone, he leaves the shaft where it has fallen; he returns the following day with the older men who then pick up the shaft and place it in the boy's quiver. If the boy were to touch the shaft, the informants thought, the eland would not die. Since the !Kung observe this practice only for a first-kill eland, it is likely that Diä!kwain was also referring to a first-kill.

The shooting of the arrow established the link between the /Xam hunter and the wounded animal. The hunter was then prohibited from running:

On his way back he does not hurry, but goes quietly along; he does not look around, but gazes quietly at what he sees, for he thinks that otherwise the eland would not look as he does, but look as if it was not afraid (id. 233-234).

The !Kung, too, explained that any hunter who has shot an eland must be very circumspect; he must walk slowly and not run: "If he runs fast, the eland will also run fast." When questioned, the informants said that this aspect of the ritual applies to other animals, not exclusively to eland; the unpublished /Xam records, as I have shown, confirm that this was also the case in the south.

The hunter's return to the camp is the next crucial stage in the first-kill ritual. The /Xam hunter stood silently on the edge of the camp until "only the grown-up men", realizing that something important had happened, asked him if he had shot an eland; the women and children remained at a distance. He replied evasively that a thorn had pricked his foot. The "old men" then looked in his quiver to see if there was an arrow with eland hair on it.

The silence or evasiveness of the hunter are also part of the !Kung observances. A !Kung boy who believes he has shot his first eland remains in the veld until late afternoon. During this period he lights a fire and, taking the ash, makes a circle on his forehead and a line down his nose; this was said to represent the tuft of coarse red hair on the eland's forehead and is a visual representation of his identification with the wounded animal. When he enters the camp, he does not speak: the people see the mark on his forehead and know that he has shot an eland. The children are then told to be quiet, because if they make a noise the eland will hear them and run far from the camp: "The eland is a thing which has *n/um*; therefore if there is loud speech it will die far from the camp, especially if the children toss up dust." The hunter, furthermore, may not go near the pot or things associated with the women, although he

may smell the aroma of cooking. These observances, involving the women and children, recall in a striking way those described by Diä!kwain.

Rules regulating how the hunter spends the night after his return to the camp applied among the /Xam as they still do among the !Kung. When the old /Xam men ascertained that the hunter had shot his first eland, they constructed a special hut away from the noise of the women and children. In this hut the hunter behaved as if he were ill: "the old man takes care of him as if he were ill, for he warms him at the fire" (id. 235). The construction of such a hut is not mentioned in any of the accounts of more general hunting observances; indeed, in Diä!kwain's account of the hartebeest observances there is, in the beliefs concerning the crying of the hunter's child, a clear implication that the man slept in his own hut.

Similar isolation after an eland first-kill is also found among the !Kung. The informants did not say that a special hut is constructed for the hunter, but he goes to the young men's hut and is isolated there.

The rituals of both San groups show that, during the night, the maintenance of the vital link between the hunter and his prey is in danger of being broken. In the south, /Kaggen was believed to intervene, as he did in the case of the hartebeest. According to Diä!kwain he did so on this occasion in the form of a louse which bit and irritated the hunter. If the man killed the louse, "its blood will be on his hands with which he grasped the arrow and when he shot the eland, the blood will enter the arrow and cool the poison". The sudden, vigorous movements necessary to slap a louse or "to catch hold of that part of our body where we feel something is biting us" would have consti-

tuted a manifestation of energy that would have been antithetical to the link the man was trying to maintain. Similar movements, rising and leaving the hut, seem, in part, to be responsible for another prohibition: the /Xam hunter was instructed by ''the old man'' not to urinate during the night. In addition to the unacceptable movements involved, Diä!kwain offered a further explanation:

If he acted so, then the poison would hold and kill the eland, for the poison would hold its bladder shut, and it would not open to pass water (id. 235).

Strikingly similar prohibitions operate for the !Kung. When the hunter goes to the hut, the youths spread out a scratchy type of grass on which he is to sleep. Like the /Xam hunter's louse, this irritates him during the night. He may not, however, forsake the grass bed for a more comfortable one as this movement would secure the escape of the eland; instead he must endure the discomfort quietly, but not sleeping well. This, the informants explained, will then be the case with the eland: it will not run far, but will also not sleep well and thereby recover its strength. My knowledge of the /Xam beliefs led me at this point to ask if the hunter may urinate during the night. I was told that he may; but the informants added that he is given a little water with certain roots so that the eland will not urinate and lose the poison. This provided yet another unexpected and detailed parallel with the /Xam beliefs. The informants further explained that the practices concerning the hunter's restless night and the loss of the poison apply to first-kill eland only, so

confirming again my belief that Diä!kwain's account is indeed of such an occasion.

In the morning the tracking of the wounded eland commences. The /Xam hunter did not himself take part in the tracking; he directed the others to the spot where the animal had been shot so that they could pick up the spoor; he then returned to the camp. Those following the track did not cross the spoor: ''we walk on one side of its spoor''. This was done, Diä!kwain explained in a subsequent note (id. 5316 rev.), so that they would not tread upon the spoor.

The !Kung men who accompany the hunter in the morning loosen their bow strings when they, too, set out to pick up the eland's spoor. Since !Kung consider that sweat and the foam that falls from the mouth of a pursued eland possess powerful *n/um*, certain precautions have to be taken to avoid them on the ground. The spoor must be followed obliquely: a hunter unscarified for eland must not cross the trail. If he does so, it is believed that he will become tired and confused, but if he has scarifications on his legs, he will not become weary.

Another critical stage is reached when the eland is finally found dead. The /Xam hunter who had shot the eland remained in the camp until the heart had been cut out; only then could he approach the carcass. In the published version the text is incomplete at this point (id. 237), the word */kɔ:ɔ̈de* in the original being left untranslated, though Lloyd elsewhere translates it as ''magic power''.[8] The translation of the passage should therefore read,

When they have cut it to pieces and cut out the heart, then he joins the men who are cutting it up, after the

heart is cut out because they are afraid that it is a thing which has magic power.

Amongst the !Kung, the finding of the eland is also marked by various observances. The !Kung boy who has shot the eland does not approach the dead animal directly; he crouches down behind an old man and places his arms around him; they both then pretend to stalk the animal. This is called ''bringing the boy to the eland'' and the position is like the one adopted by a medicine man and a novice when the young man is learning how to go into trance and to cure (Biesele, pers. comm.).

At this crucial stage, the approaching of the dead animal, there is concern about what, in the previous chapter, I showed to be a characteristic of the eland which greatly interests the San. Diä!kwain spent some time telling Lloyd about this feature. He explained that they did not allow the hunter himself to go near the dead animal because they believed that his scent would make the eland ''lean''. Similarly, it was believed that if anyone's shadow fell on the carcass or if many people looked directly at it (id. 239) it would become ''lean''. Before they opened up the dead animal, they performed a further ritual to ensure and protect the animal's fat: they cut off the animal's tail and used it to beat the carcass:

When they beat the eland with its tail, it seems to sigh[9] just as they are used to sigh; when they eat eland's fat then they sigh like that, so they beat the eland with its tail to fatten it (id. 238).

The !Kung express their concern about the fatness of the eland in a different way: no hunter, whether young or old, may approach the eland

with a torn loin cloth or with flaps hanging down from his loin cloth; these loose parts are tucked between the buttocks. If this were not done, the informants explained, the eland would be thin and lean and the fat would "fall to pieces" like the leather loin cloth. Kan//a considered these two practices to be so important that he insisted on demonstrating them; at the time of the interview he was wearing trousers, but he went to put on his loin cloth in order to make the matter perfectly plain. Both the /Xam and the !Kung, then, performed rituals at the same stage to prevent the "eland from becoming lean".

Diä!kwain's description of the eland rituals ends after his account of the prevention of "leanness" in the dead animal; but there is more to the !Kung first-kill rituals. Before I proceed to examine these further rituals I emphasise briefly two points which indicate that Diä!kwain's account deals principally with *first-kill rituals* and not merely general eland hunting.

The first point is that Diä!kwain distinguished carefully between the hunter and "the old men, the heads of the family". It is they who were said to question the hunter on his return from the hunting ground and to instruct him in the observances he must follow. This distinction in itself strongly suggests that the /Xam account, like the !Kung observances, is primarily concerned with a first-kill eland. The assumption is further strengthened by a second point: no mention is made of the hunter's already having a wife; on the contrary, the way in which the women and children are referred to collectively suggests that the hunter is unmarried. The hartebeest observances, on the other hand, state quite definitely that the hunter is married.

It is true that Diä!kwain's account ends with the observances relating to the fatness of the eland, but I believe that does not necessarily preclude the possibility that the /Xam did have other unrecorded observances about which Diä!kwain did not think to tell Lloyd. The account was given to Lloyd over a period of some days and we are now unable to tell if it was terminated prematurely. My own !Kung informants could not remember everything at once and I had to keep checking the order of events and asking "What do you do after that?"

Even though we cannot now be certain that any further practices were observed by the /Xam, I believe that the close parallels between the two sets of rituals makes it probable that at least the concepts expressed by the subsequent !Kung observances, if not the rituals themselves, existed among the /Xam also. The subsequent !Kung observances are, I suggest, relevant to a fuller understanding of the southern San "eland symbol"; I therefore continue now with an account of the !Kung eland first-kill rituals.

After the !Kung boy "has been brought to the eland", a fire is lit a few inches in front of the eland's forelock. The boy's bow is placed on and at right angles to the "female" fire stick while the fire is being kindled. The bow is held in this position by the fire-maker's left foot near the point at which the fire is being made. Ashes from this fire are rubbed on the bow so that "the bow will drink the anger of the fire". This fire is lit so that when hunting eland the boy will find that "the eland's face will split and it will die". It is also said that the boy's face will be the opposite of the dark ash of the fire; it will be light or shining. To express this idea the informants used the word

//*hára*. This seems to be the same word that the /Xam used to mean shining specularite, but owing to our ignorance of the tone of the /Xam word we cannot be certain on this point.[10] The fire lit before the eland's forelock is not used for cooking as it is said to be a medicine fire; coals are taken from it to light the cooking fire a short distance away.

The liver and some other parts are then cooked at this second fire by the hunters, but a portion of the liver is taken home for the women. If, when first skinning the eland, somebody takes a portion out and roasts it badly, the rest of the animal will also not cook properly. The regular eland medicine dance is then danced.[11] But first the men look to see how much fat is on the eland; then "you dance in praise of the fat". A medicine man who has eland *n/um* goes into trance and "cures". The dance is performed only by the hunters; no women are present. This is the only occasion on which the men themselves do both the dancing and the clapping. Certain parts of the eland are buried in the second fire and cooked overnight; they are the parts which are considered to have *n/um*: the skin of the chest (dewlap), the tail cut off about one third of its length from the body, the lower part of the hind legs and the middle of the back of the neck. Over these so-called "medicine" parts is placed a piece of skin and on top of this the contents of the eland's stomach. The whole is left to cook over night. In the morning the smell of the fat is said to be beautiful. The stomach contents are thrown away and the older men eat the medicine parts; the boy eats only the parts without *n/um*. The women are still in the camp and do not take part in this meal.

Then the men return to the camp with the cut-

up meat of the eland and the other members of the band are drawn into a ritual relationship with the boy. Every time the men bring in an eland the women sing to praise them, crying out, "Euu! Euu!", the same sound they use to praise a girl at puberty. This peculiar sound is used for no other animal "because they don't have fat". When the women see what the boy has done they "praise him"; his mother runs up to him holding her breast and flapping it in a standard gesture signifying motherhood as she cries out, "My son! My son! How is it that you are such a little thing and yet you have killed such a big thing that is so fat?" Then the women set about pounding *sã* (buchu) with their digging sticks. If this were not done, the eland would in future hear the sound of women and run far away, but "if you do it now, the next eland will hear the sound and not run away". The eland likes *sã* because the plants which it eats are also aromatic; the eland does not itself smell of *sã*, but it smells very sweet and of fat. In further explanation of the use of *sã* in the first-kill rituals, the !Kung informants explained that, as the pounding continues, the whole camp begins to smell of *sã*. This causes everybody's brains to go "Pah! Pah!" This sound signifies to the !Kung a happy state in which social tensions are dissipated (Biesele, pers. comm.).

After the pounding of the buchu, the eland rituals continue. The eland's throat and collar bone, both of which have *n/um*, are boiled to make a broth which only the men who have been through the ceremony may eat. The fat which rises to the surface of this broth is taken off and placed on another dish. The boy then sits cross-legged on the centre of the eland's skin which is spread out on the ground. While in this position he is scarified on the right arm for a male eland or on the left for a female. The cuts are made with a broad, flat metal knife which is also used for cutting hair and for scarifying people who are sick. The boy's skin is pinched into a long fold and small transverse nicks are made. When all the cuts have been made, the medicine is rubbed in; this comprises fat from the eland broth, burnt eland hair and portions of certain medicine trees. Scarification is used, the informants explained, not only in the "creation" of a new hunter, but for each large game animal a man kills: Kaishe proudly called upon us to look at all his scars. There is no record of such scarification playing a part in the /Xam boys' first-kill rituals, but reports confirm that they used scarifications to ensure success in the hunt (Bleek, 1936, pp. 145-146). Such success, the !Kung explained, was the purpose of their own scarifications.

After the scarifications have been completed, the !Kung boy sits holding his bow pointing out in front of him, the string uppermost, while an old man takes the right foreleg of the eland, or the left if it is a female, and makes a circle of eland hoof prints around the skin on which the boy is sitting. As this is done, the eland hoof makes the characteristic clicking sound which the animal makes as it walks. The circle of hoof prints around the seated boy is made so that when he hunts in future the eland will not go off in any direction, but the boy will have to find the track. When the circle of hoof prints has been completed, the eland foot is placed in front of the boy. In the next stage of the ritual the eland's forelock, ears, hairy skin of the dewlap and the tail tuft are hung together and dipped into the fat collected from the surface of the eland broth. The fat is then flicked over the boy's shoulders and smeared on his body. While this is being done, the boy must not look around, but keep his eyes downcast: "that is how elands will behave when he hunts them in future." Hairs from the eland's ears are then placed on the boy's temples. When these observances have been completed, the boy drops the bow, plucking the string with his thumb as he does so; this is how the eland will in future fall when he goes to hunt. He then picks up the bow and leaves the eland tracks. After the ritual has been completed, the whole band and visitors gather to eat and sit around singing the eland song which is said to resemble the wailing of hyenas cheated of the eland meat. In this way the ritual sequence comes to an end.

Having now described the complete !Kung first eland-kill rituals, I wish to emphasize certain points in them and in the /Xam rituals which suggest relationships of two kinds; these relationships are represented diagrammatically below.

/Xam	!Kung
Boys' first-kill	Boys' first-kill
Girls' puberty	Girls' puberty

I have, during the course of my description of the rituals, pointed to the close relationship that exists between the /Xam and the !Kung rituals, the horizontal relationships in my diagram. The numerous points of similarity suggest very strongly that the /Xam and the !Kung share a common conceptual framework in which the eland symbolises the same values. This lends further support, over and above the similarities between the girls'

puberty rituals of these two San groups to which I drew attention in Chapter Four, to the important suggestion that it is legitimate to draw cautiously on the !Kung ethnography in a discussion of certain *carefully defined* southern San symbolic associations.

The second type of relationship, the vertical ones in the diagram, is not between the rituals and beliefs of widely separated San groups, but between sets of rituals observed by the same group. There was, I believe, a parallelism between the /Xam girls' puberty rituals and their boys' first eland-kill observances, even as there is between these two ritual sequences among the contemporary !Kung. The demonstration of this second type of relationship shows the close integration of San thought and points to the possibility of the eland having similar significances in *all four* sets of rituals.

The similarities between the two sets of /Xam rituals lend still further, but indirect, support to my contention that Diä!kwain was giving Lloyd rituals for a first eland-kill and not for all eland hunts. In the first place, we note where the hunter spends the night. Diä!kwain explained that "the old men make a hut for him at a different place". That the idea of "seclusion" which this recalls parallels the girls' rituals is confirmed by another custom: an old man made a fire at the isolated hut and there took care of the hunter "as if he were ill". The imagery of illness here is possibly partly related to the identity of the hunter with his dying prey, but, I suggest, if the "caring for" the hunter is seen in association with the idea of the girls' *!koukenka //nein*, the "hut of illness", the comparison with the girls' menarcheal rites is inescapable. The hunter is, indeed, cared for in a

manner that seems at variance with this "link" in the dying prey.

The parallelism is perhaps most clearly seen in the presence in both sets of !Kung rituals of two key sounds. When the girl is placing eland fat and buchu in the camp fires, everybody cries, "Euu! Euu!" This sound, I discovered, is also used on the occasion of the boys' first eland-kill. The other sound is the clicking of the eland's hoofs. In the girls' rituals the sound is made by the tapping of iron knives and axes; in the boys' rituals it is produced by an actual eland hoof. This sound is one of the features which make the eland metaphorically present. Another practice that functions in the same way is the keeping of the eyes downcast. This is done by both the !Kung boys and the !Kung girls, informants explained, so that the eland will in future behave like this and will not see the hunter stalking up to them.

In addition to these practices, the word $n \neq um$, "create", is used in both contexts. The scarifications are said to "create" a new hunter. Other contexts in which the word is used are illuminating. It is used in the common sense to make any artefact. It is also used in the girls' puberty rituals: the Eland Bull dance "creates" a new woman. In the creation myths it is used of the creation of the animals. In the curing dance it is used in connection with the transferring of n/um from a medicine man to a novice.

Apart from sounds, behaviour and words, certain substances are also used in both boys' and girls' rituals. Eland fat, that highly prized commodity, and buchu are used in similar ways. Both the "new maiden" and the "new hunter" are anointed with eland fat and, in the case of the boy, it is part of the scarification medicine. Buchu, a substance

which, by virtue of its sweet smell, the !Kung associate with the eland,[12] is, in the menarcheal rites, mixed with eland fat, which is then rubbed on the girl and which she places in the camp fires. In Chapter Four I suggested that odour, in /Xam and in !Kung thought, is considered to be a medium for the transference of power and influence. It is the scent of the !Kung "new hunter" that makes the eland lean, and the scent of a "new maiden" was believed by the /Xam to anger the Rain (L.V.2.3868) and harm young boys (L.V.6.4390 rev.). In the !Kung boys' first-kill rituals the power of the smell of the pounded buchu has the marked beneficial social effects signalled by the sound "Pah!"

The girls' rituals performed at the onset of puberty and the boys' first-kill rituals, as I have now shown, employ a similar cluster of symbols, chief of which is the eland itself. They also have a similar function: both mark the attainment of adult status and eligibility for marriage. The boy, by killing a large game animal, especially an eland, proves himself capable of supporting a family and so a desirable son-in-law. The rituals for a first-kill, however, go further and ensure that the "new hunter" will also be a successful, skilful and diligent hunter. He will come upon eland spoor as he did those made around him during the scarification; when he stalks up to the eland they will not observe his approach, because, during the rituals, he kept his own eyes downcast; after he has shot his arrow, the eland will fall for him as certainly as his bow fell at the end of the rituals. The essential and inherent unpredictability of the eland hunt will be reduced and controlled.

The subsequent eland-kills, ensured by the rituals I have described, will also be important

events in the "new hunter's" life and the life of his band. I have, in this chapter, so far been concerned only with those aspects of eland hunting that relate to a boy's first-kill eland; but it would be wrong to overlook other eland-kills: not all eland-kills are first-kills.

During all eland hunts, I was told, the !Kung deem it prudent to use not the regular word for eland but the avoidance word *tcheni*, "dance". The /Xam men's respect word for eland was *ein*, "meat" (L.VIII.27.8433). Unfortunately, the circumstances in which the /Xam used this word were not recorded, but I believe it reasonable to suppose that, like the !Kung word, it was used especially during an eland hunt. At first glance these two words, "meat" and "dance", may appear to have little in common, but the concepts are indeed related and, in some ways, complementary. An exegesis of the significance of these two concepts which, the respect words suggest, are particularly associated with eland, provides further understanding of the meaning of the eland to the San. I deal first with the concept of "meat" before going on to discuss the complementary concept of "dance".

Plant foods and small animals may be eaten by the San alone or shared among the nuclear family; the meat of bigger antelope is subject to the rules of sharing. Among the /Xam differences of opinion existed about the sharing of intermediate animals. /Han≠kassō explained that some /Xam shared porcupine meat, while others did not (L.VIII.6.6591 rev.); but larger animals were always shared. A man who did not share, but ate what he shot while he was out on the hunting ground, was said by the /Xam to be an "angry" man (L.II.14.1317-1321) and was given a pejor-

ative name, "decayed arm" or "hyena" (L.II.20. 1793 rev.; Bleek and Lloyd, 1911, p. 125). It seems that the quality of "anger" as used in this and similar contexts related not so much to bad temper, but to any antisocial behaviour. Failure to share meat and so mark social relationships was considered most reprehensible.

The practice of sharing impressed numerous early travellers[13] who met the southern San. Lichtenstein (1928, II, p. 63), writing in the first decade of the nineteenth century, went further than most of these early writers and noted an important social concomitant of a good supply of meat: when a large quantity of meat was brought into the camp, others came "without any ceremony, or waiting for an invitation to partake of it". The same social effects still obtain among the !Kung and other northern groups, amongst whom recent writers have noted detailed rules governing the distribution of meat.[14]

The meat of the eland, the largest and fattest of the antelopes, provides for the gathering of the largest number of people. The man who distributes meat under such circumstances not only expresses wide social relationships, but also creates far-ranging social obligations: the more meat he distributes, the more closely he binds himself and his family to a wide circle of other people. Meat, in this way, provides both economic security and social status. The !Kung express this idea by saying that the distribution of meat increases the "weight" of a family (Reichlin and Marshall, 1974, p. 23) and bride service is constantly spoken of in terms of meat (Marshall, 1960, p. 338). In these circumstances, I suggest, the eland came to represent the widest range of social relationships: by shooting an eland a hunter set in motion a

system that involved and brought together a large number of people. The hunter is, in this sense, a catalyst of social relationships and an initiator of social integration. These associations of "meat" should, I believe, be borne in mind when considering the /Xam avoidance word for eland: "meat" means social relationships and obligations; "eland" means the optimum social relations and obligations.

But the presence of so much meat in the camp often heightens social tensions (Lee, 1969). Smouldering animosities can flare up if someone considers himself slighted by a niggardly portion of meat. A heavy responsibility therefore rests upon the man whose task it is to distribute the meat. Arbousset (1846, pp. 245-246) describes an incident in the Malutis in which a son shot a wildebeest. When his father, who had hunted in another direction, returned home empty handed, the insolent son refused to share his meat with him. The enraged father shot a poisoned arrow at the son, wounding him slightly. The wound was treated and the son's life was saved. Later in the evening, after the meat had been fairly distributed, "the father and the sons . . . chattered away in the kraal as if nothing unpleasant had happened". This incident illustrates the way in which the presence of meat both heightens and dissipates tensions: the more plentiful the meat, the more marked are the effects.

It is the dissipation of tensions that is particularly implied by the !Kung men's respect word for eland, "dance", an activity which frequently follows upon the provision of much meat. Informants explained that this respect word is used especially at the beginning of a hunt; after the animal has been wounded the hunters themselves

may call it by its regular name *!n*, but others must continue to show respect by using the word *tcheni*. Asked why the word for dance was used as a respect word for eland, an informant explained: "Your heart is happy when you dance." This, he thought, was an adequate explanation. Happiness, relaxation of tensions are the ultimate effects and associations of an eland-kill, whatever tensions may initially arise. The way in which the dance relaxes social strain and the part played by the eland in that activity I discuss in Chapter Seven.

The concepts of "meat" and "dance" with their social concomitants are the final link in the chain of events started by the wounding of an eland with a poisoned arrow. If the eland hunt has such connotations in addition to the importance suggested by the first-kill rituals, one might expect to find, as numerous writers have claimed (e.g. Dornan, 1925, p. 53; Holz, 1957, p. 163), that the southern San artists were interested in depicting hunts. In fact scenes of men hunting antelope are not as common as is popularly supposed and in them eland appear less frequently than other animals. Pager (1971, p. 335) found that there are only 29 hunting scenes among the 3909 paintings in the Ndedema Gorge; only 4 of these 29 hunt scenes involve eland. Sixteen hunt scenes show rhebok and other small antelope being hunted. In the Underberg area Vinnicombe (1976, p. 363) found only 8 hunting scenes in a total of 8478 paintings. The same situation obtains in the Barkly East area: only one painting shows an eland being shot at by a man using a bow and arrow (Fig. 16).

If the painted eland are the polysemic symbols I believe them to be, it may appear strange that more hunted, wounded and even dead eland were not depicted to signify the role of the eland in the

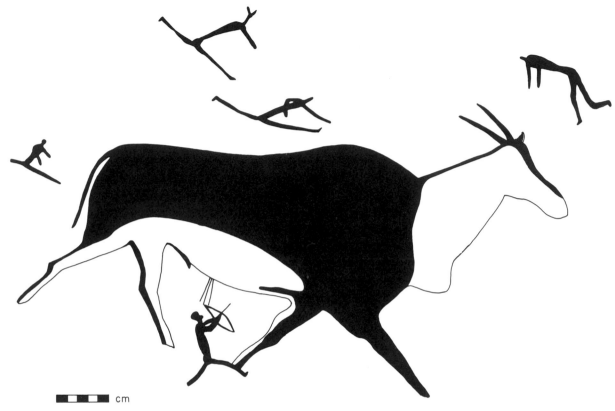

Fig. 16. Lauriston, Barkly East.

rites of passage and the social effects of a kill. The manner in which the painted symbols function is, however, more subtle than that rather simplistic belief implies. The significance of eland extends beyond the events of the actual hunt; it lies not in the techniques and skills of the chase, but in the antelope itself: the antelope, rather than the activity, is the symbol. To show the ways in which I believe the rock art, apart from the few simple activity groups like hunts, directed and focused the

attention of the original viewers on aspects of eland symbolism I draw attention to further features of a painting (Fig. 15) I first discussed on p. 48.

I was there concerned with the eland herd which, I explained, my !Kung informants identified as a mating herd. This herd is superimposed on two large, striding therianthropes of the kind Pager (1971, p. 340) has called "antelope men"; the figure on the right holds out arrows and both

carry what are probably bows. The right hand figure may also have, protruding over his shoulder, the sticks tufted with feathers which the southern San used in hunting (Barrow, 1801, I, p. 285; Stow, 1905, p. 84; Bleek and Lloyd, 1911, pp. 285-287, 359-361; Bleek, 1924, pp. 58-59, 1932, p. 341). One of the most interesting features of this painting is the trail of hoof prints which is being left by the left hand figure. These spoor are painted in black, but, owing to the fugitive nature of this paint, some are poorly preserved; the nature of the reproduction, however, gives them a clarity of outline which they do not possess on the rock surface. The !Kung informants, having been shown my copy of the painting, were asked by Biesele to identify the spoor before I had any discussions with them about eland. They expressed doubt about the less well preserved examples: one, they thought, could just possibly be that of a giraffe; the other poorly preserved ones, they said, did not represent any animal known to them. The clearer ones, on the other hand, they identified positively as eland spoor and added the observation that, unless one is highly skilled in these matters, it is easy to confuse eland spoor with cattle spoor.[15] The spoor depicted in the paintings, however, were not, the informants claimed, those of cattle. This valuable identification by the !Kung informants suggests that at least some of the so-called "antelope men" are in fact "eland-men"; this is a point I discuss further in Chapter Seven.

The Burley I painting (Fig. 15) seems to present a cluster of symbols. Eland mating is, I suggest, related, by the superimposition of the herd, to hunters. I do not claim that the painting is necessarily signalling a coherent "message" which can be "read" as saying, for instance, "Here is part of an eland hunting ritual." The painting does, however, seem to be presenting an "association of ideas" or a "symbol cluster" which it is not unreasonable to infer may have included some of the rich ideas that are present in the first-kill rites.

Eland hunting and eland mating, both implied by the Burley I painting, are, in the boys' first-kill and in the girls' puberty rituals respectively, associated with personality development.[16] This aspect of the boys' rituals was described by Kan//a:

His heart is burning hot towards meat; he desires meat. He has become a real hunter and will spend the whole day out and not come back to camp.

This statement reflects one of the !Kung's chief values: the hunter should be indefatigable, not lazy. When he sees his scarifications, he will be reminded, they say, that he should not be idling in the camp, but should be out on the hunting ground. The girl, likewise, attains mature development through her eland rituals, as I pointed out in Chapter Four. The role of the eland in rituals signalling a coming to maturity is a topic I take up again in Chapter Six.

In addition to the concept of personality development, the association of ideas implied by the Burley I painting might also have included a reference to beliefs concerning general hunting. The conflation of eland hoofs with a human body might have suggested the link believed to exist between the hunter and his prey.[17] An even more daring suggestion is that this concept was also expressed by the superimpositions of an eland on human figures in numerous other paintings. In the Barkly East sample there are 21 such cases, ten of which involve not single figures but groups of from 2 to 5. Owing to the nature of superpositioning it is not always possible to tell whether these figures are carrying hunting equipment, but such equipment is discernible in 47% of the total number of forty figures under eland. The depiction of hunting equipment need not, however, have been essential to the meaning I am tentatively suggesting. The Burley I painting (together with many others) may have presented, then, not a simple, direct "message" which could have been readily translated by all San viewers, but rather a subtle interplay of such ideas as "sex", "fertility", "eland", "hunters", "personality development", "balance" and "potency".

This painting seems to me to lend strong support to my suggestion that many of the paintings of eland are not merely icons or scale models of real animals, but symbols with complex associations and values of the type implied by the first-kill rituals. In analysing the significance of the eland in first-kill and girls' puberty rituals I have by no means exhausted its meaning: it plays an important role in a further rite of passage, marriage. It is to this next link in the concatenation of eland symbolism that I give attention in the following chapter.

Notes

(1) The San knowledge of game movements and skill in stalking and tracking fascinated the early writers (Alexander, 1838, I, p. 283; Baines, 1864, p. 116; Mackenzie, 1871, p. 141; Herbst, 1908, p. 11; Dornan, 1925, p. 110). The modern !Kung, also practised hunters, are able to distinguish the tracks of a wounded animal in

amongst those left by other members of a herd (Thomas, 1969, p. 188).

(2) A ''link-shaft'' arrow comprises a reed shaft, usually notched to accept the bow string, a torpedo shaped ''link'' of bone, a short reed collar and, finally, the point. When the arrow strikes an animal the impact drives the ''link'' into the collar, splitting it and allowing the shaft to fall away. A quiver containing such arrows was found in the Natal Drakensberg in 1926 (Vinnicombe, 1971). The southern San arrow points were made of stone (Dunn, 1873, p. 34), bone (Harris, 1838, p. 310; Chapman, 1868, I, p. 53), iron (Kolben, 1731, I, pp. 241-242; Thunberg, 1796, I, p. 161; Leslie, 1828, p. 82; Lichtenstein, 1928, II, p. 248; Wikar, 1935, p. 179; Paravicini, 1965, p. 169) and even glass (Frere, 1882, pp. 327-328; Dornan, 1917, p. 45). Glass points made by Bleek's informants are now in the Museum of the Department of Archaeology, University of Cape Town.

The early writers report a variety of San poisons including plants (Leslie, 1828, p. 80; Stanford, 1910, p. 438), especially the euphorbia (Le Vaillant, 1796, II, p. 135; Alexander, 1838, I, p. 284), snake venom (Thunberg, 1796, I, p. 162; Campbell, 1822, p. 30; Steedman, 1835, I, p. 148; Moffat, 1842, pp. 54-55; Mackenzie, 1871, p. 504; Dornan, 1925, p. 114; Lichtenstein, 1928, II, p. 55) and ''a certain deposit in clefts in rocks in the Cape Colony'' (Mackenzie, 1871, p. 504; also Barrow, 1801, I, p. 24). The Kalahari San obtain their poison from the larvae of a beetle, Chrysomelidae (Baines, 1864, I, p. 64; Chapman, 1868, I, p. 53; Selous, 1893, p. 107; Bleek, 1928, p. 14; Metzger, 1950, p. 89; Tobias, 1957, p. 34; Steyn, 1971, p. 300). For a comprehensive survey of San poisons see Shaw and Wooley (1963).

In an important but, curiously, unpublished report, ≠Kássin gave the only first-hand account of the preparation of /Xam poisons (L.IV.1.3472-3479); he described the use of poisons made from plants and snake venom.

(3) It is in this situation of dubious outcome that /Kaggen was believed to intervene; the significance of this intervention for a correct understanding of /Kaggen is a matter I consider in Chapter Nine.

(4) Among both !Kung and /Xam, ''heat'' is associated with a high degree of potency and ''coolness'' with quietness and an absence of power. The !Kung speak of ''cooling'' a man's anger (Lee, 1969, p. 62) and ''heating'' a medicine man's potency until he enters trance (see Chapter Seven). A menstruating !Kung woman throws a hot coal at her husband's knife or axe before using it; if she touched his hunting equipment, she would ''cool'' the poison. The southern San believed poison could be ''cooled'' by the dew or a ''new maiden's'' saliva (Bleek and Lloyd, 1911, pp. 67, 79).

(5) The !Kung of Angola hold the same belief and ''in the case of a small beast'' the hunter goes so far as to lie down and pretend to be dead for a few moments (Estermann, 1976, p. 11).

(6) The throwing of stones seems to have been regarded by the /Xam as an insult or act of disrespect. Children were told not to throw stones at locusts (Bleek, 1935, p. 9) and girls at puberty were warned not to throw stones at the newly fallen rain (Bleek, 1933, p. 300).

(7) Biesele (1975, I, pp. 153-154) found that the !Kung classify animals according to the colour their flesh is conceived to be. The ''red meat'' category includes the large antelope and also some smaller antelope like steenbok and duiker. The ''black meat'' animals comprise wildebeest, warthog, bat-eared fox and jackal. The ''white meat'' group includes carnivores together with leguaan and hare. It is worth noting that the animals which receive numerical emphasis in the southern San rock art are all of the ''red meat'' kind. The only large antelope not in the ''red'' category, the wildebeest, was painted very rarely (see Appendix), although it inhabited the fringes of the Drakensberg in vast herds and was eaten by the southern San (Backhouse, 1844, p. 337; Arbousset, 1846, p. 129; Brooks, 1876, p. 124; Mohr, 1876, p. 133; Widdicombe, 1891, p. 3; Bleek and Lloyd, 1911, p. 87; Ellenberger, 1953, p. 80; How, 1962, p. 39; Stanford, 1962, p. 100; Thompson, 1967, I, p. 53). Seen in the light of the !Kung colour taxonomy, the omission of the wildebeest from the art lends further support to my suggestion that factors other than pure aesthetics were governing the selection of subject matter.

(8) ''Magic power'' is a concept I examine in more detail in Chapter Seven.

(9) In the manuscript ''sigh'' has been rendered ''break wind'' (L.V.18.5363).

(10) I am grateful to Biesele for drawing my attention to this linguistic point. Sparkling black specularite was mined by the southern San and used to decorate their hair (Bleek and Lloyd, 1911, p. 375). The substance has been found in San graves (Mason, 1954; Humphreys and Maggs, 1970).

(11) I examine the part played by the eland in the medicine dance in Chapter Seven.

(12) The sweet smell of the eland has attracted the attention of a number of writers (Lichtenstein,

1928, II, p. 30; Arbousset, 1846, p. 45; Bryden, 1899, p. 427; Shortridge, 1934, p. 613). Bryden (1893, p. 422) describes the dismembering of an eland: "As I stripped away her sleek, smooth coat, a strong sweet perfume, redolent of pleasant herbs, came to my nostrils."

(13) See Le Vaillant, 1796, III, pp. 186-187; Shaw, 1820, p. 25; Philip, 1828, pp. 6-7; Moffat, 1842, p. 59; Arbousset, 1846, p. 244; Borcherds, 1861, p. 114; Stow, 1905, p. 41; Dornan, 1909,

pp. 442-443; Ellenberger and Macgregor, 1912, p. 7; Dunn, 1931, p. 8.

(14) See Fourie, 1928, pp. 100-101; Metzger, 1950, p. 25; Marshall, 1961, pp. 236-241; Silberbauer, 1965, pp. 49-50; Heinz, 1966, p. 43; Tanaka, 1969, p. 11; Steyn, 1971, pp. 283, 286.

(15) The similarity between the spoor of eland and cattle has been noted by Methuen (1846, p. 109) and Bryden (1893, pp. 392, 502).

(16) An equivalence in San thought between hunting and mating has been suggested by Marshall (1959, p. 354) and McCall (1970).

(17) Vinnicombe (1976, pp. 332-334) has suggested that some of these therianthropes may represent the spirits of medicine men. The way in which the paintings relate medicine men to animals by conflation is examined in Chapter Seven.

Chapter 6

Marriage and the Eland

In this chapter I examine the central panel of what I have called a ritual triptych and bring to a close a sequence of chapters which has been largely, but not entirely, a discussion of "operations" with either the "eland symbol" or an eland antelope. The boys' first eland-kill and the girls' puberty rituals which were the subject of the preceding two chapters are considered by the San to establish eligibility for marriage; the ways in which all three rites of passage — the two puberty rituals and marriage—are linked form the subject of this chapter, and draw together some aspects of the meaning of the eland which may be reflected in many of the depictions of that antelope in the rock shelters. The "object" of many, but not necessarily all, of these painted symbols was, I argue in this chapter, not specifically one or other of the rites of passage, but embraced the totality of meaning implied by the eland's ritual use in all three contexts. Although it is not possible to associate particular paintings of eland specifically and exclusively with marriage, I believe that an exploration of the significance of the eland symbol in San ritual and art would be incomplete without a discussion of this important ritual context. I therefore begin again by describing the ritual use of actual members of this species in the marriage observances of both the southern and the northern San.

The southern record is, unfortunately, more than usually limited on the subject of marriage. The Bleeks seem to have taken little interest in marriage customs; or, perhaps, the informants had little to say on the subject. Dorothea Bleek (1924, p. x) laconically summed up what she was able to learn about /Xam marriage customs from the collection bequeathed to her by her father and her aunt:

They have no particular marriage form, yet they are monogamous, and man and wife generally remain faithful to each other till death. Sometimes the young couple build their hut near the bridegroom's father's, sometimes near the bride's. They seem to keep the family groups fairly even. They do not often have many children.

Nowhere in the Bleek collection is there any mention of /Xam marriage rites. This lacuna is partially filled by von Wielligh (1921, III, p. 119).[1] He reports that a /Xam man wishing to marry shot a springbok and placed it near the huts of the girl's band. The following day he shot another animal and took it again to the camp of the girl whom he wished to marry. If the buck of the previous day was still where he had left it, he knew that his overtures had been rejected; if, however, the parents of the girl had removed it, he knew he had been accepted and he placed the second buck in the same position as a further offering to his future parents-in-law.

More details of a connection between marriage and the provision of food by hunting come from the Maluti San. Dornan (1909, p. 442) reports that a young man wishing to marry a girl was obliged to kill an animal, ''generally the largest and fiercest he could find'', and to give ''the best part'' to the girl. A more reliable source than Dornan confirms the main elements of this report and adds further highly significant details. In the 1850s Silayi, a Tembu, spent three years living with a San band in the southern Drakensberg; in his statement to Stanford (1910, pp. 437-438) he reported that a young San man of this region was expected to present the father of the girl whom he wished to marry with the breast and heart of an eland. This, he said, was all that was necessary to confirm the marriage; no hut was built as they all slept in one cave.

Silayi did not, unfortunately, make any specific reference to the way in which the hunter secured the eland. Arbousset (1846, p. 249), however, reporting from the nearby Malutis, described how the San suitor ran down ''an antelope'' as ''proof of his agility''. If Arbousset's report is read in conjunction with Silayi's, it seems that the running down of an eland and the presentation of the heart to the father of the girl are two practices that could have been combined in the Maluti San marriage observances.[2]

Hunting was important not only, as von Wielligh, Silayi and Arbousset indicate, as a prelude to marriage but also after marriage. Bleek's remarks concerning the location of a newly married couple's hut imply that bride service was not a rigid /Xam practice. There are, nevertheless, indications that a young man was, at least sometimes expected to hunt with and for his father-in-law (Bleek and Lloyd, 1911, p. 285; L.II.6.630). A clearer picture emerges in the Malutis, where the young man undertook to accompany his in-laws everywhere and ''to procure game for them'' (Arbousset, 1846, p. 249). It is clear that in this region at any rate bride service was the accepted practice, as it still is among the northern San.

The two most clearly discernible elements of southern San marriage customs, hunting first as a prelude to marriage and then during the subsequent period of bride service, are, in fact, both found among the more northern groups. The killing of an eland as a gift to the bride's parents is reported from the !Kung by Metzger (1950, pp. 54-58, 79). Once the young !Kung man's advances have been accepted by his beloved he sets out to hunt an eland. When the animal has been wounded, he attempts to drive it back to the camp of the girl's parents and to kill it as close as possible to their hut (see also Dornan, 1925, p. 125; Vedder, 1938, p. 85). He then gives the fat of the eland's heart to the girl's mother and so validates the marriage. If the eland is found to be with calf, it is considered a most propitious sign. After the meat of the eland has been distributed by the girl's mother, the Eland Bull dance is performed, as it is at the girl's puberty rituals. While the dance is being performed, the bride sits at the entrance to her hut.

Metzger's report concerning the Eland Bull dance as part of the marriage ceremonies confirms Marshall's (1959, p. 356) belief that the !Kung wedding ceremony is closely related to the girls' puberty rituals. She cites five observances which appear in both rituals. First, the bride, like the girl at puberty, is carried and isolated so that her feet do not touch the ground. Secondly, the bride's head is covered to prevent the sun from shining on it; the sun in such a context, is a ''death thing'' and the girl at puberty is hidden from it. Thirdly, the bridal ''scherm'', like the girl's hut, is specially built and set apart from the others. The next common feature, the anointing of the bride with eland fat, is considered to be particularly important. The fifth common observance is the painting of a design on the forehead and cheeks.

Marshall was unable to discover the meaning of this red design on the face: informants replied simply, ''It is our custom.'' It is, however, possible that the line down the nose was originally intended to represent the tuft of red hair on the forehead of an eland. This, I was told, is the significance of the marks made on the face of a boy who has shot his first eland. The parallelism between the boys' and the girls' puberty rituals is, as I pointed out in the two previous chapters, reflected in the phrase used to describe a girl at puberty, ''She has shot an eland'', and other comparable observances. If part of the marriage ritual is, as Marshall probably rightly believes, related to the girls' puberty rituals, there is also reason to believe that other elements correspond to the boys' first eland-kill observances of which Marshall was not aware. For example, at both the first-kill and marriage, the boy attempts to drive the eland back as closely as possible to the camp.

The driving of the eland back to the camp is one of the ''operations'' with this antelope that deserves closer attention. Although Arbousset unfortunately fails to mention any particular species, it is worth noting here that the eland is the antelope most readily secured by this technique. In a comparatively short time it becomes winded and eventually stands stock still, refusing to move in

any direction; no antelope is as easily taken. This unusual characteristic has been widely noted.[3] If the wind is fairly strong, it stubbornly refuses to run in any direction other than upwind (Sparrman, 1789, II, p. 154; Selous, 1893, p. 75; Bryden, 1899, p. 431; Smith, 1939, I, p. 136); in the absence of any wind, however, it is possible to drive the animal back to the camp and so slaughter it close at hand. The early travellers and hunters, who accomplished this feat on horseback, considered it a masterly achievement and aspired to impress their associates with this ability.[4] The modern !Kung, too, consider the driving of an eland a laudable accomplishment, because the other members of the band can easily come to the place of the kill and admire it as it is being dismembered (Biesele, pers. comm.).

The feat of driving an eland back can be more easily managed in the hot season than in winter because the heat soon causes the animal to become winded; in the Kalahari, the summer rains likewise contribute to the ease with which an antelope is run down because the soft ground impedes its progress (Fourie, 1928, p. 99). Oral evidence on the driving back of eland in the summer was obtained by Vinnicombe (pers. comm.) from an old Sotho man living near the Sehonghong shelter in Lesotho. This shelter is in the highland sourveld area which provides suitable grazing for only a few summer months (Carter, 1970), so we must assume that the old man's remarks applied to that season. The Sotho informant told Vinnicombe that his father had told him that it was the custom of the San to drive eland back to the top of a bluff opposite the shelter and then slaughter them there. While the men were doing this, the women sang and clapped "to give them strength", as they

do during the curing dance. Although the informant did not say this was done specifically for marriage, the statement provides interesting confirmation of the suggestion that the feat of driving an eland was indeed practised in the higher areas of the Drakensberg.

It is, therefore, of particular interest that a recurring theme in the Drakensberg rock art is the depiction of an eland apparently being pursued or driven, rather than hunted with bow and arrows. Figure 17 shows such a painting from Giant's Castle: a single "infibulated" male figure pursues an eland. The rather strained position of the eland's head and neck probably indicates its exhaustion: the chase is nearing its climax. Methuen (1846, p. 109) reports that a pursued eland holds its head in this horizontal position to catch fresh air, an observation confirmed by my !Kung informants. Other similar paintings have been illustrated by Willcox (1963, plate 33) and by Vinnicombe (1976, 288; Figs 92, 205), who also believes that they may "in some way be connected with" marriage ceremonies.

Fig. 17. Main Caves, Giant's Castle.

The unique tractability of the eland is, I believe, one of the factors which have led to its supreme position in San ritual; but this attribute alone seems to be insufficient to account for the considerable attention which is accorded it. Another contributory feature is undoubtedly the eland's fatness and especially the vast amount of fat around its heart. It was the fat of the heart, according to both Silayi and Metzger, which was given to the mother of the bride. The /Xam believed (as the !Kung still do) that the fat of an eland's heart possessed a supernatural potency (Bleek, 1932, p. 237). Eland fat features prominently in all three parts of the San triptych of rites of passage. In the !Kung menarchal rituals it is rubbed on the girl and she subsequently places a little in each fire in the camp; in the boys' observances the fat is used in the manufacture of the scarification medicine; in the marriage rituals of both the Maluti San and the !Kung the groom gives the fat to the bride's parents and among the !Kung the bride is anointed with it. In Chapter Four, dealing with the girls' puberty rites, I discussed some of the associations of fat in !Kung thought. Fat, and especially eland fat, I suggested, was associated with the state of balance in food supply, water availability, weather and social relations which the "new maiden" renovates. It is used again in the marriage rituals, I believe, to signify the same concept. As the marriage rituals include parts of the boys' and girls' puberty rituals, so the fat again plays its part, connoting and bestowing the desired balance, not only on the couple but also on the whole band.

The ritual emphasis on eland fat raises again the key question to which I have alluded in the previous two chapters: why did the San select this

particular antelope to feature in the ritual triptych I have been discussing? Why should it, and especially its fat, be considered particularly appropriate in situations signalling change in socio-sexual status? This is a question which exercised my mind for a long time; but my reading of zoological works and other descriptions of the antelope failed to provide an answer to what is a fundamental question in the consideration of the fat prominence of the eland in San thought and art. The beginning of an answer to the problem came during a discussion with !Kung informants on the characteristics of various antelope. It was pointed out to me that the female of most species has more fat than the male; the female gemsbok, for example, is more desirable than the male on this account. With the eland, however, the position is uniquely reversed: the male has more fat than the female. This exceptional state of affairs results to some extent from the large accumulation of fat around the heart of the bull eland. This, I must emphasize, is a point which the !Kung themselves find remarkable: it excites their interest and they consider it to be an important distinguishing feature of the eland. The animal is, in their thought, almost androgynous in that, by the male's possession of so much fat, the usual differentiation is uniquely reversed.

It is, I believe, essentially because of this curious physical characteristic, that the eland is thought to be apposite in situations marking eligibility for marriage and in the marriage observances themselves. In the two preparatory rites of passage the neophytes are, *like the eland*, considered to be sexually ambivalent: the girl is spoken of as if she were a hunter who had shot an eland, while the boy is secluded and cared for as if he were

menstruating—both are neither male nor female during the liminal period of the rites. In the marriage ritual, which is closely related to the two puberty rituals, the sexual availability which has been celebrated in the first two rituals is fulfilled. The uniqueness of the eland, then, consists not only in its exceptional tractability and in the sheer quantity of fat which it possesses, but in the anomalous reversal of the usual proportion of fat between the male and the female.

The successful killing of the "androgynous" bridal eland initiates a new phase of hunting in bride service: after marriage, the !Kung hunter lives for an extended period with his father-in-law, hunting for him and establishing co-operation between the families and the bands. The interdependence created through marriage and subsequent bride service facilitates social movement, opens up wider territorial exploitation and extends the web of reciprocity. The !Kung say the "weight" of the family is increased. The most desired marriage is the one which most increases the "weight" of the family.

Because the eland, more than any other antelope, increases the "weight" of the family, it became, I suggest, a symbol of social and cultural unity: it represents the increasing "weight" of the family through the union of male and female in marriage. In saying this I am reaching a similar conclusion to Vinnicombe, but via a different route. She believes that the San saw their band structure reflected in the seasonal fission and coalescing of the eland herds. Although this attractive suggestion cannot be rule out, I believe it is rather through its complex symbolism and its social concomitants that the eland comes to represent the widening web of social relationships

and interdependence. This, I suggest, was implied by Mapote, the old Maluti man, when he told How (1962, p. 38) that he would paint an eland "because the Bushmen of that part of the country were of the eland". In this evocative remark, which Vinnicombe has aptly paraphrased in the title of her book, Mapote provided striking evidence that the act of painting could involve a statement or proclamation of social and cultural identity. I suggest that the people were "of the eland", not for the specific reason which Vinnicombe suggests, but partly because of the key position which this antelope demonstrably held in those rites concerned with the web of social relationships: it was the eland which "linked" and gave cohesion to the divisions of San society. It is usual to refer to the rituals which mark changes in social status as *rites de passage*. In view of the eland's pervasive role in these rites I propose it be regarded as the San *animal de passage*.

It is as though a person changes status "through" the eland: the liminal stage of the rite and the person in that stage are intimately associated with the *animal de passage*. It is through symbols of this kind that society is symbolically united; that unity is proclaimed by the *animal de passage*. It was, I believe, this unifying quality of the eland that made it possible for Mapote to declare that the people were "of the eland" and to paint an eland to express the notion of being "of the eland". But the proclamation and possible re-inforcement of social unity through painting was in yet another way linked to the eland.

When Mapote prepared to paint the eland he called for the blood of a freshly killed eland; if the blood were not fresh, it would coagulate and not

mix with the pigment and soak into the rock. The ochre, *Qhang Qhang*, had to be prepared at full moon by a woman who heated it over a fire until it was red hot. The rich red pigment was then ground between two stones in preparation for subsequent mixing with the eland's blood (How, 1962, p. 35). In the event, Mapote had to be content with ox blood, no eland being available. The very activity of painting was, according to this account, a co-operative, if somewhat arcane, enterprise between men and women: they worked together to produce the image of the eland.

As How points out, the need for fresh eland blood determined that the painting would take place after an eland kill. The killing of an eland, I have explained in Chapter Five, was an important social event characterized by the arrival of visitors from all the neighbouring bands, the heightening of social tensions and the dissipating of those tensions in the sharing of the meat and the ensuing apotropaic dance. The dance and the part played by the eland in that further activity I discuss in the next chapter.

In presenting my interpretation of the symbolic role of the eland in San rites of passage, I have suggested that many of the multitude of eland paintings in the rock shelters of southern Africa might, as part of their meaning, have proclaimed social unity through recalling the ritual use of this antelope. It is, I believe, in the bulk of the vast number of eland paintings and not necessarily only in certain hunt or "driving" groups that the values discussed in this and the previous two chapters are expressed. After the killing of an eland, not exclusively as part of a rite of passage, and during the extended social intercourse consequent upon such a kill, it was, as Mapote implied, appropriate to state graphically the solidarity of San society by depicting this antelope on the walls of the rock shelter; the ephemeral dance lasted only a few hours, and once the meat had been eaten the visitors departed, but the painting of the eland stood in perpetuity proclaiming the values associated with it. This painted, symbolic statement, always before the eyes of the inhabitants of the shelter, provided, I suggest, affective reinforcement of the social bonds it signified and also reassurance that those who hunted the eland, enjoyed the subsequent dance and viewed the painting of the eland were indeed all "of the eland".[5]

I have, in this chapter, tried to show how the eland becomes, in San thought, ritual and art, a "linking" or unifying symbol, an *animal de passage* which in its ritual use stands between and draws together the divisions of San society. We may imagine in the left-hand panel of the ritual triptych the new maiden who has "shot and eland", together with the mature women performing the Eland Bull dance; in the right hand panel, with the old hunters dancing the eland medicine dance, is the new hunter, who has shot his first eland; in the central panel are the new maiden and the new hunter joined in marriage and set in the rich chiaroscuro of eland symbolism.

Notes

(1) Von Wielligh first met the /Xam in 1870 in the vicinity of Calvinia. Although some of his material may be suspect, the value of his four volumes of folklore has, perhaps, been underestimated.

(2) The association between hunting and marriage is found in another widespread San custom: the offering of hunting equipment to the prospective bride. If she accepts the equipment, she accepts the offer of marriage. This custom has been reported by Chapman (1868, I, p. 258), Fourie (1928, p. 93), Vedder (1938, p. 86) and Metzger (1950, p. 47), though not from the southern San.

(3) See Sparrman (1789, I, p. 92), Barrow (1801, I, p. 262), Burchell (1822, p. 219), Harris (1838, p. 263), Methuen (1846, p. 109), Arbousset (1846, p. 44), Baines (1864, p. 116), Bryden (1893, p. 388), Selous (1893, p. 439), Lichtenstein (1928, II, p. 30), Silberbauer (1965, p. 36) and Steyn (1971, p. 297).

(4) See Sparrman (1789, II, p. 154), Collins (1838, V, p. 2), Cumming (1850, I, pp. 253, 314), Mackenzie (1883, p. 42), Bryden (1893, p. 389), Selous (1893, p. 120), Smith (1940, II, p. 45) and Roberts (1951, p. 305).

(5) Hammond (1974, p. 619) has similarly suggested that the "*majority* of the Cantabrian animal art" was concerned with "bridging" social divisions: "it is within this area of human relationships, with other men rather than with the numinous or the environment, that the answer is to be sought".

Chapter 7

—————————————————————*The Medicine Man and the Eland*—————

In the previous three chapters I discussed a set of rites of passage in each of which the eland plays a prominent role: by these rites certain social divisions are bridged and united. The graphic signs with which I dealt there were all, at their simplest level, iconic in that they exhibited a visual similarity to their objects; these objects were observable elements in nature—people and animals.

Now, in this chapter, I go a stage further and deal with an activity which links the totality of society to an analeptic power. I argue that some of the paintings are associated with that activity and, in marked contrast to those discussed in previous chapters, are not iconic since they do not signify natural objects, but depict imagined or even hallucinatory entities: conceptual and visionary forms translated into graphic representations. It has been customary to label these paintings as "mythological", but the term is not helpful, because it implies that these curious depictions signify fantastic creatures which featured in southern San mythical narratives now lost. I try to show that they are not "mythical" in that sense; they are rather the product of the experience which links society with the supernatural, in fact the central religious experience of the San. That experience is the altered state of consciousness known as trance, the esteemed accomplishment of the medicine men and the ecstatic climax to which the drama of the medicine dance moves through a crescendo of successive phases.

The /Xam preoccupation with medicine men and their depiction in the paintings of dances is evident from both the published and the unpublished records. It would probably have been even more evident in the Bleek manuscript volume (L.XX) which contained the /Xam remarks on many of Stow's paintings and which has most regrettably been lost in recent times. Some of these remarks were, however, published with Stow's copies of paintings (1930). In four of these copies, the /Xam informants detected the presence of "sorcerers"; of another painting also illustrated by Stow (1930: caption to plate 52) the unnamed informant said, "These are sorcery's things." It seems that in this second case he was referring to the paintings themselves rather than to the items depicted; the remark even suggests that the activity of painting might in some instances have been part of a medicine man's tasks, a point to which I return in the next chapter. Before discussing in detail certain features of San medicine men and the dances in which they participate, I describe briefly dancing in general as it appears in the southern San ethnographic and painted record.

The southern San dances showed several well-marked spatial arrangements. Stow (1905, pp. 113-119) described a range of southern dance forms, including the generally scattered chor-

eography depicted in numerous paintings (Fig. 20; also Vinnicombe, 1976, Fig. 222). In a more regular pattern the men danced in a circle, producing a rut of that shape in the ground (L.VIII. 9.6825; Barrow, 1801, I, p. 284). One such dance is depicted in a remarkable painting from Lonyana, Kamberg (Fig. 18). This painting is in some ways similar to the Fulton's Rock girls' puberty dance (Fig. 10): a figure lies in a hut while others dance around it, but there are significant differences. The central figure in the Lonyana group is not covered by a kaross and is being attended to in some way by another kneeling figure. Furthermore, unlike the Fulton's Rock dance, most of the figures dancing around the hut are male, not female. I clarify these and other features below.

While the southern San men danced in one of these patterns, the women provided the important musical accompaniment by singing and clapping (L.VIII.27.8414 rev.). Further rhythmic background was supplied by dancing rattles which the men wore (Bleek and Lloyd, 1911, p. 351). All these dances were not, of course, medicine dances; some were probably purely for entertainment and did not involve trance performance.

There is a marked similarity between these southern San dances and the curing dances still performed today by the !Kung and other San groups. Curing dances among the !Kung are started usually by the women whose task it is to clap the rhythm and sing the medicine songs. They sit in a tight circle around the fire while the men dance in a line around them employing short, heavy dancing steps, moving now clockwise and now anticlockwise. As the dance continues the feet of the dancers produce the circular furrow which

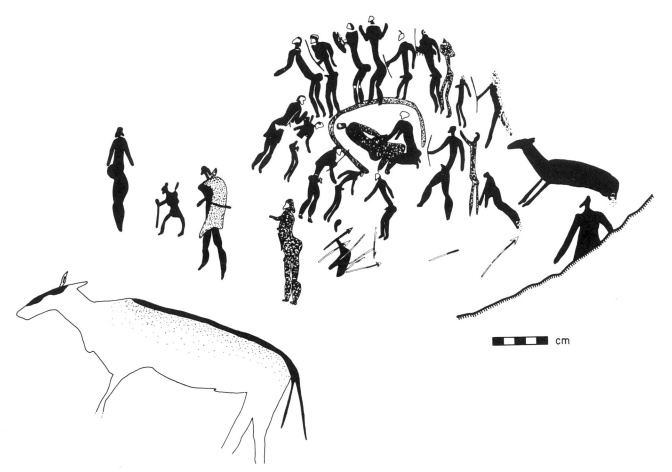

Fig. 18. Lonyana, Kamberg. The hatched line represents a break in the rock face.

the !Kung call *n≠ébe* (Marshall, 1969, p. 356).

The most important participants in a curing dance are the medicine men; it is their activities that transform an ordinary entertaining dance into the central religious ritual of the San. To provide an understanding of medicine men and their depiction in the paintings I examine first the /Xam beliefs concerning these people.

The /Xam word *!gi:xa* (plural *!gi:ten*)[1] was translated by Lloyd as "sorcerer". Dorothea Bleek in preparing portions of the manuscripts for publication changed Lloyd's "sorcerer" to "medicine man". Schapera (1930, p. 195) preferred the word "magician", but rightly recognized the inadequacy of any English word or phrase. Marshall (1976, p. xxi), after many years of using

"medicine man", has recently resolved to employ the !Kung word *n/um k''xau* (medicine owner). I shall not now dispute over terms; I use the translation "medicine man" which, whatever its limitations, has become the accepted phrase in the San literature; to persist with the /Xam word *!gi:xa* and its exotic plural seems, in face of the general practice, perverse.

The /Xam spoke of four overlapping categories of medicine men: *!khwa-ka !gi:ten* (medicine men of the rain), *opwaiten-ka !gi:ten* (medicine men of the game), *//xi:-ka !gi:ten* (medicine men of illness) and, lastly, *!gi:ten* without any further appellation. The *!khwa-ka !gi:ten* receive attention in the next chapter; here I am concerned chiefly with the *opwaiten-ka !gi:ten* and those designated simply *!gi:ten* who performed curing rituals. It seems likely that these last named were often also game and rain medicine men.

To accomplish their ends the /Xam medicine men went into trance, in which state they manipulated a supernatural potency. In the Bleek collection this potency is called variously *!gi, /kɔ:ɔde* and *//ke:n*. The first of these words, *!gi*, is part of the word for medicine man, as *n/um* is part of the !Kung word *n/um k''xau*. The other words appear in certain contexts as synonyms for *!gi* and, although they may have had different connotations, a detailed examination of the literature has led me to believe that their denotation was essentially the same: a supernatural power or energy which was possessed by such diverse things as eland, hartebeest, locusts, rain and girls at puberty. This power was also used by medicine men in the curing rituals and was further supposed to enable them to perform out-of-body travel.

This southern San concept of the power used by the medicine men and encountered in certain "strong" things is very similar to that of *n/um* among the !Kung (see Vinnicombe, 1972a, p. 199). According to Marshall (1969, pp. 350-353), *n/um* is a "supernatural potency" used by medicine men in curing. It exists in the medicine songs and plants, but also in a variety of things including eland, the sun, falling stars, rain, bees, honey, blood, giraffes and fires made in certain circumstances. *N/um* can become so strong that it can be highly dangerous; in this condition the !Kung call it a "death thing" or a "fight". Medicine men activate their *n/um* in order to go into trance and to cure; in the process of activation the *n/um* is said to be heated until it boils and appears on the body in the form of sweat.

The southern San medicine men who manipulated the potency which I have been describing are identifiable in the paintings of the dances by a number of distinguishing features; I discuss first the appearance of the medicine men and then the activities which they are depicted as performing. The southern medicine men, like the contemporary !Kung, did not use any elaborate regalia expressly to signify their status. The use of the items I describe was not universal: some of the paintings show a few dancers with a certain item and others without it. As with other areas of San belief and practice there seems to have been a considerable latitude to accommodate personal preferences.

Amongst the garments known to be worn by the southern San in their dances was a type of cap. The two springbok medicine men mentioned by Bleek's informants both wore caps made from the scalp of a springbok and sewn so that the ears stood out. One of these people was a woman named Tãnõ-!khauken who explained that the springbok would follow the cap wherever it went; it thus gave her control over the movements of the game (Bleek, 1935, p. 46; 1936, p. 144). The use of eared caps must have been fairly widespread because Doke (1936, p. 470) describes one worn by a ≠Khomani bride. Such caps with prominent buck ears are frequently depicted in the rock paintings. Sometimes they appear on medicine men who are taking part in a dance as in the scene at Fetcani Bend (Fig. 21A) and sometimes on hunters (Lee and Woodhouse, 1970, Fig. 57) or men engaged in indeterminate activities (Vinnicombe, 1976, Figs 160, 247). The use of caps made from the scalps of gemsbok specifically in medicine dances was described by Diä!kwain. The published version of his remarks (Stow, 1930, caption to plates 13 and 14) seems to have been rephrased by Dorothea Bleek who was apparently under the impression that *//ke:n* denoted a dance rather than, as I have suggested, a supernatural potency; Lloyd's unpublished manuscript version gives a more literal translation: "They wear such caps at the time when they do the *//ke:n's* doings" (L.V.10.4745). The donning of the caps thus seems, in some cases, to have been preparatory to participating in a medicine or curing dance.

Another form of headgear which is associated exclusively with dances comprises one or two long feathers attached to a tightly fitting cap. These feature prominently in the well-known dance scenes at Barnes's Shelter, Giant's Castle (Willcox, 1956, plate 36) and Mpongweni (Willcox, 1963, Fig. 35; Vinnicombe, 1976, Figs 217, 227). It is not known whether these feather head dresses had any significance or were simply decorative, but in some paintings they are worn by figures who are almost certainly in trance.

Another type of decoration that did have special significance is also depicted in the paintings. Dancers are often shown with bands, frequently painted in white, around the biceps, knees and wrists (Figs 18, 19, 20, 21A). Whilst some of these may have been merely decorative others were particularly associated with the medicine dance (L.V.10.4745 rev.). The contemporary !Kung still wear rings of animal skin, but these are not associated specifically with the dance, although they are believed to have *n/um* and to bring good fortune in the hunt by enabling a man to run faster and shoot better.

A feature that is associated only with the dance is the dancing rattle; numerous paintings of dances show men wearing dancing rattles (Figs 19, 20, 21A). Sometimes, in minute and astonishing detail, the paintings show the rattles as being made up of separate torpedo-shaped segments. These are probably the individual springbok ears which the /Xam women dried and filled with small berries to produce the characteristic swishing sound (Burchell, 1822, p. 63; Arbousset, 1846, p. 248; Bleek and Lloyd, 1911, pp. 351-353; Dornan, 1917, p. 44).

Another item that is depicted in many paintings of dances is the dancing stick. Sometimes a man holds one, sometimes two; both uses are shown in the Fetcani Glen painting (Fig. 19). In numerous dance scenes, men using two sticks are shown to be dancing with their torsos in a horizontal position, the sticks being used to maintain balance (e.g. Fig. 20). How (1962, pp. 20, 43), writing of Orpen's Melikane painting (1874), did not associate this posture with dancing; she interpreted the figures as being disguised for hunting and carrying the sticks to simulate the forelegs of an animal. I know of no hunting scene in which sticks are used in this manner; there are, however, sufficient examples of the use of two sticks and this posture in paintings of dances as to leave no doubt that dancing, not hunting, is depicted. The !Kung usually dance with only one stick which they use chiefly to give balance, but informants and Biesele said they knew of people who preferred to dance with two sticks. I could discover no further significance in the sticks or the way in which they are used by the !Kung. A fly-whisk, shown in the southern paintings (Fig. 21A), is another object with which the !Kung consider it merely pleasant to dance.

Although the medicine men are frequently depicted with the visual characteristics which I have so far described, there are other features that are more closely related to their function as medicine men and which I examine in greater detail because they are directly connected with trance performance and the identification of a cryptic set of paintings. Trance, the crucial state to which the medicine man aspires, is the condition in which he is able to benefit the community; the dancing, which I have been describing, leads up to and helps to induce trance. In the state of trance the medicine man performs his curing, exorcising known and unknown ills from all present at the dance; the main purpose of trance is, indeed, to cure.

Amongst the /Xam curing involved the sniffing out of the patient's body of what was harming him, a practice known as *sŭ*; Lloyd, perhaps following Campbell (1815, p. 316), translates *sŭ* as "snoring". After the medicine man had sniffed out the evil, he sneezed out the "harm's things" which were said to resemble arrows,[2] little sticks (a belief still held by the !Kung, Marshall pers. comm.) or various animals; as he did this he suffered a nasal haemorrhage. There are indications that this curing operation was accomplished while the medicine man was in trance (Bleek, 1935, p. 1). Bleek and Lloyd, not having worked in the field with San, quite understandably did not appreciate the nature of trance performance, but the informants' accounts of their medicine men's activities make it clear that /Xam trancing was very similar to that practised today by the !Kung. This is a crucial point to which we must give closer attention.

While the /Xam medicine man was curing he trembled, shivered and experienced a rising sensation. Diä!kwain explained that when a novice was learning to trance he was given the nasal blood of his mentor to smell; this caused his "gorge" to rise (Bleek, 1935, p. 14). The same informant, trying, on another occasion, to convey to Lloyd the sensation of trance, said that it seemed as if the medicine man's "vertebral artery would break", and that when a medicine man was experiencing out-of-body travel his "vertebral artery has risen up" (Bleek, 1935, pp. 22, 23). Lloyd's translation of the word *!khāūä* in these passages as "vertebral artery" is, I believe, an error arising from her lack of familiarity with trance. Used as a verb (as many /Xam nouns can be) the word means "to boil" (Bleek, 1956, p. 425) and was probably the southern San's metaphor to describe the rising sensation experienced in the region of the spine as a man goes into trance. The identical "boiling" metaphor is still used by the !Kung;[3] indeed, the whole /Xam account is remarkably similar to descriptions of trance experience given by !Kung medicine men to Lee and to Katz:

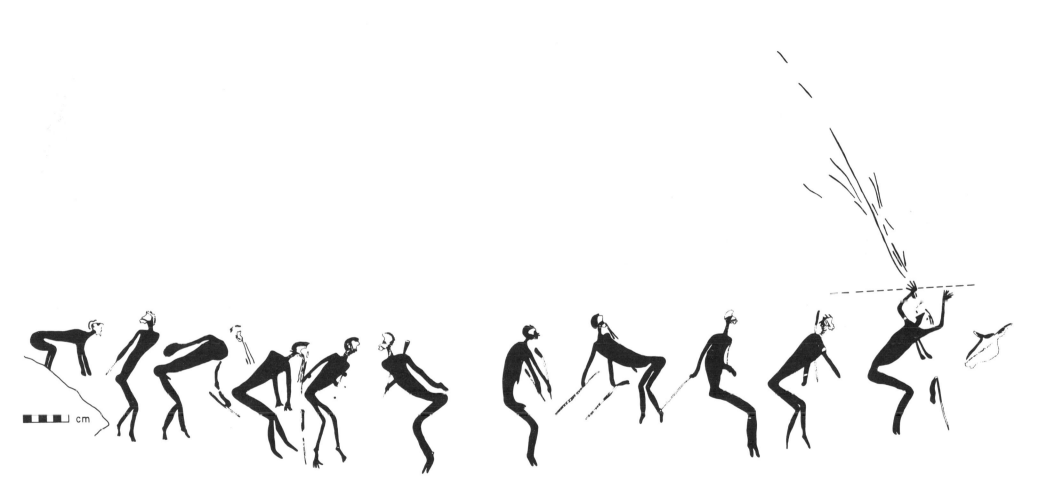

Fig. 19. Fetcani Glen, Barkly East. The broken line marks the angle between the ceiling and the wall of the rock shelter.

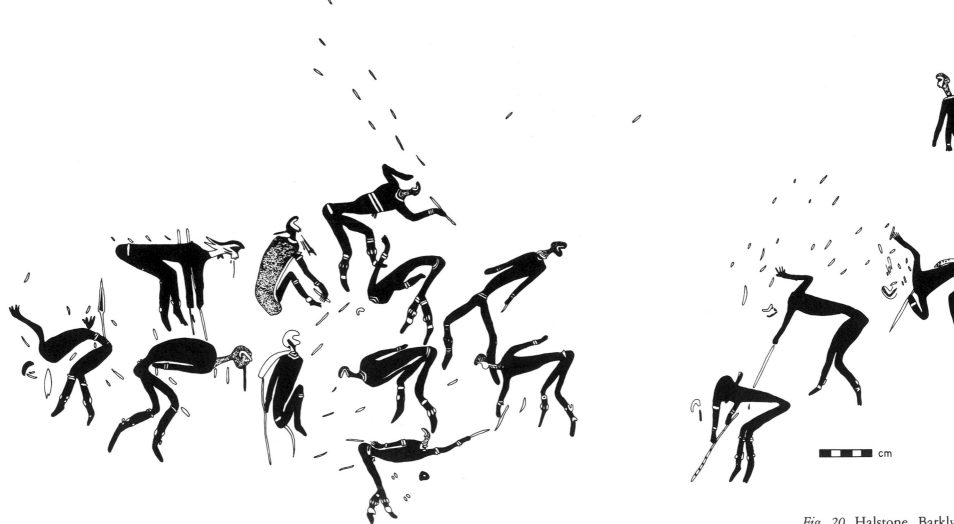

Fig. 20. Halstone, Barkly East.

Bushman medicine is put into the body through the backbone. It boils in my belly and boils up to my head like beer. When the women start singing and I start dancing, at first I feel quite all right. Then in the middle, the medicine begins to rise from my stomach. After that I see all the people like very small birds, the whole place will be spinning around and that is why we run around . . . You feel your blood become very hot just like blood boiling on a fire and then you start healing (Lee, 1967, p. 31).

You dance, dance, dance, dance. New *n/um* lifts you in your belly and lifts you in your back, and then you start to shiver. *N/um* makes you tremble; it's hot (Katz, 1976a, p. 286).

Amongst the southern San the sensation of boiling was accompanied by another important concomitant, nasal haemorrhaging. This is frequently depicted in the paintings and is, in fact, one of the chief diagnostic features of the medicine men. In the Fetcani Glen (Fig. 19) painting, for instance, at least four of the eleven dancing men are bleeding from the nose. In the Halstone group (Fig. 20) three dancing figures and one seated figure are shown with blood issuing from their noses. In the curing ritual the /Xam medicine man took his nasal blood and rubbed it on the patient in the belief that its smell would keep evil things away (Bleek, 1935, pp. 20, 34). Amongst the !Kung Marshall (pers. comm.) heard of only one occasion on which a medicine man suffered a nasal haemorrhage, but Biesele (pers. comm.) found that some !Kung medicine men do use nasal blood when curing a person who is considered to be very sick. In explaining this practice the informants told me that, as with the /Xam (Bleek, 1935, p. 34), it is the smell of the blood that is efficacious.

Both the ethnographic and the painted record suggest that nasal haemorrhaging was an important part of the southern San curing dance. Arbousset (1846, pp. 246-7) described Maluti San dancing and falling into trance "covered with blood, which pours from the nostrils". The same phenomenon was described by Qing (Orpen, 1874, p. 10) who went on to liken the trance experience to death. This metaphor is the same as that of the !Kung who, together with people in other parts of the world (Lewis, 1971, p. 58), also refer to trance in terms of death. The stage of deep trance in which the medicine man lies rigid or trembling, moaning and uttering short shrieks is called *kwe!i*, "like dead". The older, more experienced !Kung medicine men are able to avoid this extreme state by controlling the boiling of their *n/um* (Lee, 1968, p. 40). Qing's description of this "death" state could in large part easily apply to the contemporary !Kung medicine men: "Some fall down; some become as if mad and sick; blood runs from the noses of others whose charms are weak" (Orpen, 1874, p. 10).

The curing technique of the Maluti medicine men, used in this state of trance, was also similar to the !Kung: "When a man is sick, this dance is danced round him, and the dancers put both hands under their arm-pits, and press their hands on him" (Orpen, 1874, p. 10). This, I suggest, is what is depicted in Fig. 18: dancers circle around a hut within which a medicine man rubs sweat on his recumbent patient. The !Kung believe that sweat is the visible expression of the *n/um* on the body (Lee, 1967, p. 33), especially that from the armpit (Marshall, 1962, p. 251). A !Kung medicine man explained to me that, as with the nasal blood, the smell of the sweat keeps the *//gauwasi* away, but the main thing is that the sweat has

healing power in it. This, he said, was true of sweat from the face, head and armpits, not, for instance, from behind the knee. Numerous paintings (e.g. Fig. 21A) show men and sometimes women with lines which might represent sweat issuing from the armpits (see Vinnicombe, 1976, p. 259).

When the *n/um* has boiled to the surface of his body in the form of sweat, a man may succumb to the rising trance and sink to the ground. This is considered by the !Kung to be a dangerous condition: his spirit has left his body and he must be cared for by the other medicine men and the women. This caring is an important element of the dance which has been well illustrated and described by Marshall (1969, pp. 378-379; plates 6-11). The /Xam also cared for a man in trance. The singing of the women was believed to soothe the medicine man and they also rubbed him with fat and gave him buchu to smell (Bleek, 1935, p. 23). The !Kung, too, believe that buchu "cools" or reduces the trance state. In the dance described by Arbousset (1846, p. 247), the women wiped the perspiration off the collapsed dancer and jumped across his recumbent form until he revived. In the Fetcani Bend dance group (Fig. 21A) a man, sagging limply, is approached by another figure who also bleeds from the nose. I compare this representation of caring with a photograph (Fig. 21B) of a !Kung man in trance, kindly supplied by Mrs L. Marshall; the similarities are remarkable.

A painting illustrated by Vinnicombe (1976, Fig. 217) probably shows the same caring situation. In this group a man sags forward, while he is supported from behind by a woman. Another figure appears to hold him from the front while a second clapping woman faces him. The group is entirely consonant with the caring practice which

Fig. 21. A: Fetcani Bend, Barkly East.

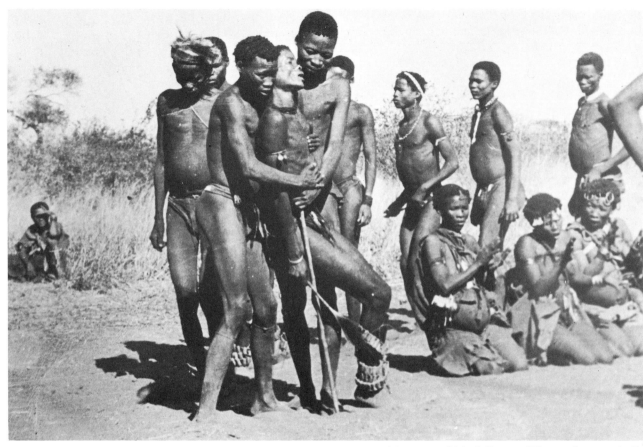

Fig. 21. B: A !Kung medicine man in a trance is supported by two of his fellows. (Photo: L. Marshall)

was an important part of the medicine dance which is evidently taking place in this animated scene.

The caring, trancing and other features of the medicine dance which I have so far described and identified in the paintings constitute only a part of this key San activity. In the San medicine dance there is little manipulation of physical ritual

objects: it is rather concepts that are being manipulated. I argue that, whilst no eland is physically present at the dance, that antelope nevertheless often plays an important part. To clarify the way in which the "eland concept" rather than the "eland antelope" is used in "operations" in the context of the dance I discuss the San notions of "possession" and the medicine song. It is the

beliefs concerning these two related ideas which, together with the trance experience that I have already described, provide the basis for a discussion of what has become probably the most controversial type of rock painting.

In terms of the /Xam notion of "possession" a medicine man was said to "possess" or "own" one or more specific creatures. The game medicine

men were differentiated according to the creature they were believed to possess; a man who, for instance, was thought to possess springbok was called *wai-ta !gi:xa*, "medicine man of springbok". Possession was, however, not necessarily limited to one item. /Kannu, a medicine man, was said by /Han≠kassō to possess both locusts and rain (Bleek, 1933, p. 388).

Related to the concept of possession of animals by medicine men is the medicine song. The song of the Maluti trance dance had been given to the people, Qing claimed, by /Kaggen himself. The importance thus attached to the song is reminiscent of the !Kung medicine songs which are thought to have been given by ≠Gao N!a, the great god, and to have been endowed by him with the *n/um* which the medicine men use in their curing. The !Kung medicine songs are named after a variety of "strong" things, not necessarily all animals; there are, for instance, the important eland song, the gemsbok song and the iron song. I learned that a particular song enjoys great popularity for a while and is then superseded by another. Nevertheless, there is one song that retains its popularity unaffected by the vogue of the time: this is the eland song, which, because of its special associations, I discuss in more detail below.[4]

A !Kung medicine man will consider himself to possess one or possibly two of these medicine songs rather in the way that the /Xam considered their medicine men to possess certain things. In speaking of these songs, the !Kung say that a man has eland medicine or giraffe medicine as the case may be. The nature of the relationship between the animal named and the *n/um* manipulated by the medicine man is elusive but important to an

understanding of some paintings. Marshall (1969, p. 369) was unable to clarify this relationship; the !Kung simply said both were "strong". Similarly she could not find out anything about the relationship between the *n/um* of the songs and the *n/um* of the animals and things of the same name.

In attempting to learn more about these problems in the hope that I should obtain some insight into the /Xam notion of the possession of animals, I found that the idea of control, which seems to have been prominent in the /Xam concept of possession, is not entirely absent from the !Kung beliefs. When a man with eland medicine dances and cures, the eland are supposedly attracted and stand out in the darkness beyond the light of the camp fire, as the eland is said to be attracted by the Eland Bull dance at the girls' puberty rituals. Whilst the point cannot be demonstrated beyond question, it is, therefore, of interest to note that eland have been painted in close juxtaposition to both the Fulton's Rock puberty scene (Fig. 10) and the Lonyana curing ritual (Fig. 18). Similarly, a !Kung woman who possesses elephant medicine told Biesele (pers. comm.) that elephants come when they dance elephant medicine, and that one night an elephant came so close that she stood right before it and was even cradled in its tusks.

The relationship between the medicine man and the thing possessed does not admit of a simple explanation, but I would, nevertheless, like to make a few observations. Among both the !Kung and the /Xam the thing possessed seems to be the medium through which the medicine man receives his unique power and experience. Trance performance facilitates contact between the terrestrial

world and the spirit world; one conductor of power from the spirit world to the mundane is the animal possessed by the medicine man and celebrated in the medicine song which is his peculiar forte. Trance makes this relationship particularly real and visual, for the !Kung medicine men say that in trance they "see" the animal that is linking them to the supernatural power over which they exercise control. Trance thus enables them to see what they believe. Whether this is also true of medicine men who possess, say, sun medicine, I was not able to ascertain, but in the case of animals the trance experience has the effect, it seems, of rendering in visual terms the "conductor" of supernatural potency.

Something of the possession relationship and the effects of trance vision may be represented in certain paintings. A painting[5] in the Ncibidwane Valley depicts what appears to be a dancing man followed by an eland standing on its hindlegs (Fig. 22). The man's head and neck, white like the eland's, taper into an extended white line. The eland, which does not appear to have front legs, is painted with horns that similarly trail off into long white streamers comparable with those I discuss below. This otherwise puzzling painting represents in a remarkable way, I suggest, the close relationship between the dancing man and his source of power, the eland. The eland is a graphic metaphor of the man.

Another painting which may depict the same relationship is at Fetcani Glen (Fig. 19). It shows a line of dancing men, most of whom carry sticks and four of whom bleed from the nose. The figure on the extreme right faces a carefully painted eland head; this figure's fingers extend onto the ceiling of the shelter and red lines appear to issue from

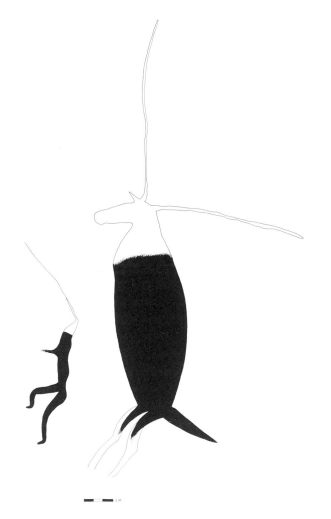

Fig. 22. Upper Ncibidwane I, Giant's Castle.

them. The painting may represent a dance being performed after an eland-kill and the head, in this view, may be a literal depiction, but it is also possible that it represents the potency possessed by one or more of the dancers.

The same possession relationship might also be depicted in the figure on the extreme left of the Burley II dance scene (Fig. 23). This figure has a clear eland head and horns; his hoofs, we may infer, are also eland hoofs like those of the men in Fig. 15 (see Chapter Five). The connection between eland and dancing is further suggested by the two eland superimposed on the Burley II group. It is not impossible that we have depicted here another dance involving the use of potency related to eland; the therianthropic figure may represent a medicine man who possessed eland power. This figure's connection with medicine men is further suggested by the line which extends from its nose and which probably represents the nasal blood of trance performance. The eland was, as we have seen, considered by the southern San to be the supreme antelope, /Kaggen's favourite, and was explicitly said to possess supernatural power. It is likely, therefore, that possession of eland would have been considered especially efficacious in the curing dance.

Be this as it may, there is a further iconographic feature that links medicine men and eland. In 1969 and 1971 Woodhouse drew attention to the presence in the rock paintings of strange relationships between men and eland. These paintings include depictions of men touching the nose of an eland, grasping an eland's tail, adopting a kneeling posture close to the head of an eland, jumping over the back of an eland and groups of men in a kneeling posture surrounding a herd of eland. In the earlier of the two papers Woodhouse suggested that some of these paintings might depict a relationship that "had developed somewhat beyond a strictly utilitarian hunting situation into a sporting and ceremonial approach

similar to bullfighting and bull-jumping in the Mediterranean area" (Woodhouse, 1969, p. 65). In the second paper Woodhouse presented further evidence from the paintings to confirm his earlier interpretation. He added that the postulated "sport" of eland-jumping might have been performed when the eland was "stupefied by a poisoned arrow" (Woodhouse, 1971a, p. 346).

Woodhouse (1971b, p. 128) has also described the kneeling posture seen in certain representations: "The subject is a human figure, frequently wearing an animal-head mask, painted in a kneeling position with buttocks resting on heels, body bent forward and with arms usually stretched straight back and fingers spread out. Sometimes there is a group of such figures. In other cases there is a single figure only". Figure 24 shows such a kneeling figure from Giant's Castle. In his discussion of the examples described and illustrated in this paper Woodhouse (1971b, p. 131) proposes that those with animal heads are wearing masks and that the stylized attitude was adopted in hunting, either to camouflage the human form or in a ritual hunt akin to bullfighting, an idea he had first suggested some years earlier (Woodhouse, 1964, p. 303). There is, however, little evidence for this interpretation in the ethnographic record.[6] More interestingly, Woodhouse recognizes that there is "a very fine dividing line" between figures in the kneeling posture and the paintings that are generally referred to as "flying buck"; I discuss both types of painting below.

This is not the first time that the "bullfighting" theory has been proposed in an interpretation of rock art: Ortego (1956) had drawn parallels between examples of Spanish cave art and bull-jumping in Minoan Crete. In an attempt to

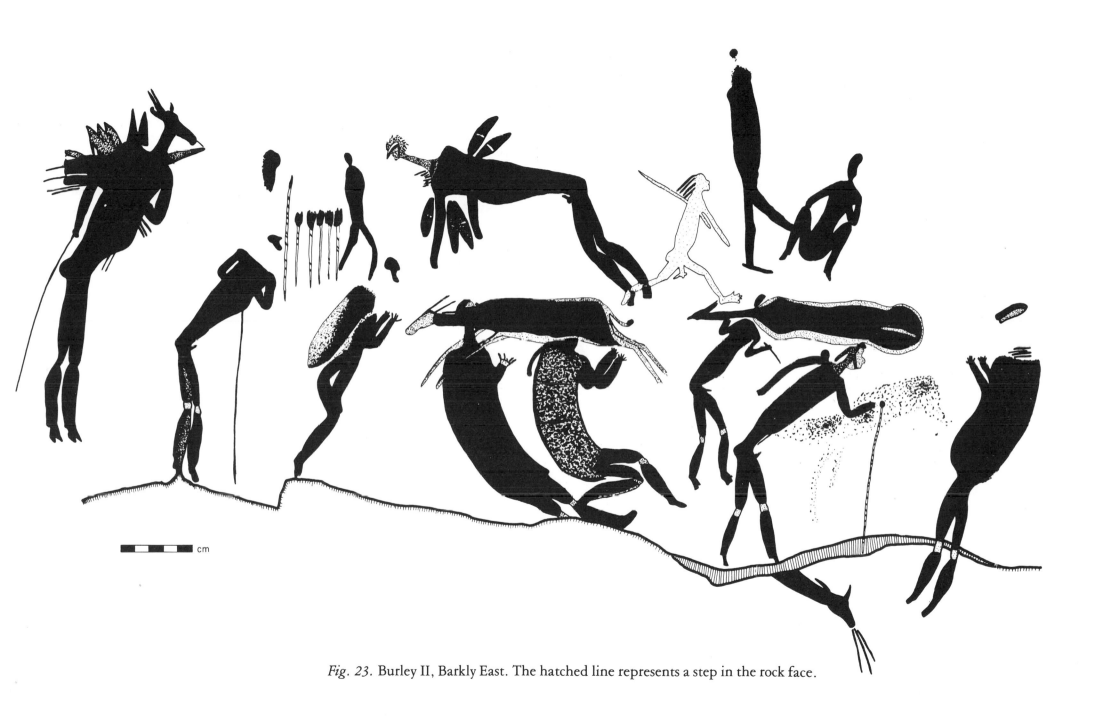

Fig. 23. Burley II, Barkly East. The hatched line represents a step in the rock face.

Fig. 24. Barnes's Shelter, Giant's Castle.

explore the feasibility of this interpretation for some of the eland paintings, I discussed the topic with !Kung informants. They ridiculed the notion entirely: "It would get you with its horns," they said. "Nobody would be foolish enough to do anything so dangerous." To probe the matter further I (somewhat mendaciously) told them that certain San, away to the south, had told me that they did this. The suggestion was still greeted with scepticism; a wounded eland, or one that is succumbing to the effects of poison, was to be treated, they said, with the utmost caution: it could easily toss an unwary hunter. It would be more consistent with their view, then, to see paintings that have been interpreted as men leaping over eland (Woodhouse, 1969, Figs 1 and 2) as simply showing what happens to men who foolishly go too close to a wounded eland. Alternatively, they may be interpreted in terms of yet other concepts related to those which I have been developing in this chapter.

Featuring prominently among the range of representations described by Woodhouse are the so-called "flying buck". This type of painting was apparently first noted by Moszeik (1910, pp.

57-58) in the eastern Cape and later by Mason (1933, p. 133) in the Cathkin Peak area of the Natal Drakensberg. In his account of the paintings in Eland Shelter, Mason described and illustrated what he called "winged-antelopes" (Fig. 25). Mason's report has perhaps invested these paintings with more of the numinous than they deserve. Certainly, his impression of them as "winged" has persisted; but these paintings did not receive close consideration until 1964 when attention was again drawn to them by Lee and Woodhouse who had,

in turn, been directed to them by Vinnicombe.

Many, though by no means all, of the flying buck (as I shall, for the present, continue to call them) have a number of characteristic features, prominent among which are the long penniform "streamers" which extend from the upper back or nape of the neck. Frequently the "buck" have no legs, but in some representations the legs appear to be drawn up beneath them like the kneeling human figures I have already described. Another feature is the curious appendages which hang from

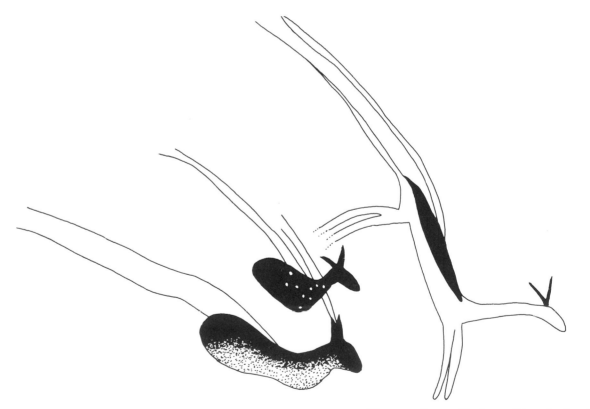

Fig. 25. Camp Shelter, Giant's Castle.

the chests of many examples. Pager (1971, p. 343), acknowledging a wide range of forms within this category, has proposed the following composite definition of flying buck, or *ales*, as he prefers to call them: "A human or anthropomorph having wings or holding arms in a wing-like posture; an antelope with pterygoid extremities or streamers; a zoomorphic creature with bird-like body and pterygoid extremities and/or bird-like tail." The Latin word, *ales*, which he presumably chose to emphasize a common element, means, as an adjective, "winged"; as a noun it means "a fowl, a bird (only of large birds, while *volucris* includes also insects that fly)" (Lewis and Short, 1958, p. 82).

This assumption (shared by all commentators since Mason) that flying buck are indeed flying deserves closer examination. It is chiefly the trailing streamers or "wings" that give this impression, which may, however, be simply the result of a western convention: in cartoon drawings speed and flight are often suggested by a similar technique. In some paintings, it is true, the flying buck does appear, *in terms of our ideas of perspective*, to be in flight. Pager (1971, Fig. 379) illustrates a case from Procession Shelter, Cathkin Peak, in which a legless flying buck appears to be "hovering above a row of 'antelope men'". If, however, the flying buck in this scene had legs or even vestigial heels, as many do, the impression of flight would have been largely destroyed. In his collation of 45 flying buck from various shelters Pager (1971, Fig. 381) illustrates examples similar to the Procession Shelter one, but with legs. We must conclude that, in spite of the streamers, there is no firm evidence that all of these representations are supposed to be flying. However, a few of

them, especially those which appear to have feathers on their arms, do give the impression of flight quite strongly and may depict the sensation of flight which is often said to be part of trance experience. Nevertheless I am inclined to believe that this aspect has been over-emphasized. Similarly, I am unconvinced by the evidence offered to support what has come to be the favoured explanation for what these supposedly flying creatures are intended to signify.

Proceeding from the assumption that flying buck are indeed flying, Lee and Woodhouse cite Schapera's (1930, p. 178) reference to a paraphrased statement by one of Bleek's informants. The full, unpublished note reads: "We who are Bushmen, were once springbucks, and the Mantis shot us, and we really cried (like a little child). Then the Mantis said, we should become a person, become people because we really cried" (L.VIII. 4.6365 rev.) Lee and Woodhouse couple this statement that the San were formerly springbok with another reference by Schapera to Trenk's report (1910, p. 168) that the Namib San believed the spirits of the dead flew about in the air and showed themselves to children "in ghost-like animal forms of oxen, horses or gemsbok" (Schapera, 1930, p. 168). Lee and Woodhouse (1964, p. 73) conclude from these two disparate references that the paintings portray "spiritual or religious beliefs, that the human spirit takes the form of a 'flying buck' on leaving the body". In their second paper on this topic the same writers provide further examples of flying buck, but understandably despair of any explanation beyond the notion that the paintings have "some underlying religious meaning" (Lee and Woodhouse, 1968, p. 16). They follow this remark by referring

to a novel by the Hobsons (1944) in which an old Kalahari San tells his grandson that the spirit of a man houses itself in the body of an animal as it goes to the "eternal Bokveld". These references are the sole and rather friable foundation for the view that these paintings depict airborne spirits of the dead. Yet subsequent discussions have tended to accept the argument.

One of these discussions is by Vinnicombe (1976, p. 239) who has also noted the frequent association of flying buck with eland. In further support of the view that the flying buck represent spirits of the dead, she argues first that the /Xam associated spirits with the wind. To establish this connection she cites references which she has used elsewhere (Vinnicombe, 1972a, p. 200; 1976, p. 334)—in my view more correctly—to demonstrate the presence in /Xam thought of a concept similar to the !Kung beliefs concerning *n!ow*. *N!ow* is possessed by men and certain animals; when a man kills an animal his *n!ow* interacts with that of the animal to effect a change in the weather (Marshall, 1957). In neither the !Kung nor the /Xam beliefs, however, is there any suggestion that the wind or the *n!ow* possessed by a man is the same thing as his spirit, although the !Kung do associate the //gauwasi with whirlwinds (Thomas, 1969, p. 69).

Having postulated an association between spirits and the wind, Vinnicombe goes on to demonstrate, more correctly, that the wind was sometimes spoken of as a bird. She then concludes her discussion of these representations by suggesting that

In the thought processes of man in general, not only of the Bushmen in particular, birds occupy an inter-

mediary position between the supreme spirit (sky) and human beings (earth). That winged creatures should be used as a symbol of mediation between life and death, between the physical and the spiritual, would seem to be an inherent tendency of the human mind (Vinnicombe, 1976, p. 242).

The attractive explanation of flying buck offered by Vinnicombe, by Lee and Woodhouse and also by Pager (1975b) seems to me to be insufficiently tied to the ethnography. In the first place, /Han≠kassō said that the /Xam were springbok *before* they were people, not—a quite different proposition—that they became springbok *after* death. On the contrary, there is no indication that the /Xam entertained this belief. Diä!kwain's account of two apparitions indicates that the dead were thought to appear in human, not zoomorphic, form (Bleek and Lloyd, 1911, pp. 365-371). //Kábbo explained that when a man dies his heart falls from the throat to the middle of the body where it remains (L.II.12.1124); he then goes on a journey to a vast hole in the ground (L.II.6.670 rev.). ≠Kāssin claimed: "At death we are finished, our thoughts ascending, leave us, while our bodies . . . are in the earth" (L.IV.1.3445). A still fuller account of /Xam ideas of life after death was given by /Han≠kassō:

All people become spirit when they die. My grandfather used to say, spirit people. He said, Ye have uttered for us the old people's names, as if the old people were not dead people, and they come to harm us on account of it, because, they do not possess their thinking strings [//khu//khuken. 8310 rev.: with which they understood]. Therefore they are wanting to come to harm us, if we utter their name by night (L.VIII. 26.8310-8312).

Diä!kwain expressed a similar idea when he said of the dead that "the angry people . . . took a person away" (Bleek and Lloyd, 1911, p. 367). These statements by /Xam informants suggest concepts very similar to !Kung notions of the //gauwasi, the pathogenic spirits of the dead whose malign influences are combated in the curing dances. In neither /Xam nor !Kung thought does there appear to be any suggestion that the spirits of the dead were thought of in zoomorphic terms; my questioning of the !Kung certainly provided no support for the belief. The /Xam, furthermore, thought of death as darkness, not life and pleasure; there is no confirmation of the romantic notion of an "eternal Bokveld". There is, on the other hand, strong evidence both in the paintings themselves and in the ethnography for a quite different explanation. It is to a discussion of this alternative explanation that I now turn.

I wish first to draw attention to some of the postures depicted in the paintings of dances. I have alluded to the bending forward position: sometimes dancers in this position are supporting their bodies by means of sticks; frequently they are bleeding from the nose in trance performance. An examination of the Halstone scene (Fig. 20) shows that some men in this bending forward posture have their arms stretched backwards either parallel to their bodies or behind the line of the back and they also bleed from the nose (see also Vinnicombe, 1976, Figs 224, 217 for men in the arms-back position). Sometimes men with their arms in this position are shown as having fallen to their knees; these figures, too, frequently bleed from the nose (Fig. 24). These features, as I have shown, are all intimately connected with trance performance. Marshall (1969, pp. 363-364) has,

in fact, described this position in the curing dance of the !Kung: "Some when they are dancing very ardently bend forward until their torsos are at right angles to their thighs . . . At moments of highest intensity all the men would be stamping loudly and some young, very vigorous dancers would be bent over in the right-angle position."

In discussions with !Kung informants I learned further that this "right-angle position", an explanation of which is crucial to an understanding of the paintings of flying buck, was recognized by them as one frequently adopted by dancing medicine men. In response to a question about the position, Kaishe rose to demonstrate and, unprompted by any suggestion or further question of mine, placed his arms in the backward position exactly as depicted in the paintings of dancers and flying buck. This, he said, is the position adopted "when n/um is going into your body, when you are asking God for n/um". The position is important but not sustained. He went on to speak of a trance dancer named Sao, living at /Ai/ai, who, it seems, speaks frequently of the n/um entering his body while he is in the arms-back, bending forward posture.

This, I suggest, is the explanation for this widely noted position in the paintings of dancers: it is the climactic moment when the medicine man achieves the contact with supernatural power for which he has been striving. When a man achieves this state and enters deep trance, he sometimes falls to his knees in the position frequently associated in the paintings with the arms-back posture. The extension of the arms is, then, a stylised dancing posture and is not necessarily indicative of flight as has been supposed. Some men enter deep trance so violently that they execute a complete

somersault (Marshall, 1969, p. 376; Lee, 1968, p. 40); a highly decorated figure in the arms-back posture and apparently somersaulting has been painted at Leeuwkraal, Dordrecht (Lee and Woodhouse, 1970, Fig. 49; Rudner, 1970, plate 52; see also Vinnicombe, 1976, Fig. 218).

In other paintings of dances a further significant element makes its appearance. Mainly human figures are shown dancing or kneeling in the arms-back position and bleeding from the nose, but they also have theriomorphic features, either the heads or hoofs of antelope. This is clearly seen in a group at Fouriesburg which has been illustrated by Lee and Woodhouse (1970, Fig. D27). Two such figures are shown in the bending forward, arms-back position while a third kneels, but unlike the bending forward, arms-back figures I have discussed so far, all three are depicted with clear antelope heads. The species of antelope intended is not easy to determine; it is possibly eland. Even clearer representations of bending forward dancers with eland heads are in the Melikane dance scene copied by Orpen. The Orpen copy is not very accurate, but shows that the figures had clear, black horns at that time. Vinnicombe's (1976, Fig. 223) recent copy shows that only two of the men are wearing karosses and not three as Orpen shows. Antelope, particularly eland, make their appearance in dance scenes in other ways. In the Burley II painting (Fig. 23) women (?) clap while a central man dances in the bending forward position. To the left stands the therianthropic figure with eland head and antelope, probably eland, hoofs; he appears to be bleeding from the nose (as is the highly curious buck-headed serpent which protrudes from a natural step in the rock face). In other paintings arms-back figures are associated

with eland: Woodhouse (1971b, p. 131, Fig. 1) has shown these figures facing and apparently surrounding eland, for, as he says, "sport without the intention of making a kill".

What all these paintings show, in my view, are men in trance and associated with antelope, particularly eland, pointing to a conceptual relationship between medicine men and antelope.[7] This

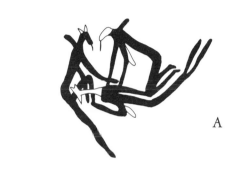

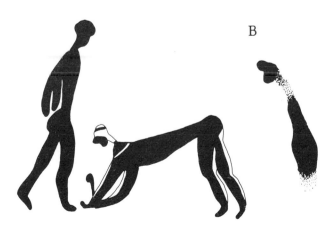

Fig. 26. A: Advance Post, Lesotho (after Walton). B: The Krantzes, Kamberg.

relationship may, I believe, be an expression of the concept of animal possession which, I have shown, is an integral feature of the curing dance; it is possible that as a medicine man went into trance his being was thought to become fused with that of the animal he possessed and that this is reflected in the conflated therianthropic figures shown in the position which the !Kung say is adopted by medicine men when they are receiving *n/um*. Some therianthropes are dancing; others are in the kneeling posture that has led them to be called flying buck.

This view permits the reinterpretation of numerous hitherto enigmatic paintings; I refer briefly to three. The first, Fig. 26A, has been interpreted, together with other similar paintings, as mourning for the dead (Frobenius, 1973, pp. 102-103); Walton (1957, p. 279, plate IV), on the other hand, sees it as a ritual murder: "a medicine-man with the murderer, preparing to remove or removing blood and probably flesh, from the victim". A less macabre interpretation is that two therianthropic medicine men, bleeding from the nose, are caring for a third who lies supine in trance. Of another painting (Fig. 26B) Willcox (1973, plate 63) has written: "One little red figure makes obeisance while a third looks on." But this, too, appears to be a trance group: one man stands (or dances) with his arms in the backward position; another falls to the ground in trance. A third painting, illustrated by Vinnicombe (1976, Fig. 100), shows a therianthropic figure in the arms-back position standing near an eland; she suggests that this figure may represent a "protecting spirit". I believe it is yet another association of a trance figure with eland. This repeated association calls for further comment.

Fig. 27. Martinsdale, Barkly East. The light grey colour of three of the eland suggests their advanced age.

cm

A particular feature of eland behaviour might have been a reason for the !Kung and /Xam beliefs which link this antelope with trance performance. When an eland is pursued, it sweats more than any animal; this sweat, like the sweat of a medicine man, is considered by the !Kung to contain very powerful *n/um*. Brought to bay and near death, the eland trembles and shivers, its nostrils are wide open, it has difficulty in breathing and its hair stands on end (Metzger, 1950, p. 57). As it dies ''melted fat, as it were, together with blood'' gushes from its nostrils (Sparrman, 1789, II, p. 153).

The San artists' awareness of these behavioural characteristics is demonstrated by numerous paintings of dying eland. A particularly well-preserved one (Fig. 27) shows a wounded and bleeding eland being separated from a herd by spear-carrying men and dogs: it stumbles, its head is lowered, it bleeds from the nose and has hairs standing on end. Other paintings of dying eland have been depicted with very exaggerated erect hairs; these have, understandably enough, been mistaken for ''mythical'' creatures and dubbed ''bristle bulls'' (Pager, 1971, p. 339; Figs 185, 276).

The similarity between the death throes of eland and the throes of a man entering the ''death'' of trance are numerous and it is possible that the southern San perceived the analogy and consciously associated trance with the death of eland.

Impressive confirmation of this suggestion comes from a painting at Game Pass, Kamberg (Fig. 28), which has been published by Willcox and by Lee and Woodhouse. Willcox (1973, Fig. 44) believes the figures to be ''humorously drawn'' and that the central figure ''appears to be bowing to the one on the right''. Lee and Woodhouse (1970, p. 44, Fig. 51) have interpreted the scene in terms of their ''eland-fighting'' theory; they also believe the figure on the extreme right to be wearing ''a tightly-fitting skin suit''.

Certain significant features suggest that the real meaning of the painting is to be sought elsewhere. The staggering eland with lowered head has been painted with exaggerated hairs standing on end along its neck, hump, dewlap and rump. Holding the tail of the eland is a therianthropic figure which, like the one on the extreme right, is of the ''split-body'' variety (Vinnicombe, 1976, pp. 234-235). This figure has its legs crossed in imitation of the dying eland and has some hair standing on end. Immediately to the right a figure bends forward in imitation of the eland's lowered head and its arms are in the posture which I have shown is indicative of trance; a short kaross hangs down in front of it. Futher to the right is a second ''split-body'' therianthropic figure which, like the eland, has hairs standing on end over much of its body and limbs; this figure's curious head, hoofs, tail and white chest and stomach further reflect an affinity with the eland. This, I suggest, is the explanation of the ''split-body'' figures: the distinctive feature has been created by the painters' attempt to depict the white belly of the eland on human figures viewed from the front. Where the fugitive white paint has faded (or, perhaps, not been added) a ''split-body'' effect has resulted.

The whole Game Pass group clearly shows that the San discerned the parallel between eland *in extremis* and trance performance. The dying eland became a powerful metaphor of the trancing medicine man, and the paintings show in a remarkable way the interaction between the two elements of the metaphor: the ambivalent medicine man, hovering between this world and the beyond, is given form and value by metaphorical interaction; his experience is graphically and evocatively represented (Fernandez, 1974; Black, 1962, pp. 25-47). As he exploits the eland's power he interacts with it so that he shares some of its characteristics, and it, in turn, becomes a highly charged symbol of the climactic moment in the San's most important religious ritual. The metaphor informs and transforms.

The erect hair which plays such a significant role in the depiction of this metaphor can be seen on many therianthropes (e.g. Pager, 1971, Figs 379, 380); the same feature is, in a Barkly East painting associated with a kneeling figure which bleeds profusely from the nose (Fig. 29A). Another figure, also from Barkly East (Fig. 29B), shows a different combination of trance characteristics: it bleeds from the nose, has what are probably intended to represent hoofs and, in addition, has white hairs standing on end; it is also painted next to an upside down, dead eland which is not shown in this copy.[8] Similar paintings have been classified by Pager (1971, p. 340) as ''antelope men'' and, together with flying buck, interpreted by him as ''spirits of the dead''. These figures have antelope heads or hoofs or both; some bleed from the nose and some are hirsute. Many wear long karosses[9] and have pronounced shoulders reminiscent of an eland's hump; they are frequently painted in long, imposing processions. A painting at Kamberg (Fig. 30) shows a relationship between the so-called ''antelope men'' and the long kaross clad figures: both the ''antelope man'' on the left and the long kaross clad figures in this painting are

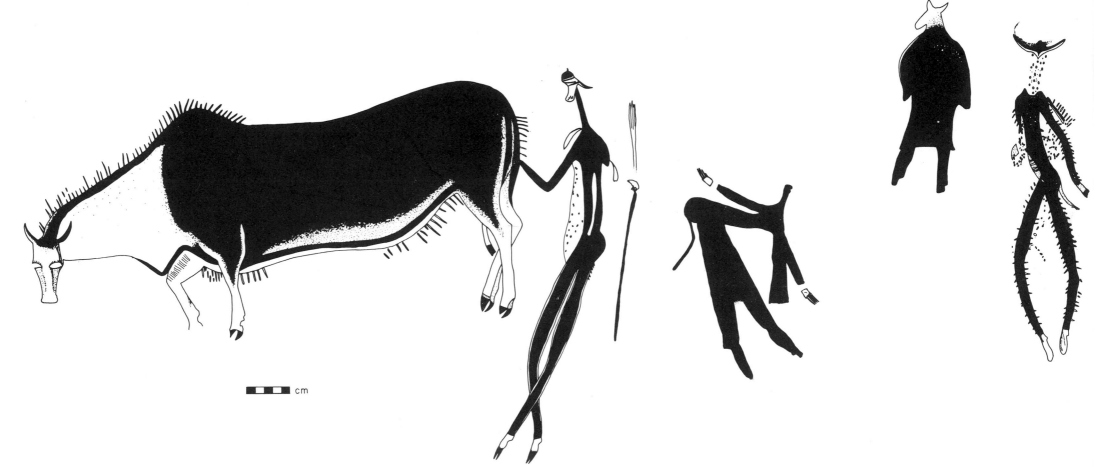

Fig. 28. Game Pass, Kamberg.

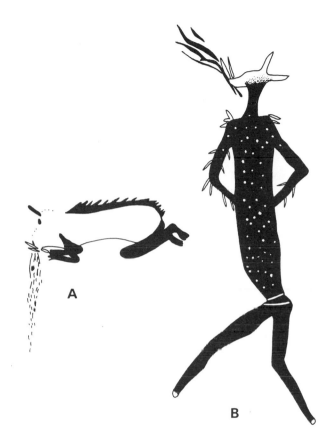

Fig. 29. A: Burley I, Barkly East. B: Halstone, Barkly East.

depicted with hoofs and hairy legs. The figure on the extreme right holds at least two fly-switches and appears to have its arms in the backward position, although the "twisted perspective" employed by the painter tends to obscure this feature.

If the widely distributed painted characteristic of hair standing on end is intended to signify proximity to death, as I believe it is, the Game Pass panel (Fig. 28) provides a clear link between the death of eland and the "death" of trancing medicine men, an association which is perhaps implied by other paintings of therianthropes in which an eland is not actually depicted.

The cumulative effect of all this ethnographic and pictorial evidence is, therefore, that the paintings of dancing and kneeling men in the arms-back position and the so-called "antelope men" all depict trance performers and, secondly, that the eland frequently associated with them by either juxtapositioning or conflation are connected with the source of the power they manipulate in trance. On these assumptions, I now take the argument a stage further and reconsider the representations of fully-fledged "flying buck" which are often painted in isolation. Pager (1971, Fig. 381) has provided a convenient collation of 45 examples which form a continuum between men in the arms-back position and fully developed flying buck. I shall make a few observations on these representations.

At least one quite clearly represents an "eland flying buck", but the species of most is obscure. The "eland flying buck" comes from a group which also includes three (plus the remains of a fourth) therianthropic figures in the kneeling, arms-back position (Pager, 1975a, p. 23). At least four of Pager's 45 flying buck are bleeding from the nose in the manner associated with trance performance and ten are hirsute. In some cases the characteristic "streamers" seem to be metamorphosed arms, but in others they appear in addition to arms. These "streamers", I suggest, do

not necessarily represent flight, as has been supposed, but rather the supernatural potency entering the body of the medicine man; they are not trailing, as the flight interpretation implies, but entering into the body at the upper part of the spine or back of the neck. This is, in fact, the place into which, according to !Kung informants, the *n/um* is put; it is also the area of the body associated with /Xam trance performance—the "vertebral artery" (see above). Knowing that the !Kung also believe that medicine men eject through the neck the evil they have drawn out of the bodies of those they are curing (Marshall, 1969, p. 370), I enquired whether this ejection was accomplished in an arms-back position. The informants denied this possibility.

Although the !Kung informants denied that evil would be expelled while the medicine man was in an arms-back position, the question deserves closer attention. The !Kung call the area of the back of the neck the *n//au*; this is the place explicitly designated to be the spot at which sickness is expelled from the body of a medicine man. If a person with a "bad *n//au*" (*n//au /"xau*) were to be bitten by a lion it would be precisely on this spot. Special feelings are also attributed to this spot: it tingles if a person with whom one has an avoidance relationship sits behind one (Biesele, 1975, I, p. 188). A similar belief was entertained by the /Xam who believed there to be a "hole" in the nape of the neck (Bleek and Lloyd, 1911, p. 357). In an account of an all-night dance, /Han≠kassō told Lloyd that at dawn the sun shone "upon the backs of their heads (literally, upon the 'holes above the nape of their necks')" (Bleek and Lloyd, 1911, pp. 355-357). This is of particular interest because the !Kung believe dawn to be a

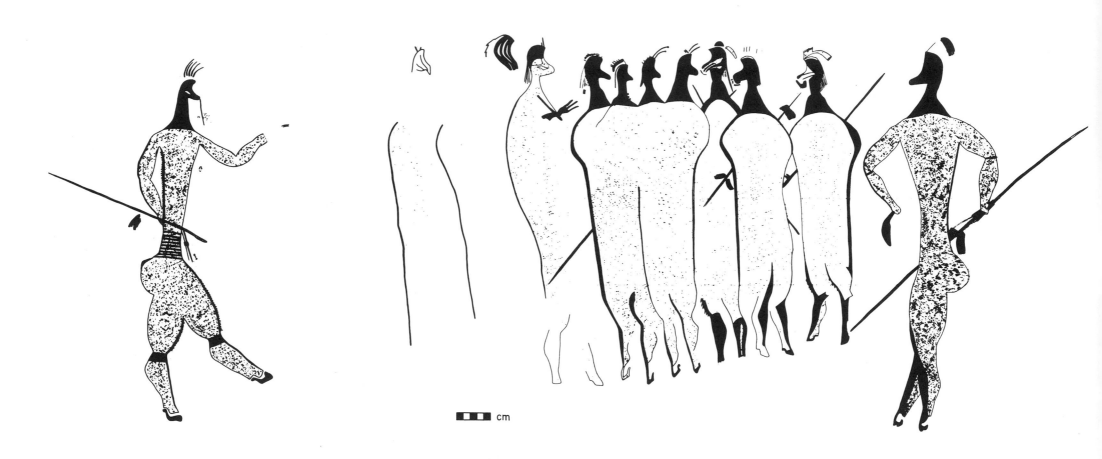

Fig. 30. Cleopatra, Kamberg.

time of especially strong *n/um* which is associated with the rising sun. At this time the dancing is very vigorous. In a different context, Diä!kwain reported that, when his first wife had been very ill, she complained that it felt as if something were sticking in her "neck hollow" (Bleek, 1932, p. 246). When the woman who was carried off by !Khwa (the Rain) wished to calm !Khwa, it was on this part of his neck that she rubbed buchu (Bleek and Lloyd, 1911, p. 197). Furthermore, as with the !Kung, the /Xam, it seems, also considered this part of the body to be sensitive to the presence of others: "When a woman who had gone away is returning to the house, the man who is sitting there feels on his shoulders the thong with which the woman's child is slung over her shoulders; he feels the sensation there" (Bleek and Lloyd, 1911, p. 333). There does, therefore, appear to be some evidence that !Kung beliefs concerning the *n//au* spot were present among the /Xam. Although there is nothing to suggest that the /Xam medicine men expelled the sickness through this spot, the possibility that the streamers which emanate from this region of the backs of flying buck represent expelled sickness cannot be entirely discounted.

In addition to the streamers we have been examining, lines are sometimes shown emanating from the top of the head of both flying buck and kneeling, arms-back figures; these lines are often depicted together with the streamers from the back of the shoulders. An explanation of this further feature of flying buck may also be found in trance performance. When a !Kung man enters trance, he is supposed to experience out-of-body travel. Biesele (1979) obtained a long account of this experience from an old, blind !Kung medicine

man. When the spirit leaves the man's body, it does so through the head and goes to do battle with //Gauwa and the //gauwasi who are believed to bring sickness (Marshall, 1969, pp. 377-378). Some curers claim to be able to see at a distance while in trance and describe distant scenes (Lee, 1968, p. 45). The /Xam also believed in out-of-body travel, accomplished during sleep, in the form of an animal or bird. These abilities varied from place to place. Diä!kwain said that the medicine men near //Kábbo's home could change themselves into birds, and, when they wanted to kill people, into jackals (L.V.8.4701 rev.; Bleek, 1935, pp. 15, 18); in this way they were able to tell what was happening at distant encampments. The medicine woman Tãnõ-!khauken was able to perform this feat apparently without turning herself into an animal (Bleek, 1936, pp. 142-143). The /Xam called such out-of-body travel /xãũ, a word which Bleek translates as "magic expedition" (Bleek, 1935, pp. 23, 31; 1936, p. 132). Although the /Xam record does not speak specifically of this being done while the medicine man was in trance, we must acknowledge the distinct possibility of some so-called flying buck representing medicine men experiencing out-of-body travel and the lines emanating from the top of the head being the spirit leaving the body.

This new understanding of lines from the head, erect hair, antelope heads and other frequently repeated features enables us to interpret many paintings without recourse to fanciful concepts for which there is no support in the San ethnography. One such painting is the well-known group at Balloch, Barkly East (Fig. 31; also Battis, 1948, p. 165; Lee and Woodhouse, 1964, Fig. 4; 1970, Fig. 202). Indeed, this painting was crucial to the

formulation of the theory that flying buck are spirits of the dead (Woodhouse, 1971c, p. 110), and its reinterpretation is a test of the ideas outlined in this chapter. A lion, complete with fearsome claws and teeth, appears to pursue running men; above the men are numerous flying buck. Writers have seen this animated group as depicting misfortune or near misfortune on the hunting-ground: men fleeing from an enraged lion have their zoomorphic spirits hovering above them prior to their imminent demise.

This popular and dramatic explanation of the painting does not, however, allow for the metaphors I have been considering or for certain features of the painting itself. Close inspection shows that some of the men as well as some of the flying buck are bleeding from the nose; a number kneel and have their arms in the significant backward posture. Moreover, some of the running men have antelope hoofs, and most of them and the flying buck are covered with finely drawn white hairs which have been mistaken for body decoration. These are, therefore, medicine men in trance. The lines which issues from the men's heads do not connect them individually to the flying buck above, as has been claimed; the lines lead from the heads of both men and flying buck and more probably represent the spirits of the medicine men leaving their bodies on out-of-body travel.

The depiction of the charging lion does not preclude this interpretation of the painting. On the contrary, the lion may also be explained by San beliefs about trance and does not necessarily mean that the painting records a sensational historical event. When a medicine man entered trance, his spirit left this world and travelled to the "other

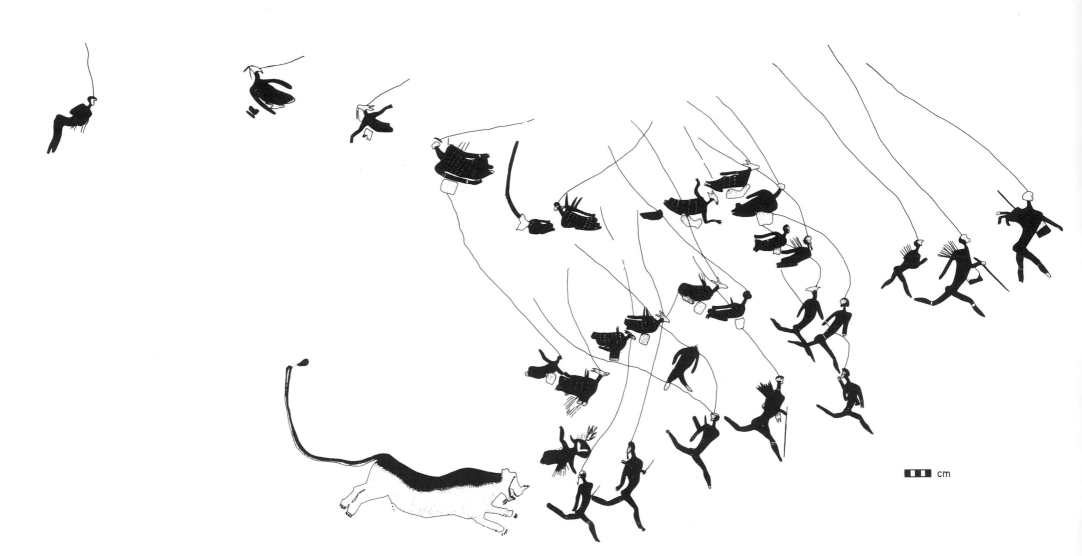

Fig. 31. Balloch, Barkly East.

world'' of the beyond: the ambivalence of his state seems to have been expressed in the belief that he could assume the form of either an antelope or a lion. The flying buck and processions of hirsute therianthropes depict men who have adopted the acceptable antelope form. Other less fortunate men became lions and were associated with a different kind of hair: both /Han≠kassō and Diä!kwain spoke of ''lion's hair'' coming out on the back of a man in trance (Bleek, 1935, pp. 2, 23). This dreaded condition was, I believe, a metaphor for the uncontrolled biting and violent spasms of a man in the throes of trance and, more generally, for the dangerous possibilities of trance. !Nuin-/kúiten, a medicine man who realized that he was ''not a patient man'' when he was in trance, feared that he would inadvertently harm people; therefore, explained Diä!kwain, he ''hides his lion's body, for he feels that if people were to attack him, he would hurt the people'' (Bleek, 1936, p. 132). The word given here as ''attack'' is perhaps better translated in this context as ''tease'' or ''annoy'' (Bleek, 1956, p. 610). The same ''impatient'' medicine man once went on out-of-body travel in the form of a lion and killed a farmer's ox with disasterous results (Bleek, 1936, p. 132). /Xam hunters, who found that a wounded lion would not die, assumed it was an ''angry'' man on just such a supernatural journey (Bleek and Lloyd, 1911, p. 187).

To prevent the undesirable transformation into a lion the trancer's fellows rubbed his back with fat to remove the hair (Bleek, 1935, pp. 2, 23). In this part of the caring rituals antelope fat was used to combat the lion's hair. Antelope and lions in fact belong to opposed San taxa: for the /Xam antelope were ''hoofed creatures'' (*opwai*) and

lion ''pawed creatures'' (*//khe//khe*) creatures which ''walk on hair'' (Bleek, 1936, p. 131). The !Kung call pawed creatures *jum* and also use the word to describe strange and potentially dangerous people. As a verb *jum* means to go on out-of-body travel in the form of a lion (Biesele, pers. comm.).

The southern San's application of the fat of one taxon to counteract the hair of the other taxon may therefore be seen as a symbolic expression of the dangerous, volatile state of a man in trance: he could, if not appropriately attended, slip into the feared form of an ''angry'' lion. The lion was the symbol of the antisocial possibilities of trance, while the antelope was the symbol of the socially beneficial medicine man. The antisocial medicine man used his powers malignly to shoot mystical ''arrows of sickness'' at people, which could, in turn, be deflected by the protective activities of the men who used their powers positively.

If my view of the painting is correct, the lion is not a feline bent on consuming unwary hunters, but a medicine man who has had the misfortune to change into a lion and whose antisocial behaviour is symbolized by the way he is pursuing and attempting to bite his companions. Some of his associates have, on the other hand, assumed the more desirable features of antelope. The artist has graphically portrayed the ambiguity and danger of the medicine man's role by presenting, in a single composition, contrasting metaphors drawn from opposed animal taxa.

Many other paintings which appear to depict close encounters with felines may be similarly interpreted. One at Mushroom Hill has long been thought of as a ''caricature'' of a ''charging leopard'' (Willcox, 1956, Fig. 52). A leaping feline seems to surprise a group of men, one of

whom appears to be somersaulting while two others cling to one another. Close by stand two therianthropes which bleed from the nose. Amongst the figures are numerous red strokes very similar to those which are part of the Halstone dance (Fig. 20) and the Sehonghong rain-making scene (Fig. 9B). These strokes and the therianthropes suggest that this is another depiction of the dangers of trance.

The flying buck and the pawed creatures are, therefore, opposed parts of a complex set of beliefs in which the benign medicine man was associated with antelope, the socially positive taxon, while the uncontrollable and dangerous possibilities of trance were symbolized by ''angry'' lions, members of the antisocial taxon ''pawed creatures''. As might be expected, the negative, feline metaphor is less frequently depicted than the favourable antelope metaphor (see Appendix, p. 135).

To clarify and summarize my interpretation of what have hitherto been called ''flying buck'' I now present two composite sets of illustrations. The first group (Fig. 32) shows the successive stages of trance performance: dancing, bending forward, arms back, nasal bleeding, falling to the knees, caring for the man in trance and, finally, sitting beneath a kaross to rest and control the rising trance. These are comparable with the second group (Fig. 33) which shows a similar range of trance behaviour but with the addition of therio-morphic features and culminating in flying buck. The first group shows the actual, observed trance behaviour; the second shows the same range but with a conceptual overlay. The second group depicts what the San believed rather than what they saw or, possibly, what some of them believed they saw. The relationship between believing and

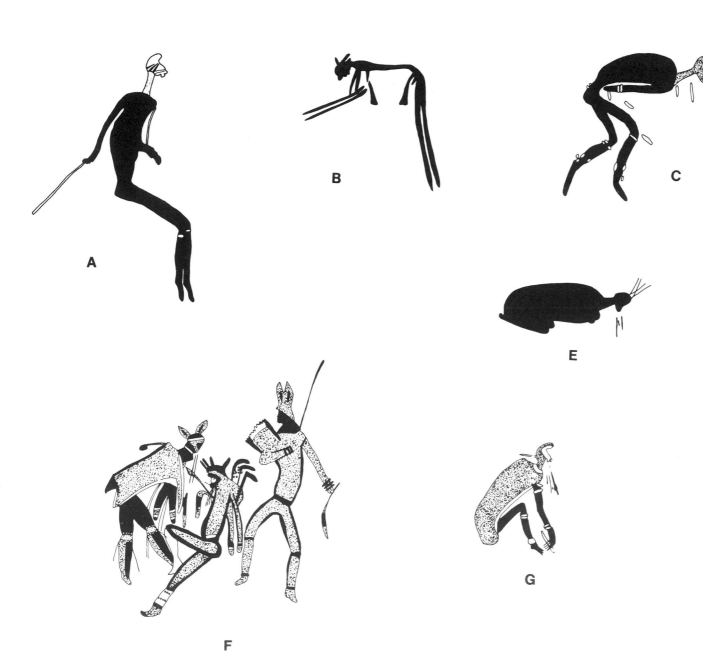

Fig. 32. Stages of trance performance. A: figure dancing with two sticks; red lines on a white face. Fetcani Glen, Barkly East. B: figure with two sticks dancing in the bending-forward position. Upper Africa, Giant's Castle. C: figure in bending-forward position and with arms parallel to sides; blood issues from the nose. Halstone, Barkly East. D: a figure with arms back has fallen to the kneeling position; a second figure bends over, perhaps to care for the man in trance. Bamboo Hollow, Giant's Castle. E: a figure kneels and bleeds from the nose. Barnes's Shelter, Giant's Castle. F: a medicine man, bleeding from the nose, collapses in trance; another, bending forward and also bleeding, approaches him. Fetcani Bend, Barkly East. G: a man, bleeding from the nose and wearing a kaross, sits out of the dance, perhaps to recover from trance. Halstone, Barkly East.

Fig. 33. "Conceptual" stages of trance perform-ance. A: part of a dance scene. A figure with an antelope head dances in the arms-back position. Naudeslust, Fouriesburg. After Lee and Woodhouse (1970, Fig. D27). B: figure in arms-back position with antelope head and feet. The white marks probably represent hair standing on end. Fulton's Rock, Giant's Castle. C: figure in kneeling, arms-back position with antelope head; hooves on all four limbs. It appears to have hair standing on end. Qacha's Nek, Matatiele. D: figures in kneeling and arms-back position face a group of eland. Mountain View, Harrismith. After Woodhouse (1971b, Fig. 1). E: upper figure in kneeling and arms-back position; animal hooves on arms and legs; bleeding from nose. It appears to hold a curious skull-like object. A line of dots emanates from neck. Appendages from chest appear on other similar paintings, but they are difficult to explain (see also A above). Lower figure, in a comparable position, has animal ears. War Trail, Barkly East. F: "Flying buck" with white "streamers". Skopongo II, Giant's Castle.

seeing and what may be intermediary between these two, trance vision, I discuss in more detail in the next chapter.

Because there is such strong evidence that the so-called flying buck are symbols of medicine men in trance, there seems to be no valid reason for persisting in calling them flying buck or for adopting the neologism *ales*. Of course, once a term like ''flying buck'' has become embedded in the literature and popular debate it is very difficult to change it; nevertheless, if the notion that the paintings represent spirits of the dead is to be discarded (as I believe it should), it may be opportune to propose a more apposite substitute. I have rejected the possibility of suggesting a /Xam word because such words, on account of the difficulties of pronunciation, are unlikely to find general acceptance. I have also rejected the simple phrase ''trance figures'' because this would not distinguish between the therianthropes and the ''flying buck''; although they all have their origin in the experience of trance, it would, I believe, be valuable to distinguish between them. I therefore propose, not a complete neologism, but only a modification of the popular term. The phrase ''trance-buck'', I suggest, would be more appropriate than ''flying buck''; it conveys the orgin of these paintings in trance and also refers to some of their peculiar characteristics.

If my arguments are valid, we may regard the trance-buck as complex, but unified, representations of medicine men in trance. The observed characteristics may include backward extension of the arms, nasal bleeding and exudation of sweat: the believed characteristics may include emanations of potency to or from the neck or back, out-of body travel and associations with particular animals, especially the eland. Individual representations may show all or only some of these characteristics. As depictions of trancers, these paintings would have been powerful symbols of the benison of the medicine men's activities. These symbols are within the known range of beliefs and interests of the southern San; my explanation does not import fanciful notions which find no support in the ethnography. Instead, I emphasize the trance dance which is the main religious ritual of the !Kung and which the ethnography and paintings together strongly suggest was also the case among the southern San.

It is the medicine men who, by their trancing, have access to and control of powers which bestow protection upon the members of the band. The medicine men move into trance and contact with the supernatural through the agency of the ''strong things'' which they possess—they facilitate the altering of states of consciousness; these maieutic creatures are, among the !Kung, often eland. The range of /Xam beliefs concerning this antelope and the paintings themselves indicate that its role among the southern San may have exceeded in importance that which it still enjoys among the !Kung. We may, therefore, see the eland itself as the medium through which many medicine men obtained the potency which enabled them to enter trance and exorcise sickness and evil from the bodies of the people. There is no more dynamic concept in San thought, even as there is no more puissant symbol than the eland. As the eland stands at the entrance to male and female adult status and to marriage so, for those who possess its supreme potency, it is the medium which gives access to the mystical experience of trance.

Notes

(1) The !Kung use the same word, *!gi:xa*, to describe a particularly accomplished medicine man (Biesele, pers. comm.).

(2) Marshall (pers. comm.) has suggested that the arrows which lie scattered in the foreground of the Lonyana painting may be depictions of the mystical ''arrows of sickness''. This is an attractive interpretation, but they may alternatively represent arrows placed down by visitors as a sign of friendship (Chapman, 1868, II, p. 23; Stow, 1905, p. 49; Heinz, 1966, p. 102). Some paintings (e.g. Battiss, 1948, p. 157; Pager, 1971, Figs 169, 343) show groups of seated people with hunting equipment close by, but in these cases the arrows are in bags and not scattered as they are in the Lonyana painting, so Marshall may well be right.

(3) Vinnicombe (1976, p. 320) believes that the /Xam ''associated medicine men with *cold*'', not with boiling as do the !Kung. The word *!khãũä* and other associations of heat with potency (see note 4, Chapter Five) suggest this is not so. The ''cold'' referred to by /Xam informants was, I believe, used in some instances in the context of *controlling* the rising sensation of trance. In other cases it seems to have been used to describe the ''shivering'' of a man in trance. The metaphor of ''cold'' to describe this trembling and the metaphor of ''boiling'' to describe the sensation in the spine and the activation of the medicine are not mutually exclusive. The San of East Griqualand used /kõ to mean both ''to dance'' and ''to boil'' (Bleek, 1956, p. 317).

(4) In !Kung thought trance is associated with eland not only through the especially important eland medicine song, but also in another way

which recalls this antelope's most important characteristic and the role it plays in rites of passage. In a tale collected by Biesele (1975, I, p. 181), the great god, wishing to enter trance, takes eland fat, puts it in a tortoise shell and heaps glowing coals on top of it. He sniffs the smoke and begins to trance; he then rubs the fat on himself.

(5) This painting was first copied in 1893 by Louis Tylor, nephew of Sir Edward Tylor; his copy is now in the Pitt-Rivers Museum, Oxford (Vinnicombe, pers. comm.). There appears to have been no serious deterioration in the preservation of the painting since 1893.

(6) For a discussion of this point see Pager (1975b, pp. 404-405). The ethnography does, however, contain numerous references to a hunter disguising himself as an ostrich (Harris, 1838, p. 310; Alexander, 1838, II, pp. 145-7; Moffat, 1842, p. 64; Tindall, 1856, pp. 30-31; Stow, 1905, pp. 84-85; Dunn, 1931, pp. 32-33; Wikar, 1935, p. 179), a ruse which appears to be depicted in a painting copied by Stow (1905, plate 7). See also Burchell (1822, II, p. 41) for a description of a springbok-skin disguise.

(7) The suggestion that some of the therianthropic figures might be medicine men has been current for some time, though it has never been adequately demonstrated. Battiss (1948, p. 20) refers to an "animal-headed sorcerer" and Vinnicombe (1976, p. 314) writes of "a definite triadic association between sorcerers, humans with animal characteristics, and the ceremonial Dance of Blood", but neither she nor Battiss develops the idea in any detail.

(8) An interesting feature of this painting is the depiction of two white "tusks". Similar "tusks", usually only one, are frequently found on therianthropic figures (e.g. Vinnicombe, 1976, Figs 109, 232, 233) and may, because of the associations which I have noted, be a further, but at present inexplicable, indication of trance performance.

(9) Such long kaross-clad figures at Game Pass were identified by Breuil (1949) as "foreigners"; Schofield (1949), on the other hand, thought they depicted "Bantu". Both writers failed to notice the figures' hoofs.

Chapter 8

———*The Rain and the Eland*——————

In the previous chapter I offered an explanation of certain symbolic paintings by relating them to some of the activities of /Xam medicine men. I now turn to a related theme in which trance performance also played a vital part: rain-making. In discussing trance in the context of the curing dance, I suggested that the medicine men were manipulating not physical, ritual objects, but metaphors, and that in some of the paintings these metaphors have been rendered in visual terms; the paintings of trance-buck, I suggested, are a complex product of trance vision and are better considered as symbols.

In this chapter I take the discussion towards another category of enigmatic paintings, some of which are likewise purely symbolic. To understand these paintings it is essential to reach a clear understanding of further San metaphors. The basic analogy with which I am concerned is between "rain" and "animal". As my discussion proceeds, I try to show how the perception of an analogical relationship between "rain" and "animal" characterizes San thought, ritual and art; I describe the progression of a metaphor—if "progression" can be conceived of in other than temporal terms. This analogical relationship— rain : animal—became among the southern San a powerful and pervasive notion which could be manipulated in ritual situations and even rendered in graphic terms, so that "believing" was transmuted into "seeing".

The analogy originates in rain as a meteorological phenomenon. Southern African rain frequently comes in one or other of two contrasting forms: the thunderstorm and the softer, soaking rain. On the expanses of the southern African interior a thunderstorm is often seen in the distance on a summer afternoon: a dark cloud, sometimes illuminated by flashes of lightning, moves slowly across the horizon. From the cloud fall columns of rain, sometimes dark, sometimes incandescent, depending on the position of the sun. The approach of the storm is often heralded by a period of stillness during which the thunder rolls ominously; then the wind whips up the dust and the large, stinging drops of rain and sometimes hail pound down on the land. The other, more sustained, type of rain is, by contrast, gentle. The sky is completely overcast and a mist may obscure the distant view; the fine rain falls softly, soaking into the ground.

The /Xam referred to these two types of rain as male and female respectively. The "he-rain" (*!khwa: gwai*) was said to blow up dust and destroy huts (Bleek, 1933, p. 309). It was feared and the San over a wide area of southern Africa attempted to drive it away by lighting fires.[1] The less destructive "she-rain" (*!khwa: /aiti*) was said by //Kábbo to "rain softly on the ground, so that it is wet deep down in the middle. Then the bushes

will sprout and become nicely green, so that the springbok come galloping'' (Bleek, 1933, p. 309). The !Kung, who make the same metaphorical distinction between male and female rain (Marshall, 1962, p. 234), distinguish them further by the ''footprints'' which the drops make in the dust. The male rain, they say, leaves sharp, pierced ''footprints'', while the female's ''footprints'' are wide, soft splashes (Thomas, 1969, p. 147).

The dark rain cloud of the ''male'' rain was spoken of by the /Xam as the ''rain's body'' (L.VIII.1.6070-6071). Sometimes this ''body'' was said to have ''ribs'' (L.II.25.2255). The columns of rain falling from the ''body'' of the cloud were spoken of by the /Xam as the ''rain's legs'' (Bleek, 1932, p. 341; 1933, p. 305), a phrase, I found, that is still used by the !Kung; it was on these ''legs'' that the cloud was thought to ''walk'' across the land. The actual precipitation which formed the ''legs'' was spoken of as milk or blood (Bleek, 1933, pp. 309, 310).

In addition to the ''legs'' the /Xam recognized other ''appendages'' hanging down from the clouds: the ''rain's tail'' (L.VIII.23.7996) and the ''rain's navel'' (L.VIII.1.6063-6068).[2] The wispy clouds that often characterize the under side of a thunderstorm were called the ''rain's hair'' (Bleek, 1933, p. 310). The mist, a feature particularly associated with the female rain, was called, no doubt by analogy with a man's breath on a cold day, the ''rain's breath'' (Bleek and Lloyd, 1911, p. 193; Bleek, 1933, p. 309).

All these phrases are expressions of the basic analogy between rain and an animal which was suggested to the San by certain characteristics of southern African rain. The level of acceptance of this analogy was the same among the /Xam as it is

among the !Kung. Speaking of the ''rain's legs'', /Han≠kassō explained to Lloyd that he was perfectly aware that the ''legs'' were, in reality, nothing more than ''rain liquid'' (Bleek, 1933, p. 311). A similar disclaimer was also obtained by Lloyd from //Kábbo about the ''rain's ribs''; these, he said, were in fact, ''long, dark, thick cloud'', not ''real'' ribs (L.II.25.2254 rev.). When I was discussing rain with !Kung informants, I found an identical situation: having told me that the columns of falling rain were called the ''rain's legs'', ≠Oma!oma hastened to add that the ''legs'' were really ''little drops of water''. These statements show clearly that all the elaborations of the basic analogy were and still are recognized by the San as metaphorical: they are simply ways of speaking about a natural phenomenon. The San are not so credulous as to suppose that a rain cloud ''is'' an animal: on the contrary, at this level, they perceive an analogical relationship.

Among the /Xam, but not as far as I could ascertain among the !Kung, the metaphor was expressed, at another level, by a more specific conceptualization of a ''rain-animal''; this conceptualization could be spoken of independently of the meteorological phenomenon which, I believe, was its origin. The word the /Xam used for ''rain-animal'' is *!khwa:-ka xoro*. *!Khwa*, as I explained in Chapter Three, means both rain and water; when referring specifically to precipitation the phrase *!khwa //ki* (rain liquid) was used. *Xoro* means ''ox'' or ''cattle'' and is so translated in other contexts (e.g. Bleek, 1936, p. 132); an ''ox for slaughtering'', for example, is */ã/ã-ka xoro*. The word does not mean specifically a bull. When /Han≠kassō was giving Lloyd the story *A Woman of the Early Race and the Rain Bull*, he simply used

the word *!khwa*, but, perhaps in response to a question put to him by Lloyd, he explained in a subsequent note that *!khwa* resembled a *xoro*, adding that he meant a *xoro gwai*, a bull (Bleek and Lloyd, 1911, p. 193).

In translating *!khwa:-ka xoro* as ''rain bull'', it seems probable that the Bleeks were following precedent and not dealing with an entirely novel concept. Bleek may well have been familiar with Alexander's (1838, II, p. 198) report that the Namaquas believed that in certain deep pools there lived a ''water bull, which is black and has large horns''. At night, the Namaquas believed, this ''water bull'' came out to eat grass and then dived under the water again before day. The similarities to /Xam beliefs are certainly striking.

In view of this earlier report by Alexander, I suspect that Lloyd, perhaps as a result of a tradition already familiar to the Bleeks, sometimes translated *xoro* as bull when ''ox'', ''cow'' or simply ''animal'' would have been equally or more appropriate. Indeed, in the first account of the ''rain-animal'' given by Diä!kwain, Bleek translated *!Khwa:-ka xoro* as ''water cow'' (B.XXVII.2540ff); when this statement was repeated to Lloyd shortly afterwards, the identical phrase was translated ''water-bull''. For the present, then, I suggest that the concept of a ''rain-creature'', set up by the analogy between rain and an animal, had a distinct tendency to be of bovine form, whether a bull, an ox or a cow.[3]

!Khwa as a ''rain-animal'', in turn and at yet another closely related level, was projected by the /Xam into a ritual. Three accounts of such a ritual were obtained by the Bleeks. According to //Kábbo, himself a rain medicine man (L.II.6.625), a person desiring rain would approach a relative

known to possess the requisite powers. This man, who was spoken of as an old man, promised to "cut a she-rain which has milk, I will milk her, then she will rain softly on the ground . . . I will cut her, by cutting her I will let the rain's blood flow out, so that it runs along the ground" (Bleek, 1933, p. 309). This cutting, the old man told the people, would be done on the mountain top; to arrive there the "rain's man" would ride on the rain-animal (L.II.25.2238 rev.). While he was working his magic, it was imperative that no one lit a fire as that would chase the rain away. The origin of the details of this account at the first analogical level is quite clear.

//Kábbo's son-in-law, /Han≠kassō, in his account of the ritual, explained that an old man wishing to make rain spoke first to the dead "who are with the rain" and then to the rain itself. The dead people were thought to have bound the rain as with a horse's reins; the medicine man loosed the thong and permitted the rain to fall (Bleek, 1933, pp. 304-305). The rain's medicine man then seized the rain and broke the "rain's ribs" and scattered them over the dry land.

The Katkop informant, Diä!kwain, in response to Orpen's copy of the painting showing four men leading the "rain-animal" (Fig. 9B) explained that the rain medicine men went to a waterhole, being careful to keep to windward lest the creature smelt them (B.XXVII.2540-2608; Bleek, 1933, pp. 375-378; Bleek, 1935, pp. 14-15). At night the animal supposedly went out to graze and then the men threw a noose over its horns. This was a hazardous accomplishment; Diä!kwain spoke of an instance of the thong breaking and the subsequent escape of the rain-animal. The man responsible for this turn of events was advised to use buchu in

future: "If the bull had smelt buchu, it would have been calm and gone quietly without struggling". When the rain medicine men had successfully secured the animal, they led it over the countryside where they wished the rain to fall. An experienced medicine man led the procession while the novices followed. The animal was then killed and dismembered. Some of the "water's flesh" was then scattered where the medicine men wished the rain to fall and the rest was broiled. In Diä!kwain's account, then, it is the medicine men, and not the spirits of the dead, who "bind" the rain-animal.

These three accounts, incorporating elements of what I have designated the first two analogical levels, also contain indications that the rain-animal concept has shifted to another level, ritual. Before suggesting how these apparently fanciful reports could have had a ritual basis, I draw attention to two opposed types of action which are found in each of the accounts.

In the first place the animal is brought under the control of the medicine man. This stage is reflected in the ideas of "catching", "binding", "leading" and so on. The capture and control of the creature was accomplished by the use of thongs which were by stealth and cunning attached to the creature. The second stage involved the contrary ideas of "loosening", "cutting" and "dismembering". Both these stages are appropriate to the bovine elements in the conceptualization of the rain-animal and it is possible that in some cases, especially where the San were in contact with herders, that this procedure may actually have been performed with such an animal.

The last century San were widely respected by the pastoral Bantu-speaking people for their

ability to bring rain, but most accounts of their providing this service give no information on the techniques they might have employed. One account does, however, offer a tenuous clue (Report 1883). The Pondomise chief, Mhlouhlo, is said to have killed an ox or oxen in times of drought and to have thrown the carcasses of the animals into a pool wherein his predecessor's body had been placed. As in the /Xam reports, the elements of control and then release are present. The same Pondomise were also accustomed to employ San rain-makers. When they resorted to this approach, they sent cattle to the San. What the San did with the cattle is not recorded in this account, but the report points to a possible association between cattle and rain-making.

Another, more significant, report concerns the Korana. These Khoikhoi people were in close contact with the southern San and indeed a San "leader", who called himself Swarts, lived with the Koranas and his people intermarried freely with them (Engelbrecht, 1936, p. 48). The San were in great demand by the Koranas as "doctors"; in this way the Koranas became familiar with the curing dance and the healing practice called "snoring" (Engelbrecht, 1936, pp. 73-74). When the Korana themselves wished to make rain, the old men went out into a secluded part of the veld where they killed one head of cattle. A rib of meat was taken out of each side of the animal and roasted over a fire, as were the clavicular portions. The rest of the meat was cooked and eaten by the old men. The bones were burnt as well as the fat, for "it was the pleasant smell of the fat which had to ascend to heaven" (Engelbrecht, 1936, p. 175). If we bear in mind the intimate contact between the Koranas and the

San, the similarities between these rituals and those described by the /Xam informants appear too close to be co-incidental. Not only does the Korana ritual embody the two elements of capture and dismemberment, but it also contains what may be a reflection of the significance of the "rib" which I discussed in connection with the first level of analogy. It seems probable then that, when possible, the San too used oxen in their rain-making rituals. These oxen were probably either stolen or given to them by those desiring their assistance.

Although the ox may be the most likely candidate for use in San rain-making rituals, another possibility must be considered. The most tractable of all antelopes, the eland, has, despite first impressions, much in common with the ox. The physical similarities between the two creatures is something of which the San themselves are aware. In the first place the hoof print of an eland is remarkably similar to that of an ox (Methuen, 1846, p. 110; Bryden, 1893, pp. 382, 502); this similarity, I pointed out in Chapter Five, the !Kung considered important enough to draw to my attention. Further similarities between these two animals may be noted. When eland are browsing or resting to ruminate (Abbott, 1968, p. 10) they occasionally "blow" like cattle, although they are normally taciturn (Shortridge, 1934, p. 615). The eland's flesh is, moreover, very similar to good quality beef (Bryden, 1893, p. 434). Barrow (1801, I, p. 262), in likening the eland to the ox, wrote: "The head, the thick neck, and the dewlap of the male, the body, legs, and hoofs are bovine . . . Its habit, its gait, its size, and general appearance, are those of the ox." It is, therefore, not surprising that the !O !Kung of Angola apply the word //ni to both eland and cattle (Bleek, 1956, p. 619). In speaking of eland, the southern San also frequently likened them to oxen. When Qing was discussing the whereabouts of /Kaggen, he spoke of the eland being "in droves like cattle" (Orpen, 1874, p. 3); and, when /Han≠kassō was giving Lloyd the myth of the creation of the eland, he said that the animal grew large "like an ox (xoro)" (Bleek, 1924, p. 7; L.VIII.6.6523).

The eland and the ox may then have been seen by the southern San as in some ways related creatures; in any event the phrase *!khwa:-ka xoro* does not exclude the possibility of an eland being used in the rituals under discussion. But there is a much clearer indication of an association between eland and rain. Vinnicombe cites Lloyd's (1889, p. 9) allusion to the myth of the rain in the form of an eland. Although both Lloyd and Bleek (1929b, p. 307) refer in passing to this myth, it has never been published and has remained inaccessible to all writers. In view of its inaccessibility, I give a version that is but slightly shortened:

The rain, in the form of an eland, is shot by one of the early race of people

A very long time ago a man hunted !Khwa, the Rain, as he was grazing, champing the grass quietly. At that time the Rain was like an eland. The man stealthily stalked the Rain and discharged an arrow at it. The Rain sprang to one side when the arrow struck it and galloped off. The man went to the spot where the Rain had been grazing and recovered the shaft of his arrow. He replaced the shaft in his hunting bag and returned to camp where he lay down to sleep.

Early next morning he told the people he had shot the Rain and they all followed up the Rain's spoor. As they were tracking the wounded Rain, a mist came up. After some while they caught sight of the Rain lying down. They went up to it and began cutting up the meat. But when they put the meat on to roast, it just vanished, being burnt up in the fire. When they raked over the coals looking for the meat, they found it was burnt up. They persevered in their attempts to cook the meat, but in the end all the meat had disappeared and the fire had burnt out.

Then an old man said, "I thought I would go when I had eaten this eland's meat, but I have not eaten it, though I roasted it. So now I will go."

And another man said, "We will also do so, for we did not realize what sort of eland it was. We had better go, for it is an eland whose meat we do not eat."

But, as they were leaving, the Rain saw that they were making ready to go. The Rain therefore shut them in; the Rain's navel shut them into the hut and they were terrified.

Then the Rain turned the men into frogs and they hopped away to the pond.

Told to /Han≠kassō by his mother
(L.VIII.16.7461-17.7472).

This myth deals with a number of issues simultaneously; I refer only to those which are now relevant. In the first place, the tale provides clear evidence of an association between certain eland and rain, but the nature of the association requires some clarification. In one sense the eland *is* the rain, its flesh being water; when portions are placed in the fire to roast they evaporate and disappear. In another sense the eland is !Khwa's representative, a symbol of the !Khwa concept. The dual nature of this concept is evident in the story: first, the rain is the mild mist which was said by one informant to be specifically the she-rain's

breath (Bleek, 1933, p. 309); then the rain becomes "angry" and "shuts them into the hut", a characteristic of the male rain, the thunderstorm. However, the most important implication of this myth for our present purposes is that it suggests the possibility of the /Xam using an eland in rain-making observances: if a certain type of eland can *be* !Khwa, as the tale suggests, we must allow the possibility of these eland, not normally caten, being captured, led and killed in rain-making rituals.

In addition to this important myth there is further evidence to suggest that the southern San associated eland with water. Aspects of its behaviour might have contributed to this association. Stevenson-Hamilton (1912, p. 130) reports that eland are generally browsers and enjoy cropping the tops of young river reeds (see also Shortridge, 1934, p. 613). In both //Kábbo's and /Han≠kassō's accounts of the creation of the eland, emphasis is laid on the fact that the eland was created in the water amongst the reeds (Bleek, 1924, pp. 1,5). This is also the case in Diä!kwain's unpublished version: "He called the eland from the middle of the reeds . . . that he might stand in the middle of the reeds when he had eaten up the food, he should go to stand in the reeds" (L.V.1.3608-3609; also 3521, 3522, 3631). In the Maluti version of the creation of the eland, /Kaggen nurtures the young calf in "a secluded kloof enclosed with hills and precipices, and there was one pass, and it was constantly filled with a freezingly cold mist" (Orpen, 1874, pp. 4, 8). The description of these places suggests very strongly the montane equivalent of the /Xam waterhole, while the mist recalls the notion of the rain's breath.

Arbousset (1846, pp. 46-47) records very similar Basuto beliefs. In a song in praise of the eland, the antelope is said to be "a cow that conceals its calf in the unknown fords of the rivers; It is the cow of Unkonagnana". Unkonagnana (little nose) was said to be an imaginary shepherd who tended herds of eland. This is possibly a version of the Maluti San belief concerning /Kaggen's presence with the eland herds. In the same song the eland is also spoken of as an ox: "An ox which one presents as food to his uncle or his aunt."

A further characteristic of eland behaviour also relates to water. The eland, unlike most antelope, is independent of water; using its horns to dig up succulent roots, it is able to subsist without recourse to running or standing water (Shortridge, 1934, pp. 612, 613). In a discussion of animal behaviour, !Kung informants deemed this feature of the eland's behaviour to be of sufficient interest to warrant their offering the information unasked for; they considered it to be of great importance. It may be that this aspect of its behaviour could have led the San to think of the eland as having water in its own body, as is indeed implied by the myth I quote above.

The habits of the eland, /Xam ways of speaking about the eland, and beliefs concerning its creation all point to an association of this antelope with water. Furthermore, a connection between the behaviour of the eland and the behaviour of the rain-animal is implied in the creation myths. This is especially so in /Han≠kassō's version. He speaks of /Kaggen calling the eland "out from the middle of the water" (L.VIII.6.6516). At this stage of its creation the behaviour of the eland closely resembles that of the rain-animal as it appears in the descriptions of the rain-making

rituals: the eland slept in the water but went out to graze (L.VIII.6.6529) and /Kaggen goes to feed it at night (L.VIII.6.6511).

In addition to the implication of the eland's place of birth and its behaviour, there are other references that associate the antelope, or parts of it, with the male rain. Vinnicombe (1976, pp. 44, 52) cites an 1851 report in the *Natal Independent* that a party of cattle-rustling San, pursued by Zulus, "resorted to magic, and summoned a torrential downpour of rain by blowing a blast on an eland horn". A comparable situation is evident in one of the tales given by Qing: control of the male rain is achieved by /Kaggen in the form of an eland. /Kaggen, desiring to kill an eagle, transformed himself into a "large bull eland"; when the eagle attacked the eland, hail fell, stunning the bird (Orpen, 1874, pp. 8-9).

Traces of a similar association between eland and the male rain are also to be found among the !Kung. In one of their tales ≠Gao!na, the great god, snaps an eland hide thong to make a noise like thunder (Marshall, 1962, p. 236). Biesele (1975, I, p. 179) has recorded another story in which ≠Gao!na attempts to make lightning by hanging the bones from the back of an eland's neck in a tree, but he was unsuccessful and the bones fell down onto the sand. Then he tried again using the horns which "stood up straight"; this time he was successful.

Associated with the eland horns in this myth are three songs. The words, say the !Kung, are meaningless: "the music works with the eland horns". In discussing the songs of the eland horns, Biesele (1975, I, p. 195) cites England's work on San music. England (1968) describes a certain musical scale which he calls the "Rain-Eland Scale". It is different from the other scales in use

and he surmises that it is of great antiquity. It is found in both the Eland Bull dance of the girls' puberty rituals and the Rain Song, *!Ga Ts'i.* England believes that the Rain Song might be "a musical vestige of a past rain-making ceremony" which may have been shared with Central and Southern groups.

The "Eland-Rain Scale" directs our attention to a more subtle relationship in !Kung thought between eland and rain. As I pointed out in Chapter Four, one of the many benefits bestowed by the performance of the Eland Bull dance at a girl's puberty ritual is that rain will fall in that band's area; if the dance is not performed, rain will fall elsewhere, and the remiss band will be left parched. Here, in these rituals in which the girl is likened to both an eland and a hunter, the performance of the Eland Bull dance ensures an adequate fall of rain.

There is, then, much ethnographic evidence to suggest an association in the thought of the San between eland and rain or water. In the light of this considerable body of evidence it is possible that an eland, the most tractable of all antelope, was, on occasion, actually caught, led and dismembered by southern San in their rain-making rituals. Indeed, apart from the bovids I have already discussed, the eland is probably the most likely creature for use in such rituals simply on the grounds of the ease with which its movements can be controlled.

I make these suggestions on the assumption that the rituals, as described by the /Xam informants and Qing, have a foundation in reality and that they were not merely imaginary or mimed entirely by human participants. There is, on the other hand, evidence that rain could sometimes be caused to fall without recourse to an actual ritual performance. Some rain-makers were said to bring rain simply by "dreaming" about it (Bleek, 1933, p. 389); this is what //Kábbo did when he caused rain to fall at Mowbray: "I dreamt that I told the rain to fall . . . The rain assented to me" (L.II.6.624 rev.). //Kábbo did not say whether his "dream" included any features of the rituals he described to Lloyd (Bleek, 1933, p. 309). It is, then, possible that, occasionally, the "rituals" existed only in the imaginations of the /Xam.

Whatever may have been meant by "dream" in the context of rain-making, there are elements in the accounts of the rituals that suggest the presence of another kind of "dream": trance. Rain-making was one of the accomplishments of the /Xam medicine men; as I showed in a previous chapter, trance performance was a major technique of those medicine men. Trance may account for some of the otherwise inexplicable events which the medicine men were said to experience during the course of the rain-making rituals. //Kábbo, in his account of the rituals, said that the medicine man, riding on the rain-animal, travelled to the top of a mountain where he slaughtered the animal and allowed the blood to flow down onto the arid veld. This seemingly fanciful account, like so much of San thought, is explicable in terms of trance. In the previous chapter I referred to the /Xam beliefs concerning out-of-body travel by medicine men. This statement concerning the journey to the mountain top on the back of the rain-animal is, I suggest, a typical product of the medicine man's trance experience (see Biesele, 1979). Trance, as an accomplishment of rain medicine men, was also implied by Qing: the men in the Sehonghong rain-making painting were said by him to have participated in the circular curing dance (Orpen, 1874, p. 10).

A number of possibilities therefore exist at this, the third analogical level. The /Xam rain-making techniques which were said to incorporate a rain-animal may have been "trance rituals" or simply a "dream"; it is also possible that the medicine men, on occasion, used an actual creature in the rituals. This creature could have been variously an ox or even an eland. A feature of the rituals, whether of the "dream" or the "actual" variety, was the medicine man's ability to trance. Some of these possibilities receive further confirmation at what I call the fourth analogical level.

The "rain-animal" concept, which, I have suggested, took its origin in metaphors of a meteorological phenomenon and became the "object" of what may in some circumstances have been an acted-out ritual, was further employed at another analogical level, the painted symbol. The depiction in the rock art of rain-animals and rain-making rituals is one of the best attested features; it was, indeed, as a result of //Kábbo's being shown Orpen's (1874) copy of the Sehonghong scene that the /Xam beliefs concerning rain-making first came to light. Both /Xam and Maluti informants recognized that the painting depicted the rain-making rituals I have already described. Four men, two of whom hold what may be buchu, lead a "rain-animal"; the hair standing on end on the creature's nose and back probably indicates that it is near to death (see Chapter Seven); there is actually more hair than Orpen's copy shows (Vinnicombe, 1976, pp. 337). A number of Stow's (1930) copies were also said by /Xam informants to depict rain-animals.

The various paintings identified by San informants as rain-animals cover a fairly wide range of forms. A number are vaguely like a hippopotamus (Willcox, 1963, Fig. 10c; Lee and Woodhouse, 1970, Figs 190, 191 and 192; Vinnicombe, 1976, Fig. 241). Some of these hippopotamus-like figures have curious long "trunks" which curl around the animal (Fig. 34; after Lee and Woodhouse, 1970, Fig. 192). These paintings together with the natural habitat of the hippopotamus have led some writers to speculate on the possibility of the southern San having used an animal of this species in the rain-making rituals. This is a superficially attractive theory, but it is doubtful if the performance of the rituals would have been practical with a hippopotamus. Furthermore, the hippopotamus does not feature at all largely in /Xam thought: I have no record of any /Xam reference to the animal. Nevertheless, we cannot discount entirely the possibility of the hippopotamus being one of the significata of the paintings of rain-animals.

Other examples of these paintings depict creatures that are somewhat bovine in form (Lee and Woodhouse, 1970, Fig. 240; Vinnicombe,

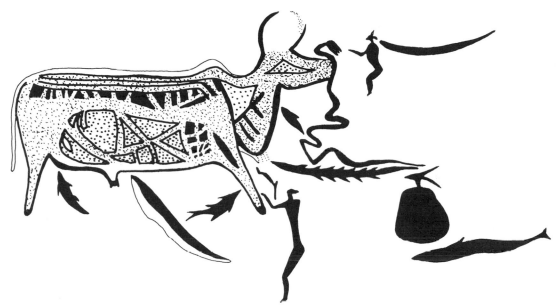

Fig. 35. Sand Spruit, Lesotho.

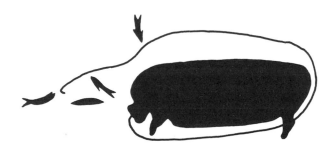

Fig. 34. Limburg, Zastron.

1976, Fig. 240; see also my Fig. 37). Of these generally bovine forms, one illlustrated by Stow (1930, plate 67a; my Fig. 35) has fairly clear bovid horns, dewlap and hump; it was identified by a /Xam informant as "the water bull". These paintings lend some support to the suggestion I made above: on certain occasions the southern San might have used a bovid in the performance of the rain-making rituals.

A further class of rain-animal is generally antelope in form (Tongue, 1909, Fig. 32; Stow, 1930, plates 18, 41). Whilst some of these are too vague to permit identification of species, some, like one illustrated by Stow (1930, plate 58; my Fig. 36), have been painted with what appear to be eland horns. Although none of these is identi-

fiable beyond doubt as an eland, they do suggest that antelope may have contributed to the form of some of the painted rain-animals.

Two other features are sometimes associated with these rain-animals. Painted over and around some are curved lines (Lee and Woodhouse, 1970, Fig. D31). One /Xam informant, commenting on the Rouxville example told Lloyd that the lines represented a rainbow and added that the rainbow is particularly associated with the "she-rain" (Stow, 1930, plate 34). Other paintings of rain-animals are surrounded by fish (Figs 34 and 35; see also Tongue, 1909, plate 32; Stow, 1930, plates 18, 67a; Lee and Woodhouse, 1970, Figs 191, 192), another persuasive suggestion that the depictions are connected with water or rain.

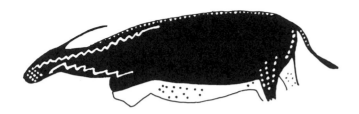

Fig. 36. Beersheba, Smithfield.

I have so far dealt with those paintings, generally classed and in some cases identified by /Xam informants as rain-animals, and which, because of their rather vague shape, cannot be identified with any certainty. There is, however, another class of painting in which the eland is central and which should, I believe, be classified among the rain-making scenes; these paintings show eland apparently tied up or connected by rope-like lines. Vinnicombe (1976, pp. 334-344, Figs 95, 102, 109, 214, 237) illustrates and interprets a number of such groups as rain-making scenes. Another painting (her Fig. 111) is not cited by Vinnicombe in this connection, but it may be a further example. The eland in this painting is surrounded by curious human figures. Above the back of the eland, a horizontal human figure, which appears to have eland horns, holds a thong which, from inspection of the painting *in situ*, I suspect is looped around the eland's neck and thus accounts for the animal's raised head. Another figure holds the eland's tail. Beneath this group is a fore-shortened eland seen from above.

This painting, I suggest, depicts the first stage of the rain-making ritual sequence, the apprehension of the rain-animal—in this case an eland. A sudden jerk of the animal's head has pulled the man holding the thong from his feet and illustrates the danger of the thong breaking. To the right of the eland is a strange slug-like creature; through its neck is a curious object with a triangular head. A similar object is impaled in the foreshortened eland that stands beneath the captured one. If this scene is indeed connected with rain-making rituals, the slug-like representation may be explained as one of !Khwa's creatures. !Khwa was thought to possess a variety of creatures including snakes, frogs and tortoises. /Han≠kassō described a further creature known as *!khwa:-ka //kerri-si-!kau*, the rain's caterpillar:

They dwell in the water; they are large. They do not have hair on their backs. They are going into the water, they run out of the water . . . Their back's things, they are red. The Bushmen do not eat them; for they are poisonous (L.VIII.1.6074-6075).

This report suggests the possibility that the painted "slug" is, in fact, "the rain's caterpillar" and is associated with the "apprehended" eland in the same way that fish, also !Khwa's creatures, are associated with some of the painted rain-animals.

Two other paintings illustrated by Vinnicombe (1976, Figs 102, 109) show what might have been the beginning of the second stage of a rain-making ritual involving an eland. In the first of these paintings, the antelope, having been captured and bound (as suggested by the red lines on its legs), awaits dismemberment; blood pours from its nose. The second painting shows a similarly "bound" eland surrounded by figures which I discuss below. These and other paintings of men apparently apprehending eland may be depictions of stages in a rain-making ritual sequence involving an actual animal. Such paintings tend to confirm the suggestion that, if the rituals were actually performed, an eland antelope may, on occasion, have been used as a ritual object. The operations performed with the eland would, as the accounts of the rituals suggest, have included the capture, leading and dismemberment of the animal in the belief that where its ribs and blood fell rain would also fall.

The bound and dying eland of these paintings suggest, in terms of the beliefs I described in Chapter Seven, a further important element which is, moreover, also frequently found in the groups featuring rain-animals. The element to which I allude, trance, is clearly depicted in the Bamboo Mountain painting which is now preserved in the Natal Museum, Pietermaritzburg (Vinnicombe, 1976, Fig. 240). A rain-animal is shown being led by a thong apparently attached to its nose. One man holds out a tufted stick (buchu ?) towards the creature's nose (see Lee and Woodhouse, 1970, Fig. 24 for a comparable painting). Following the animal are two men bleeding from the nose; the upper of these two is in the bending forward position and seems to have his arms parallel with his sides.

Trance elements are, in fact, found in a number of similar paintings featuring a rain-animal or an eland. One of these (Vinnicombe, 1976, Fig. 109), features a "bound" eland surrounded by eight figures all of which show one or more of the characteristics of trance performance: antelope heads and hoofs, hair, the arms-back posture and penniform streamers emanating from the head. Medicine men are therefore clearly engaged in some activity involving the "bound" eland. A painting at Giant's Castle (Fig. 37) shows what is

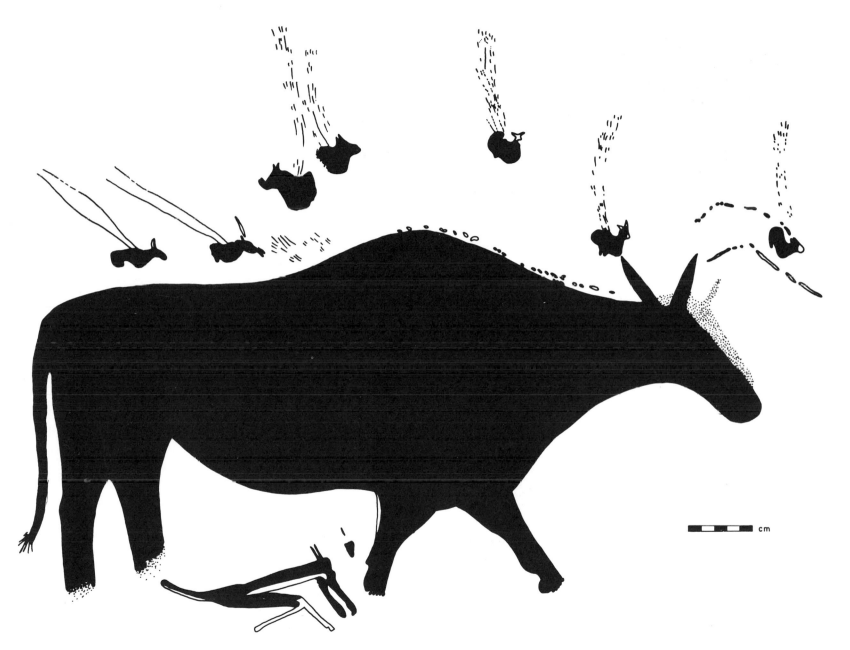

Fig. 37. Camp Shelter, Giant's Castle.

probably a rain-animal surrounded by what I have called trance-buck. A painting like this takes the transmutation of medicine men, already apparent in the painting of the ''bound'' eland, to the extreme in fully developed trance-buck.

Similar features are seen in another depiction at Blue Bend (Fig. 38). The rain-animal in this large, imposing scene is preceded by a striding therianthropic figure with antelope head and hoofs; immediately in front of the rain-animal are two smaller therianthropes, one of which bleeds from the nose. Behind the animal stands a white faced man who appears to be driving the creature. To both the right and the left of this central group are other therianthropic figures in the kneeling and arms-back posture. One of these figures is bleeding from the nose; two have ''streamers'' issuing from their heads. The two leaping rhebok are probably part of this composition. I think that they are associated on grounds of a remark made by Qing which I have discussed in detail elsewhere (Lewis-Williams, 1980).

He said that the men with rhebok heads (like the running figure at Blue Bend) had died and that they lived in rivers and tamed eland and snakes. Because he added that they had been ''spoilt'' by the ''dance of blood'', it is clear that he was using ''died'' and ''spoilt'' metaphorically to mean that they were in trance—as the !Kung still do. The ''taming'' of eland and snakes is probably a mistranslation of the San concept which relates the medicine men to the creatures they ''possess'' and whose potency they exploit. ''Lived in rivers'' is, I believe, another slightly confused translation of a trance metaphor. Qing was using the idea of being underwater as a metaphor of the trance experience: sounds in the ears, a sense of

weightlessness and being in another world, inhibited movement, altered vision and final loss of consciousness. Qing was, therefore, implying that the medicine men's activities involved an ''underwater'' experience and it was in this state that the imaginary rain-animal, itself a metaphor, was apprehended before being led across the veld in an extension of the hallucination.

Certainly, within these rain-animal scenes there is the full range of forms I discussed in relation to medicine men. At one end of the scale, as in the Bamboo Mountain painting, the medicine men are recognizable by the depiction of actual, observed trance behaviour; at the other end of the transmutational continuum are trance-buck like those in the Giant's Castle painting. In the previous chapter I proposed that trance vision could possibly account for some of these forms: in trance, the medicine man ''saw'' the transmutation taking place in accordance with the San concepts concerning the relationship between a medicine man and the creature he was thought to possess. The same factor, the effects of trance vision, should also be considered in the paintings of rain-animals because, as I have now shown, both the ethnography and the paintings themselves indicate that trance was a part of southern San rain-making rituals.

I noted in the previous chapter that a medicine man in trance ''sees'' the animal he is said to possess; in trance a man who possesses, for instance, eland is thought to cause the eland to come to the place of the curing dance where they are visible to him. This ability of the medicine man to materialize the animal which is the metaphor of his access to supernatural potency may, I suggest, explain some of the vaguely

formed paintings of rain-animals. The rain, already at one analogical level conceived of in zoomorphic terms, may have appeared in the trance vision of a medicine man like one of the rain-animals depicted in the paintings. This means that some of the rituals said to involve rain-animals might, as I have already suggested, have been entirely the product of the trance experience: the concept of rain, in its zoomorphic, metaphorical form, could in these instances have been the ''animal'' which the medicine men claimed to capture, lead, bind and dismember. In these ''trance rituals'' there would, then, have been no actual creature present.

But it is also possible that on other occasions the rituals were performed with real animals, either oxen or eland, and that the trance vision of the medicine men ''superimposed'' on the real animal the form of what I have called the second analogical level, the concept of a rain-animal. In these circumstances trance vision transformed the real creature, with which the ritual operations were being performed, into the conceptualized rain-animal which we now see depicted in the art. Some of the paintings may, in this way, be palimpsests of three analogical levels: the conceptualized rain-animal, the actual rituals or ''trance rituals'' into which it was projected and, finally, the pictorial symbol.

The way in which the rock art could present a unification of these levels deserves some consideration. It is possible that a medicine man communicated to an artist what he experienced while participating in rain-making rituals and that the painter then attempted to depict the experiences of which he had been told; a more likely explanation, I am inclined to think, is that the artist was himself a medicine man and that he was

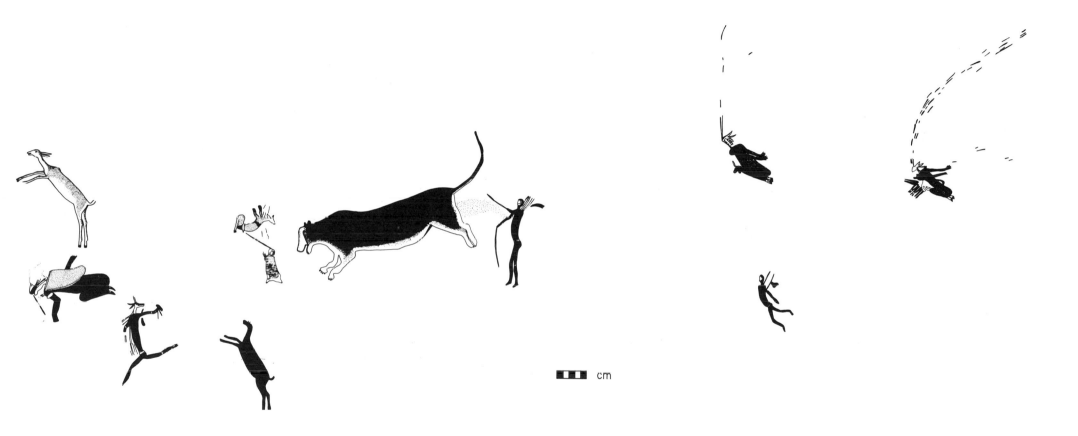

Fig. 38. Blue Bend, Barkly East.

depicting his own trance experience. There is nothing in the literature to suggest that painters could not also be medicine men. Dornan (1917, p. 49), on the contrary, was told of a Masarwa San named Nshimane who was both a painter and "a great rain doctor" and was held in high esteem. It therefore seems quite possible that in some of the paintings of rain-animals and trance-buck we have striking, first-hand records of the hallucinations which the artists themselves experienced while in trance. Katz (1976b, p. 86) found that !Kung medicine men have "richer fantasies" and are more "inner-directed" than those who do not regularly experience trance. Such enhanced sensitivity could have contributed to the combining of the analogical levels achieved by the southern San painters.[5]

The recalling of the hallucinations of trance is said, in some other societies, to provide deep satisfaction; Lewis (1971, p. 53) quotes Shirokogoroff's account of the Tungus on this point. The powerful, positive values which the !Kung associate with trance performance and which, it seems, the southern San likewise attached to trance in both curing and rain-making, suggest that the recollection and depiction of trance experience might also have been profoundly satisfying for the southern San artists and viewers. The depiction in tranquillity of the various powerful experiences of trance—rain-animals, therianthropes and trance-buck—possibly provided satisfaction and reassurance for the artist and also for the other members of his band. There is nothing esoteric about trance; it is open to all. Today the !Kung listen respectfully and with interest to the medicine men who are keen to communicate their trance experiences; each account is received as a revelation of what is really going on in the other world (Biesele, pers. comm.). The relevance of trance experience to an understanding of much of the San rock art has been either overlooked entirely or greatly underestimated.[6]

The suggestion that some of the artists might have been medicine men who depicted the hallucinations of their own trance experience raises the question whether the painters sometimes manipulated the painted symbols in a way comparable to the manner in which the medicine men used the concept of a rain-animal to induce rain to fall. The use of engraved symbols in rain-making rituals has, in fact, been proposed though not quite in these terms (Vinnicombe, 1972a, p. 201; Pager, 1975a, p. 48). I have elsewhere (Lewis-Williams, 1977b) discussed the passage on which this suggestion is based (Dunn, 1931, p. 46) and have tried to show that it contains multiple ambiguities. The passage actually means that Dunn saw a rock on which was engraved a number of human figures holding a rope apparently attached to the nose of a hippopotamus. In the light of this reading the only direct evidence for the use of southern San rock art in rain-making rituals evaporates and we must conclude that there is no reason to believe that rock art did other than merely depict beliefs concerning rain-making.

Even if there is no evidence for the actual use of the rock art in rain-making rituals, there are suggestions of a further and more subtle relationship between rain and the art, possibly placing the art in the framework of the southern San seasonal pattern of life. Carter (1970), by an important analysis of climatic and vegetational zones, has been able to show that it is likely that the San bands amalgamated and migrated to the higher areas of the Drakensberg, where the paintings are chiefly concentrated, during the period from September to the end of January; for the rest of the year, Carter suggests, smaller bands inhabited the lower regions where paintings are not nearly as numerous (van Riet Lowe, 1956).[7] We may infer from the distribution of paintings and Carter's suggested migration pattern that painting was virtually restricted to the summer months, the wet season. Carter (1970, p. 57) has also suggested that we should consider the possibility of "annual ceremonies in which painting was an integral part".

Carter does not attempt to define the "annual ceremonies"; I suggest, however, that such "ceremonies", associated with larger bands, would have been chiefly curing dances of the kind I described in Chapter Seven. It is, therefore, of interest to note that the practice of painting may have coincided with the summer rains and with an increase in trance activity. Many of the paintings—dances, therianthropes, trance-buck, rain-animals and certain eland—may, therefore, be seen as a product of an increase in trance performance following the amalgamation of the San bands at the beginning of the summer rains and migration to the rock shelters of the higher areas.

Carter has also pointed out that the period of the summer rains is the time when the eland herds amalgamate and move to the new sweet grass of the higher areas,[8] as he believes the San also did. This is confirmed by Ellenberger (1953, p. 257) who obtained his information from an old Sotho informant: "The Bushmen disappeared at the same time as the eland and the blesbok. They arrived in Lesotho following the migration of these animals" (my translation).

There is thus persuasive evidence to suggest that, before their migration pattern was disrupted by the presence of other peoples, the Maluti San inhabited the rock shelters of the Drakensberg mainly during the wet summer months. Even though there is no similar evidence from the /Xam of summer montane residence, //Kábbo's account of rain-making suggests that they associated rain-making with the mountains, no doubt because of the clouds that gathered around the peaks. The !Kung hold a similar view of the Tsodilo Hills. These hills are thought by many !Kung to possess powerful *n/um* and to be the origin of the weather. The clouds, they say, dwell inside the Tsodilo Hills and emanate from them like smoke (Biesele, pers. comm.). A similar meteorological situation occurs in the Drakensberg: in the late morning, clouds start to form on the crest and peaks of the High Berg and later develop into the thunderstorms which characterize the summer afternoons. The first of these summer storms was the occasion for San dances (Barrow, 1801, I, pp. 283-284; Stow, 1905, p. 112; Herbst, 1908, p. 13; Dornan, 1925, p. 136) which probably exploited the potency of the newly fallen rain. The short white strokes which surround the dancers in Fig. 20 suggest that this painting may depict such a dance.

There is, then, evidence for the suggestion that the San of the Drakensberg area might have associated mountains and rain with eland herds at the time when they amalgamate, give birth and, at the end of the season, mate (Stainthorpe, 1972, pp. 33, 36); this complex might in turn have been associated with rock painting. Painting, in these circumstances, could have marked the start of the season of heightened social activity consequent upon the first rains of summer. The rain-animal symbol, whether of the imprecise zoomorphic form or in the form of an eland, might have expressed something of the values associated with this season.

Although rain-making rituals were seasonal activities, they were, nevertheless, crucial, for they marked, celebrated and effected the breaking of the winter drought; they stated and communicated as well as accomplished. In the areas fringing the Malutis and the Drakensberg the first summer rains initiated the important changes I have described: the springing up of the summer grasses, the migration of the antelope herds, the movement of the San people from their huts on the plains to the rock shelters of the Cave Sandstone and a resurgence of painting. Rain was, in a very real sense, a catalyst of socio-geographic change. The joy that followed this change was expressed by /Ian≠kassō: "They do this when rain falls, they come out, they run about. They are all red" (L.VIII.17.7463 rev.). The same informant's father expressed his pleasure in the spring when he approached /Kannu, the rain medicine man: "Please let it be wet, that the bushes may grow beautiful. For a place is beautiful when it is sprouting, when the mountain tops are green" (Bleek, 1933, p. 388).

At first glance such a picture of idyllic affluence, leisure and convivial social activity would lead one to suppose that the painted rain symbols signified only positive values; but this is misleading: the /Xam view of times of plenty was ambivalent. In Chapter Seven I showed that the presence of much meat in the camp, as from an eland-kill, has the effect of raising social tensions and was a critical as well as an enjoyable time. Rain, too, was considered to be equivocal, not only in its contrasted male and female forms, but also in its social effects. Because of this, /Xam medicine men sometimes had misgivings about making rain:

Now the people will act as they always do, when rain falls, they do not take care of one another, for they do evil actions and do not seek food for them; then they fight when they have grown fat, after rain has fallen (Bleek, 1933, p. 377).

The summer season, therefore, brought with it danger as well as blessing. The feared heightened social tensions consequent upon affluence meant a concomitant increase in the mechanisms for the reduction of those tensions: sharing, dancing, trance performance and curing. To these activities, I now suggest, may be added painting in that the artist provided symbols of social unity and security. Chief among these symbols was the eland, the antelope which marked the passage from one socio-sexual status to another; which, because of its supernatural potency, provided access to trance experience and the ability to "cure" the entire band of known and unknown ills and misfortunes. In addition to being the southern San *animal de passage* and a source of potency I suggest that, through its association with *!khwa*, the eland stood on the threshold of the summer season of montane residence and plenty.

The eland, indisputably the most powerful animal in southern San thought, derived its potency from its unique metaphorical status: it is not surprising, then, that an animal that "said" as much as the eland was regarded by the /Xam as /Kaggen's favourite creature and, as I show in the next chapter, might in certain situations have become, through a still further extension, a metaphor of /Kaggen himself, a final apotheosis.

Notes

(1) See Sparrman (1789, I, p. 148), Thunberg (1796, II, p. 163), Leslie (1828, p. 80), Borcherds (1861, p. 115) and Bleek (1933, p. 309).

(2) For a discussion of this curious phrase see Lewis-Williams (1977a).

(3) At this level, the rain was also sometimes personified. It is not always easy to determine whether informants are speaking of a rain-animal or a personification of rain; this is the case in the tale *A Woman of the Early Race and the Rain Bull* (Bleek and Lloyd, 1911, pp. 193-199). At times in this story !Khwa is said to court the "woman" (probably a girl secluded at puberty) and at other times !Khwa is an animal on whose back she rides. A clearer personification of !Khwa is evident in the von Wielligh (1921, II, pp. 61-69) collection of /Xam folklore: von Wielligh's informants spoke of !Khwa having children of his own. Bleek (1929b, pp. 307-308) summed up this rather confused position by saying that, although the /Xam did not represent !Khwa as a man or a god, he was respected and feared and, like /Kaggen, had the power to change people into animals. For a discussion of the rain-animal see also Schmidt (1979).

(4) See Stanford (1910, p. 439), Potgieter (1955, p. 3) and Callaway (1969, p. 10).

(5) There is a further, less direct, suggestion that the paintings of the central highlands might have been associated with medicine men. The Sotho medicine men, who would have been conversant with many San customs and beliefs, scraped the paint from the walls of rock shelters and used it in their own medicines; the remains of some of these paintings have been mistaken for rock engravings (Wilman, 1910, p. 418; 1968, p. 19; Laydevant, 1933, p. 362). I have observed paintings similarly treated in the Kamberg area.

(6) Another enigmatic feature of the rock art that is, I believe, associated with trance and related concepts is the widely reported meandering red line, often fringed with white dots (Woodhouse 1975). Numerous paintings show this feature associated with dying eland, men in the arms-back posture and trance-buck. For a full discussion see Lewis-Williams (1981).

(7) There is a good deal more evidence than that cited by Carter to support this view (see Leslie, 1828, p. 80; Arbousset, 1852, p. 361; Dornan, 1909, p. 442; Stanford, 1910, pp. 45-46; Ellenberger and Macgregor, 1912, p. 10). Morrison (1975) has, however, tried to show that the San could have subsisted in the Drakensberg during the winter months.

(8) Again there is more evidence for this than is cited by Carter: Brookes (1876, pp. 120, 121), Wells (1933, p. 126). The same pattern obtained further to the west in the Sneeuwberg (Sparrman, 1789, II, pp. 176-178), but not in the north eastern Orange Free State (Barter, 1852, p. 89).

Divination and Divinity

In the foregoing chapters I have been concerned largely with the operational dimension of some of the objects of the painted signs: in an attempt to explore some of the possible significances of these signs I have described and discussed what the San actually did with, in the first place, the eland antelope and, secondly, the eland metaphor in certain ritual contexts. The later chapters have tended to be more exegetical than the earlier in that I have had to analyse informants' statements concerning their beliefs rather than accounts of rituals performed with actual objects. In this, the last interpretative chapter, the emphasis is even more heavily on the exegetical as I confront some aspects of what has become one of the major areas of controversy and misunderstanding in San studies. I refer to the southern San beliefs concerning /Kaggen and the part played by this being in San religion.

The suggestion that the southern San had any religion at all would have astonished the early travellers; the missionaries, as a result of the failure of most of their efforts to convert the San, were especially sceptical. Moffat (1842, p. 59), who despaired of bringing the San into the Christian fold, held this view: "He knows no God, knows nothing of eternity, yet dreads death, and has no shrine at which he leaves his cares or sorrows." Tindall (1856, p. 26) declared even more comprehensively to a Cape Town audience that "he has no religion, no laws, no government, no recognised authority, no patrimony, no fixed abode . . . a soul, debased, it is true, and completely bound down and clogged by his animal nature". Later in the nineteenth century similar views were still being expressed by Holub (1881, p. 5) who "did not notice any evidence of a religion among the Bushmen"; he adds, however, that they had "a kind of esteem for a certain snake". This remark probably reflects the writer's generally vague notions about the San, but it may refer to San beliefs concerning the "water-snake". Bertin (1886, p. 56) likewise agreed with the writers who thought the San had no religion and, in his phrase, "really no idea of a divinity". If by "divinity" he meant specifically the theological formulation of the Christian religion, he was, as I show below, correct, but this does not, of course, mean that the San entertained no religious beliefs at all. The conclusion that the San were without religion was closely related to the general distaste which many writers felt for their way of life. As recently as only 20 years ago, Stopa (1959, p. 105) claimed that the San have "an almost infantile type of thought, and a very low stage of culture development"—a bizarre judgement in the light of the foregoing chapters of this book.

Other early writers, who did not deny that the San had a religion, nevertheless represented it as a satanic one. The notion that the San worshipped

the devil accorded well with and gave expression to the disgust which many of the early writers felt for them. Reports of San belief in an evil being date from the eighteenth century (Sparrman, 1789, I, p. 148; Thunberg, 1796, II, p. 163) and continue right up to the beginning of the twentieth century (Currlé, 1913, p. 117). The writers of this extended period reported beliefs which they variously labelled "devil", "satan" or "evil deity". The use of such words appears, for example, in a little known "Contribution from a Bushman" which was published in the *Orange Free State Monthly Magazine*. This informant was known as Kina-ha or Toby. He was apparently the same informant who was interviewed by Charles Sirr Orpen, whose notes were eventually transmitted to Stow; according to Stow (1905, pp. 103, 134) Kina-ha spent some time at the Bethulie Mission Station "under missionary instruction". His remarks must, therefore, be read with this influence in mind. Kina-ha (1877, p. 83) distinguished two personages, a benign spirit, *T'koo*, and a "wicked spirit", *T'ang*. The T'koo of Kina-ha's report is quite possibly not San, but a form of the Xhosa word *Tixo*, God. T'ang, however, is clearly a transcription of the more generally reported San name rendered by the various English demonic terms. The name was first recorded by Arbousset (1846, p. 253) who gave it as *Kaang*. Later reports by Casalis (1889, p. 159), Stow (1905, p. 113), Ellenberger and Macgregor (1912, p. 7) and How (1962, p. 28) all seem to depend primarily on Arbousset's report, although in Ellenberger and Macgregor and in How the word is given in the form *Qhang*. I employ Bleek's /Xam transcription of the name, /Kaggen, this having become the generally accepted form.

The widely reported "demonic" nature of /Kaggen derives, I believe, mainly from a misunderstanding of certain southern San beliefs and tales. The word "devil" and associated terms like "wicked" and "evil" were used by the early writers to translate a complex concept which overlaps only partially with the equally complex concept implied by our own terminology. That overlap lies in the area of "deception", "trickery" and "mischief" rather than in the area of "evil" or "wickedness", though these are not entirely absent from the concept of /Kaggen. The San ideas which the English words so inadequately render are particularly apparent in two important but unpublished statements which Lloyd obtained from /Han≠kassō and //Kábbo.

On 12th December 1875, when /Han≠kassō was checking the translation of the account of the eland observances which he had given to Lloyd and he came to the point where /Kaggen, in the form of a louse, torments the sleeping hunter, an analogy with an incident that had taken place a month earlier sprang into his mind. It appears that some people, probably children on 5th November, had attempted, by donning disguise, to frighten and tease the San informants staying with the Bleek household at Mowbray. This circumstance struck /Han≠kassō as illustrative of the nature of /Kaggen:

The Mantis imitates what people do also, when they want us who do not know Guy Fox [sic] to be afraid. They change their faces, for they want us who do not know to think it is not a person. The Mantis also . . . cheats them that we may not know that it is he (L.VIII.17.5434 rev.).

This remarkable and perceptive piece of eth-

nography suggests that the concept of /Kaggen involved belief in one entity which was thought to be capable of assuming different forms. The protean nature of /Kaggen in hunting contexts is an aspect which I examine in more detail below; here I suggest that this capacity to change form was, at least partly, thought of in terms of "cheating", "deceiving" and "tricking" human beings. Indeed a change of /Kaggen's form is a feature of many of the "trickster" tales (e.g. Bleek and Lloyd, 1911, pp. 3-17; Bleek, 1924, pp. 15-18).

The aspect of the southern San concept that is more closely related to the Christian notion of "evil" is apparent in a statement given by //Kábbo:

J.T. says that while the Bushman is lying asleep very hungry, without any food, the /Kaggen comes and puts it into his thoughts to steal a beast. The Bushman refuses but /Kaggen puts his thoughts together with the Bushman's thoughts and "dries om" [turns round] the Bushman's thoughts so that he goes and steals a beast (L.II.4.501 rev.).

Here is a case in which the idea of "deceiving" and "trickery" is easily confused with the Christian ideas of "temptation", "evil" and "Satan". Bleek (1874, p. 11) himself was aware of the distortion involved in this kind of crude translation.

The so-called "trickery" of many of the tales really involves situations of uncertainty or unpredictable outcome in social relationships and hunting rather than the idea of "wickedness" which gave rise to the mistaken belief that the southern San worshipped "the devil". I shall not now pursue any further the "trickster" aspect of

the /Kaggen concept as it appears in the folk tales; instead I point to a second and related feature of the early travellers' reports concerning Khoisan religion.

Numerous writers, starting with Grevenbroek in 1695, reported that the "Hottentots" worshipped an insect; this insect, the praying mantis *(Mantis religiosa)*, has become known popularly as the "Hottentot god". Schmidt (1973) in a detailed and erudite discussion of the Khoisan names for this insect has shown that, amongst many groups, it bears the same name as the highest being, the name which was erroneously translated "devil". Amongst the southern San this name was /Kaggen, but whether /Kaggen should be translated as "The Mantis" in the folk tales has become a controversial issue. Schmidt's discussion of the names and the ethnographic material relating more generally to the /Kaggen concept is a valuable and scholarly contribution to San studies, but I believe she goes too far in denying an association between the being of the myths and the praying mantis:

The creature had, in common with other oracles, the name of the highest being, but was not identical with him . . . The creature *Mantis religiosa* does not appear in the myths of the Bushmen . . . [/Kaggen] must certainly be thought of in his physical manifestation as a small anthropomorphic goblin and not as a mantis (Schmidt, 1973, p. 124; my translation).

Whilst I agree that /Kaggen was not thought of as identical with the insect of the same name, I believe there to be reason to suppose that there was a connection which has been overlooked by such writers as Schmidt, Gusinde (1966) and Pager (1975a, pp. 66-67). In spite of what these writers claim, there is evidence in the myths themselves that /Kaggen was *in some circumstances* thought of in his insectiform manifestation. During the course of many of the /Xam trickster tales /Kaggen "grows feathers" and escapes from the scene of his predicament. That in these numerous flying episodes he was being conceived of as a mantis and not as a bird or goblin is indicated by a passage from the story of /Kaggen and the Ticks' Sheep. Speaking of a future time, /Kaggen says,

You, the Ichneumon, shall then go to dwell in the hills with your mother. She shall truly become a Porcupine, she shall live in a hole, while Grandmother Dasse shall live in a mountain den, for her name is really "Dasse". I shall have wings ["shall get feathers" in MS L.II. 33.2986], I shall fly when I am green, I shall become a little green thing. You, the Ichneumon, shall eat honey, because you will be living on the hill (Bleek, 1924, p. 33).

Each member of /Kaggen's family is to become the creature which his or her name suggests and is to dwell in surroundings appropriate to those creatures. /Kaggen's wife /Huntu!katt!katten, will become a rock rabbit or "dasse"; !Xo will become a porcupine; their son, /Ni, will become a type of mongoose. This passage makes nonsense of the suggestion that Bleek was uncertain of the translation of these names (Pager, 1975a, p. 66), and, in view of the evidence that /Han≠kassō actually identified a praying mantis as "/Kaggen" (L.VIII. 9.6770), it seems certain that the "little green thing" that flies is indeed that insect.

The praying mantis also becomes one of /Kaggen's manifestations in other circumstances. In the story of /Kaggen's visit to the Lion's house (Bleek, 1924, pp. 15-18), the Lioness "stood upon the Mantis to crush him". To escape he "got feathers" and "flew up into the sky". *At this point in the tale* it seems that the narrator was thinking of an insect being trampled upon rather than, as Schmidt suggests, a goblin. Another instance in which the anthropomorphic form grades into the insect is in the observances attendant upon the shooting of a hartebeest which I described in Chapter Five.

A clue to the solution of the problem of the relationship between /Kaggen and the insect of the same name seems to me to lie in San ideas about omens and oracles to which Schmidt draws attention. The earliest reports concerning the Khoisan and the mantis suggest that the insect was thought of as ominous, either, as Schmidt points out, good or bad. Kolben (1731, I, p. 98-99), a writer whom Le Vaillant (1796, p. II, p. 316) considered "as dogmatic as ignorant", described this belief concerning the mantis in characteristically extravagant terms:

The arrival of this Insect in a *Kraal*, brings Grace and Prosperity to all the inhabitants . . . If this Insect happens to alight upon a *Hottentot*, he is look'd upon as a Man without Guilt, and distinghish'd and reverenc'd as a Saint and the Delight of the Deity ever after.

Thunberg (1796, I, p. 65), generally a more conservative writer, denied that the "Hottentots" worshipped this insect, but confirmed Kolben's report that the creature was regarded as a good omen:

It was certainly held in some degree of esteem; so that they did not willingly hurt it, and deemed that person or creature fortunate on which it settled, though without paying it any sort of adoration.

These reports together with others cited by Schmidt show that in certain circumstances the mantis was regarded as an omen. These circumstances comprised mildly unusual occurrences like the creature's flying into a hut (Kling, 1932, p. 41) or alighting on a person (Hahn, 1881, p. 42). In Chapter Five I referred to the belief that the mantis's appearance on a hunter's quiver was taken by the San to mean that he had successfully wounded a hartebeest; Hahn (1881, p. 84), in a very similar report, notes that a Khoikhoi hunter believed he would be successful if a certain kind of mantis crept onto him or onto his weapons. Such events involving the movement of a creature from its usual place in nature into the human sphere are in Africa widely interpreted as ominous. In its natural surroundings the insect may be unremarkable; out of those surroundings it assumes an ominous significance which some Khoisan people regarded as bad, others as good. Schmidt (1973, p. 110) explains this apparent contradiction by citing Köhler's (1966, pp. 160-161) interpretation of the Kxoe word *tçô* which means not only "medicine" but also everything which is taboo or forbidden. An informant's application of this concept to the mantis could easily be misunderstood by westerners who tend to think of omens as only bad. Different individuals as well as different groups of people do, in any case, regard the same omen as good or bad: the important point to note here is the widespread agreement among Khoisan people that the mantis was, in certain unusual circumstances, ominous.

It is but a short step from omens to oracles: if a creature may of itself be ominous of future events, the possibility exists that it could be approached to provide the desired information. It was the approaching of the mantis as an oracle that, I suggest, gave rise to the European's belief that it was "worshipped". Kolben (1731, I, pp. 98-99) describes "Hottentots" singing and dancing around the insect and "throwing to it the Powder of an Herb they call *Buchu*". This incident is very similar to an account of a Khoikhoi practice obtained by Schmidt (1973, p. 112). She was told that the people sat on their haunches around the mantis while the medicine man *(!gai-aob)* enquired of the insect whether rain could be expected. These and other similar reports describe customs which could easily be misunderstood to express worship of the mantis, but were in fact a questioning of an oracle: the oracle was approached in certain standardized postures which perhaps involved kneeling before it (quite simply because the creature was on the ground or a low bush) and speaking to it, which practices together the Europeans interpreted in terms of their own culture as "worship". It was, I believe, the mode of consulting the oracle that gave rise to the popularly held belief that the mantis was the "Hottentot god"; the phrase was not maliciously invented by the settlers to denigrate the Khoisan, as has been suggested, although it may subsequently have been used in this way.

The manner in which the mantis oracle responded to the questions put to it involved upward and downward movements. In the account obtained by Schmidt the creature was thought to raise its forelegs if rain could be expected and to lower them if the drought was to continue. The same up/down movements are described by van der Post (1971, p. 148) in a report also cited by Schmidt. Although the van der Post report is possibly much garbled, it may, if seen in the context of other reports, be deemed to contain remnants of traditional beliefs concerning the mantis and the manner of its response to oracular questioning. The head movements of the mantis feature again in a comparable report by Holm (1965, p. 51), also cited by Schmidt.

The eye and head movements of the mantis are indeed one of its numerous peculiar characteristics: it fixes one with an implacable gaze and moves its head in an uncanny manner. This characteristic of the mantis is shared by another otherwise quite different creature, the chameleon, which watches its prey with intense, revolving eyes. It is, therefore, not surprising to find that the chameleon was another San oracular creature and was questioned to ascertain whether rain would fall. It responded with upward and downward movements of its eyes (Smith, 1939, I, pp. 163-164; Bleek, 1936, pp. 135-136). A further characteristic that the chameleon shares with the mantis is that the San considered it to be "poisonous" (L.II. 1.195). It was also, like the mantis, thought to be ominous.

In addition to the mantis and the chameleon, a further creature seems, again by virtue of its curious head movements, to have been a San oracle. Arbousset's (1846, p. 255) translator represents him as saying that the Maluti San "worship an insect of the caterpillar tribe, the *caddisworm*". The ensuing account, however, describes the creature *(N'go)* as living, not in water as caddisworms do, but on bushes and in the veld. It seems that the bag or basket worm is what Arbousset intended. This creature constructs for itself a case of small pieces of grass out of which it extends its head when it seeks food. Before setting out on hunting expeditions the Maluti San

questioned this insect; if it moved its head in a semicircle, it signified that the hunter would be successful. Like both the mantis and the chameleon it was said to be "poisonous". Ellenberger and Macgregor (1912, p. 7), in their account of San religion, depend largely on Arbousset's work, but they have changed the translation of *N'go* to "praying mantis"; I do not believe that they had any authority for this change other than the popular legend of the "Hottentot god".

It appears, then, safe to assume that, as Schmidt suggests, the mantis was one of a number of oracular creatures for *some* Khoi and for *some* San. Those early reports which deny that the Khoisan held the mantis in any regard (e.g. Sparrman, 1789, I, p. 150) are not necessarily contradictory. As with omens, people entertain individual preferences in divination and oracles. The mode of interview employed by the early travellers, generally brief and unsatisfactory, would, in any case, fail to elicit the gradations of the /Kaggen concept. Even more recently the failure to distinguish between divination and divinity appears to have been the cause of this type of confusion. Gusinde (1966) quotes a San woman's indignant comment recorded in a mission report—if, indeed, the report may be believed:

The white people there, who call themselves Christians, told us that the God who had created heaven and earth is not our God. They showed us a sort of fly which they called the Hottentot God and they said: "Look that's your God" (translation by Pager, 1969, p. 76).

Christians speak of Christ as the Lamb of God and even address him as Agnus Dei, but they do not, except in certain contexts such as stained glass windows, picture him in that form or maintain any ritual relationship with lambs. A Christian would also be indignant if a lamb were pointed out to him with the observation, "Look, that's your God." To say Christ is the Lamb is not identical with the statement, the lamb is Christ. Because an oracular creature has the same name as god, it does not follow that all members of the species are incarnations of god.

Something of the relationship between the insect used in divination and the divinity, which among many Khoisan groups shared the same name, may be inferred from Arbousset's report. According to Arbousset the Maluti San believed that /Kaggen was the "Master of all things"; they explained that "one does not see him with the eyes, but knows him with the heart" (Arbousset, 1846, p. 253). He was said to be "worshipped in times of famine and before going to war" and was thought to give or refuse rain and game. The "worship" of which Arbousset writes here is again probably largely consultation in unpredictable circumstances, as indeed are all the situations given by the informant. In the "prayer" which Arbousset records, the hunter, appearing to address the bagworm, says, "Lord [Kaang], lead me to a male gnu" (Arbousset, 1846, p. 256). Here, I suggest, it is /Kaggen, "The Master of all things", who is being addressed, not the insect *(N'go)*; the hunter placed himself before the insect, because it was through the head movements of the insect that /Kaggen gave his answer.

A further element is introduced here by a shift from divination of the future to control of the future; /Kaggen can not only foretell the outcome of the hunt, but he has the power to "bring a male gnu under my darts" (Arbousset, 1846, p. 256). /Kaggen is able both to predict and to intervene in mundane affairs, and so he moves from the sphere of divination to divinity. One of the most important areas of "unpredictability" for the San is hunting. I have already referred to some San practices of divination in hunting; now I turn to the way in which /Kaggen was thought to exercise his mastery of "all things".

Although the San "prayer" recorded by Arbousset beseeches /Kaggen to grant success in the chase, it appears that, for the most part, /Kaggen was on the side of the antelope. In Chapter Five I described the /Xam beliefs concerning a hunter who has shot an eland: the link between the man who has wounded an antelope and the animal itself means that the man should walk slowly, limp and generally behave as if he were the wounded buck. During this period of unpredictability and doubtful outcome, /Kaggen, in order to secure the escape of the wounded antelope, tries to "trick" the hunter. /Kaggen cannot prevent the death of the animal: he is not omnipotent; but he can distract the hunter and cause him to break the link between himself and the wounded animal. Once this link has been shattered, the prey can escape.

To accomplish this end /Kaggen, the intervener, as /Han≠kassō explained in this Guy Fawkes analogy, is able to change his form at will. This is seen in a number of accounts. To distract the gemsbok hunters /Kaggen transformed himself into a hare: if the hunter kills the hare, the gemsbok will recover from the effects of the poison (Bleek, 1924, p. 12). Something of this belief may also be reflected in //Kábbo's otherwise enigmatic confusion: "I felt that I had not seen a springbok.

For, I saw a hare'' (Bleek and Lloyd, 1911, p. 311).

I have already described the circumstances under which /Kaggen becomes a louse and irritates a hunter who has wounded an eland; if the man kills the louse ''its blood will be on his hands with which he grasped the arrow when he shot the eland, the blood will enter the arrow and cool the poison'' (Bleek, 1932, p. 236). In Dorothea Bleek's published version of this instance of /Kaggen's intervention on behalf of an antelope, the louse is said to be ''vermin''. The /Xam word was actually translated for Lloyd by the informant as ''slechte ding'' (bad thing; L.V.17.5343 rev.). This phrase recalls the !Kung phrase *chi dole* (*chi*, thing; *dole*, bad) which they apply to mantises (Marshall, 1962, p. 222). As Schmidt (1973, p. 110) suggests, the !Kung phrase probably derives from the idea of ''medicine'' which can be both good and bad. The louse was not ''vermin'', as Dorothea Bleek has it, but, because it was a manifestation of /Kaggen, something ''forbidden'' or dangerously imbued with the supernatural potency I described in Chapter Seven.

The close identity between /Kaggen as an intervener in the form of a louse, a hare or some other creature in unpredictable circumstances and /Kaggen the trickster figure whom the early writers called ''the devil'' is illustrated by the words used by the informant in speaking of the louse: /Kaggen ''is trying to *cheat* him'' and /Kaggen ''seems to be *teasing* us'' (Bleek, 1932, p. 236, my italics). Indeed, it seems to me that the so-called ''trickster'' element in the /Xam /Kaggen concept may have had its origin in beliefs concerning /Kaggen's ''tricking'' of a hunter; the /Xam tales of the ''trickster'' type probably

developed from the hunting context. This is probably the correct interpretation of //Kábbo's statement that /Kaggen turns a hungry man's thoughts to a farmer's ox. /Kaggen is not the Devil tempting the hunter to ''commit a sin''; he is protecting his antelope by diverting the hunter's attention to creatures for which he is not responsible; it is another of /Kaggen's tricks.

In the hunting situation with which I have so far dealt /Kaggen's intervention has been on the side of the animals and against man. He does, however, occasionally intervene in unpredictable and dangerous situations on behalf of man. This is an aspect that is not generally acknowledged. Bleek (1874, p. 11) thought /Kaggen was

a fellow full of tricks, and continually getting into scrapes, and even doing purely mischievous things, so that, in fact, it was no wonder that his name has sometimes been translated by that of the ''Devil''.

Had Bleek lived to read the large amount of material collected by Lloyd after his death, I believe he would have revised this judgement. Although the benign intervener appears in fewer /Xam myths he is nevertheless present. An example of this type of tale is the story of the !Kwai-!Kwai bird (Bleek, 1924, pp. 45-46). In this tale /Kaggen saves the children from the malicious !Kwai-!Kwai bird, who was a man at the time, and roasts him on the fire. ''He, the Mantis, he who was grown-up, stayed with the children, he did not let one of the little children be burnt.'' This was so unusual that the informant added the following observations, indicating that he recognized that this tale had a different structure from those he had previously given Lloyd:

Yet his wife had often told him, that he was not like a grown-up person, but as if he had no sense, because he used to get feathers and fly away when he saw danger, that people seemed to be going to kill him; he used to go into the water which is opposite the hut. Then he would walk out of the water, he would walk up to the hut (Bleek, 1924, p. 46).

In an unpublished tale, probably a variation of the above, /Kaggen dreams of impending danger and warns the people of the coming of the /Kain /Kain bird who molests young girls (L.VIII. 3.6271-6303). The bird stabs girls in the breast and smells their blood which he puts on his nose; because of this, his nostrils are red. As a result of /Kaggen's warnings, a girl is armed with a knife and she manages to stab the /Kain /Kain bird who then flees. Perhaps Lloyd realized that she was hearing something unusual and asked a question about /Kaggen's thoughtful behaviour, because, at the end of the tale, the informant entered upon a very long discourse in which he emphasized again and again that /Kaggen does not always play tricks: ''He is not now deceiving us, for he has spoken the truth.''

This remark implies that /Kaggen often does trick or deceive people with his interventions, but he also sometimes intervenes on their behalf. The informant realized the /Kaggen's behaviour could be regarded as inconsistent, but he, nevertheless, recognized and even defended his essential unity: it seems clear that the /Xam originally believed in one capricious being, not two as the informant Kina-ha stated in the remarks I have already quoted.

The situations of unpredictability in which /Kaggen intervened favourably in the two tales to

which I have referred contain elements not present in the hunting context. In these tales people are not only in a situation of doubtful outcome; they are also being threatened and are in grave danger. It is, I believe, essentially the quality of uncertainty combined with danger that made /Kaggen's presence in the thunderstorm apposite in the thought of the southern San. This association is apparent in the earliest reports. Sparrman (1789, I, p. 148) found that the San of the Sneeuwberg thought that the "evil being" in whom they believed brought the thunderstorm. Thunberg (1796, II, p. 163) confirmed this belief and added that the San cursed the storm (see also Dornan, 1909, p. 443). That the danger of the storm was thought to arise from /Kaggen's capricious behaviour is clearly reflected in the beliefs of the Lake Chrissie southern San:

The living Batwa still remember how their mothers, when the lightning was in the skies, told them to hide until the dangerous games played by /a'an was over (Potgieter, 1955, p. 29).

The Maluti San likewise believed that /Kaggen had control of the thunderstorm; this is seen in a tale recorded by Orpen (1874, pp. 8-9).

Other phenomena of the heavens were also associated with /Kaggen. Two of Bleek's informants independently declared /Kaggen to be in the rainbow (Bleek, 1924, p. 60; L.II.22.1974 rev.). The /Xam further addressed "prayers" to various heavenly bodies, particularly the moon (Bleek, 1929b, p. 306), whose waxing and waning represented to the Khoisan the possibility of life after death. The moon was one of /Kaggen's creations: according to one myth it was created from his shoe

(Bleek, 1924, p. 5), quite possibly made from a piece of eland hide (Bleek, 1929b, p. 308; see also Sparrman, 1789, II, p. 156), and in another from a feather which /Kaggen had used to wipe the eland's gall from his eyes (Bleek, 1924, p. 9). In the version collected by von Wielligh (1921, I, pp. 97-100) /Kaggen made the moon from his shoe and a piece of ice.

The moon was believed to be only one of /Kaggen's many creations. In the Qing tales he appears as a more fully developed creator divinity who "caused all things to appear, and to be made, the sun, moon, stars, wind, mountains, and animals" (Orpen, 1874, p. 3; see also Potgieter, 1955, p. 29). Campbell (1822, I, p. 29) reports that the San whom he met believed that /Kaggen had "made everything with his left hand". It was, I suggest, particularly in the creation myths that Bleek and Lloyd were in greatest error in translating /Kaggen as "the Mantis". The book *The Mantis and his Friends* (Bleek, 1924) contains different classes of folk tales: creation myths, intervention tales and remarks derived from both of these. It was unfortunate that Dorothea Bleek did not attempt to draw a distinction between them when she prepared them for publication.

The southern San myths indicate that among /Kaggen's most important creations are the large antelope; of these, the eland and the hartebeest are his favourite animals. His creation of the eland is recounted in three /Xam versions (Bleek, 1875, pp. 6-7; Lloyd, 1889, p. 5) and one Maluti version (Orpen, 1874, pp. 3-4). He also gave the antelopes their characteristic colours through the medium of different kinds of honey (Bleek, 1924, p. 10). In both the /Xam and the Maluti tales the antelope are created in a hierarchy with the eland at the

top—a pattern I found to be repeated among the !Kung. The hierarchy was explicitly described by /Han≠kassō:

People say that the Mantis first made the Eland; the Hartebeest was one whom he made after the death of his Eland. That is why he did not love the Eland and the Hartebeest a little, he loved them dearly, for he made his heart of the Eland and the Hartebeest. The Gemsbok was the one whom he did not love so well, yet he was fond of the Gemsbok (Bleek, 1924, p. 12).

In all the versions of the creation myth the point is repeatedly made that /Kaggen loves the eland very dearly. In //Kábbo's version (Bleek, 1924, pp. 1-5) we are told that, when the first eland had been killed by the meerkats, /Kaggen "took his kaross, he covered his head over, he returned home weeping". /Han≠kassō said that /Kaggen considered the eland to have "no equal in beauty" (L.VIII.6.6540), and Diä!kwain dwelt on /Kaggen's grief when he found the eland dead (L.V.1.3648). In the Maluti version /Kaggen was "very angry" when he saw the eland had been killed (Orpen, 1874, p. 4).

Arising out of /Kaggen's creation and love of the eland is his desire to protect the antelope from the designs of the hunter by means of the ruses and "trickery" I have already described. In the Maluti version of the eland creation myth, Qing explained how /Kaggen secured the escape of the eland by saying that he was in the bones of the eland, and /Han≠kassō told Lloyd quite clearly that /Kaggen "does not love us, if we kill an Eland" (Bleek, 1924, p. 12). These remarks reflect the close association between the creation myths and beliefs concerning /Kaggen's foretelling the

outcome of a hunt by means of an oracular creature and then, at another level, his intervention in that unpredictable activity: /Kaggen the divinity is not far removed from the /Kaggen of divination *even in the creation myths.*

Although /Kaggen attempts to intervene on behalf of the eland by "cheating" or "tricking" the hunter, both the /Xam and the Maluti versions of the creation myth seem to emphasize a point to which I have already referred: /Kaggen was not thought to be omnipotent. He creates and loves the eland, but he also allows man to hunt the eland *under special conditions.* In the Maluti version these conditions appear to involve the use of poisoned arrows. I suggest that /Kaggen is here concerned with maintaining a balance between man and antelope. Man cannot always be successful in his attempts to kill: the outcome of the hunt is capricious but not inevitably adverse. Man, in this crucial area of San life, does not always have the edge over the antelope of /Kaggen; he is unable to push the balance too far in his own favour. If he does, /Kaggen redresses the equilibrium. The delicate balance between what I have shown in Chapter Eight to be two equally undesirable conditions, famine and glut, is maintained, in this context, by /Kaggen.

It is through the series of subtly shifting concepts I have now described that I believe /Kaggen assumes the centrality in southern San thought which Arbousset's (1846, p. 253) informants summed up in the phrase "Master of all things", the divinity who maintained the equilibrium between man and nature. The "Master of all things" was felt to be ever present, even as the unpredictability of life is always present. He was described by the Maluti San as one who is not seen with the eyes, but who is known with the heart (Arbousset, 1846, p. 253). This phrase is paralleled in a striking way by an unpublished remark by //Kábbo who told Lloyd that /Kaggen "can be by you, without your seeing him" (L.II.27.2463 rev.). He was a pervasive, omnipresent, protean presence inhabiting the crucial areas of San life, not a goblin, as Schmidt (1973) suggests, or a crudely conceived mantis as so many writers have supposed (e.g. Klingender, 1971, p. 14). The concept of /Kaggen is, thus, like so much of San thought, shifting and elusive: it is very difficult, indeed impossible, to express the San beliefs in single English words without serious distortion. The kaleidoscopic nature of /Kaggen doubtless accounts for the early writers' failure to comprehend what their informants were telling them. Arbousset (1846, p. 253) confessed that he did "not know exactly what they profess to believe" and Dornan (1909, p. 443) concluded that "the exact meaning of [/Kaggen] cannot be determined".

It was the resulting gross rendering of the subtle San concept as "the Mantis" that has led many rock art workers to seek depictions of the praying mantis in the paintings. If "the Mantis" was the most important figure in the southern San mythology, as the Bleeks suggested, then, some writers have reasoned, he must be represented in the rock art. Indeed, for some years there have been reports of paintings which their publishers claim depict /Kaggen in the form of a mantis.

Johnson (1910, Fig. 35) illustrates a painting from Bestervlei near Fouriesburg which, he says, represents a "myth-mantis". Rudner (1957, plate xxvi), in a paper on the more distant Brandberg, illustrated "a kind of human praying mantis in faded red". Later he again illustrated the same painting, but, doubtless after a period of reflection, admitted that only "by stretching the imagination" could it be related to a mantis (Rudner, 1970, p. 205, fig. 8; see also Rudner, 1956, for the same painting). How (1962, p. 28) presents two paintings from Lesotho which she claims represent praying mantises, but she does not discuss them. I reproduce one of these paintings in Fig. 39.

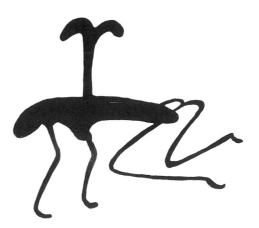

Fig. 39. Ralehlatsa, Lesotho.

A dance group at Orange Springs, Ladybrand, first published by Tongue (1909, plate xxxvi) has been described as a "mantis dance" by Battiss (1948, p. 219; see my Fig. 40). Willcox (1963, p. 16) goes further and suggests that the figures in this painting are wearing "mantis masks". The Orange Springs group of dancing men and clapping women is in a number of ways very similar to the curing dances I described in Chapter

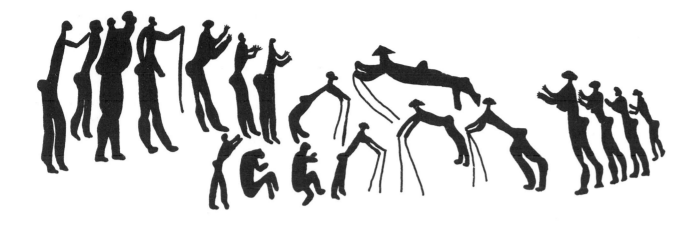

Fig. 40. Orange Springs, Ladybrand.

Seven, but !Kung informants, shown my copy of the painting, said that the rather distinctive way of holding the sticks is called "the mantis" (Wilmsen, pers. comm.). The !Kung do not seem to have a mantis medicine song and the mantis posture is not sustained throughout a dance; it may be adopted for a while during the course of any curing dance. Although they call the mantis "the messenger of god", the dance does not exploit the power of the mantis and the people are certainly not worshipping the mantis when they dance in this fashion. Nevertheless, it is possible that the southern San who accorded the mantis more attention and respect than do the modern !Kung, did have a Mantis Dance which harnessed the power of the praying mantis in the same way that the Eland Dance is associated with the potency of that antelope; it is also possible that the Mantis Dance was especially characterized by

the dancing position the !Kung still call "the mantis". This view is strengthened by /Han≠kassō's statement that //Kábbo "had manitses" (Bleek, 1936, p. 143). Like the modern !Kung who can in fact possess more than one medicine song, //Kábbo probably possessed the power of mantises, and, when his band "danced mantis medicine", it is very probable that the posture identified as "mantis" was prominent in the dance steps. The Orange Springs painting and some others like it (Battiss, 1939, plate 20; 1948, p. 155) may therefore depict a Mantis curing dance, but it does not follow that the southern San worshipped /Kaggen in the dance; such an idea is quite foreign to San thought.

The identification in the rock art of depictions of praying mantises is altogether another matter; I do not find any of them convincing. Whatever else may be claimed, it cannot be said that they are

numerous. Even if some of the paintings are indeed of oracular mantises or /Kaggen in that manifestation, the extreme dearth of examples indicates that it could not have been an important theme in the art.

If the presence of /Kaggen is to be detected in the rock art at all, it is certainly not in the form of what I have suggested is a gross rendering of an elusive concept. I propose we should examine another suggestion derived initially from the "creation" and "intervention" beliefs of the southern San. Here, as in other areas of San thought, there is a subtle shift of meaning. First, /Kaggen creates and loves the eland; secondly, he intervenes in order to save the eland. Then we learn that he is in the eland's bones and, finally, in the tale about his defeat of the eagle, he actually assumes "the form of a large bull eland" (Orpen, 1874, p. 9). There is a progression from creation to epiphany. This is not to say that all eland, or paintings of eland, should be seen as manifestations of /Kaggen; that would be a naive suggestion. The relationship is, I believe, better expressed in the celebrated reply which Qing gave to Orpen's (1874, p. 3) question, "Where is /Kaggen?"

We don't know, but the elands do. Have you not hunted and heard his cry, when the elands suddenly start and run to his call? Where he is, elands are in droves like cattle.

Vinnicombe (1976, p. 177) rightly uses this reply to show "the close association between the Bushman's creator deity and eland", but she does not analyse the statement in any detail. There are, however, certain elements in the statement which

require emphasis. First, it should be noted that in response to the question concerning /Kaggen's whereabouts, Qing did not nominate or describe a specific place like the sky; instead he significantly referred to the hunting context in which /Kaggen "cheats" or "tricks" the hunter. It is in this unpredictable *situation* rather than *place* that /Kaggen is to be found, the situation in which man's powers are in the balance and in which, do what he may, he cannot achieve certainty. At this time both hunter and eland hear /Kaggen's call. /Kaggen has intervened on behalf of his favourite and the hunter has again been "cheated", "teased" and "tricked". Then, in the second part of the statement, I suggest Qing went on to explain why /Kaggen behaves in this manner. His explanation is in terms of the Maluti eland creation myth which presents /Kaggen as the creator and protector of the eland, as do the /Xam versions, but which also goes further and explicitly associates /Kaggen with vast herds of eland: "Then they churned and produced multitudes of eland, and the earth was covered with them" (Orpen, 1874, p. 4). The amassing of multitudes of eland forms a "base" from which /Kaggen operates rather than a geographical place; he creates, loves, indwells and protects all the vast numbers of eland that inhabit the earth.

Qing's phrase, "in droves like cattle", inevitably recalls for me the profusion of eland paintings in the rock shelters. Perhaps the depiction of so many of /Kaggen's favourite antelope created an ambience in which the closeness of /Kaggen, "the Master of all things,

invisible, but known to the heart", could be most acutely felt. The San believed, in //Kábbo's phrase, that "he can be by you, without your seeing him". The many paintings of eland, over and above the associations I have discussed in previous chapters, possibly enabled this belief to be translated into visual terms: the paintings may have helped the San viewers to see what they believed. The concept of /Kaggen and his vast herds was, in terms of this suggestion, moving from one dimension, belief, to another, graphic depiction, in the same way that I have already suggested the !Khwa concept shifted from the zoomorphic image to the painted symbol.

Along with the transference of this idea to the level of graphic depiction there went, I believe, another part of the /Kaggen concept. The depiction of antelope could, in terms of the concepts I have described in this chapter, be said to be the depiction of uncertain relationships and enterprises of unpredictable outcome. It is, I suggest, principally in this uncertain, risky relationship that /Kaggen "lives, moves and has his being". The paintings are not, in this view, icons of antelope, but symbols of the uncertain relationship which was the essence of San hunter-gatherer life and in which, as Qing eloquently implied, /Kaggen is to be found.

In saying this I do not wish to exclude simpler issues. /Kaggen loved the eland and admired its beauty: the San doubtless did the same. My suggestion that the paintings may have been symbols of the concepts I have described does not

deny the very real possibility, even probability, that the San delighted in and admired the sensitive eland paintings for their beauty and technical excellence; but, conversely, such admiration certainly does not exclude, as many writers imply, the possibility that at least some of these aesthetically pleasing symbols communicated to their original San viewers some of the complex associations that I have described.

The great plethora of eland paintings have behind them, I believe, all the sets of associations I have outlined in the preceding chapters; to these multiple associations I now suggest be finally added the elusive /Kaggen concept. Divination and divinity are part of the "mental processes" which lie behind the painted symbols and from which, as Griaule (1950, p. 5) rightly observed in connection with African art, it would be "as dangerous as it is absurd" to separate them. The eland was, in southern San thought, inextricably bound up with all the facets of the complex "/Kaggen concept"; to insist that the paintings be shorn of these "mental processes" and treated as if they were all merely iconic scale models, "innocent playthings", to delight an appreciative audience would be wilfully obscurantist. The nature of the relationship between what I have called the eland symbol and the "mental processes" associated with it is, however, a complex matter which I have so far largely ignored to avoid impeding the discussion. I have reserved this and related problems for consideration in the next and final chapter.

Chapter 10

At the beginning of this enquiry I questioned the value of linguistic semiology in the analysis of visual symbolism because it implies false similarities between language and other forms of communication. One of these implications is that it should be possible, if the worker is sufficiently ingenious, to substitute systematically certain "meanings" for each symbol in all contexts, just as one can in language replace a word by a definition. But, as Sperber (1975, p. 13) has asserted, "symbolism has no semantics comparable to that of language", and I am persuaded by some of the arguments which lead him to this assertion. However, my rejection of linguistic semiology obviously leaves some major problems unresolved. One of them is my suggestion that the eland is not a symbol in one context only, but that, through its appearance in a number of seemingly disparate contexts, it is a "central" symbol.

If we allow that the eland is a central symbol, we would still want to know what it (centrally) symbolizes. Consistently with his general position, Sperber disposes of this issue by denying that a central symbol has a single meaning which can be discovered and expressed as linguistic semiology implies. Indeed, he specifically considers and rejects the approach followed by Turner (and in part by this book) on the grounds that the exegesis of a symbol produces not meaning, but further symbols. Sperber (1975, p. 15) allows that Turner is correct in noting that symbolic phenomena are regularly paired to commentaries, to proper uses, to other symbolic phenomena and that symbols are frequently interpreted by their users; but he questions whether these pairings are as regular as a linguistic semiotic would assert and whether they do indeed constitute interpretations of the symbols. In Sperber's view the interpretation of a symbol may, in turn, be interpreted: "Symbols are not signs. They are not paired with their interpretations in a code structure. Their interpretations are not meanings" (Sperber, 1975, p. 85). Symbol stands, in fact, behind symbol in an infinite regress; a central symbol cannot therefore have a central meaning.

My field work amongst the !Kung did show examples of the tendency identified by Sperber to replace one symbol with another. When, for instance, I asked !Kun/obe why the !Kung performed an *Eland* Bull dance, she replied:

The Eland Bull dance is so called because the eland is a good thing and has much fat. And the girl is also a good thing and she is all fat; therefore they are called the same thing.

In response to my question she did not "decode" the "eland symbol"; instead the highly generalized reference to a "good thing" is immediately linked to yet another specific symbol—fat. Beyond

this symbol-behind-a-symbol she did not go. Both the eland and the girl are fat and both of them are "good things"; consequently the eland is an appropriate element in that context. !Kun/obe did not say that the eland was a symbol of the girl or of anything else. This example suggests that Sperber may be right in arguing that we cannot get at the meaning of a central symbol by some "decoding" procedure.

An analysis of the eland or any other central symbol should rather begin in a modest and empirical way by pointing to its associations in the variety of contexts in which it recurs. That is, a partial answer to the problem of the meaning of a central symbol may lie, as Lowie (1952, pp. 277-301) usefully indicated long before the development of more pretentious procedures, in a comparatively simple process of association of ideas (see p. 6 above). He pointed out that if an item repeatedly appears in a certain context it can acquire symbolic value and evoke an image of the context which is its regular concomitant. It would follow that if it repeatedly appears in a variety of contexts, it would evoke all or some of those contexts, even in isolation from any of them.

This, I suggest, is the case with the eland; through its regular appearance, either as an animal or as a metaphor, in such seemingly disparate contexts as, for instance, girls' puberty and trance, it acquired symbolic status and, through its associations, recalled to San minds those contexts and the values associated with them. If the eland as a central symbol does indeed bring to mind a variety of contexts, the next question to ask is why the San made the particular associations which together give central symbolic value to the eland. Much of the argument of the foregoing chapters has dealt

with this issue; I shall not therefore rehearse the material here, but merely indicate two ways in which the eland seems to have acquired, through association, symbolic value. That is, instead of searching for the meaning of the symbol, I look for the motivations or reasons why it was selected by the San to recur in a variety of situations. These motivations or reasons for its recurrence are unlikely to be the same in each situation, as indeed the very diversity of the contexts suggests.

One class of motivations seems to derive from fairly direct associations of ideas: the San perceived a more or less immediate relationship between some aspect of the eland and some human experience. In Chapter Seven I described such a direct association between the particular behaviour of a dying eland and a medicine man "dying" in trance. Similarly, the eland's independence of running or standing water might have suggested that it was, in itself, a source of water. In other motivations, however, the association is less direct: the symbol is not immediately associated with its concomitant as in the clearly visual associations of trance, but by an intervening link. !Kun/obe's remark about girls at puberty is an example: fat is the link between the girl and the eland. The eland does not of itself directly recall a girl at puberty; as !Kun/obe implied, the possession of much fat is the link by which the eland comes to be associated with the context of girls' puberty.

These associations, whether direct or indirect, were, I believe, conscious; the San were (and in some cases still are) aware of them and could, as both the art and the ethnography suggest, explain them. Such associations, which I have derived from the San themselves and from the ethnography, may be related back to the problem of

"meaning" by treating them as the equivalent of what Hanson (1975, p. 10) has called "intentional meanings"; these he defines as conscious explanations of behaviour—explanations of which individual actors are aware. This definition seems to comprehend the notion of "associations of ideas" which I have derived from Lowie: such associations are intended by the actors.

Having connected direct and indirect associations in specific contexts to Hanson's "intentional meanings", I can now return to the wider question posed by this book: does the central symbol of the eland have a central meaning over and above the intentional associations to which I have so far confined my attention? I start to answer this question by first pointing out an important result of the recognition of a variety of associations in a set of seemingly disparate contexts. There can be no bedrock of meaning down to which we can excavate: any "central meaning" must be obtained, as Sperber has shown, in a manner other than the exegesis of symbols-behind-symbols. The question has, therefore, to be posed in another way: can the intentional meanings, put together and seen as a whole, be said to imply a "central meaning"? If the recurring central symbol in any way summarizes its manifold contexts, just what does this summary say? That is, can we construct what Hanson has called an "implicational meaning", by which he understands the "meaning intrinsic to cultural institutions of all sorts" (Hanson, 1975, p. 10)? Implicational meanings are not necessarily apprehended or expressed by members of the culture.

The temptation to propose such a comprehensive implicational meaning is great; it provides a satisfying conclusion to a study and implies that we

have in some way reached the end of the road. Willis (1974, p. 8), for instance, discusses central animal symbols in three societies and believes it is possible to discover the (implicational) meaning for each society of the man-animal relation; these meanings, he says, are "the meaning of life". The ox, he claims, symbolizes for the Nuer "transcendence of individual personality in pure, inner selfhood"; the pangolin, in the case of the Lele, symbolizes "transcendence of individual differentiation in pure communication"; and the python symbolizes for the Fipa "pure becoming or developmental change, both social and personal". Willis, in stating these implicational meanings, has actually succumbed to the temptation to reach symbolic bedrock. But to allow such comprehensive implicational meanings as those proposed by Willis is, I believe, mistaken and opens the way to the most far-fetched and abstruse meanings, none of which are empirically verifiable and which are certainly not present in the minds of any informants; such factitious implicational meanings of central symbols are indeed nothing but elegant delusions.

Those who enjoy deluding themselves may indeed look for some licence to do so from Hanson who makes what has become one of the conventional defences for the imputation of comprehensive implicational meanings. These meanings he likens to grammatical rules: the inability of most native speakers to formulate grammatical rules does not mean that no rules exist; he adds: "our prime source of information on the implicational meaning of symbols is patterns of their use" (Hanson, 1975, p. 98). There is doubtless something in this argument, but not so much as the frequent recourse to it would suggest and certainly not enough to justify what Willis and others have been doing.

For grammatical rules are properly descriptive only of usage: they simply state how the units of language are arranged in certain ways by native speakers. They are not philosophical abstractions of the kind proposed by Willis and others. Grammatical rules of the type "the verb *to be* takes the same case after as before it" are quite legitimate as statements (whatever Chomsky may feel about their descriptive value). It is, however, also possible to formulate a statement of a different, illegitimate order: "In using the verb *to be* speakers transcend the irksome restrictions of the accusative case." Such a statement does not describe what speakers do with language, but imputes a state of mind and an awareness to the speakers of which we can really know nothing; the implicational meanings proposed by Willis and others are, I believe, of this second kind and should therefore be received as the nonsense they literally are.

If, then, I deny the value of this type of implicational meaning, is that the end of my enquiry? I think not, because, if we treat the conventional analogy with grammar more strictly than has often been done, we may agree with Hanson (1975, p. 98) that "we can make statements about the meaning of symbols, statements which are formulations of the regularities in the use of those symbols". Provided, that is, we limit the scope of our statements quite strictly to such "regularities in the use" of the symbol and do not build an elaborate, abstruse statement on them. For a central symbol does seem to mark regular associations among a variety of concepts, beliefs, values and customs; that is, it occurs repeatedly in a number of "intentional" contexts. The implicational meaning of the central symbol consists, then, in all the associations it marks in the various contexts and, moreover, in the associations that its repeated use *creates among the contexts*. The implicational meaning is, therefore, a *totality*, rather than an aggregate of all available intentional meanings.

Yet this "totality" is not one which some process of addition will enable us to formulate as the "central meaning" of the "central symbol". For comprehensive implicational meanings are, I think, essentially unstatable; to try to state them is once again to succumb to the temptation to reach an illusory bedrock. "A representation is symbolic precisely to the extent that it is not entirely explicable, that is to say, expressible by semantic means" (Sperber, 1975, p. 113). The implicational meaning of the eland thus comprises all that animal's associations; it is not in any one of them. The meaning rather lies in an awareness that all the contexts are related and that awareness cannot be expressed in a single statement. In a sense, then, the structure of this book, dealing as it does with the diverse associations of the eland, is the implicational meaning of the eland.

This conclusion may seem less dejecting and evasive if I recall that no one expects a grammar to be reducible to some single proposition; but it still leaves other problems largely untouched. In particular, I have still not considered to what extent, if any, the San themselves may have been "reading" the rock art according to some such grammar. In previous chapters, I may have appeared to suggest that every San viewer and every San painter indeed "read" every painted eland in every shelter in a given way. To correct

any such impression I must now declare that I doubt very much if the San were (or are) much concerned with the "messages", or "meanings" of symbols, certainly not in the way that anthropologists are. Therefore I do not assert that every San artist had in mind all or any of the intentional associations of the eland, let alone the implicational meaning. Often there was probably only a feeling of appropriateness; if an artist had been questioned by one of the early travellers, he might well have replied with the reasonable, but maddening answer experienced by so many anthropologists: "It is our custom." An answer of that sort would not, however, imply that all the paintings were meaningless or simply "innocent playthings". The true situation may be indicated by an analogy with the Christian mass. Every participant is not at every moment continually calling to mind the meaning of every act and gesture; most participants probably do not know the meaning of a great deal of the symbolism and the ritual. But that is not to say that the rituals do not have meanings which they were originally intended to convey and which are intermittently and imperfectly recognized by those who derive comfort from the rite. Indeed, comprehensive understanding is not essential to the efficacy of the rite for any given participant. Similarly, it would be just as wrong and unrealistic to suppose that all San appreciated every significance of every eland painting. Some San may even have misunderstood the meaning, but, as Panofsky (1970, pp. 340-367) has shown in the different but not entirely dissimilar context of the *Et in Arcadia Ego* paintings, that would not destroy the meaning; it would simply substitute another one with its own satisfactions for those viewers.

Moreover, although we cannot make any universal statement about the San response to the art, we can point to evidence in the art itself which suggests very strongly that in many cases the artist, and probably his viewers, did have one of the intentional associations of the eland in mind when he painted that antelope. Those dying eland, for instance, juxtaposed with trance-figures and trance-buck, point very clearly to a conscious awareness by the artist of one of the intentional associations of eland. The trance-buck themselves similarly suggest that San artists were indeed aware of some associations of eland and that certain paintings are directly related to those associations. What the bulk of eland paintings, for which the contexts are still unrecognizable to us, conveyed to their viewers must remain unknown, but I believe it is reasonable, on the evidence presented in this book, to think that many paintings reflected the complex set of associations which constitutes the implicational meaning.

I would, then, make two suggestions about the relationship between the paintings of eland and the contexts in which that antelope was used as a symbol: first, some paintings clearly emphasize at least one of its intentional meanings and, secondly, other paintings may have reflected its comprehensive implicational meaning. But although these suggestions relate the art to other contexts, ritual and mythical, they still leave unanswered the question, why did the San paint at all?

As I tried to show in the first chapter, most previous discussions of this question have been grossly oversimplified: writers offer this or that explanation as though there is a finite range of discrete explanations from which we may choose the one we prefer. This approach has the advantages of clarity and dramatic presentation, but it also has the serious disadvantages of not being true to the complexities of San thought. The range of "theories" from which writers have chosen was not evolved from a study of San thought and belief, but from an ethnocentric point of view. The theories are all of the familiar type: "If I were a San, I should paint eland because they are beautiful or tasty or because it seems reasonable that I could thereby control them." I believe nothing is to be gained from continued presentation of this if-I-were-a-horse approach, that has been so long discredited in anthropology.

Accordingly, I have suggested that we consider instead the actual patterns of San thought. In previous chapters I have referred more than once to the "shifting levels" of San thought: concepts grade almost imperceptibly from the lexical metaphor, to conceptual formulation, to real or imagined rituals, to the "other world" of trance experience. This movement is an intrinsic feature of San (and not only San) thought and it is, I believe, in terms of this feature that the existence of the art can be better understood.

A characteristic of the "shifts" I have described is precisely a movement from the conceptual to the visual. The verbal metaphor of, for instance, the eland in the girls' puberty rituals ("she has shot an eland") is, at a second level, made visual by the Eland Bull dance: the miming and the sounds combine to make the eland metaphor more experiential. Then at a further and to us more enigmatic level the eland finally "materializes" before the eyes of the ritual participants. Similarly, in the curing dance, the trance experience of the medicine men takes the verbal metaphor, "eland *n/um*", and makes it visual: as the man with the

eland medicine dances, he "sees" the eland standing in the darkness beyond the glow of the fire. He also "sees" the transformation of himself and his dancing partners in the manner I described in Chapter Seven. Then these "visual" concepts of the trance experience are, I believe I have been able to show, rendered literally visible on the walls of the rock shelters. The rain-animal provides a further example. Metaphors like the "rain's legs", "the rain's ribs" shift to become a rain-animal capable of use in a real or imaginary ritual, and then, in a final shift, as a painted representation. /Kaggen, too, is no simple concept capable of explanation in terms of our own western stereotypes: he is also an elusive, protean concept with numerous manifestations, some of which are related to the eland.

It is in the light of this characteristic of San thought that we should see the rock art. The paintings are, I believe, another element in one shifting pattern of thought which moves from believing to seeing, the conceptual to the visual. In putting it that way I do not, of course, necessarily suggest that the paintings are the "final stage" of a chronological process; I rather urge that, although each level is distinct in itself, it is not isolated from the other levels. Nor do I suggest that we should subject these levels to that excavating process, which I have already criticized. The implicational meaning of the general

paintings of eland is not to be found ultimately in one or other of the shifting levels. Some paintings certainly reflect what happened at the ritual level, but neither the paintings nor the metaphorical levels should be thought of in a linear arrangement which can be followed until the point of origin is reached. They are, on the contrary, more like a model of a molecule: the atoms are joined in complex interrelationships which do not permit the isolation of one as the ultimate from which the others derive.

From this point of view the traditional explanations for the "motivation" of the rock art appear quite irrelevant, as I believe they indeed are. In answering the simplistic question, "*Why did they paint?*", I reply, not with any theory of motivation, but that visual representation was simply another part of the complex and subtle web of San thought and belief. I do not know "why" they painted, any more than I know "why" they "see" the eland approaching the Eland Bull dance. All I can say is, "This is the way it is in San thought and the content of the art strongly suggests that the paintings belong to the same pattern of believing and seeing". Lienhardt (1954, p. 163), in his study of the Shilluk, notes that there is a Shilluk proverb which says that "the Shilluk only believe what they see": he adds that in their human king they are able to see what they

believe. This rendering visible of a complex set of beliefs was, I suggest, also a function of many of the San eland paintings. But in considering the particular depictions of hallucinatory subjects, we may go even further than Lienhardt and say that these paintings enabled the southern San to see what they believed they could see.

The position which I have merely outline in this chapter does, I think, obviate the danger of reading into the art what is not there. It avoids the delusion of attributing totalities of meaning, which can be expressed in simple terms, to the eland symbol. Instead, I simply point to the numerous associations which, in their totality, constitute the implicational meaning of the eland. Perhaps my gesture will persuade some fellow workers that I am not really inviting them to journey into any especially hazardous "metaphysical realm".

I do not, however, claim to have pointed to *all* possible associations. The process of mutual illumination between the ethnography and the paintings will, I am sure, continue to reveal still further associations as new paintings are discovered, known sites are re-examined and the ethnography is read more perceptively. There is, indeed, no finality to this interpretation of symbolic meanings in southern San rock art and, in that sense, no conclusion to this book.

2. *Deposit and Artefacts in 38 Sites*

	%
No deposit or artefacts	9·6
Deposit only	15·1
Deposit and artefacts	72·7
Artefacts only	3·1

Part 2. Paintings

The following characteristics were noted for each individual representation (for definitions see Vinnicombe, 1967):

Human Figures

Sex:	Male; male ''infibulated''; female; indeterminate; male by bow.
Clothing:	Long kaross; short kaross; apron; European dress; cape; animal; decorated body; decorations on knees or arms; naked.
Equipment:	Bow; quiver; sectioned arrows; plain arrows; pointed arrows; spear/stick; bag/bundle; rope; rope with dots; flyswitch; buck; digging stick; shield; broad bladed spear; knobbed stick; axe; gun; powder horn.
Head type:	Round/triangular; concave; hook; hook with white face; stripes on face; animal; no head.
Headgear:	Knobs; cap; European hat; horns/feathers; hanging flaps or thongs; radiating prongs; animal ears; no headgear.
Special features:	Fingers; toes; eyes; nose; mouth; animal hoofs; wings; tail; body hair; emission from mouth; with young.
Position:	Standing; sitting; lying; walking, running; false action; upside down; bending over; on horse; dancing; squatting; kneeling.
Size:	Recorded to nearest centimetre.
Colour:	White; black; red; orange; yellow; purple.
Technique:	Monochrome; bichrome; polychrome; shaded polychrome; shaded monochrome; shaded bichrome.
Preservation:	Complete; partial.
Scene:	Standing; sitting; on the move; fighting; domestic; dance; ''mythical'', obscure.
Elevation:	Left; right; front; back; twisted.

Animal Representations

Species:	Eland; rhebuck and other small buck; hartebeest; wildebeest; other antelope—specify; baboon; giraffe. feline; bushpig/warthog; indeterminate antelope; elephant; hippopotamus; bird; fish; rhinoceros; snake; bees; dog; cattle; sheep; horse; jackal; ostrich; rabbit; eared or horned serpent; flying buck; mythical animal; other—specify.
Sex:	Male; female; indeterminate.
Special features:	Eyes; nose; mouth; wings/streamers; tufted tail; emission from mouth; carrying young; with young; stripes; dots; ears; saddle; bridle; lines on neck.
Colour:	White; black; red; orange; yellow.
Technique:	Monochrome; bichrome; polychrome; shaded polychrome; shaded monochrome; shade bichrome.
Preservation:	Complete; partial.
Elevation:	Left; right; front; back; above; foreshortening; up; down; diagonally up; diagonally down.
Position:	Standing; walking; lying; running; false action; leaping; upside down; mounted.
Size:	To nearest centimetre.
Hunt scene:	Men with bows; men with spears; trap.

Human Figures (1274; including 54 therianthropes)

1. Sex

	%
Male	16·5
Male ''infibulated''	1·9
Male by bow	8·8
Female	0·3
Indeterminate	72·5

2. Colour

	%
Monochrome:	
red	50·5
white	4·9
black	9·6
Total:	65·0

Bichrome:

red and white	21·7
black and white	1·7
red and black	4·9
Total:	28·3

Polychrome: 6·5

3. Head Types

	%
Round	35·2
Concave	15·8
Hook	18·3
Animal	3·4
Line	3·6
No head	23·7

4. Clothing

	%
Naked	79·4
Long kaross	4·8
Short kaross	10·0
Apron	1·7
Cape	4·1
Decorations on body	10·6
Decorations on limbs	9·4

5. Equipment

	%
Bow	13·4
Arrows	11·1
Bag	3·8
Spear (broad blade)	1·2
Quiver	7·0
Stick	23·1
Digging stick	0·3
Knob stick	2·1

Animals (1023)
1. Species

		%
Antelope:		
Eland	585	61·7
Rhebok	246	26·1
Hartebeest	19	2·0
Indeterminate antelope	97	10·2
Other:		
Feline	10	
Bushpig	6	
Elephant	1	
Hippopotamus	1	
Bird	2	
Fish	1	
Snake	4	
Dog	4	
Cattle	39	
Sheep	1	
Horse	7	

2. Colour

	Monochrome			Bichrome			Poly-
	R	W	B	RW	BW	RB	chrome
	%	%	%	%	%	%	%
Eland	6·0	1·2	1·5	48·2	0·7	0·2	42·2
Rhebuck	19·5	13·0	2·0	44·0	0·8	5·7	15·0
Hartebeest	26·3	0·0	5·3	52·6	0·0	0·0	15·8
Indeterminate antelope	41·2	9·3	6·2	26·8	1·0	7·2	8·2
Cattle	16·2	10·8	29·7	10·8	27·0	5·4	0·0

Symbolic Forms

Therianthropes	54
With antelope heads	42
With hoofs	19
Trance-buck	11
Other symbolic animals	13

Colour of 54 therianthropes

Monochrome	19 (35·2%)
Bichrome	22 (40·7%)
Polychrome	13 (24·1%)

References

Abbott, C. W. (1968). Eland in the Thabanyama-Injasuti area of the Drakensberg. Unpublished report, Faculty of Agriculture, University of Natal.

Alexander, J. E. (1838). "An Expedition of Discovery into the Interior of Africa." Henry Colburn, London.

Anati, E. (1964). "Camonica Valley." Jonathan Cape, London.

Arbousset, T. (1846). "Narrative of an Exploratory Tour of the North-east of the Cape of Good Hope." Robertson and Solomon, Cape Town.

Backhouse, J. (1844). "A Narrative of a Visit to the Mauritius and South Africa." Hamilton, Adams, London.

Baines, T. (1864). "Exploration in South-west Africa." Longman, Roberts and Green.

Baines, T. (1964). "Journal of Residence in Africa, 1842-1853." (Kennedy, R. F., ed.). Van Riebeeck Society, Cape Town.

Balfour, H. (1909). Introduction to Tongue, H. "Bushman Paintings." Clarendon Press, London.

Barrow, J. (1801). "An Account of Travels into the Interior of Southern Africa." Cadell and Davies, London.

Barter, C. (1852). "The Dorp and the Veld, or Six Months in Natal." William S. Orr, London.

Battiss, W. W. (1939). "The Amazing Bushman: or, Art in South Africa." Red Fawn Press, Pretoria.

Battiss, W. W. (1942a). "South African Paint Pot." Red Fawn Press, Pretoria.

Battiss, W. W. (1942b). Aesthetic approach to Bushman art. S. Afr. Mus. Assoc. Bull., 2, 12, 300-304.

Battiss, W. W. (1948). "The Artists of the Rocks." Red Fawn Press, Pretoria.

Battiss, W. W. (1958). Prehistoric rock engravings and Bushman paintings. In (Grossert, J. W., ed.) "The Art of Africa." Shuter and Shooter, Pietermartizburg.

Battiss, W. W. (1971). The aesthetic value of our rock art. In (Schoonraad, M., ed.) "Rock Paintings of Southern Africa." S. Afr. Assoc. Adv. Sci., Sp. Pub. 2, Johannesburg.

Bertin, G. (1886). The Bushmen and their language. J. Roy. Asiatic Soc., 18, 51-81.

Biesele, M. (1974). A note on the beliefs of modern Bushmen concerning the Tsodilo Hills. Newletter of S. W. Afr. Sci. Soc., 15, 3/4, 1-3.

Biesele, M. (1975). Folklore and ritual of !Kung hunter-gatherers. Unpublished Ph.D. thesis, Harvard.

Biesele, M. (1979). Old K''xau. In (Halifax, J., ed.) "Shamanic Voices". Penguin Books, Harmondsworth.

Black, M. (1962). "Models and Metaphors." Cornell University Press, New York.

Bleek, D. F. (1924). "The Mantis and his Friends." Maskew Miller, Cape Town.

Bleek, D. F. (1927). The Distribution of Bushman languages in South Africa. In "Festschrift

Meinhof.'' Freiderichsen de Gruyter, Hamburg.

Bleek, D. F. (1928). ''The Naron, a Bushman tribe of the Central Kalahari.'' Cambridge University Press, Cambridge.

Bleek, D. F. (1929a). ''Comparative Vocabularies of Bushman languages.'' Cambridge University Press, Cambridge.

Bleek, D. F. (1929b). Bushman Folklore. *Africa,* **2**, 302-313.

Bleek, D. F. (1931). Customs and beliefs of the /Xam Bushmen. Part I: Baboons. *Bantu Studies,* **5**, 167-179.

Bleek, D. F. (1932). Customs and beliefs of the /Xam Bushmen. Part II: The Lion. Part III: Game Animals. Part IV: Omens, Wind-making, Clouds. *Bantu Studies,* **6**, 47-63, 233-249, 321-342.

Bleek, D. F. (1933). Beliefs and customs of the /Xam Bushmen. Part V: The Rain. Part VI: Rain-making. *Bantu Studies,* **7**, 297-312, 375-392.

Bleek, D. F. (1935). Beliefs and customs of the /Xam Bushmen. Part VII: Sorcerors. *Bantu Studies,* **9**, 1-47.

Bleek, D. F. (1936). Beliefs and customs of the /Xam Bushmen. Part VIII: More about Sorcerors and charms. *Bantu Studies,* **10**, 131-162.

Bleek, D. F. (1936). Special speech of animals and moon used by the /Xam Bushmen. *Bantu Studies,* **10**, 163-199.

Bleek, D. F. (1932a). A survey of our present knowledge of rock paintings in South Africa. *S. Afr. J. Sci.,* **29**, 72-83.

Bleek, D. F. (1932b). !Kun Mythology. *Zeitschrift für Eingeborenensprachen,* **25**, 4, 261-283.

Bleek, D. F. (1940). Introduction to van der Riet, J. and M. ''More Rock-paintings in South Africa.'' Methuen, London.

Bleek, D. F. (1956). ''A Bushman Dictionary.''

American Oriental Society, New Haven, Conn.

Bleek, W. H. I. (1874). Remarks on Orpen's 'Mythology of the Maluti Bushmen'. *Cape Monthly Mag.* (N.S.) **9**, 10-13.

Bleek, W. H. I. (1875). ''A Brief Account of Bushman Folklore and Other Texts.'' Government Printer, Cape Town.

Bleek, W. H. I. and Lloyd, L. (1870-1879). Manuscripts. Jagger Library, University of Cape Town.

Bleek, W. H. I. and Lloyd, L. C. (1911). ''Specimens of Bushman Folklore.'' Allen, London.

Blurton Jones, N., and Konner, M. J. (1976). !Kung knowledge of animal behavior. *In* (Lee, R. B. and De Vore, I. eds) ''Kalahari Hunter-gatherers.'' Harvard University Press, Cambridge.

Borcherds, P. B. (1861). ''An Autobiographical Memoir.'' Robertson, Cape Town.

Brentjes, B. (1969). ''African Rock Art.'' Dent, London.

Breuil, H. (1930). Premiers impressions de voyage sur la préhistoire Sud-Africaine. *L'Anthropologie,* **40**, 209-223.

Breuil, H. (1931). Review of Stow, G. W. Rock paintings in South Africa. *Nature,* **127**, 695-698.

Breuil, H. (1949). Some foreigners in the frescoes on rocks in southern Africa. *S. Afr. Archaeol. Bull.,* **4**, 39-50.

Brooks, H. (1876). ''Natal; A History and Description of the Colony.'' L. Reeve & Co., London.

Bryden, H. A. (1893). ''Gun and Camera in Southern Africa. A Year of Wanderings in Bechuanaland, the Kalahari desert, and the Lake River Country, Ngamiland.'' Edward Stanford, London.

Bryden, H. A. (1899). ''Great and Small Game of Africa.'' Rowland Ward, London.

Burchell, W. J. (1822). ''Travels in the Interior of Southern Africa.'' Longman, Hurst, Rees, London.

Burkitt, M. C. (1928). ''South Africa's Past in Stone and Paint.'' Cambridge University Press, Cambridge.

Butzer, K. W., Fock, G. J., Scott, L., Stuckenrath, R. (1979). Dating and context of rock engravings in southern Africa. *Science,* **203**, 1201-1214.

Callaway, G. (1969). ''The Fellowship of the Veld; Sketches of Kafir Life in South Africa.'' Negro Universities Press, New York.

Campbell, A., Hitchcock, R. and Bryan, M. (1980). Rock art at Tsodilo, Botswana. *S. Afr. Journ. Sci.,* **76**, 476-478.

Campbell, J. (1815). ''Travels in South Africa.'' London Missionary Society, London.

Campbell, J. (1822). ''Travels in South Africa: Second Journey.'' London Missionary Society, London.

Carter, P. L. (1970). Late Stone Age exploitation patterns in southern Natal. *S. Afr. Archaeol. Bull.,* **25**, 55-58.

Casalis, E. (1889). ''My Life in Basuto Land.'' The Religious Tract Society, London.

Chapman, J. (1868). ''Travels in the Interior of South Africa.'' Bell and Daly, London.

Chapman, J. (1971). ''Travels in the Interior of South Africa'' (Tabler, E. C., ed.) Balkema, Cape Town.

Christol, F. (1911). ''L'Art dans L'Afrique Australe.'' Berger-Levrault, Paris.

Collins, R., (1838). ''Journal of a Tour on the North-eastern Boundary, the Orange River, and the Storm Mountains, in 1809.'' *In* (Moodie,

D., ed.) The Record, 5, 1-60. Robertson, Cape Town.

Cooke, C. K. (1969). "Rock Art of Southern Africa." Books of Africa, Cape Town.

Cooke, C. K. (1970). Shelters for Late Stone Age man shown in the paintings of Rhodesia. *S Afr. Archaeol. Bull.*, **25**, 65-66.

Cumming, R. G. (1850). "Five Years of a Hunter's life in the Far Interior of South Africa." John Murray, London.

Currlé, L. C. (1913). Notes on Namaqualand Bushmen. *Trans. Roy. Soc. S. Afr.*, **3**, 113-120.

Deacon, H. J., Deacon, J. and Brooker, M. (1976). Four painted stones from Boomplaas Cave, Oudtshoorn district. *S. Afr. Archaeol. Bull.*, **31**, 141-145.

Denninger, E. (1971). The use of paper chromatography to determine the age of albuminous binders and its application to rock paintings. *In* (Schoonraad, M., ed.) "Rock Paintings of Southern Africa." S. Afr. Assoc. Adv. Sci., Sp. Pub. 2, Johannesburg.

Doke, C. M. (1936). Games, plays and dances of the ≠Khomani Bushmen. *Bantu Studies*, **10**, 461-471.

Dornan, S. S. (1909). Notes on the Bushmen of Basutoland. *Trans. S. Afr. Philos. Soc.*, **18**, 437-450.

Dornan, S. S. (1917). The Tati Bushmen (Masarwas) and their language. *J. Roy. Anthrop. Inst.*, **47**, 37-112.

Dornan, S. S. (1925). "Pygmies and Bushmen of the Kalahari." Seeley, Service and Co. Ltd, London.

Dunn, E. J. D. (1873). Through Bushmanland. *Cape Monthly Mag.*, **6**, 31-42.

Dunn, E. J. D. (1931). "The Bushman". Griffith, London.

Ellenberger, V. (1953). "La Fin Tragique des Bushmen." Amiot Dumont, Paris.

Ellenberger, D. F. and MacGregor, S. C. (1912). "The History of the Basuto: Ancient and Modern." Caxton, London.

Engelbrecht, J. A. (1936). "The Korana." Maskew Miller, Cape Town.

England, N. M. (1968). "Music in the Societies of Certain Bushman groups in Southern Africa." Unpublished Ph.D. thesis, Harvard University, Cambridge, Mass.

Estermann, C. (1976). In Gibson, G. D. (ed.) "The Ethnography of Southwestern Angola." Holmes and Meier, New York.

Evans, R. J. (1971). A draft scheme for computer processing of rock art data. *In* (Schoonraad, M., ed.) "Rock Paintings of Southern Africa." S. Afr. Assoc. Adv. Sci., Sp. Pub. 2, Johannesburg.

Fernandez, J. (1974). The mission of metaphor in expressive culture. *Current Anthropology*, **15**, 119-145.

Fock, G. J. (1971). Review of Holm, E. 1969. Die Felsbilder Südafrikas-Deutung und Bedeutung. *S. Afr. Archaeol. Bull.* **26**, 93-95.

Fourie, L. (1928). The Bushmen of South Africa. *In* (Hahn, C., ed.) "The Native Tribes of South West Africa." Cape Times, Cape Town.

Frere, H. B. (1882). On the laws affecting the relations between civilized and savage life, as bearing on the dealings of colonists with aborigines. *J. Anth. Inst.*, **11**, 313-352.

Frisch, R. E. (1975). Critical weights, a critical body composition, menarche and maintenance of menstrual cycles. *In* (Watts, E. *et al.*) "Biosocial Interrelations in Population Adaptation." Mouton, The Hague.

Frobenius, L. (1931). "Madsimu Dsangara." Atlantis-Verlag, Berlin.

Frobenius, L. (1973). Rock art in South Africa. *In* (Haberland, E., ed.) "Leo Frobenius, 1873-1973". Franz Steiner Verlag, Wiesbaden.

Goodwin, A. J. H. (1947). The bored stones of South Africa. *Ann. S. Afr. Mus.*, **37**, 1-20.

Grevenbroek, J. G. (1933). An account of the Hottentots (translated by Farrington, B.). *In* (Schapera, I., ed.) "The Early Cape Hottentots." Van Riebeeck Society, Cape Town.

Griaule, M. (1950). "Arts of the Africa Native." Thames and Hudson, London.

Gusinde, M. (1966). "Von Gelben und Schwarzen Buschmännern." Akademische Druck, Graz.

Hahn, T. (1881). "Tsuni-//Goam, the Supreme Being of the Khoi-Khoi." Trübner and Co., London.

Hammond, N. (1974). Palaeolithic mammalian faunas and parietal art in Cantabria: a comment on Freeman. *American Antiquity*, **39**, 4, 618-619.

Hanson, F. A. (1975). "Meaning in Culture." Routledge and Kegan Paul, London.

Harlow, M. A. B. (1967). A detailed study of the rock art of some sites in Basutoland with special attention to the identification of a stylistic succession. Unpublished M.Phil. thesis, University of London.

Harris, W. C. (1838). "Narrative of an Expedition into Southern Africa during the years 1836, and 1837." The American Mission Press, Bombay.

Heinz, H. (1966). The social organization of the !Kõ Bushmen. Unpublished M.A. thesis, University of South Africa, Pretoria.

Herbst, J. F. (1908). Report on the Rietfontein Area of the Kalahari. Imperial Blue Book [Cd. 4323].

Hobson, G. C. and Hobson, S. B. (1944). "Skankwan van die duine." Van Schaik, Pretoria.

Holm, E. (1961). The rock art of South Africa. *In* (Bandi, H-G., *et al.*) "The Art of the Stone Age." Methuen, London.

Holm, E. (1965). "Tier und Gott, Mythik, Mantik und Magie der Südafrikanischen Urjäger." Schwabe, Basle.

Holm, E. (1969). "Die Felsbilder Südafrikas— Deutung und Bedeutung." Wasmuth, Tübingen.

Holub, E. (1881). On the central South African tribes from the South Coast to the Zambesi. *J. Anth. Inst.,* **10,** 2-19.

Holz, P. (1957). Cave paintings in South Africa, *Contemporary Review,* **192,** 162-5.

How, M. W. (1962). "The Mountain Bushmen of Basutoland." J. L. van Schaik, Pretoria.

Hubert, H. and Mauss, M. (1964). "Sacrifice: its Nature and Function." Cohen and West, London.

Humphrey, C. (1971). Some ideas of Saussure applied to Buryat magical drawings. *In* (Ardener, E., ed.) "Social Anthropology and Language." Tavistock, London.

Humphreys, A. J. B. (1974). A preliminary report on test excavations at Dikbosch Shelter I, Herbert District, northern Cape. *S. Afr. Archaeol. Bull.,* **29,** 115-119.

Humphreys, A. J. B. and Maggs, T. M. O'C. (1970). Further graves and cultural material from the banks of the Riet River. *S. Afr. Archaeol. Bull.,* **25,** 116-126.

Hutchinson, M. (1883). Notes on a collection of facsimile Bushman drawings. *J. Roy. Anthrop. Inst.,* **12,** 464-465.

Jeffreys, M. D. W. (1968). Bushman circumcision. *Afr. Stud.,* **27,** 144.

Jenkins, T. and Tobias, P. V. (1977). Nomenclature of population groups in southern Africa. *Afr. Stud.,* **36,** 49-55.

Johnson, J. P. (1910). "Geological and Archeological Notes on Orangia." Longmans, Green, & Co., London.

Katz, R. (1976a). Education for transcendence. *In* (Lee, R. B. and De Vore, I., eds) "Kalahari Hunter-Gatherers." Harvard University Press, Cambridge, Mass.

Katz, R. (1976b). The painful ecstasy of healing. *Psychology Today,* **10,** 7, 81-86.

Kennan, T. B. (1959). Notes on a journey round Basutoland by T. B. Kennan. *Lesotho,* **1,** 38-48.

Kina-Ha (1877). A contribution from a Bushman. *Orange Free State Monthly Magazine,* **1,** 83-85.

Kling, H. (1932). "Onder die Kindere van Cham." Nasionale Pers, Cape Town.

Klingender, F. (1971). "Animals in Art and Thought to the End of the Middle Ages." Routledge and Kegan Paul, London.

Köhler, O. (1966). Die Wortbeziehungen zwischen der Sprache der Kxoe-Buschmänner und dem Hottentottischen als geschichtliches Problem. *Hamburger Beiträge zur Afrika-Kunde,* **5,** 144-165.

Kolben, P. (1731). "The Present State of the Cape of Good-Hope." W. Innys, London.

Laming-Emperaire, A. (1962). "Le Signification de l'Art Rupestre Paléolithique." Paris.

Lang, A. (1899). "Myth, Ritual and Religion." Longmans, Green, London.

Laydevant, F. (1933). The praises of the divining bones among the Basotho. *Bantu Studies,* **8,** 341-373.

Leach, E. R. (1976). "Culture and Communication." Cambridge University Press, Cambridge.

Lee, D. N. and Woodhouse, H. C. (1964). Rock paintings of flying buck. *S. Afr. Archaeol. Bull.,* **19,** 71-74.

Lee, D. N. and Woodhouse, H. C. (1968). More rock paintings of flying buck. *S. Afr. Archaeol. Bull.,* **23,** 13-16.

Lee, D. N. and Woodhouse, H. C. (1970). "Art on the Rocks of Southern Africa." Purnell, Cape Town.

Lee, R. B. (1967). Trance cure of the !Kung Bushmen. *Natural History,* **76,** 9, 31-37.

Lee, R. B. (1968). The sociology of !Kung Bushman trance performance. *In* (Prince, R. ed.) "Trance and Possession States." R. M. Bucke Memorial Society, Montreal.

Lee, R. B. (1969). Eating Christmas in the Kalahari. *Natural History,* **78,** 40, 14-22 and 60-62.

Lee, R. B. (1979). "The !Kung San: Men, Women and Work in a Foraging Society." Cambridge University Press, Cambridge.

Lee, R. B. and De Vore, I. (eds) (1976). "Kalahari hunter-gatherers." Harvard University Press, Cambridge.

Leroi-Gourhan, A. (1968). "The Art of Prehistoric Man in Western Europe." Thames and Hudson, London.

Leslie, L. (1828). Some remarks on the Bushmen of the Orange River. *Edinburgh New Phil. Journ.,* April, 79-82.

Le Vaillant, F. (1796). "New Travels into the Interior Parts of Africa, by Way of the Cape of Good Hope, in the Years 1783, 84 and 85." J. Robinson, London.

Lévi-Strauss, C. (1968). "Structural Anthropology." Allen Lane, London.

Lewis, C. T. and Short, C. (1958). "A Latin Dictionary." Clarendon Press, Oxford.

Lewis, I. M. (1971). "Ecstatic Religion." Penguin Books, London.

Lewis-Williams, J. D. (1972). The syntax and

function of the Giant's Castle rock paintings. *S. Afr. Archaeol. Bull.*, **27**, 49-65.

Lewis-Williams, J. D. (1974a). Superpositioning in a sample of rock paintings from the Barkly East district. *S. Afr. Archaeol. Bull.*, **29**, 93-103.

Lewis-Williams, J. D. (1974b). Re-thinking South African rock art. *Origini*, **8**, 229-257.

Lewis-Williams, J. D. (1975). The Drakensberg rock paintings as an expression of religious thought. *In* (Anati, E., ed.) "Les Religions de La Préhistoire." Centro Communo di Studi Preistorici, Capo di Ponte.

Lewis-Williams, J. D. (1976). Review of 'People of the Eland'. *Natalia*, **1**, 6, 53-54.

Lewis-Williams, J. D. (1977a). Ezeljagdspoort revisited: new light on an enigmatic rock painting. *S. Afr. Archaeol. Bull.*, **32**, 165.

Lewis-Williams, J. D. (1977b). Led by the nose: observations on the supposed use of southern San rock art in rain-making rituals. *Afr. Stud.*, **36**, 155-159.

Lewis-Williams, J. D. (1980). Ethnography and iconography: aspects of southern San thought and art. *Man*, **15**, 467-482.

Lewis-Williams, J. D. (1981). The thin red line: southern San notions and rock paintings of supernatural potency. *S. Afr. Archaeol. Bull.* (In press).

Lewis-Williams, J. D. and Biesele, M. (1978). Eland hunting rituals among northern and southern San groups: striking similarities. *Africa*, **48**, 117-134.

Lewis-Williams, J. D., Butler-Adam, J. F. and Sutcliffe, M. O., (1979). Some conceptual and statistical difficulties in the interpretation of southern San rock art. *S. Afr. Journ. Sci.*, **75**, 211-214.

Lichtenstein, H. (1928). "Travels in southern Africa in the years 1803, 1804, 1805 and 1806." (Plumptre, A., ed.). Van Riebeeck Society, Cape Town.

Lienhardt, G. (1954). The Shilluk of the Upper Nile. *In* (Forde, D., ed.) "African Worlds." Oxford University Press, London.

Lloyd, L. (1889). "A short account of further Bushman material collected." David Nutt, London.

Lowie, R. H. (1952). "Primitive Religion." Peter Owen, London.

Mackenzie, J. (1871). "Ten years north of the Orange River: a story of everyday life and work among the South African tribes from 1859-1869." Frank Cass and Co., London.

Mackenzie, J. (1883). "Day-dawn in dark places." Cassell, London.

Maggs, T. M. O'C. (1967). A quantitative analysis of the rock art from a sample area in the western Cape. *S. Afr. Journ. Sci.*, **63**, 3, 100-104.

McCall, D. F. (1970). Wolf courts girl: The equivalence of hunting and mating in Bushman thought. Ohio University Papers in International Studies, Africa Series, No. 7.

Marshall, L. (1957). N!ow. *Africa*, **27**, 3, 232-240.

Marshall, L. (1959). Marriage among !Kung Bushmen. *Africa*, **29**, 4, 335-365.

Marshall, L. (1960). !Kung Bushman bands. *Africa*, **30**, 4, 325-355.

Marshall, L. (1961). Sharing, talking, and giving: relief of social tensions among !Kung Bushmen. *Africa*, **31**, 3, 231-249.

Marshall, L. (1962). !Kung Bushman religious beliefs. *Africa*, **32**, 3, 221-251.

Marshall, L. (1966). The !Kung Bushmen of the Kalahari Desert. *In* (Gibbs, J. L., ed.) "Peoples of Africa." Holt, Rinehart and Winston, New York.

Marshall, L. (1969). The medicine dance of the !Kung Bushmen. *Africa*, **39**, 4, 347-381.

Marshall, L. (1976). "The !Kung of Nyae Nyae." Harvard University Press, Cambridge, Mass.

Mason, A. Y. (1933). Rock paintings in the Cathkin Peak area, Natal. *Bantu Studies*, **7**, 2, 131-159.

Mason, R. J. (1954). A burial site at Driekops-eiland. *S. Afr. Archaeol. Bull.*, **9**, 134.

Meiring, A. J. D. (1943). Masarwa engraved egg-shell. *S. Afr. Journ. Sci.*, **40**, 328.

Meiring, A. J. D. (1945). The significance of the engraving of Masarwa eggshells. *Fort Hare Papers*, **1**, 1, 3-8.

Meiring, A. J. D. (1951). Some more egg-shell engraving. *Fort Hare Papers*, **1**, 5, 255-256.

Methuen, H. H. (1846). "Life in the Wilderness." R. Bentley, London.

Metzger, F. (1950). "Narro and his Clan." John Meinert, Windhoek.

Moffat, R. (1842). "Missionary labours and Scenes in South Africa." John Snow, London.

Mohr, E. (1876). "To the Victoria Fall of the Zambesi." Sampson Low, Morton, Searle and Rivington, London.

Morris, C. (1946). "Signs, Language and Behaviour." George Braziller, New York.

Morris, C. (1964). "Signification and Significance." The M.I.T. Press, Cambridge, Mass.

Morrison, J. C. (1975). Aspects of Bushman settlement and subsistence at Game Pass. Unpublished research essay, University of Natal, Pietermaritzburg.

Moszeik, O. (1910). "Die Malereien der Buschmänner in Südafrika." Dietrich Reimer, Berlin.

Munn, N. D. (1973). "Walbiri Iconography: Graphic Representation and Cultural Sym-

bolism in a Central Australian Society.'' Cornell, London.

Nagel, E. (1956). ''Logic without Metaphysics and Other Essays.'' Free Press, Glencoe, Ill.

Obermaier, H. and Kühn, H. (1930). ''Bushman Art. Rock Paintings of South-west Africa.'' University Press, Oxford.

Orpen, J. M. (1874). A glimpse into the mythology of the Maluti Bushmen. *Cape Monthly Mag. (N.S.)* **9**, 49, 1-13.

Ortego, F. (1956). Escenas de Lidia en el arte rupestre. *Congr. int. Ciene. prehist. protohist.,* **4**, 323-9.

Pager, H. (1969). Review of 'Von gelben und schwarzen Bushmännern' by M. Gusinde. *S. Afr. Archaeol. Bull.,* **24**, 75-77.

Pager, H. (1971). ''Ndedema.'' Akademische Druck, Graz.

Pager, H. (1973). Shaded rock-paintings in the Republic of South Africa, Lesotho, Rhodesia and Botswana. *S. Afr. Archaeol. Bull.,* **28**, 39-46.

Pager, H. (1975a). ''Stone Age Myth and Magic.'' Akademische Druck, Graz.

Pager, H. (1975b). The antelope cult of the prehistoric hunters of South Africa. *In* (Anati, E., ed.) ''Les Religions de la Préhistoire.'' Centro Comuno di Studi Preistorici, Capo di Ponte.

Panofsky, E. (1970). ''Meaning in the Visual Arts.'' Penguin Books, London.

Paravicini Di Capelli, W. B. E. (1965). ''Reize in de binnen-landen van Zuid-Africa gedaan in den jaare 1803.'' (de Kock, W. J., ed.). Van Riebeeck-Vereniging, Cape Town.

Parkington, J. (1969). Symbolism in palaeolithic cave art. *S. Afr. Archaeol. Bull.,* **24**, 3-13.

Parrinder, G. (1967). ''African Mythology.'' Paul Hamlyn, London.

Peirce, C. (1931—35). ''Collected papers of Charles Sanders Peirce.'' (Hartshorne, C. and Weiss, P., eds) Harvard University Press, Cambridge, Mass.

Philip, J. (1828). ''Researches in South Africa.'' James Duncan, London.

Philip, J. (1842). South Africa. *Missionary Mag. and Chron.,* **6**, 183-184.

Potgieter, E. F. (1955). ''The Disappearing Bushmen of Lake Chrissie.'' Van Schaik, Pretoria.

Reichlin, S. and Marshall, J. (1974). ''An Argument about a Marriage: Study Guide.'' Documentary Educational Resources, Inc., Somerville, Mass.

Report (1883). Report and proceedings of the Government Commission on Native laws and customs. G. 4-1883. Govt. Printer, Cape Town.

Roberts, A. (1951). ''The Mammals of South Africa.'' Central News Agency, Cape Town.

Robertson-Smith, W. (1927). ''Religion and the Semites.'' Black, London.

Rosenthal, E., and Goodwin, A. J. H. (1953). ''Cave Artists of South Africa.'' Balkema, Cape Town.

Rudner, I. (1965). Archaeological report on the Tsodilo Hills, Bechuanaland. *S. Afr. Archaeol. Bull.,* **20**, 51-70.

Rudner, I. (1970). Nineteenth-century Bushman drawings. *S. Afr. Archaeol. Bull.,* **25**, 147-154.

Rudner, J. (1957). The Brandberg and its archaeological remains. *J. S. W. Afr. Sci. Soc.,* **12**, 7-44.

Rudner, J. and Rudner, I. (1968). Rock-art in the Thirstland areas. *S. Afr. Archaeol. Bull.,* **23**, 75-89.

Rudner, J. and I. (1970). ''The Hunter and his Art.'' Struik, Cape Town.

Schapera, I. (1930). ''Khoisan Peoples of South Africa.'' Routledge and Kegan Paul, London.

Schmidt, S. (1973). Die Mantis religiosa in den Glaubensvorstellungen der Khoesan-Völker. *Zeitschrift für Ethnologie,* **98**, 1, 102-127.

Schmidt, S. (1979). The rain bull of the South African Bushman. *Afr. Stud.,* **38**, 201-224.

Schofield, J. F. (1949). Four debatable points. *S. Afr. Archaeol. Bull.,* **4**, 98-106.

Schoonraad, M. (1965). Ons rotskuns — kopieë vanaf fotos. *S. Afr. Journ. Sci.,* **61**, 11, 392-394.

Selous, F. C. (1893). ''Travel and Adventure in South-east Africa.'' Rowland Ward, London.

Shaw, B. (1820). ''Memorials of South Africa.'' Reprinted 1970. Struik, Cape Town.

Shaw, E. M., and Woolley, P. L. (1963). Bushman arrow poisons. *Cimbebasia,* **7**, 2-41.

Shortridge, G. C. (1934). ''The Mammals of South West Africa.'' Heinemann, London.

Silberbauer, G. B. (1965). ''Bushman Survey.'' Bechuanaland Government, Gaberones.

Singer, R. and Wymer, J. (1969). Radiocarbon date for two painted stones from a coastal cave in South Africa. *Nature,* **224**, 508-510.

Smith, A. (1939—1940). ''The Diary of Dr Andrew Smith 1834-1836'' (Kirby, P. R., ed.). Van Riebeeck Society, Cape Town.

Smits, L. G. A. (1971). The rock paintings of Lesotho, their content and characteristics. *In* (Schoonraad, M., ed.) ''Rock Paintings of Southern Africa.'' S. Afr. Assoc. Adv. Sci., Sp. Pub. 2, Johannesburg.

Smits, L. G. A. (1973). Rock-painting sites in the upper Senqu Valley, Lesotho. *S. Afr. Archaeol. Bull.,* **28**, 32-28.

Smuts, T. (1973). Rock paintings of the south western Cape: an investigation of the principal artistic features. Unpublished M.A. (Fine Art) thesis, University of Cape Town.

Snyman, J. W. (1974). The Bushman and

Hottentot languages of southern Africa. *Bull. Dept. Bantu Lang.*, **2**, 2, 28-44.

Sparrman, A. (1789). "A Voyage to the Cape of Good Hope." Lackington, London.

Sperber, D. (1975). "Rethinking Symbolism." Cambridge University Press, Cambridge.

Spohr, O. H. (1962). "Wilhelm Heinrich Immanuel Bleek: a Bio-bibliographical Sketch." Varia Series No. 6. University of Cape Town, Cape Town.

Stainthorpe, H. L. (1972). Observations on captive eland in the Loteni Nature Reserve. *Lammergeyer*, **15**, 27-38.

Stanford, W. E. (1910). Statement of Silayi with reference to his life among Bushmen. *Trans. Roy. Soc. S. Afr.*, **1**, 435-440.

Stanford, W. E. (1962). "The Reminiscences of Sir Walter Stanford." Vol. II. (Macquarrie, J. W., ed.). Van Riebeeck Society, Cape Town.

Steedman, A. (1835). "Wanderings and Adventures in the Interior of Southern Africa." Longmans, London.

Stevens, A. (1975). Animals in palaeolithic cave art: Leroi-Gourhan's hypothesis. *Antiquity*, **49**, 193, 54-57.

Stevenson-Hamilton, J. (1912). "Animal Life in Africa." Heinemann, London.

Steyn, H. P. (1971). Aspects of the economic life of some nomadic Nharo Bushman groups. *Ann. S. Afr. Mus.*, **56**, 6, 275-322.

Stopa, R. (1959). Bushman texts. *Folia orientalia*, **1**, 105-127.

Stow, G. W. (1874). Account of an interview with a tribe of Bushmans in South Africa. *J. Anthrop. Instit*, **3**, 244-247.

Stow, G. W. (1905). "The Native Races of South Africa." Swan, Sonneschein, London.

Stow, G. W. (1930). "Rock Paintings in South Africa." Methuen, London.

Tanaka, J. (1969). The ecology and social structure of central Kalahari Bushmen; a preliminary report. *Kyoto University African Studies*, **3**, 1-20.

Ten Raa, E. (1971). Dead art and living society: a study of rockpaintings in a social context. *Mankind*, **8**, 42-58.

Thomas, E. Marshall (1969). "The Harmless People." Penguin Books, London.

Thompson, G. (1967). "Travels and Adventures in Southern Africa (1827)" (Forbes, V. S., ed.). Van Riebeeck Society, Cape Town.

Thunberg, C. P. (1796). "Travels in Europe, Africa and Asia made between the years 1770 and 1779." F. and C. Rivington, London.

Tindall, H. (1856). "Two Lectures on Great Namaqualand and its Inhabitants." Pike, Cape Town.

Tindall, J. (1959). "The Journal of Joseph Tindall, Missionary in South West Africa, 1839-1855." (Tindall, B. A., ed.). Van Riebeeck Society, Cape Town.

Tobias, P. V. (1957). Bushmen of the Kalahari. *Man*, **57**, 33-40.

Tobias, P. V. (ed.) (1979). "The Bushmen." Human and Rousseau, Cape Town.

Tongue, H. (1909). "Bushman Paintings," with a preface by Henry Balfour. Clarendon Press, London.

Traill, A. (1973). 'N4 or S7?': Another Bushman language. *Afr. Stud.*, **32**, 1, 25-32.

Traill, A. (1974). Westphal on 'N4 or S7?': a reply. *Afr. Stud.* **33**, 4, 249-255.

Traill, A. (1979). The languages of the Bushmen. *In* (Tobias, P. V., ed.). "The Bushmen." Human and Rousseau, Cape Town.

Trenk, P. (1910). Die Buschleute der Namib, ihre Rechts — und Familienverhältnisse. *Mitt. deuts. Schutzgeb.*, **23**, 166-170.

Turner, V. W. (1966). The syntax of symbolism in an African religion. *Philos. Trans. Roy. Soc.*, b, **251**, 295-303.

Turner, V. W. (1967). "The Forest of Symbols: Aspects of Ndembu Ritual." Cornell, New York.

Tylden, G. (1946). Bantu shields. *S. Afr. Archaeol. Bull.*, **1**, 33-37.

Ucko, P. J. and Rosenfeld, A. (1967). "Palaeolithic Cave Art." World University Library, London.

Van der Post, L. (1971). "The Heart of the Hunter." Penguin Books, London.

Van Reenen, R. J. (1920). "Iets oor die Boesmankultuur." De Nationale Pers, Bloemfontein.

Van Riet Lowe, C. (1931). An illustrated analysis of prehistoric rock paintings from Pelzer's Rust. *Trans. Roy. Soc. S. Afr.*, **20**, 51-56.

Van Riet Lowe, C. (1941). "Prehistoric Art in South Africa: Archaeological Series No. V." Bureau of Archaeology, Pretoria.

Van Riet Lowe, C. (1946). Shields in South African rock paintings. *S. Afr. Archaeol. Bull.*, **1**, 38-40.

Van Riet Lowe, C. (1956). "The Distribution of Prehistoric Rock Engravings and Paintings in South Africa: Archaeological Series No. VII." Archaeological Survey, Pretoria.

Vedder, H. (1938). "South West Africa in Early Times." (Transl. of 'Das alte Südwestafrika' by Hall, C. G.). Humphrey Milford, London.

Vinnicombe, P. (1967). Rock Painting analysis. *S. Afr. Archaeol. Bull.*, **22**, 129-141.

Vinnicombe, P. (1971). A Bushman hunting kit from the Natal Drakensberg. *Ann. Natal Mus.*,

20, 3, 611-625.

Vinnicombe, P. (1972a). Myth, motive, and selection in southern African rock art. *Africa*, **42**, 3, 192-204.

Vinnicombe, P. (1972b). Motivation in African rock art. *Antiquity, 46*, 124-133.

Vinnicombe, P. (1975). The ritual significance of eland (taurotragus oryx) in the rock art of southern Africa. *In* (Anati, E., ed.). "Les Religions de la Préhistoire." Centro Preistorici, Capo di Ponte.

Vinnicombe, P. (1976). "People of the Eland." Natal University Press, Pietermartizburg.

Von Luschan, F. (1923). Buschman—Einritzungen auf Strausseneiern. *Zeitschrift f. Ethnologie*, **55**, 31-40.

Von Wielligh, G. R. (1921). "Boesman-Stories." De Nationale Pers, Kaapstad.

Walton, J. (1957). The rock paintings of Basutoland. *In* (Clark, J. D. and Cole, S., eds). "Third Pan-African Congress on Prehistory." Chatto and Windus, London.

Wells, L. H. (1933). The archaeology of Cathkin Park. *Bantu Studies*, **7**, 113-29.

Wendt, W. E. (1972). Preliminary report on an archaeological research programme in South West Africa. *Cimbebasia*, Ser. B, **2**, 1, 1-61.

Wendt, W. E. (1974). 'Art mobilier' aus der Apollo 11-Grotte in Südwest-Afrika. *Acta Praehistorica et Archaeologica*, **5**, 1-42.

Wendt, W. E. (1976). 'Art mobilier' from Apollo 11 Cave, South West Africa: Africa's oldest dated works of art. *S. Afr. Archaeol. Bull.*, **31**, 5-11.

Werner, A. (1908). Bushman paintings. *Journ. Roy. Afr. Soc.*, **7**, 387-393.

Westphal, E. O. J. (1963). The linguistic prehistory of southern Africa. *Africa, 33*, 237-264.

Westphal, E. O. J. (1971). The click languages of South and east Africa. *In* (Berry, J. and Greenberg, J. H., eds). "Linguistics in Subsaharan Africa," Vol. 7 (Sebeok, T., ed.), "Current Trends in Linguistics." Mouton, The Hague.

Widdicombe, J. (1891). "Fourteen Years in Basutoland." The Church Printing Co., London.

Wikar, H. J. (1935). "The Journal of Hendrik Jacob Wikar, 1779." (van der Horst, A. W., ed.). Van Riebeeck Society, Cape Town.

Willcox, A. R. (1955). The shaded polychrome paintings of South Africa: their distribution, origin and age. *S. Afr. Archaeol. Bull.*, **10**, 10-14.

Willcox, A. R. (1956). "Rock Paintings of the Drakensberg." Parrish, London.

Willcox, A. R. (1963). "The Rock Art of South Africa." Nelson, London.

Willcox, A. R. (1971). Summary of Dr Denniger's report on the ages of paint samples taken from rock paintings in South and South West Africa. *In* (Schoonraad, M., ed.). "Rock Paintings of Southern Africa." S. Afr. Assoc. Adv. Sci., Sp. Pub. 2, Johannesburg.

Willcox, A. R. (1972). So-called 'infibulation' in rock art. *S. Afr. Archaeol. Bull.*, **27**, 83.

Willcox, A. R. (1973). "Rock Paintings of the Drakensberg" (second edition). Struik, Cape Town.

Willcox, A. R. (1976). "Southern Land." Purnell, Cape Town.

Willcox, A. R. (1978a). So-called 'infibulation' in African rock art: a group research project. *Afr. Stud.*, **37**, 203-226.

Willcox, A. R. (1978b). An analysis of the function of rock art. *S. Afr. Journ. Sci.*, **74**, 59-64.

Willis, R. (1974). "Man and Beast." Hart Davis, London.

Wilman, M. (1910). Notes on some Bushman paintings in the Thaba Bosigo district, Basutoland. *Rep. S. Afr. Assoc. Adv. Sci.*, **7**, 417-421.

Wilman, M. (1968). "The Rock-engravings of Griqualand West and Bechuanaland, South Africa." (First ed. 1933, Deighton Bell, Cambridge). Balkema, Cape Town.

Woodhouse, H. C. (1964). How cunning were the Bushmen hunters? *Sci. S. Afr.*, **1**, 303-304.

Woodhouse, H. C. (1969). Rock paintings of 'eland-fighting' and 'eland-jumping'. *S. Afr. Archaeol. Bull.*, **94**, 63-65.

Woodhouse, H. C. (1970). Three widely distributed features depicted in rock paintings of people in southern Africa. *S. Afr. Journ. Sci.*, **66**, 2, 51-55.

Woodhouse, H. C. (1971a). Strange relationships between men and eland in the rock paintings of South Africa. *S. Afr. Journ. Sci.*, **67**, 6, 345-8.

Woodhouse, H. C. (1971b). A remarkable kneeling posture of many figures in the rock art of South Africa. *S. Afr. Archaeol. Bull.*, **26**, 128-131.

Woodhouse, H. C. (1971c). "Archaeology in Southern Africa." Purnell, Cape Town.

Woodhouse, H. C. (1975). Enigmatic line feature in the rock paintings of southern Africa. *S. Afr. Journ. Sci.*, **71**, 121-125.

Wright, J. B. C. (1971). "Bushman Raiders of the Drakensberg." University of Natal Press, Pietermaritzburg.

Young, R. B. (1908). "The Life and Work of George William Stow." Longmans, Green and Co., London.

Index

STUDIES IN ANTHROPOLOGY

Under the Consulting Editorship of E. A. Hammel,
UNIVERSITY OF CALIFORNIA, BERKELEY